HAUNTED
PLACES

HAUNTED PLACES

ROBERT GRENVILLE

amber
BOOKS

Published by
Amber Books Ltd
74–77 White Lion Street
London
N1 9PF
United Kingdom
www.amberbooks.co.uk
Appstore: itunes.com/apps/amberbooksltd
Facebook: www.facebook.com/amberbooks
Twitter: @amberbooks

ISBN: 978-1-78274-521-1

Project Editor: Sarah Uttridge
Designer: Mark Batley
Picture Research: Terry Forshaw

Printed in China

Contents

Introduction

Do ghosts exist? Are hauntings real? Can the spirits of the dead interact with the living? If you are seeking a definitive answer to any of these questions, then this is not the book for you. However, if you wish to conduct your own investigation, then within this volume you will find a catalogue of locations from private homes to abandoned institutions where some believe paranormal activity to take place. Why not visit and come to your own decision?

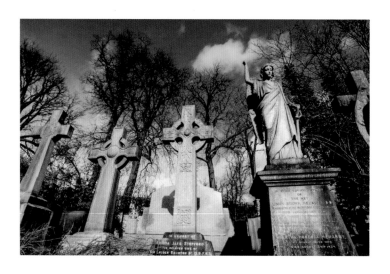

For readers of a less active disposition, this book brings you images and stories from around the world of apparent hauntings and supernatural events. Some of the stories related here are horrific and barbarous in nature, including actions that would be regarded as crimes worthy of the highest sanction, yet they were condoned or even encouraged by official bodies at the time. Other events are tragic accidents, with no blame attached to the living or the dead.

Whether you are a believer or not, read on and discover a world of unexplained occurrences and strange tales.

ABOVE:
Highgate Cemetery, London, UK
RIGHT:
Bran Castle, Brasov, Romania

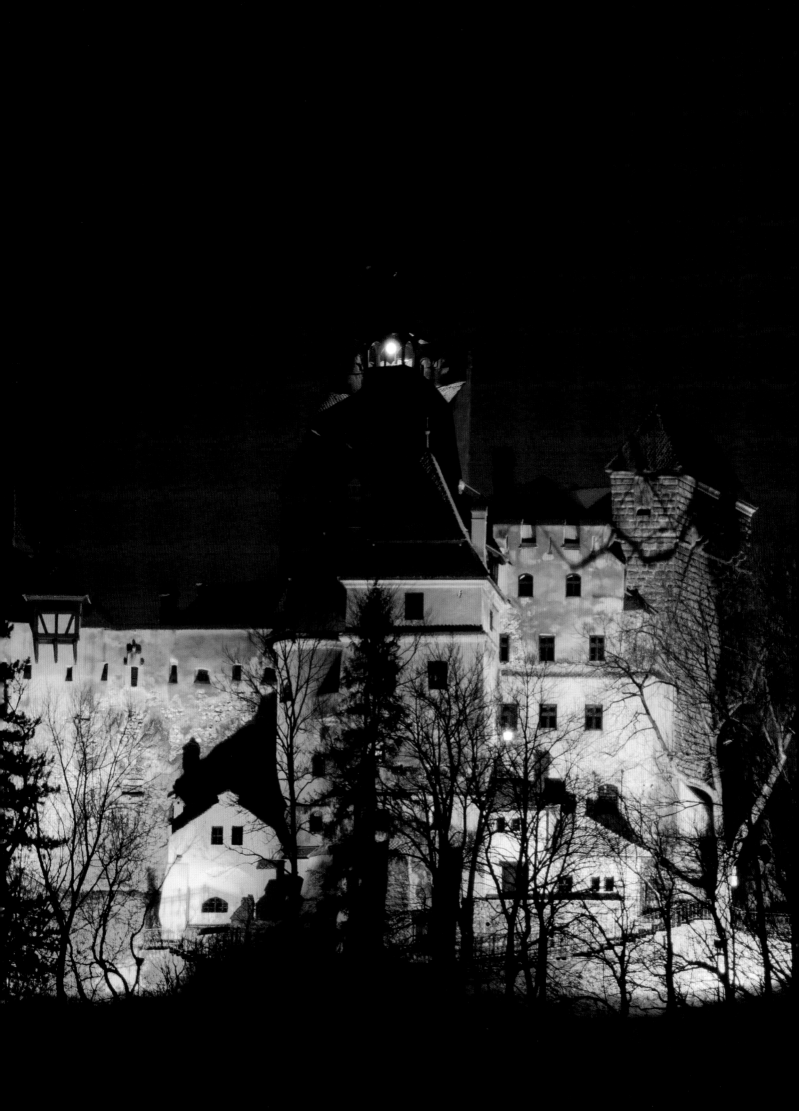

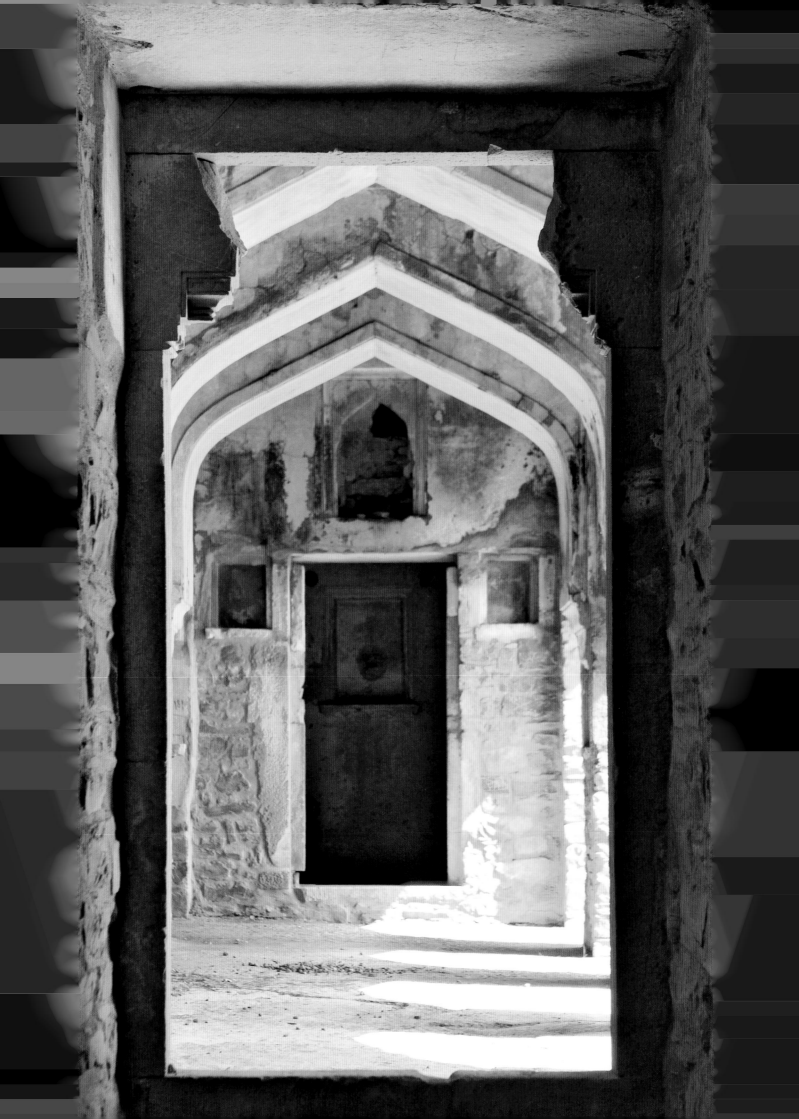

Castles & Forts

Castles belong to an age of chivalry, adventure and good deeds performed by pious armoured knights – but they also belong to an age of poor sanitation, primitive medicine and the regular use of torture. To live in the Middle Ages was to live in a time of danger, at risk of death from disease and starvation as much as from battle or violent robbery. This was the age of Vlad the Impaler, a man notorious for his cruelty to his thousands of victims, and robber barons who stole from the rich and poor alike. Many castles contained dungeons for imprisoning criminals and hostages, while executions were carried out in the courtyards of these great community buildings. During sieges, the occupants of a castle would be forced to live in dirty conditions, with little fresh food and water available. Even after castles had become obsolete for their main purpose as defensive strongholds, their strong walls and garrisons made them ideal for conversion to prisons. Given their long, rich history, and the fact that many are now visited each year by thousands of tourists, it is unsurprising to discover that many castles have at least one ghost story attached to them. Dungeons are cold, dark places – perhaps they attract the spirits of those who once perished there, or perhaps they cannot escape their chains even after death?

LEFT:
Bhangarh Fort, Rajasthan, India
Reputedly the most haunted spot in the whole of India, Bhangarh Fort was supposedly either cursed by a *sadhu* (holy man) whose house it overshadowed, or by a black magician who was crushed to death by a boulder enchanted by one of his own love potions. The Archeological Survey of India has erected a sign outside the gate forbidding anyone to stay inside the fort during the hours of darkness. It is said that those who have tried have never been seen again.

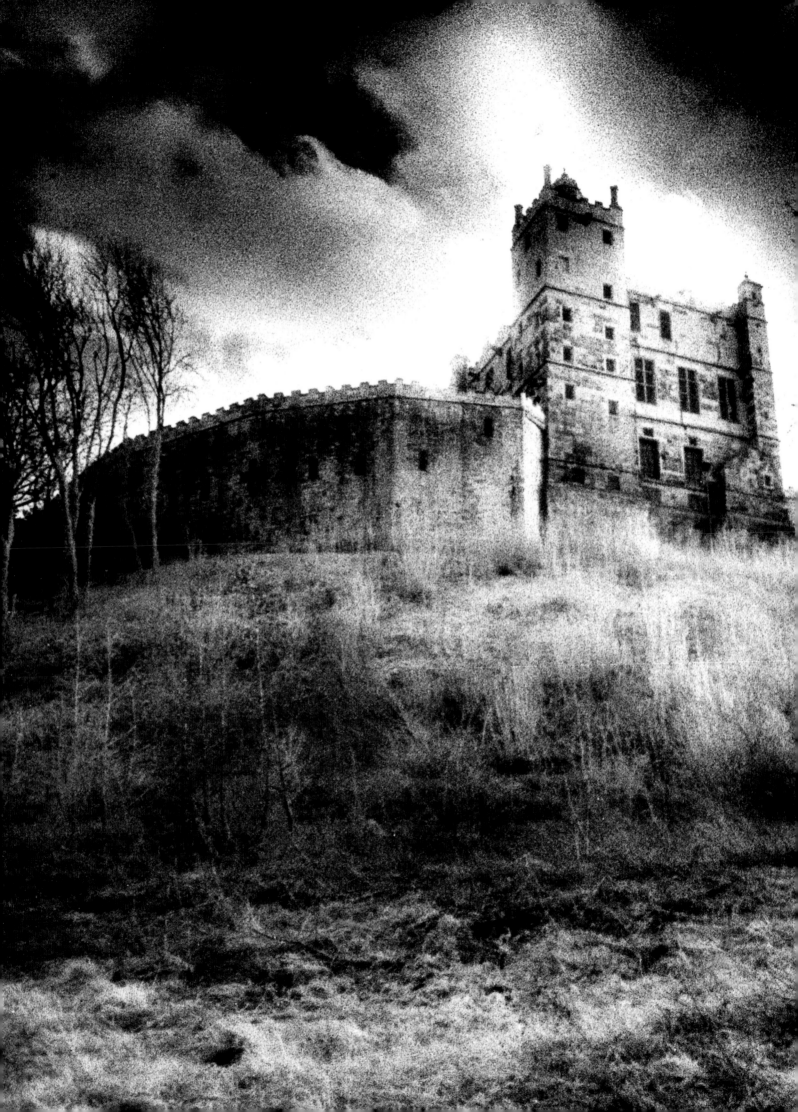

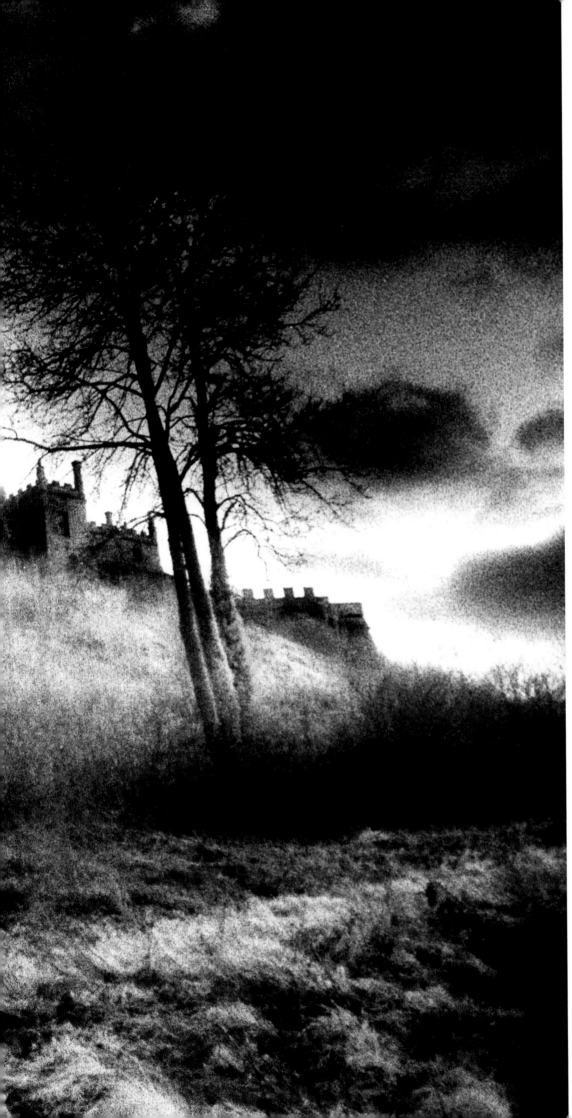

Bolsover Castle, Derbyshire, UK
Surrounded by burial grounds and pits full of plague victims, Bolsover has a long history of sightings of unusual phenomena. Builders and security guards have resigned after seeing lights and hearing noises, while items left in locked rooms have moved during the night. A 'Grey Lady' is reported to haunt the grounds, and a ghostly child will hold the hands of visitors to the castle's gardens.

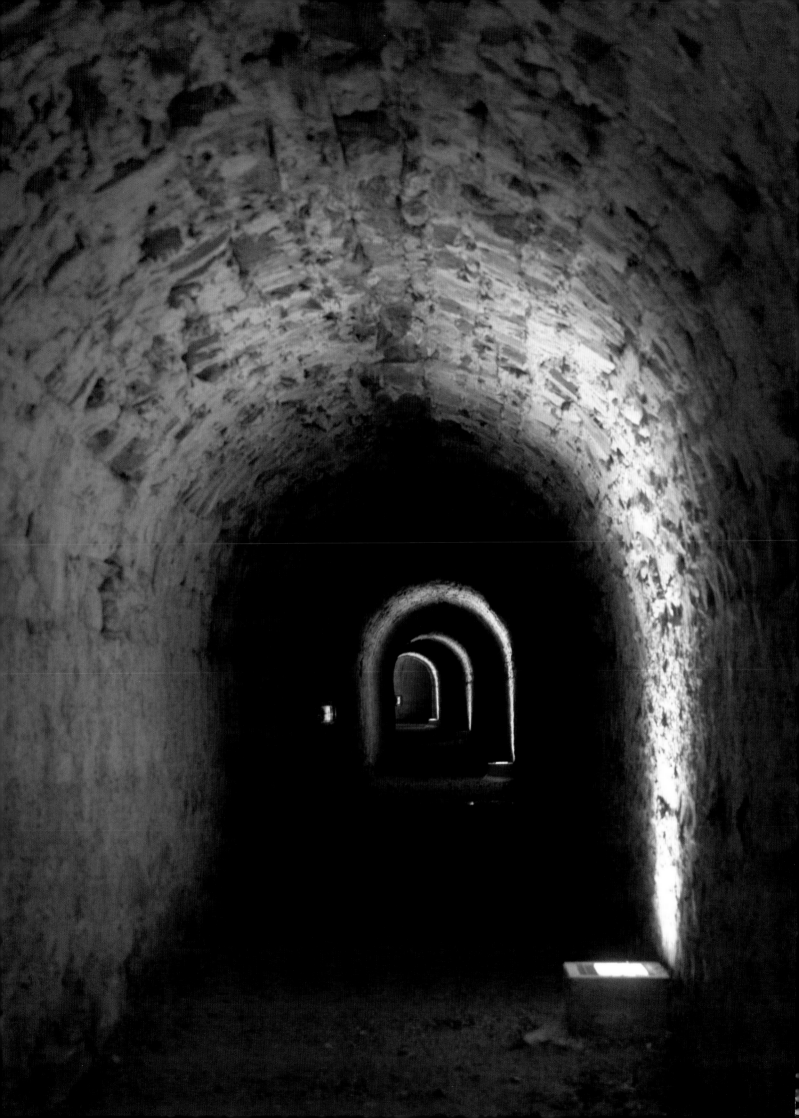

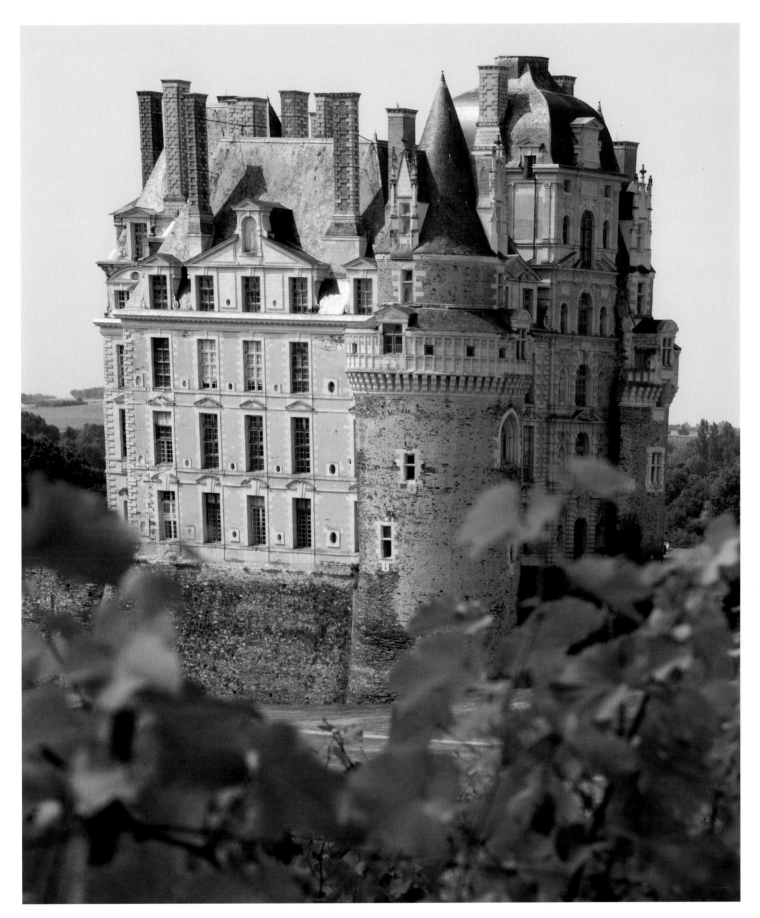

LEFT:

Tunnel, Château de Brissac, Angers, France

A 'Green Lady' has haunted the château since her murder in the 15th century. It is said Charlotte de Brézé was caught cheating with her lover by her husband Jacques.

ABOVE:

Château de Brissac, Angers, France

In a fit of rage, Jacques killed both of them. Charlotte is now seen dressed in her favourite green dress, but her face is that of a corpse, with holes in place of her eyes.

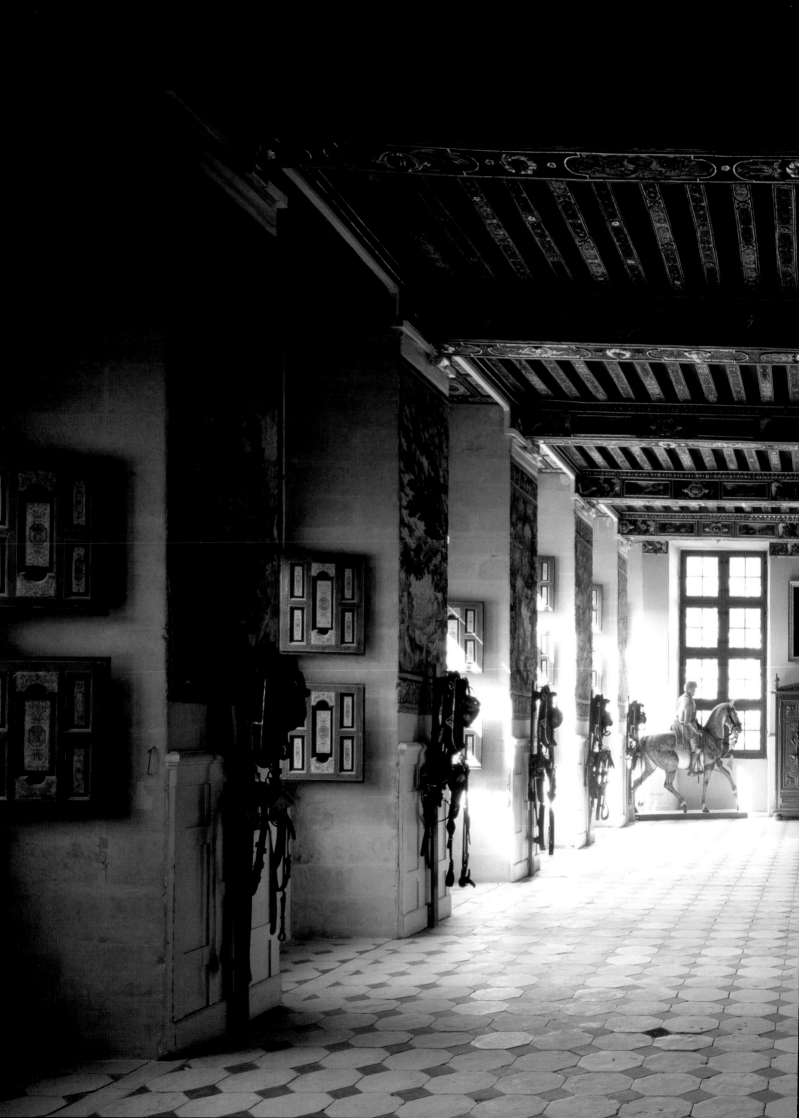

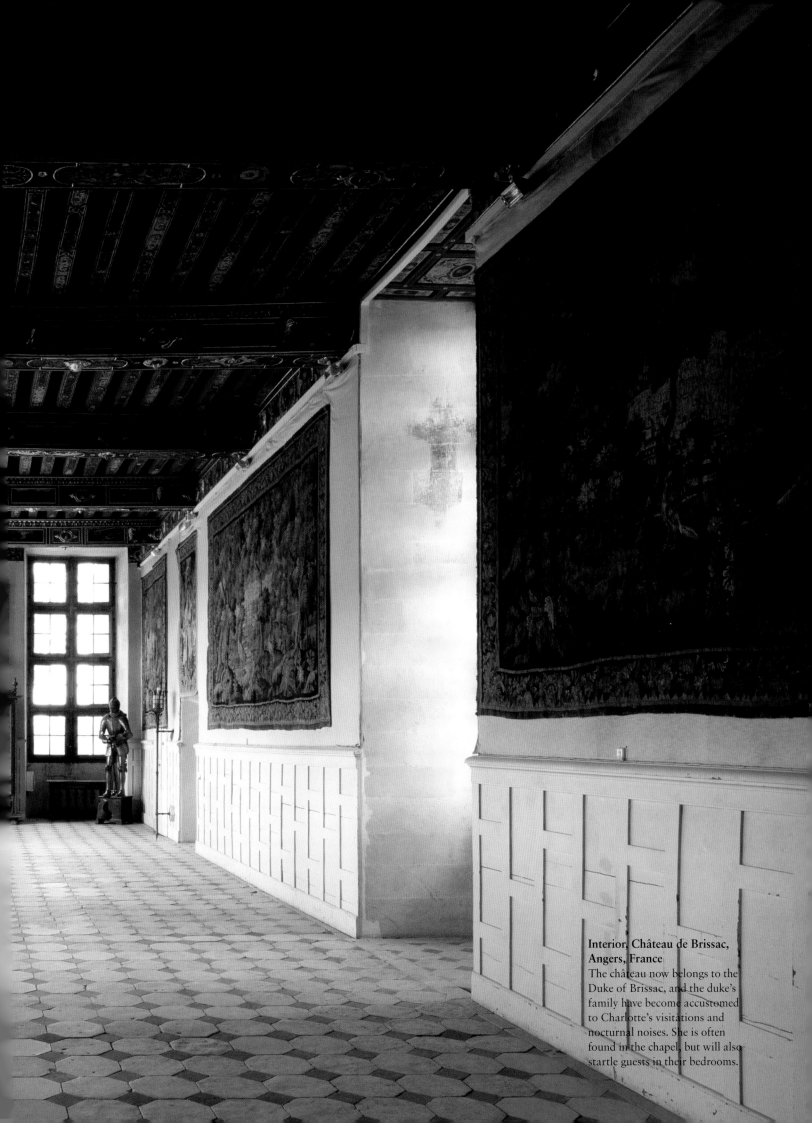

**Interior, Château de Brissac,
Angers, France**
The château now belongs to the
Duke of Brissac, and the duke's
family have become accustomed
to Charlotte's visitations and
nocturnal noises. She is often
found in the chapel, but will also
startle guests in their bedrooms.

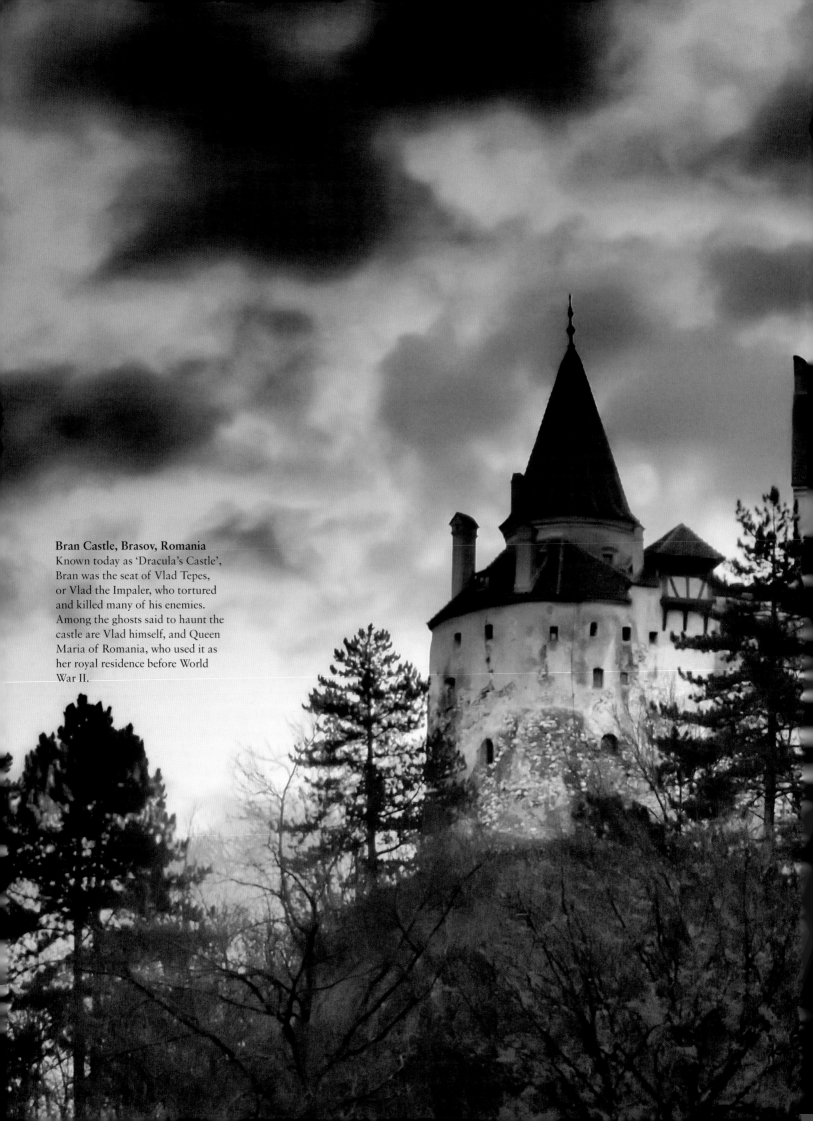

Bran Castle, Brasov, Romania
Known today as 'Dracula's Castle',
Bran was the seat of Vlad Tepes,
or Vlad the Impaler, who tortured
and killed many of his enemies.
Among the ghosts said to haunt the
castle are Vlad himself, and Queen
Maria of Romania, who used it as
her royal residence before World
War II.

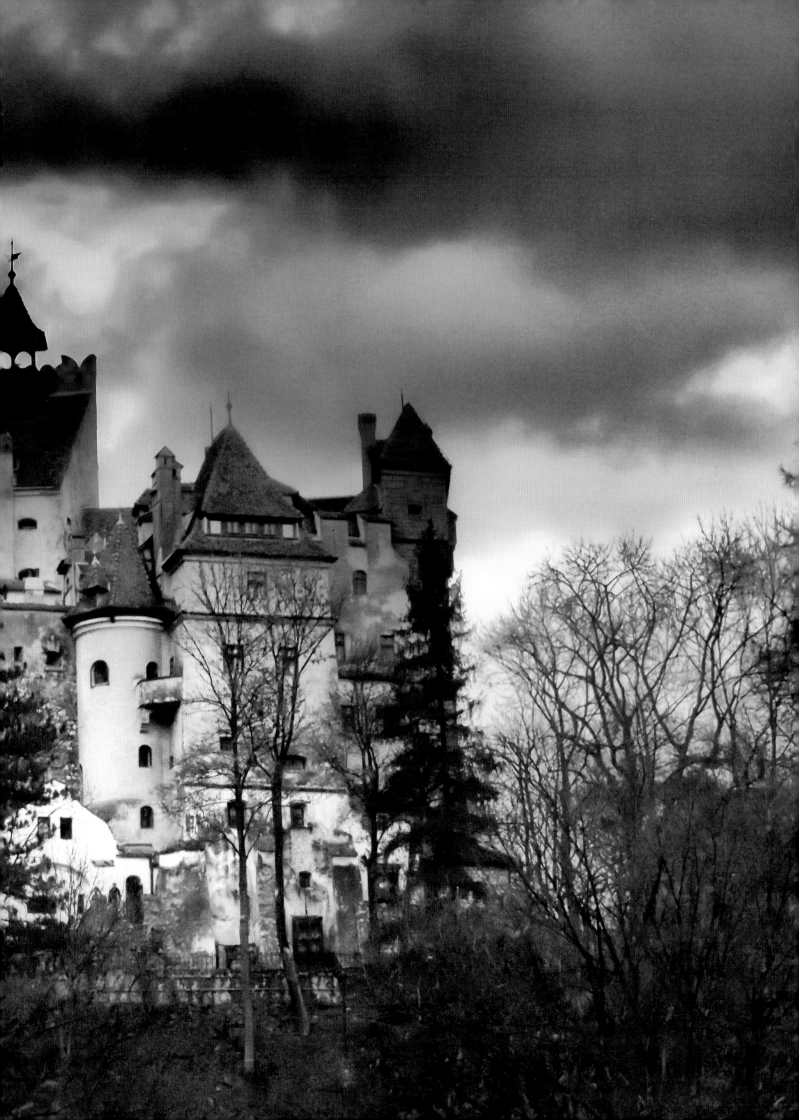

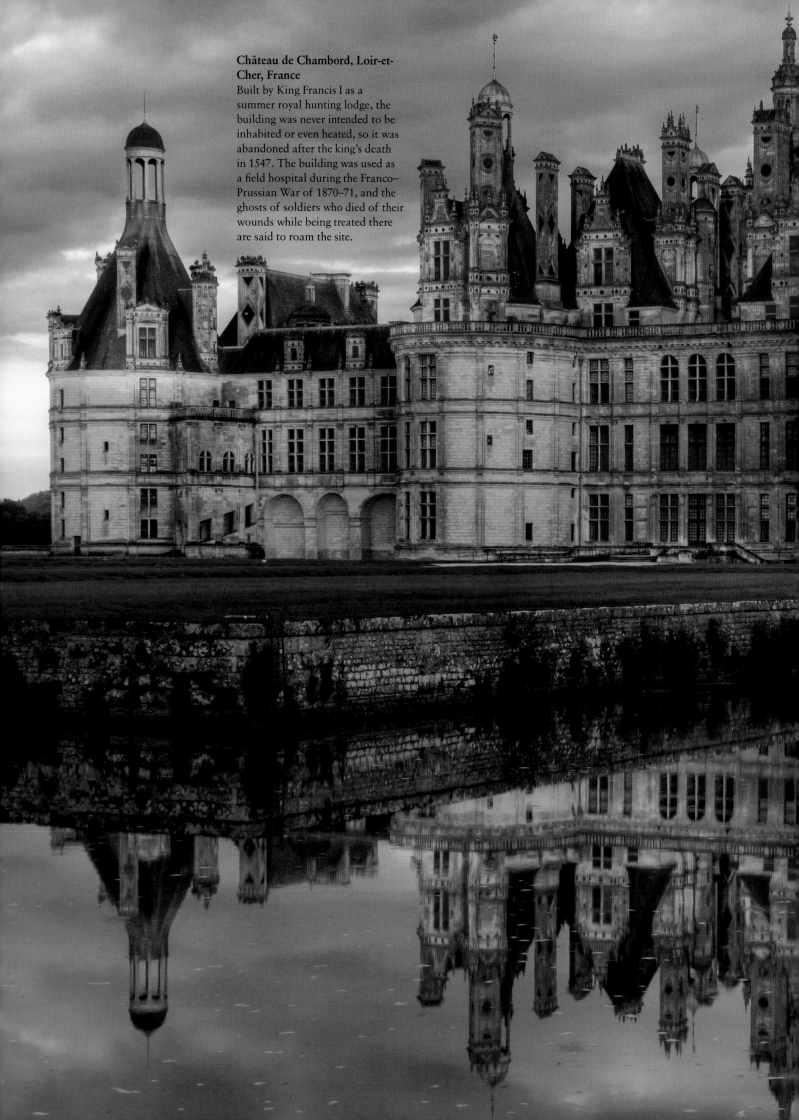

Château de Chambord, Loir-et-Cher, France
Built by King Francis I as a summer royal hunting lodge, the building was never intended to be inhabited or even heated, so it was abandoned after the king's death in 1547. The building was used as a field hospital during the Franco–Prussian War of 1870–71, and the ghosts of soldiers who died of their wounds while being treated there are said to roam the site.

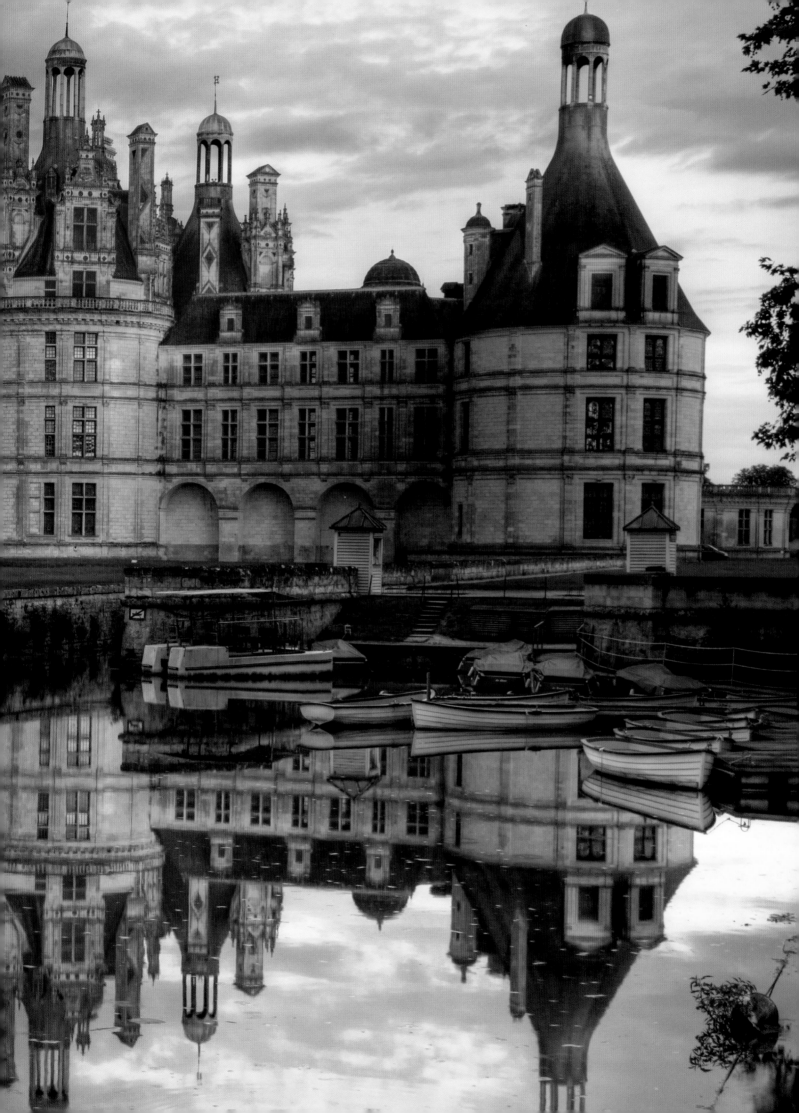

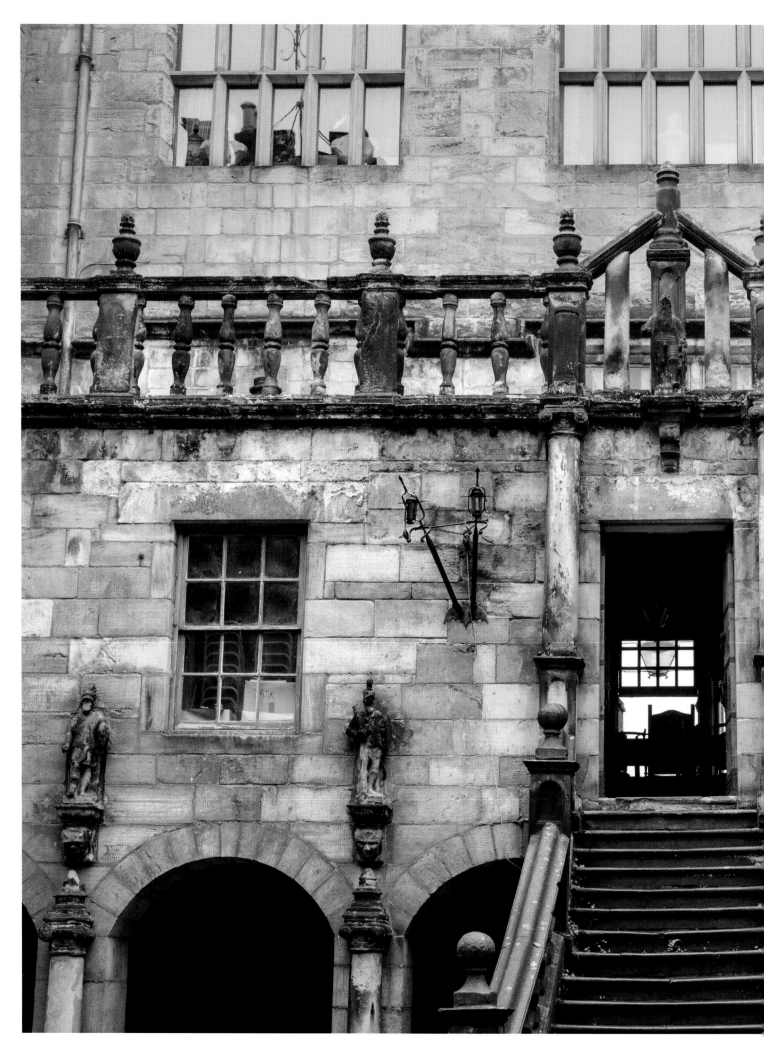

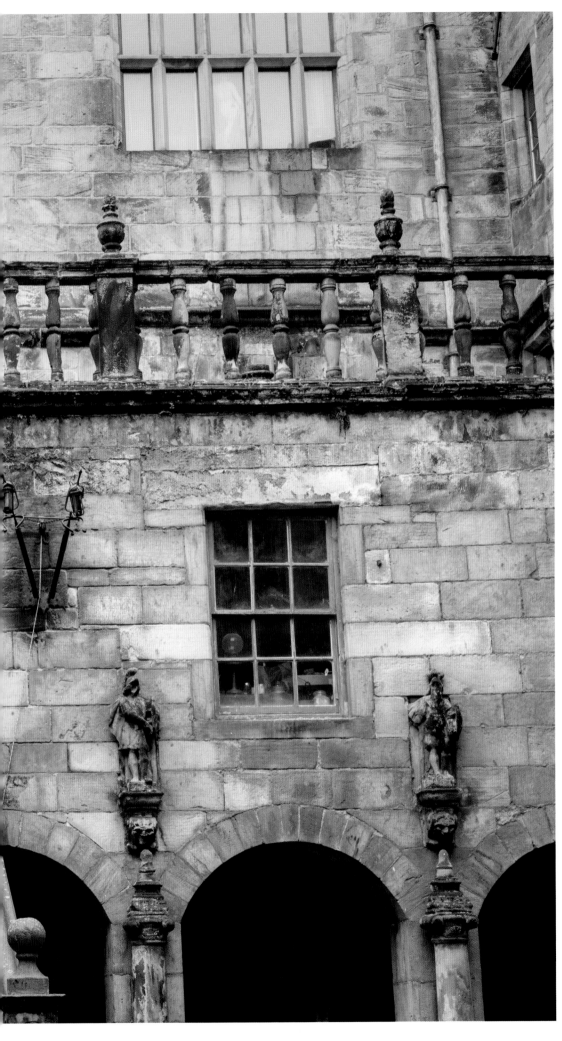

Exterior, Chillingham Castle, Northumberland, UK
Close to the border with Scotland, this English castle is home to many a restless spirit. The 'Blue Boy' (also known as the 'Radiant Boy') is supposed to be a young boy who saw documents on the Spanish Armada and was walled up alive for his trouble – a child's skeleton was found during renovation works years later. Other supernatural residents include Lady Berkeley, whose husband ran off with her own sister, and John Sage, a former torturer reportedly responsible for the deaths of hundreds of Scots, who was torn apart by a crowd while being hanged for murder.

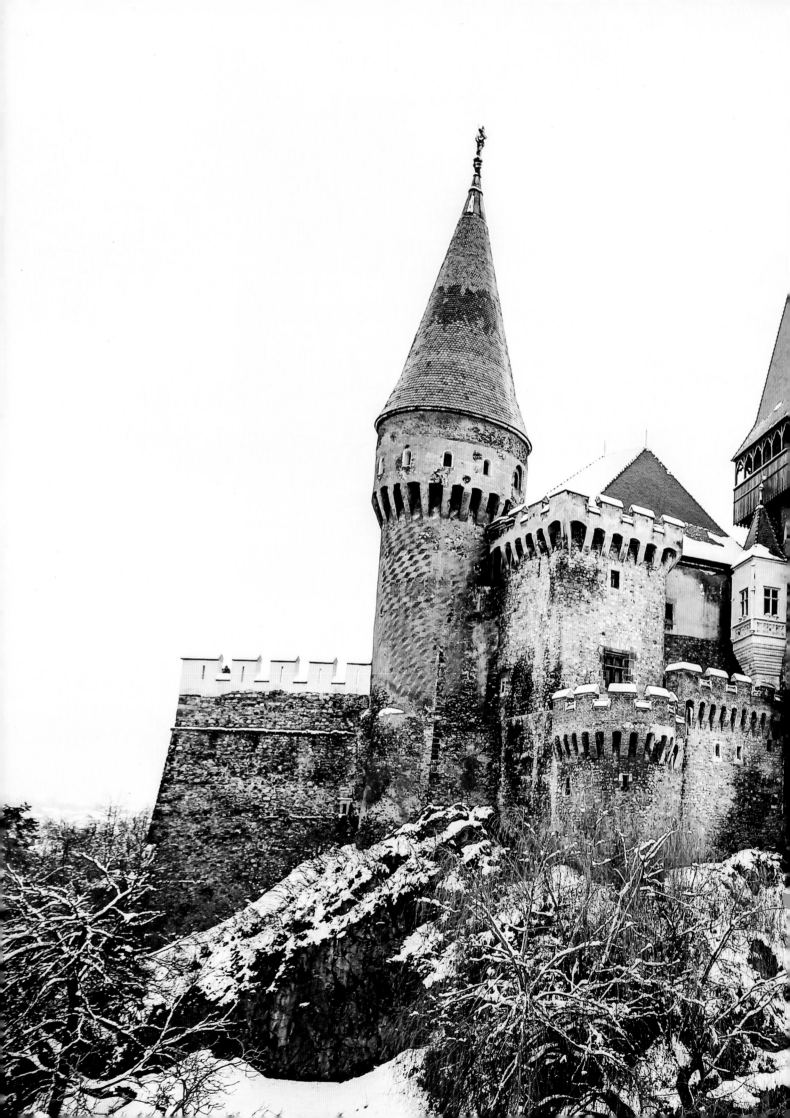

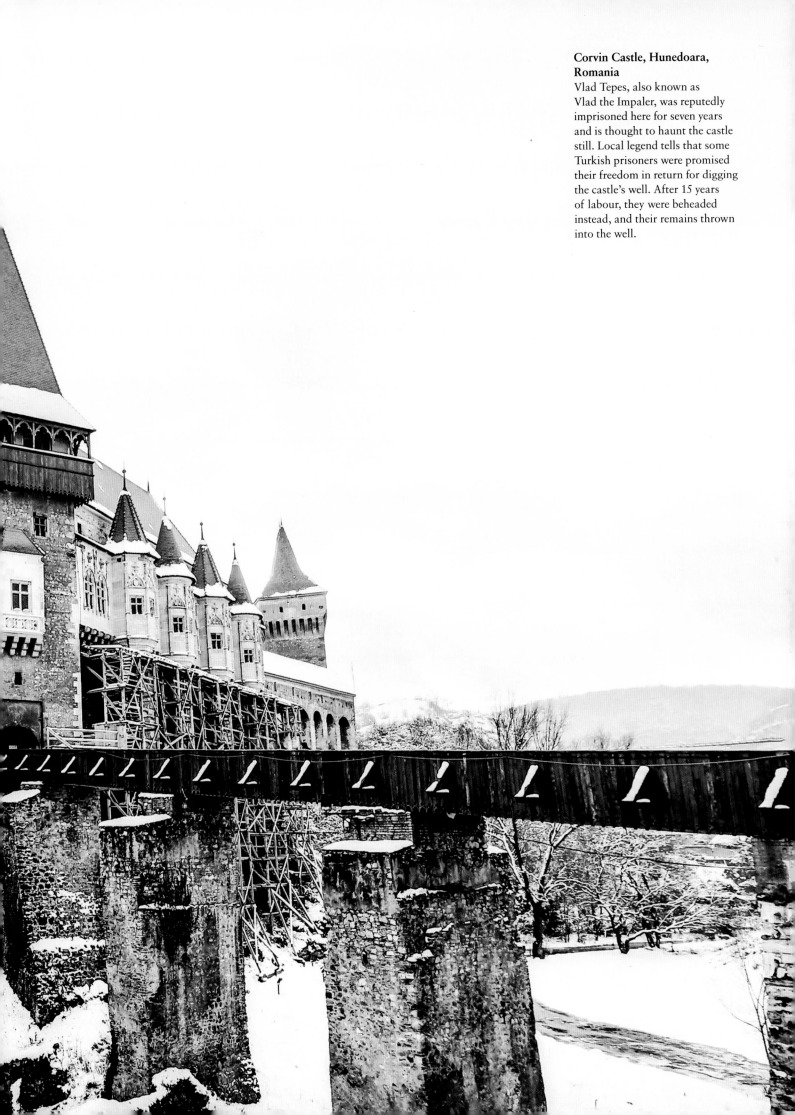

Corvin Castle, Hunedoara, Romania
Vlad Tepes, also known as Vlad the Impaler, was reputedly imprisoned here for seven years and is thought to haunt the castle still. Local legend tells that some Turkish prisoners were promised their freedom in return for digging the castle's well. After 15 years of labour, they were beheaded instead, and their remains thrown into the well.

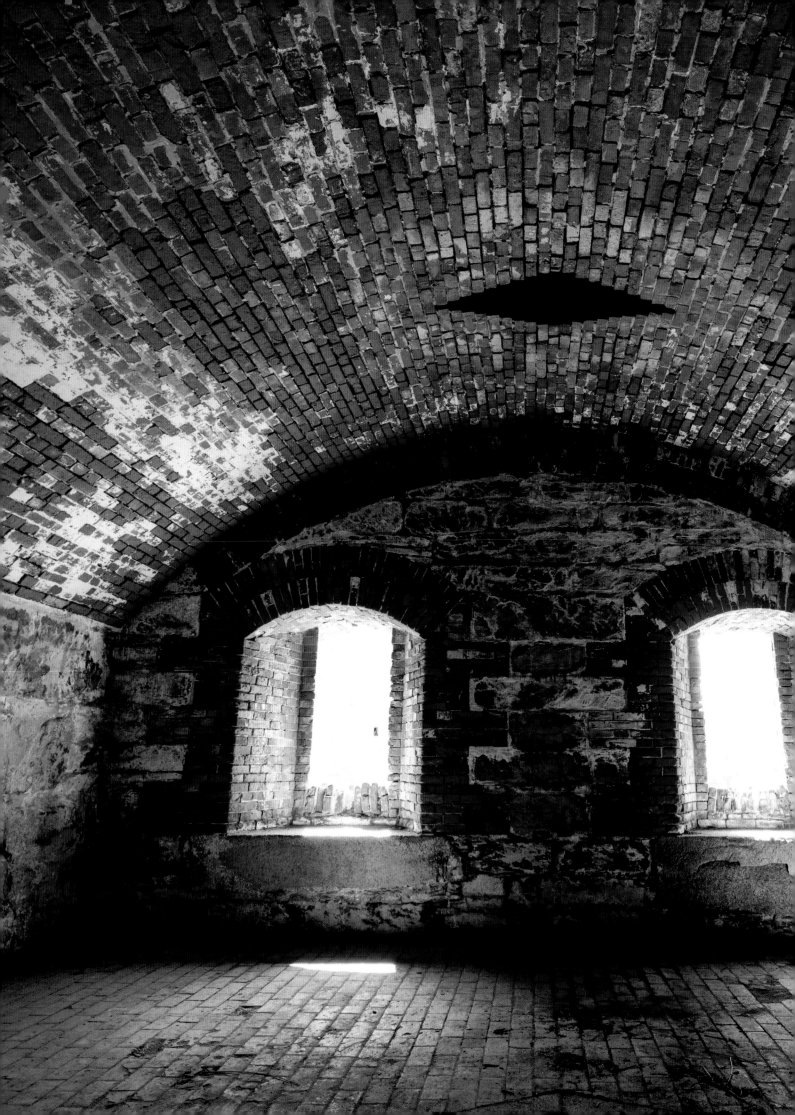

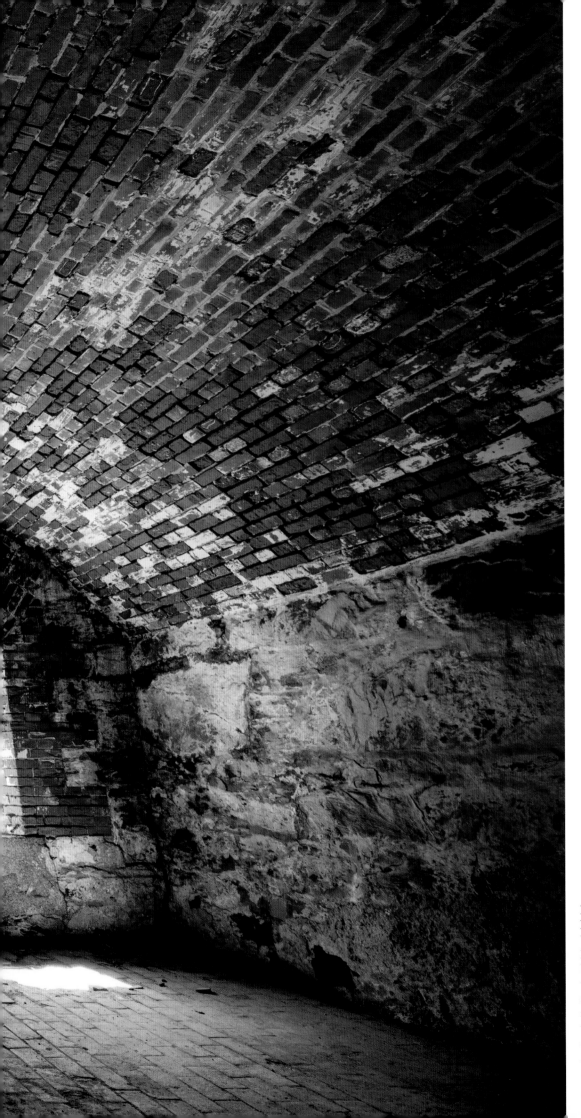

Fort Adams, Newport, Rhode Island, USA
Visitors to this National Historic Landmark fort have reported being pushed and shoved by unseen forces. Various garrison soldiers met untimely ends at the fort, including one who shot his wife and then killed himself, and another who threw stones at a friend, who then shot him dead.

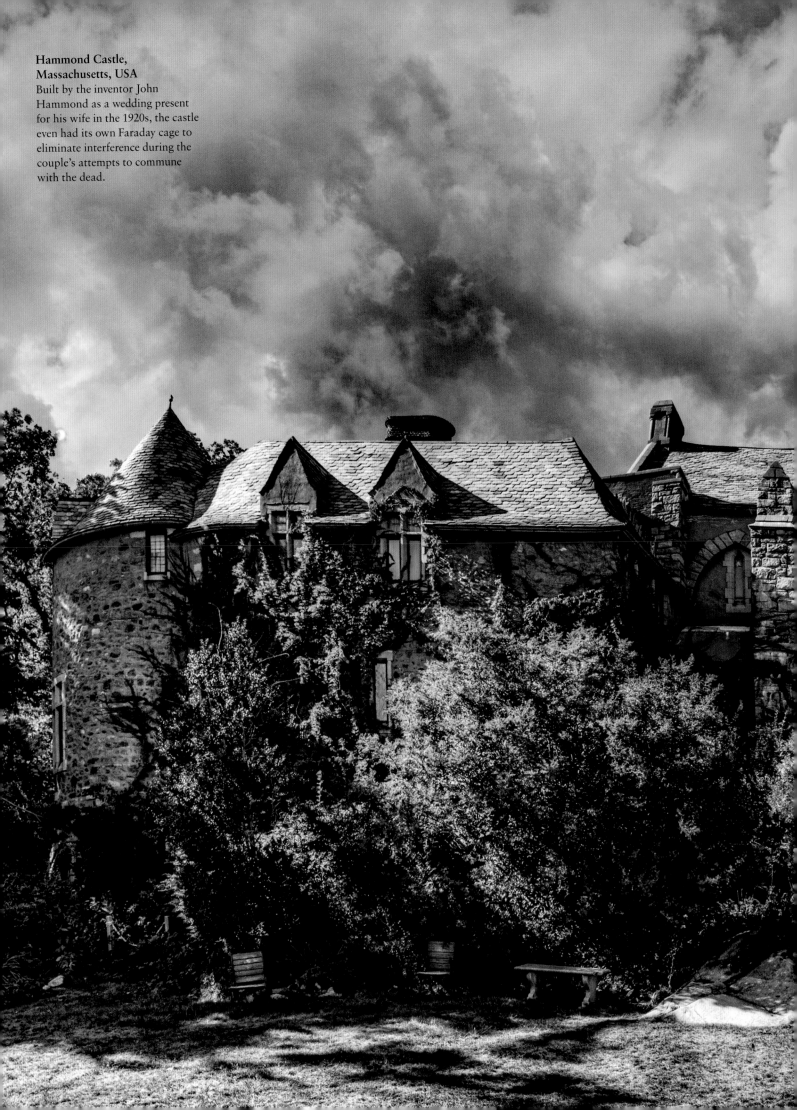

**Hammond Castle,
Massachusetts, USA**
Built by the inventor John
Hammond as a wedding present
for his wife in the 1920s, the castle
even had its own Faraday cage to
eliminate interference during the
couple's attempts to commune
with the dead.

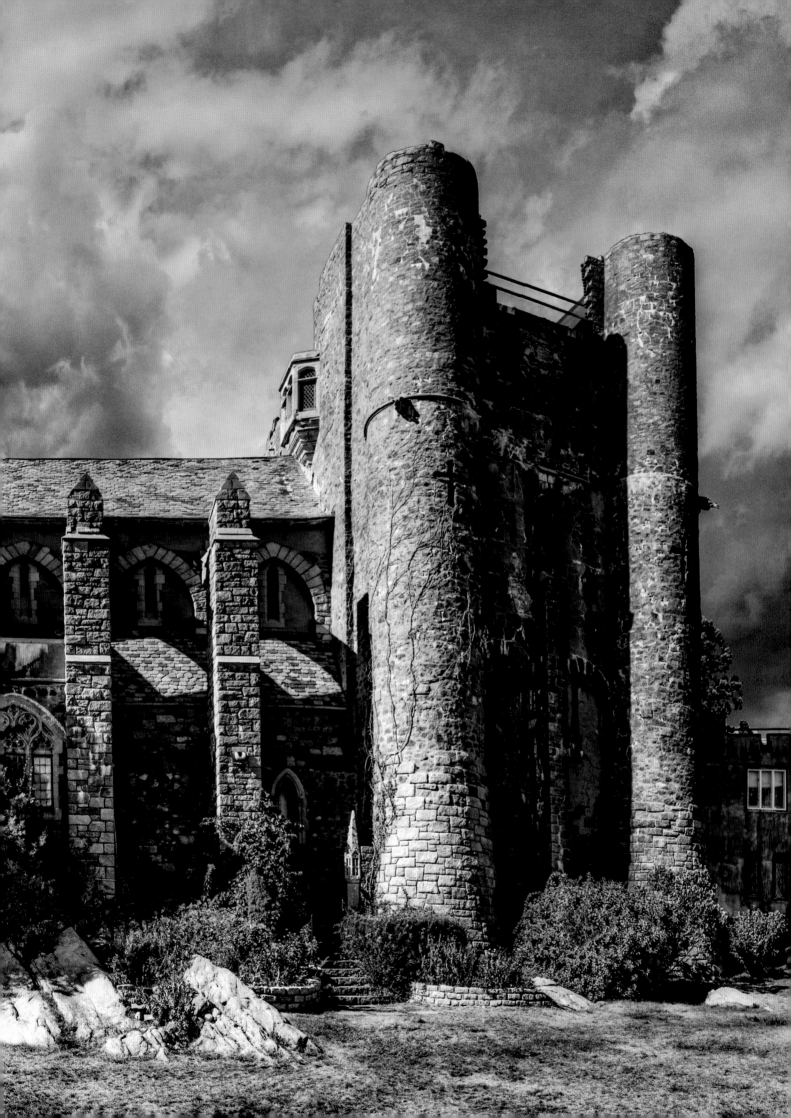

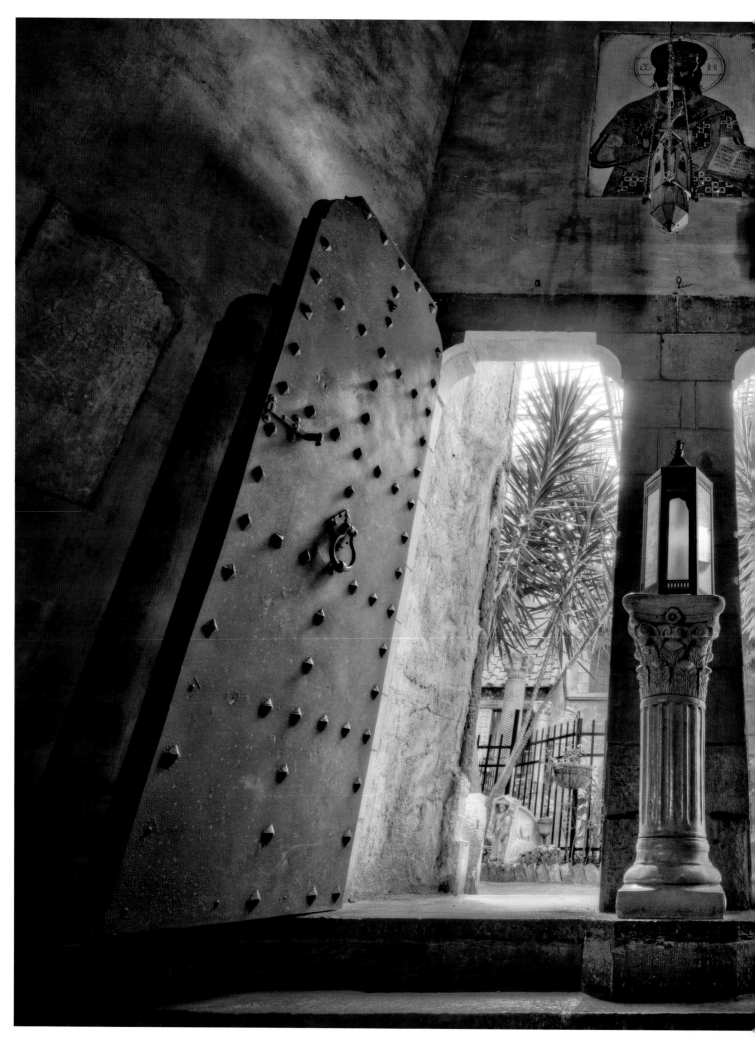

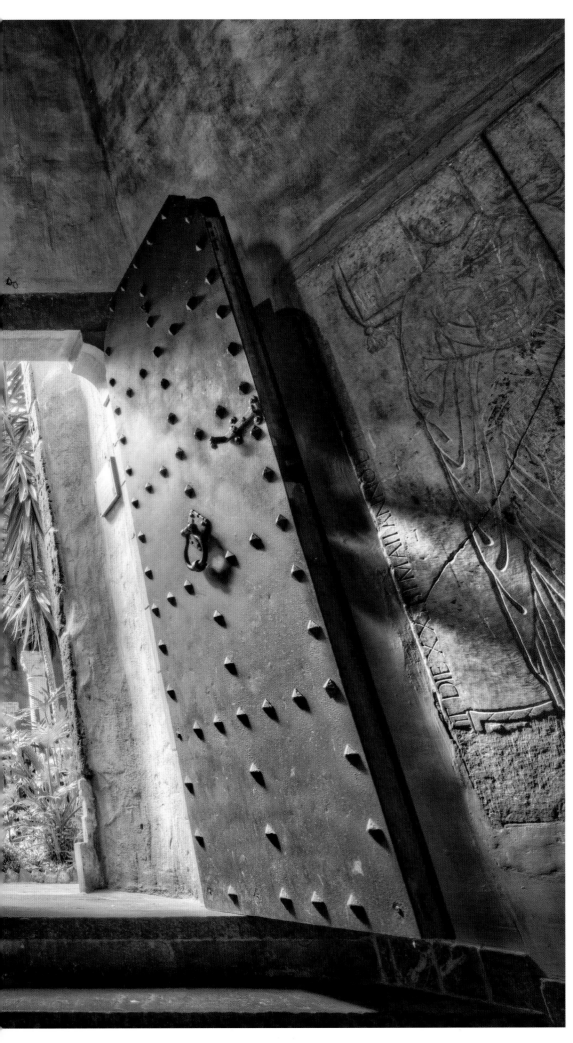

LEFT:

Great Doors, Hammond Castle, Massachusetts, USA
As well as his interest in spiritualism, Hammond was a keen collector of antiquities. His collection included a skull from a member of Columbus's crew, and the tomb of a Roman child.

OVERLEAF:

Gargoyle, Hammond Castle, Massachusetts, USA
Although his wife was buried elsewhere with her family, both Hammonds are reported to haunt their former home. A red-haired woman is frequently seen at weddings held at the castle, and disappears without warning. Other spirits, perhaps those invited during the seances held by the couple, have also been seen, and unexplained voices have been heard by visitors.

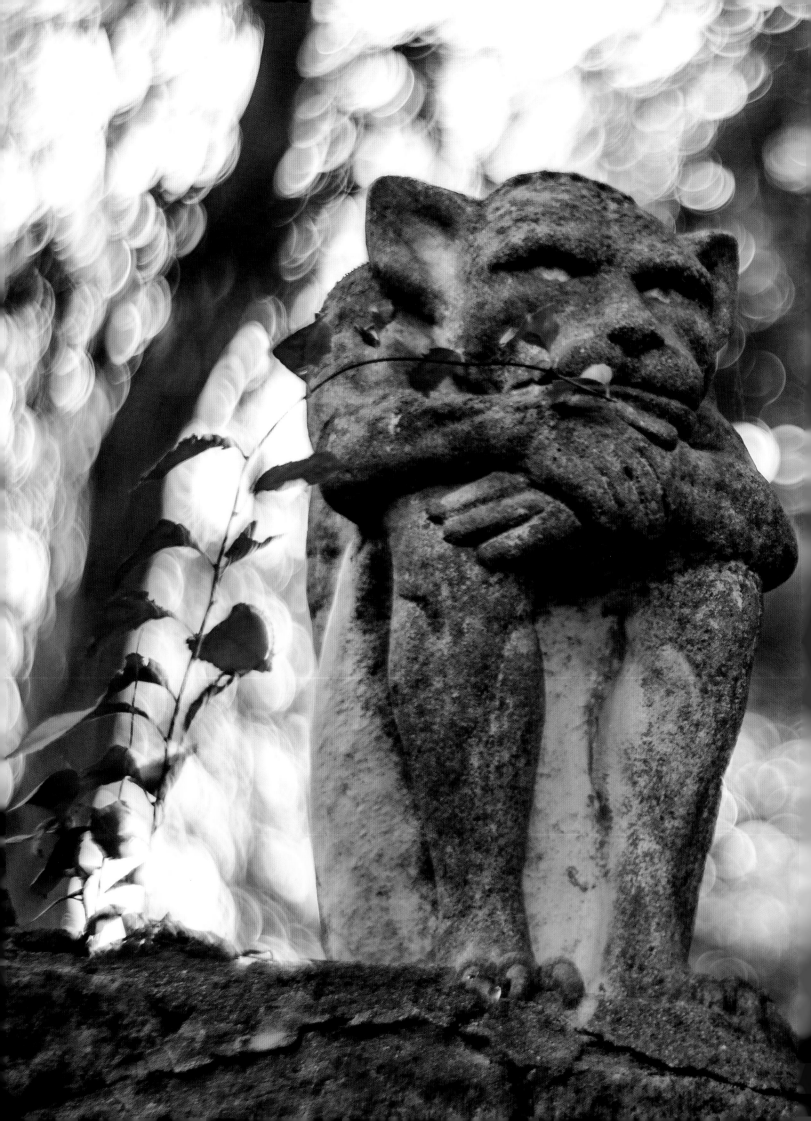

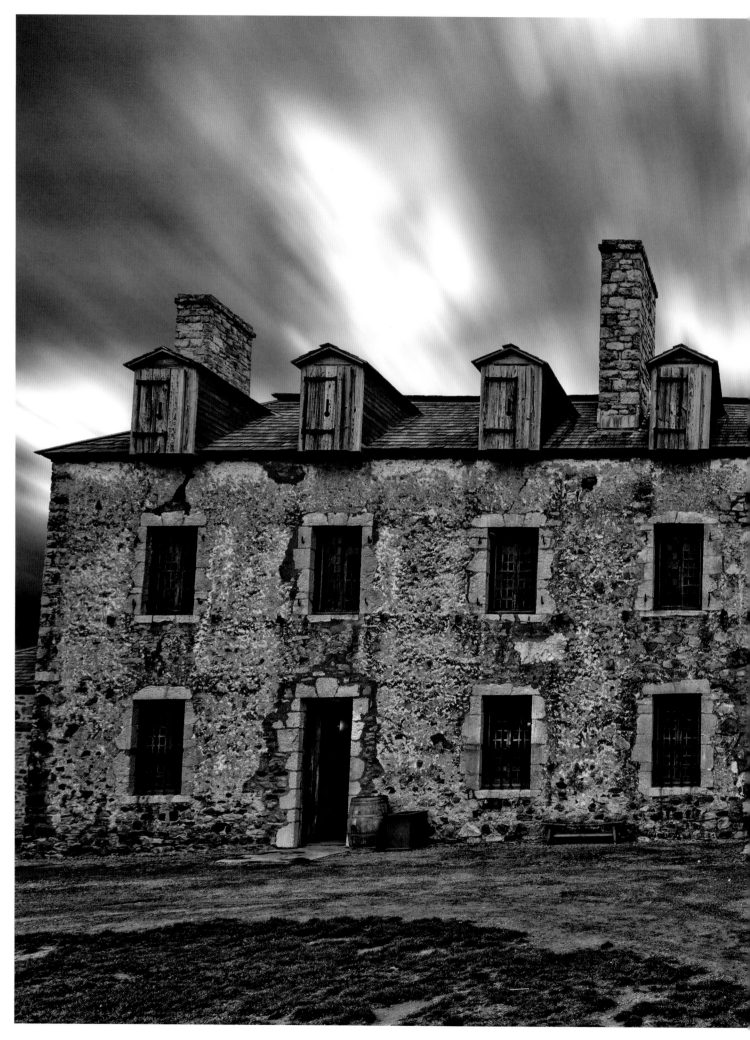

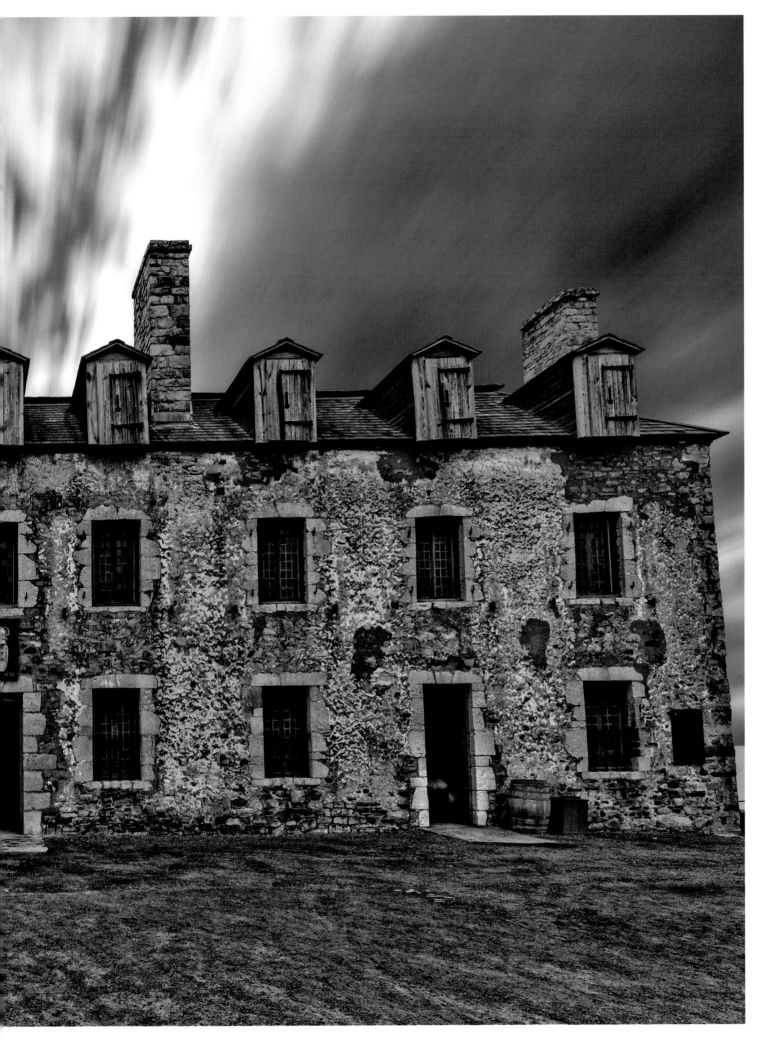

PREVIOUS PAGE:
Old Fort Niagara, New York, USA

Originally built by the French on the mouth of the Niagara River in the 18th century, the fort was later captured by the British and, later still, the Americans.

RIGHT:
Interior, Old Fort Niagara, New York, USA

Two French officers stationed at the fort competed for the attentions of a Native American woman. During a party, both being very drunk, they fought a duel and one killed the other. Realizing he would be executed for murder, the victor cut off the head to make it look like a Native American attack before dropping the headless body down a well to hide it. According to legend, several weeks later noises were heard from the well, and the figure of a headless officer emerged. The next day the well was searched and the body found – and the murderer was subsequently tried and hanged for his crime. It is said that the figure climbs from the well every full moon at midnight to search for his head.

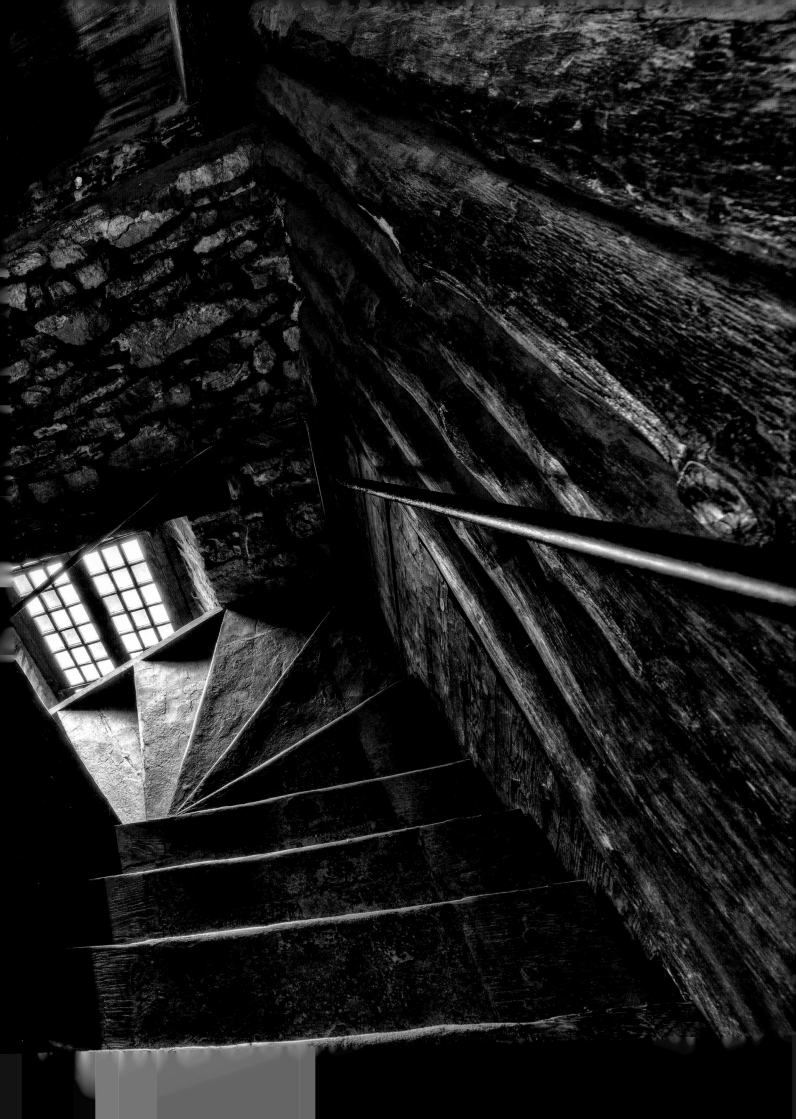

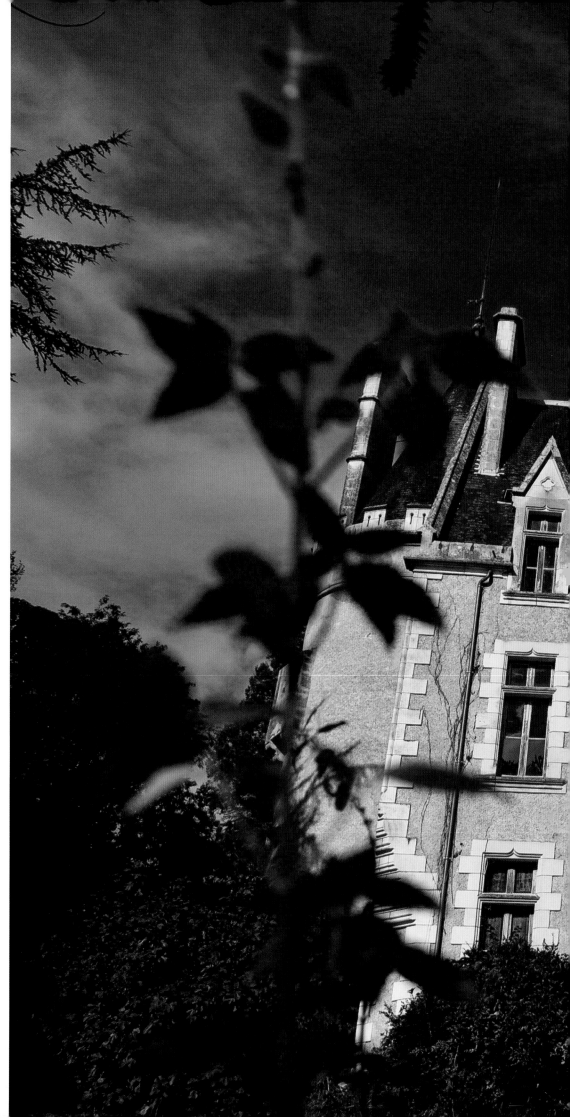

Château de Fougeret, Queaux, France
The château has become known for its supernatural occupants since new owners took over the building after it had stood empty for many years. Visitors who have stayed overnight with the family report seeing figures and hearing voices ordering them to leave.

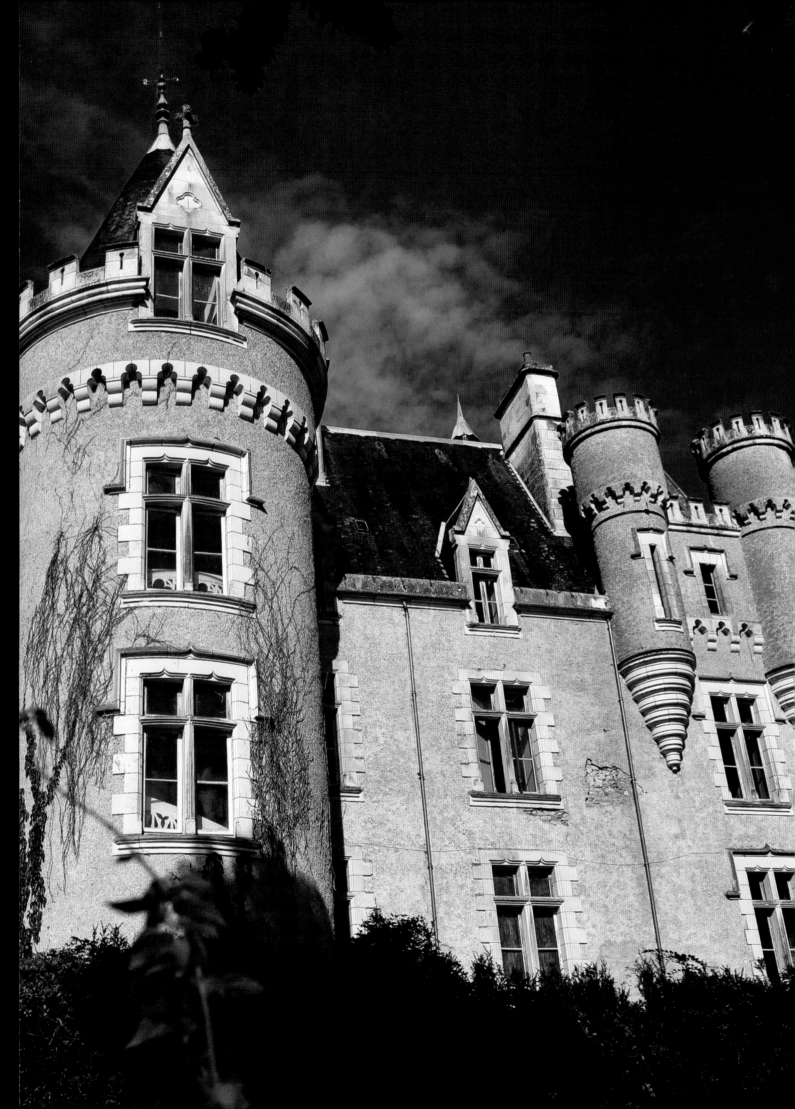

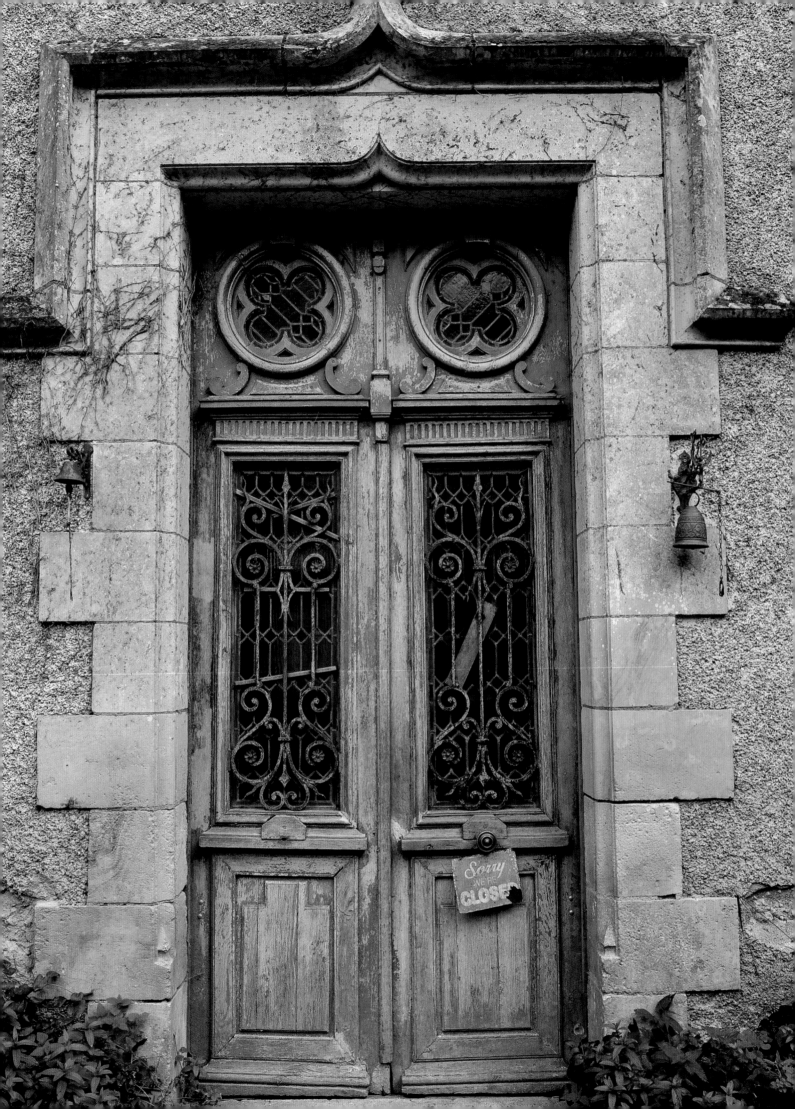

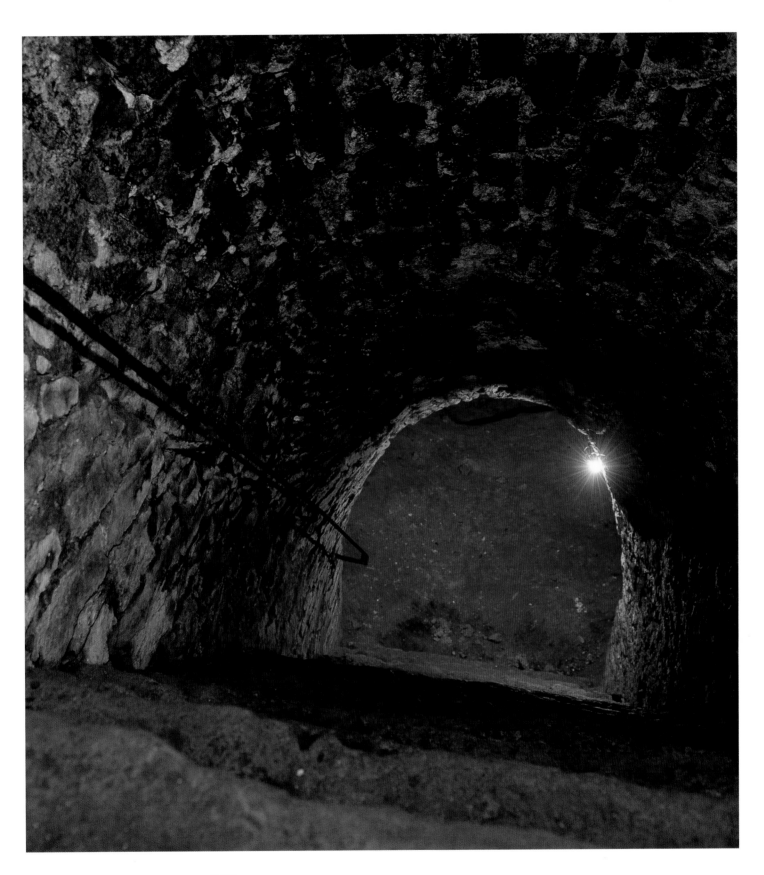

LEFT:

Door, Château de Fougeret, Queaux, France

The family themselves have had many encounters with the supernatural, including hearing and smelling people eating, and seeing strange figures at the window when they leave. A small girl named 'Alice', supposedly a child who died in 1924, sings nursery rhymes.

ABOVE:

Staircase, Château de Fougeret, Queaux, France

Another figure that has been sighted and even allegedly photographed is 'Felix', a man who died in 1898. The owners also claim that an unknown spirit, possibly with a dog, plays with their own pet dog. The building regularly hosts ghosthunters.

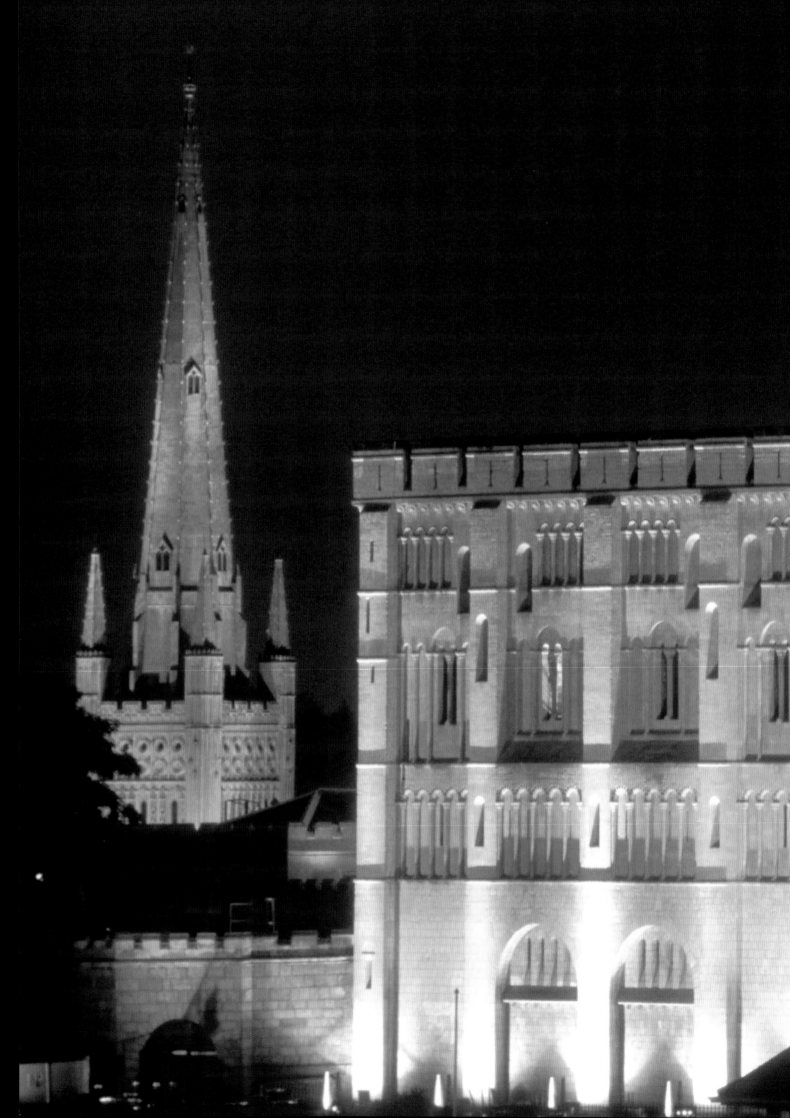

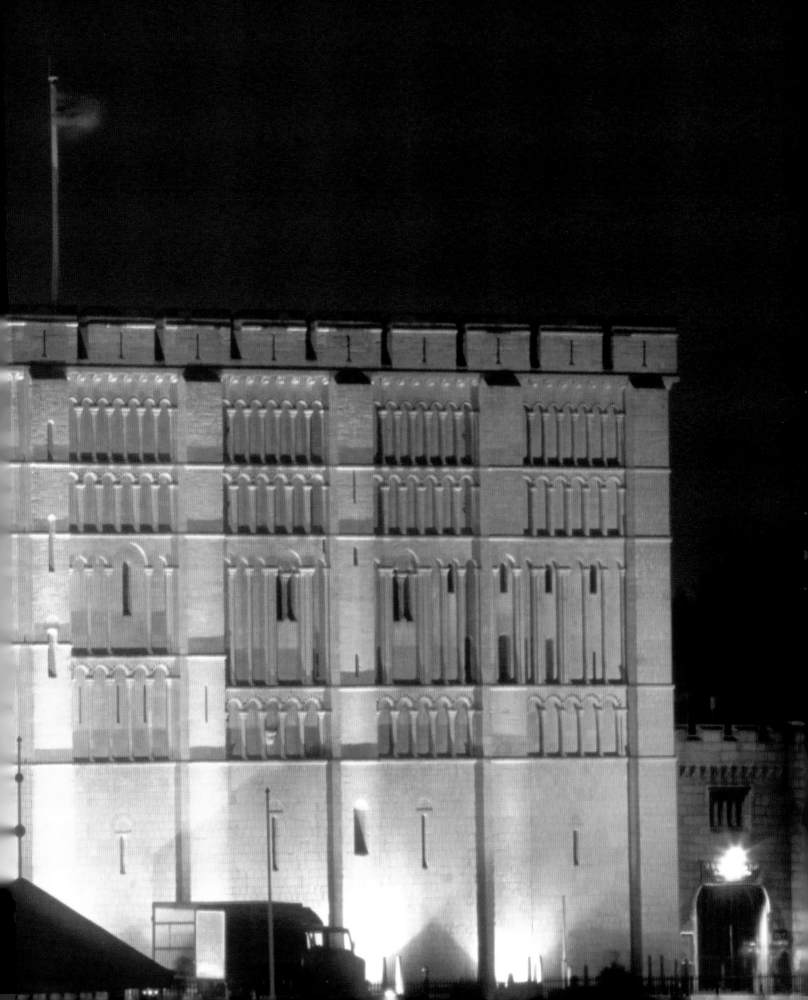

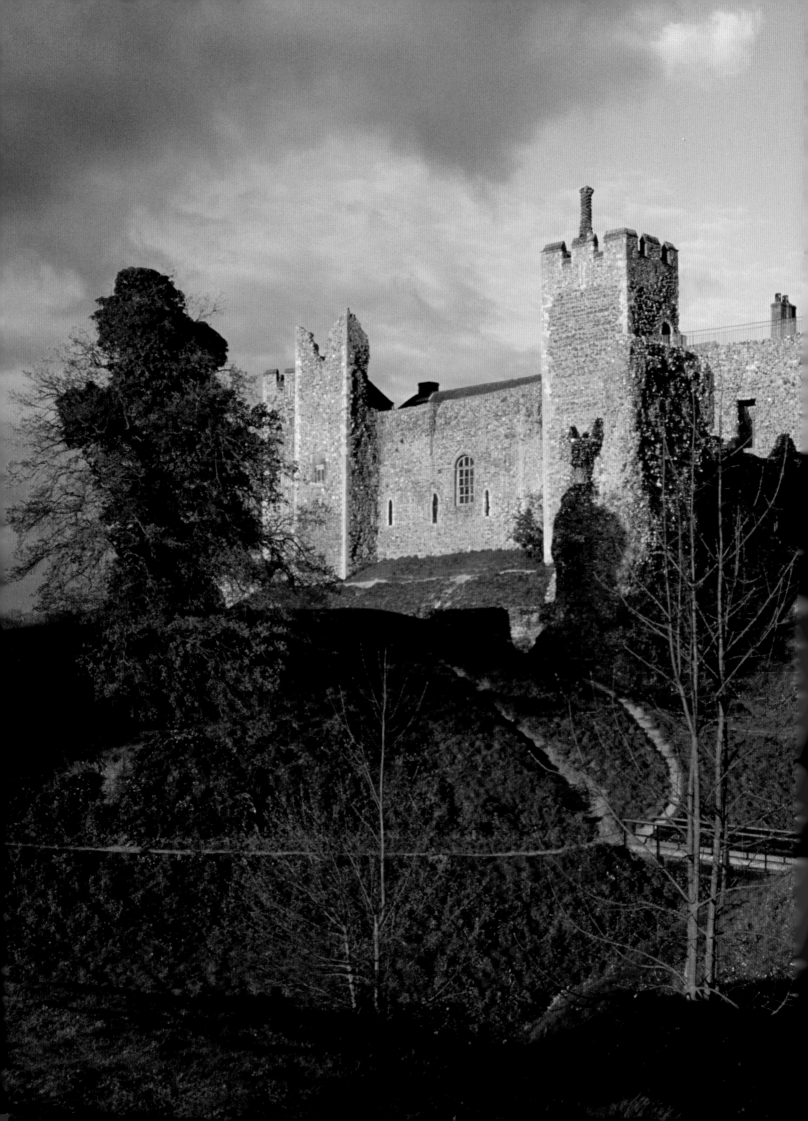

PREVIOUS PAGE:
Norwich Castle, Norwich, UK
For much of its life the castle was used as a prison. Robert Kett, the leader of a rebellion in Tudor times, was hanged from the castle walls in a gibbet, and sightings have been made of his ghostly corpse hanging on a wall, complete with its gibbet. A floating skull has been reported by several visitors, allegedly from an execution that went wrong. The hangman miscalculated the weight of the criminal, and he was decapitated by the rope. The 'Black Lady' who roams the art gallery is supposedly the ghost of a Victorian woman who cut off her violent husband's head with a billhook.

LEFT:
Framlingham Castle, Suffolk, UK
Famous as the castle where Queen Mary I was kept imprisoned by her brother, Edward VI, before she became queen, Framlingham is also known for more supernatural occurrences. Visitors to the castle have encountered the faces of spirits in some of the old rooms, noises on the stairs and the sounds of screams and children playing.

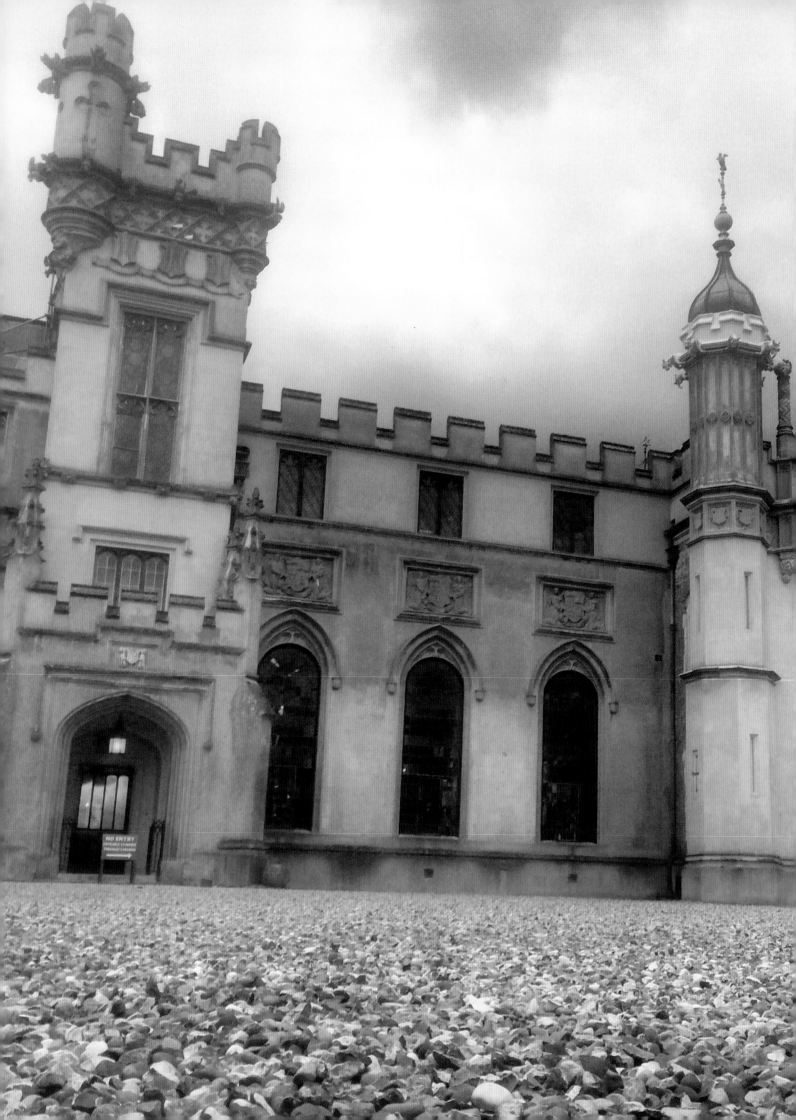

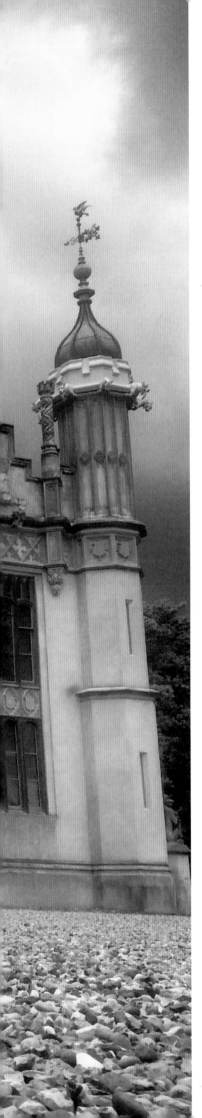

LEFT:

Knebworth House, Hertfordshire, UK
Lord Cobbold, the current owner of Knebworth, believes his ancestors, including the Victorian novelist, poet and playwright Edward Bulwer-Lytton, still haunt the house.

ABOVE TOP:

Knebworth House, Hertfordshire, UK
Knebworth is home to the 'Yellow Boy', who appears to guests as a premonition of their own death. Lord Castlereagh, a British Foreign Secretary in the 19th century, committed suicide after seeing him.

ABOVE RIGHT:

Grounds, Knebworth House, Hertfordshire, UK
'Spinning Jenny' was reportedly a young woman from the 18th century who killed herself after being prevented from seeing her lover. She haunts the room in the East Wing.

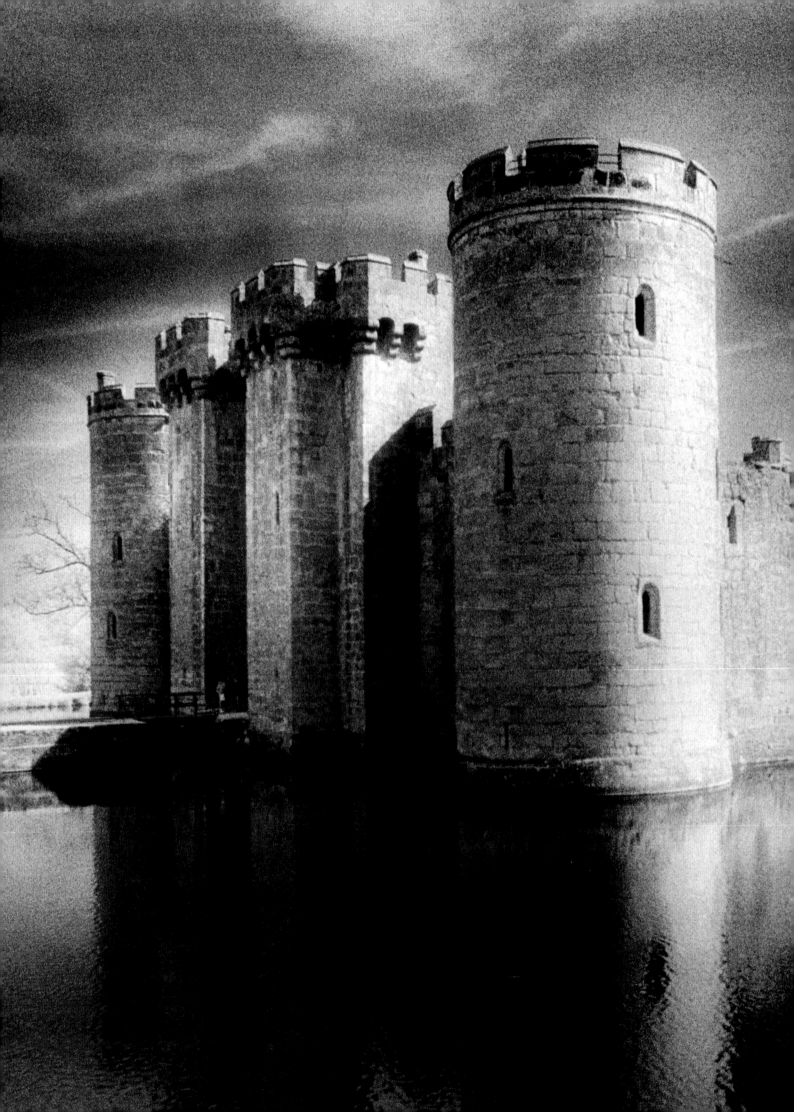

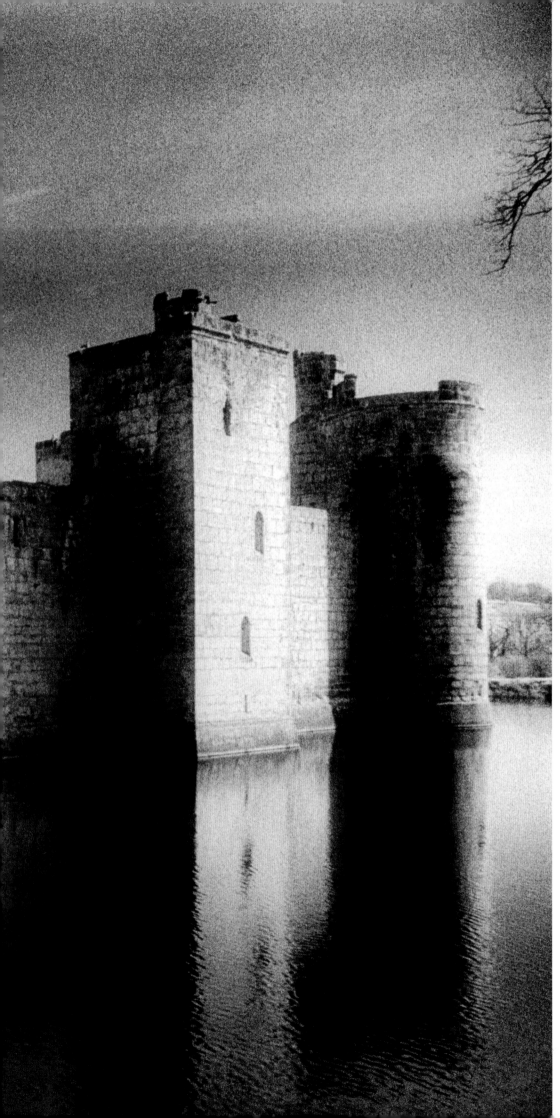

Bodiam Castle, East Sussex, UK
A 'Red Lady' is said to haunt
this castle, dating from 1385. She
has been seen at night on one of
the towers, staring out into the
surrounding countryside, as if
waiting for someone to return.
A 'Victorian Boy' has also been
seen on the castle's bridge, but he
disappears halfway along, as if he
fell in and drowned.

47

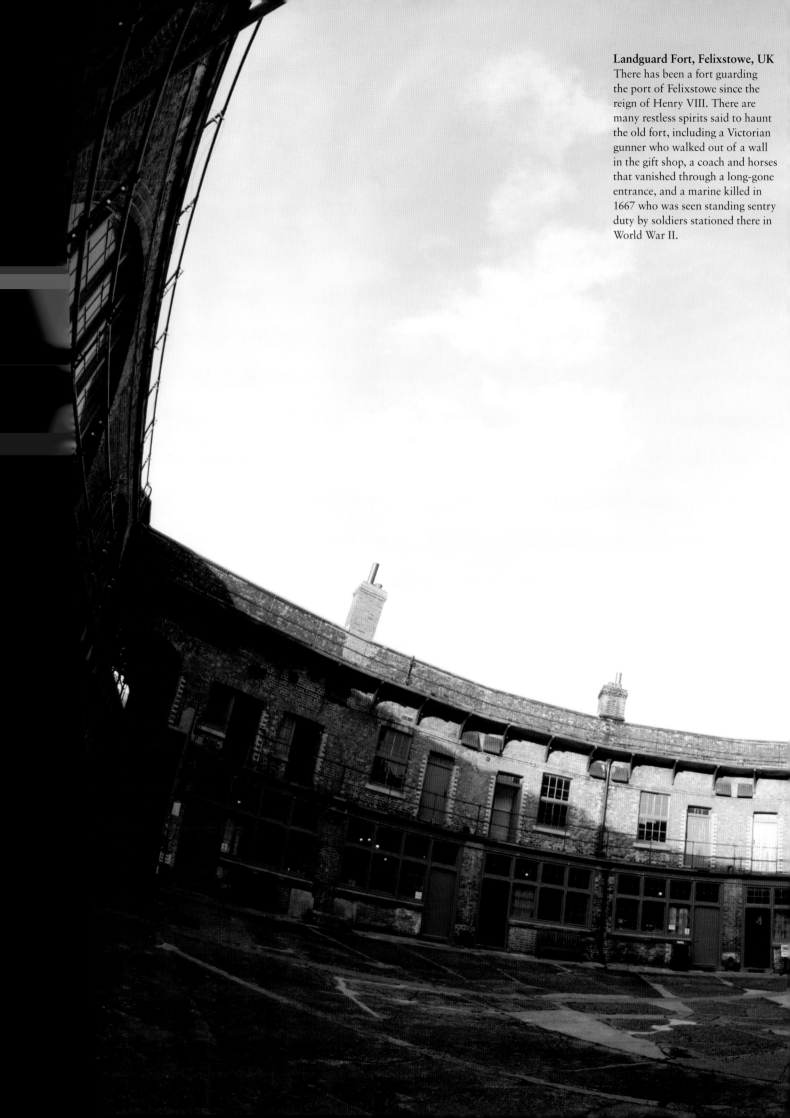

Landguard Fort, Felixstowe, UK
There has been a fort guarding the port of Felixstowe since the reign of Henry VIII. There are many restless spirits said to haunt the old fort, including a Victorian gunner who walked out of a wall in the gift shop, a coach and horses that vanished through a long-gone entrance, and a marine killed in 1667 who was seen standing sentry duty by soldiers stationed there in World War II.

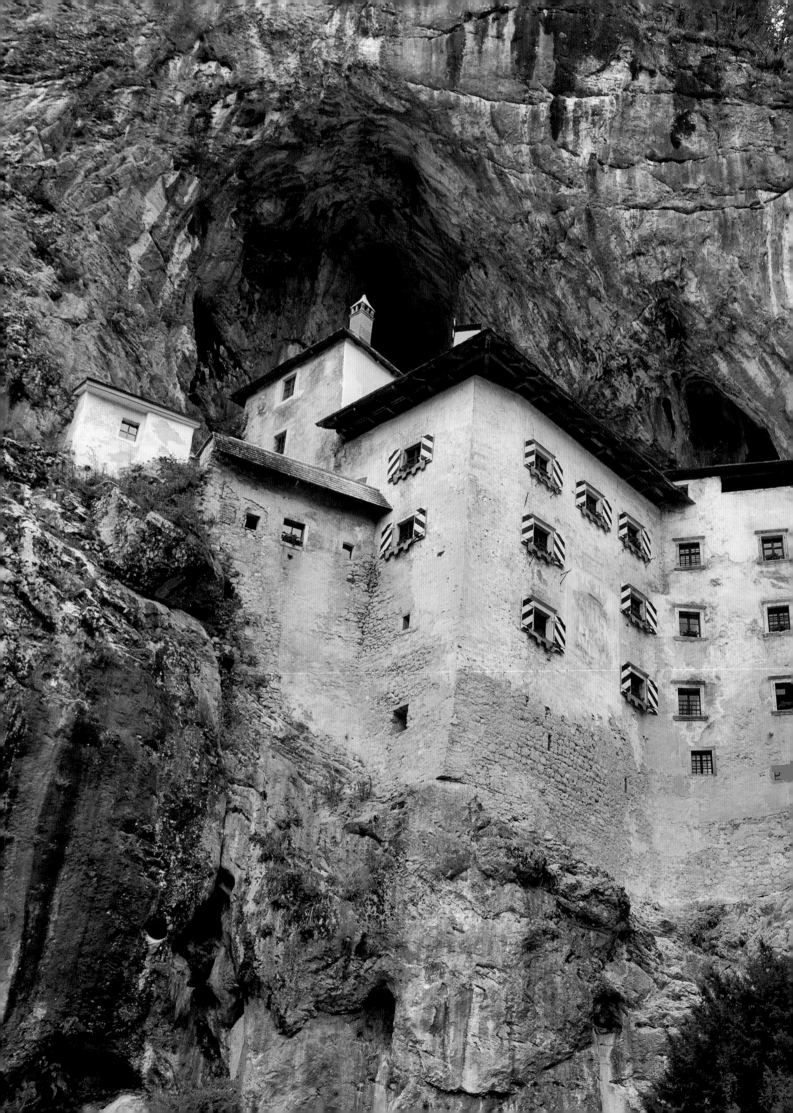

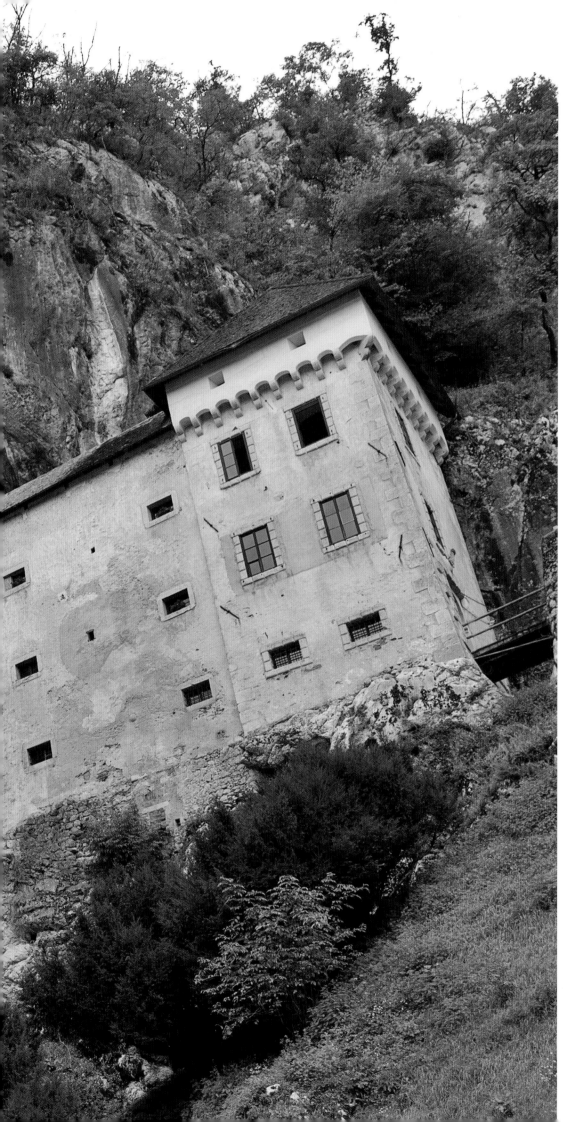

Predjama Castle, Slovenia
Built in the 13th century at the front of a large cave in a limestone cliff, the castle was viewed as almost impregnable. It was home to a robber baron named Erazem Lueger, who was besieged by the forces of the Holy Roman Emperor. He was killed by a cannonball aimed at his toilet after being betrayed by a servant. Prisoners in the castle were tortured and then thrown into a cave. If they didn't die immediately, then their wounds or lack of food and water would kill them soon enough. The spirits of these victims are reported to haunt the castle to this day.

Château de Randan, Auvergne, France

Once owned by members of the French royal family, Randan was destroyed in a mystery fire in 1925. The family was no stranger to the occult, with one duke, later to become regent during Louis XV's minority, asking a medium to predict the date of Louis XIV's death. Perhaps other spirits were invoked by his descendants that linger here today.

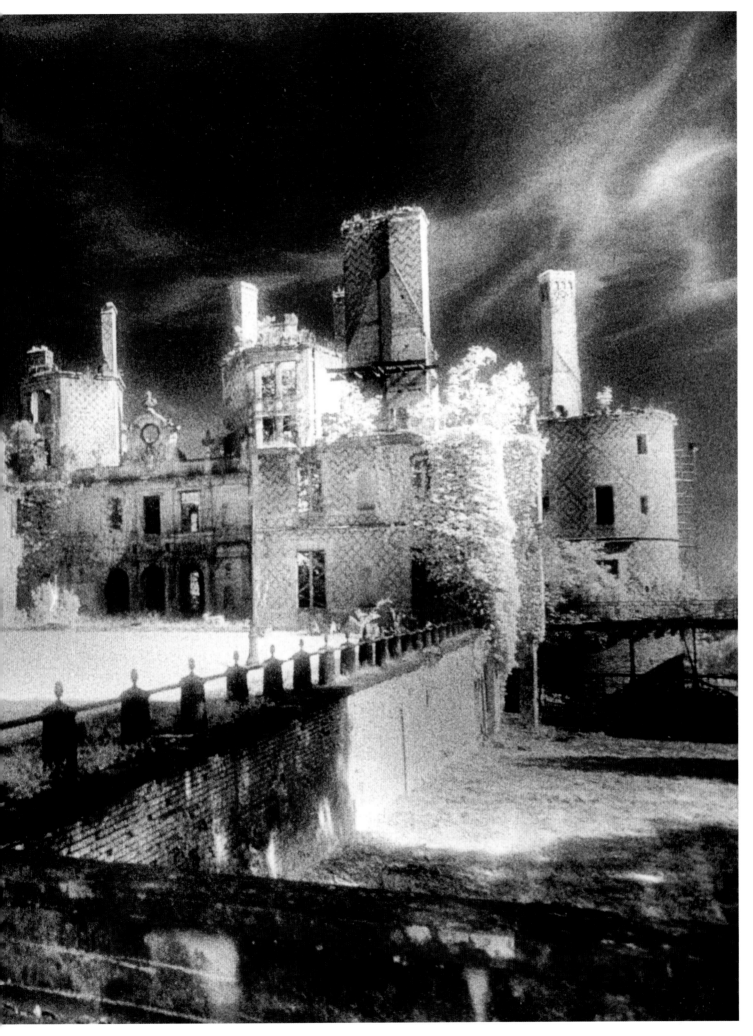

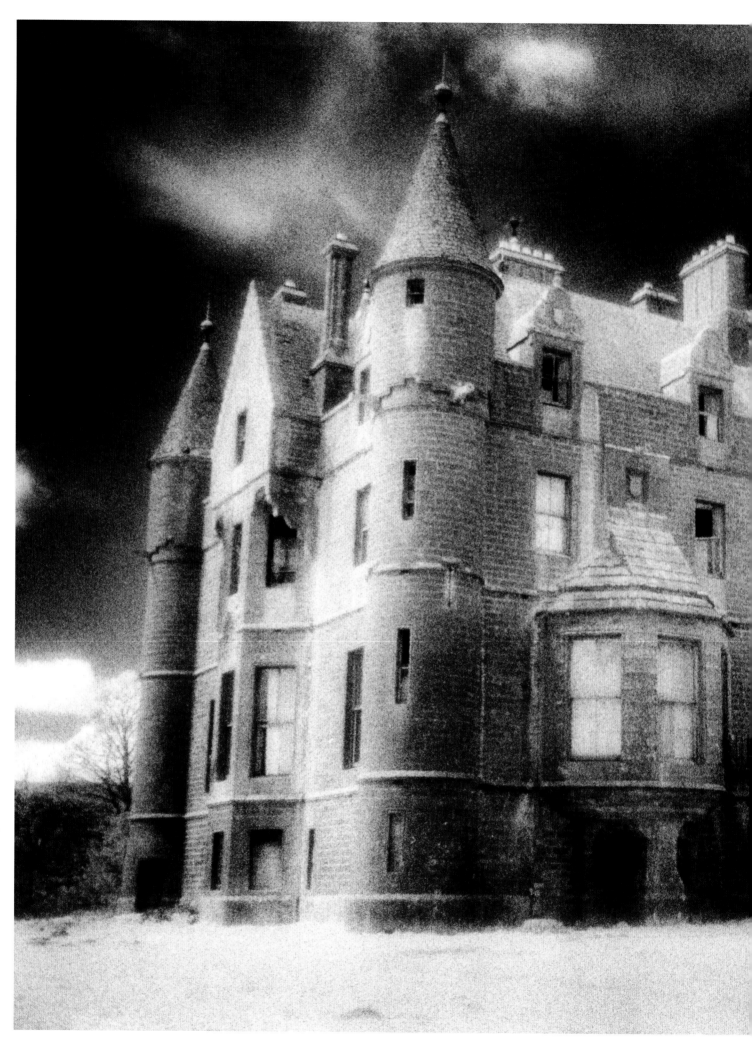

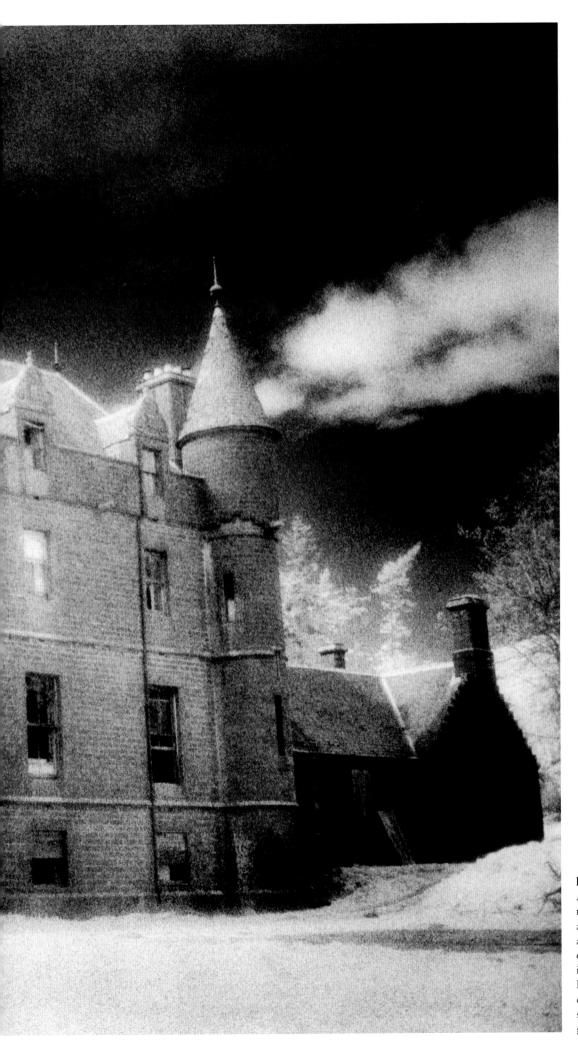

Balintore Castle, Perthshire, UK
Abandoned since the 1960s but now being restored, the castle is in a remote part of Scotland. There are many documented supernatural occurrences at the property, including a housekeeper who smelt Lady Langman's perfume on the day that she died abroad, and a sighting of a small boy dressed as a gypsy on the drive.

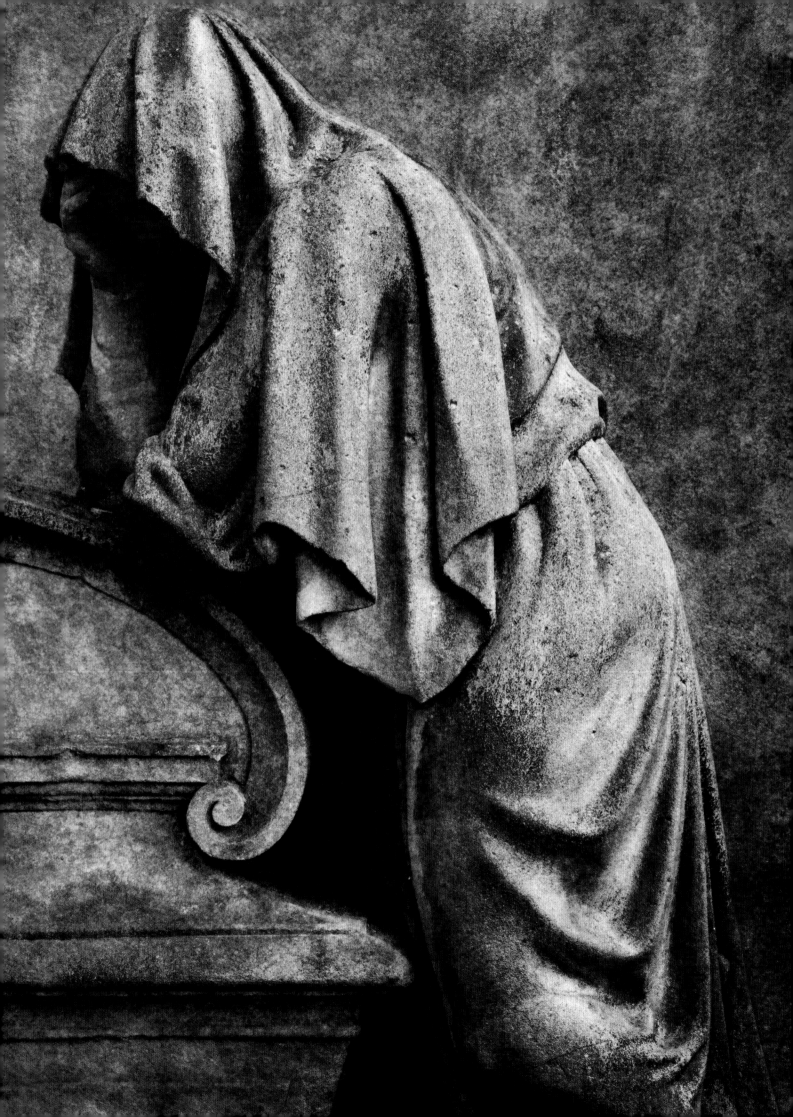

Cemeteries

Where are ghosts or other spectral happenings most likely to be found? Logic would suggest that a burial ground containing hundreds or thousands of bodies is more likely to have at least one restless soul present than a quiet road junction or a regular family home. The evidence presented by the cemeteries featured in this chapter – most of which are over a century old – appears to show that these sites are indeed hotbeds of hauntings, apparitions and unexplained occurrences. Throughout Europe, as cities outgrew the capacities of their medieval churchyards, the rapid founding of Victorian-era suburban burial grounds,

with their elaborate gothic memorials, provided fresh impetus for the discovery of ghosts and unnatural phenomena. In America, too, new graveyards were established on the outskirts of towns and cities as more immigrants arrived to seek their fortunes. Today, many of these now-faded cemeteries are notorious for their nocturnal visitors. Here in this chapter is just a small sample of the many cemetery locations where otherworldly events have been observed and even documented on film. Some of the cemeteries shown may be familiar, as they have been used as locations for movies. As you will see, though, truth can be stranger than fiction…

LEFT:
Weeping Woman Sculpture, Greyfriars Burial Ground, Perth, UK
Founded on the site of an old Franciscan monastery destroyed in the Scottish Reformation, this burial ground boasts some gravestones dating back as far as 1580. Some of the older stones have been relocated and it is believed that this may have disturbed the residents, causing the mysterious shadows and strange noises that have been seen and recorded.

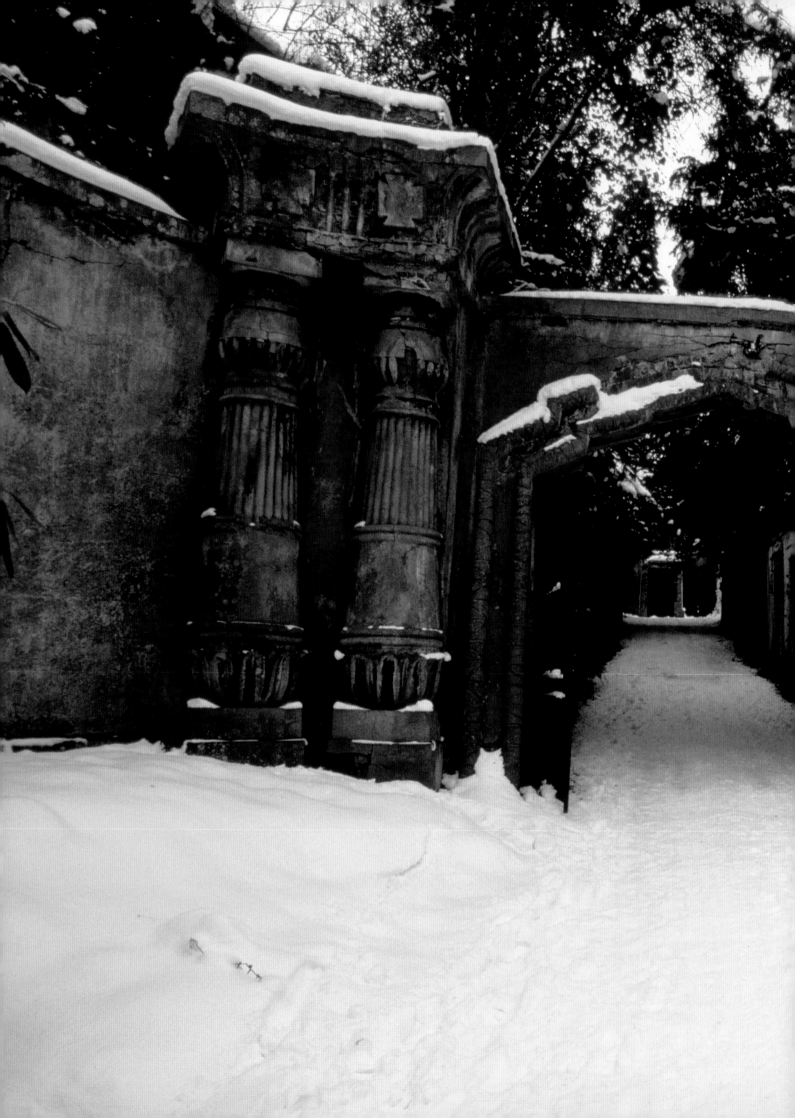

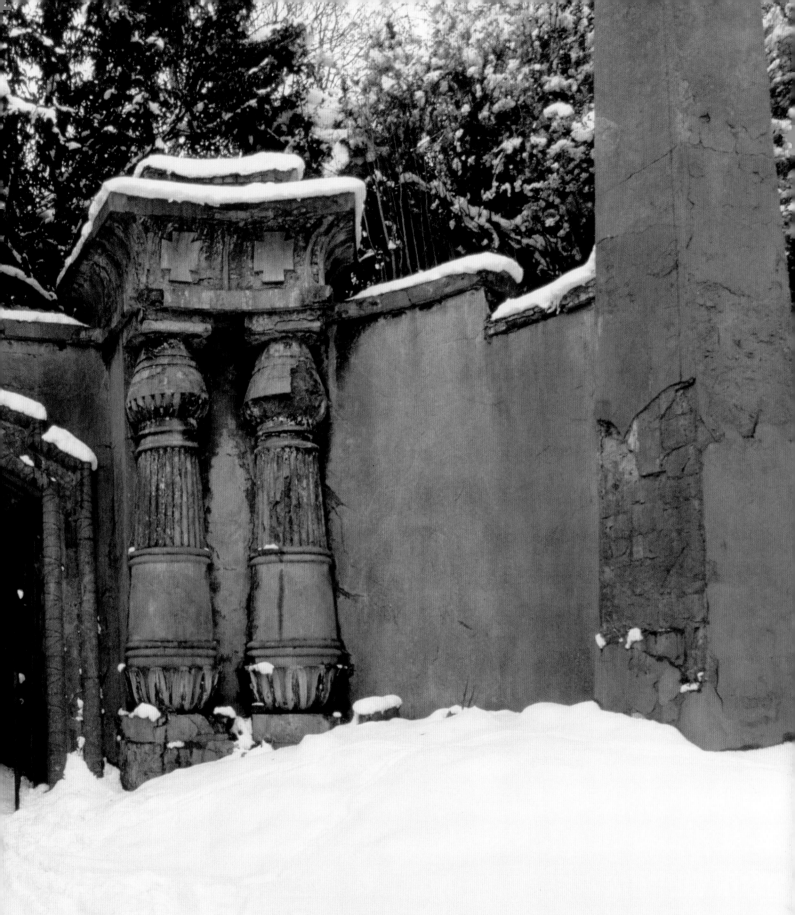

**Egyptian Avenue, Highgate
Cemetery, London, UK**
One of the 'Magnificent Seven'
cemeteries established to
accommodate the rising numbers
of Victorian London's dead,
Highgate saw tens of thousands
buried in its 17 acres over
approximately a century from the
time it opened in 1839.

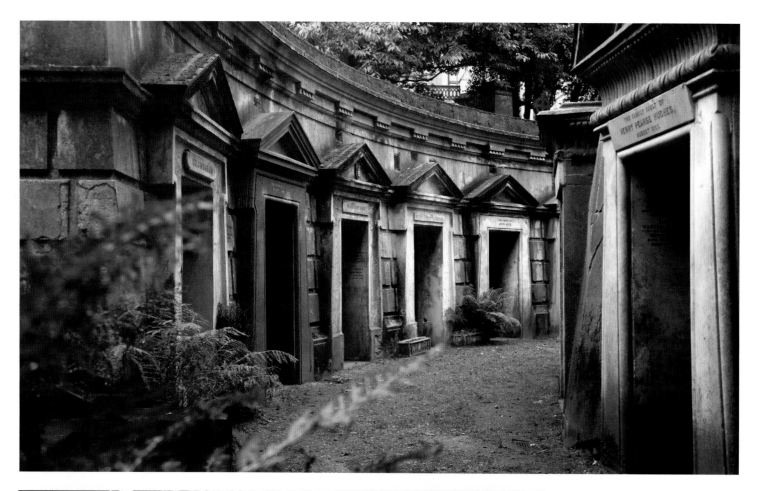

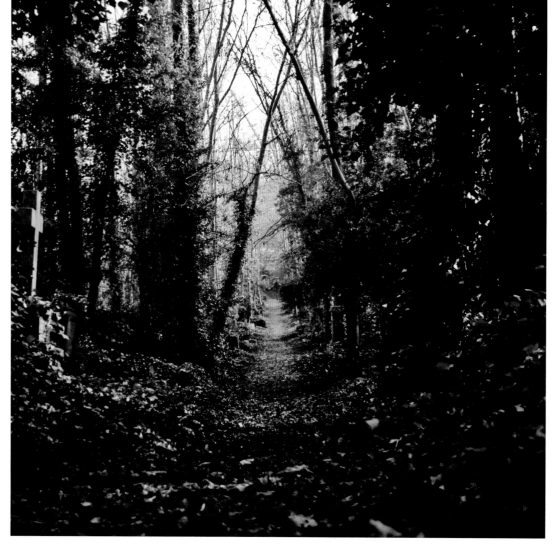

ABOVE:
Circle of Lebanon Vaults, Highgate Cemetery, London, UK
The cemetery was effectively abandoned after World War II, and sightings began to increase as it became more unkempt, culminating in the 'Highgate Vampire' scare, which saw journalists and camera crews trying to spot the undead.

LEFT:
Mystic Forest, Highgate Cemetery, London, UK
In the 1980s, a group of volunteers began to restore the cemetery, and sightings became less frequent. However, the 'Mad Old Woman', who searches feverishly for the children she supposedly murdered, has been seen by many visitors. Another common sighting is the 'Shrouded Ghoul', who floats staring at the sky, but disappears if approached.

RIGHT:
Otto Christian Emanuel Kamp's Gravestone, Highgate Cemetery, London, UK
Kamp's grave is typical of the many ornate memorials found in the cemetery. He died in 1921, and his wife joined him in 1933.

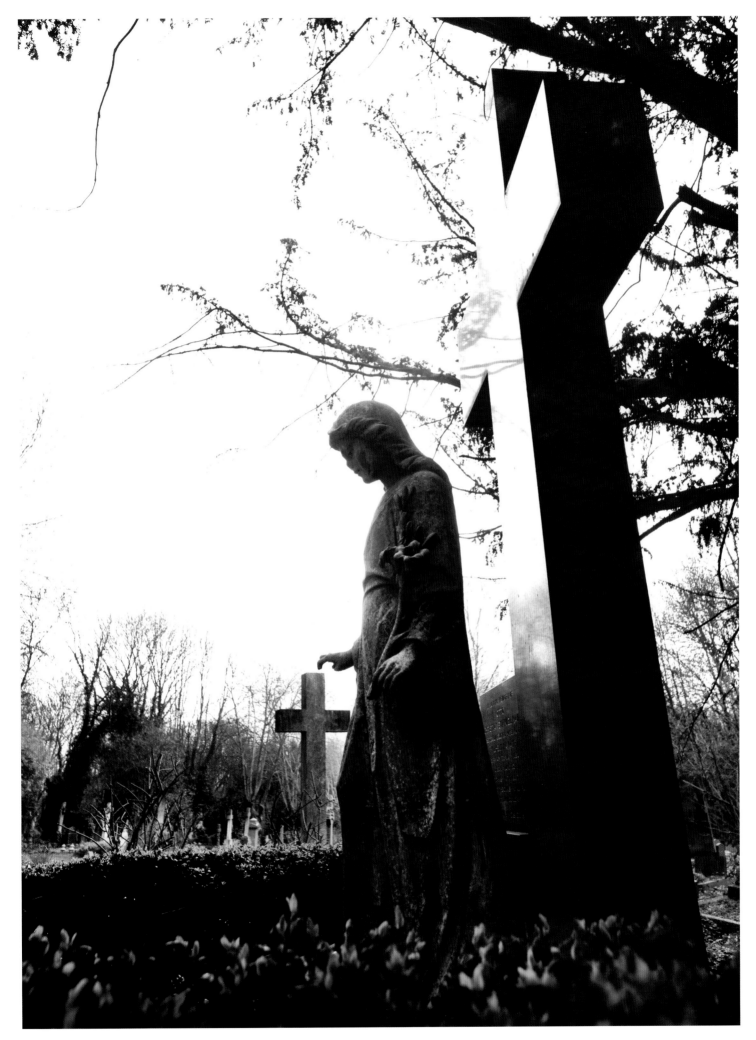

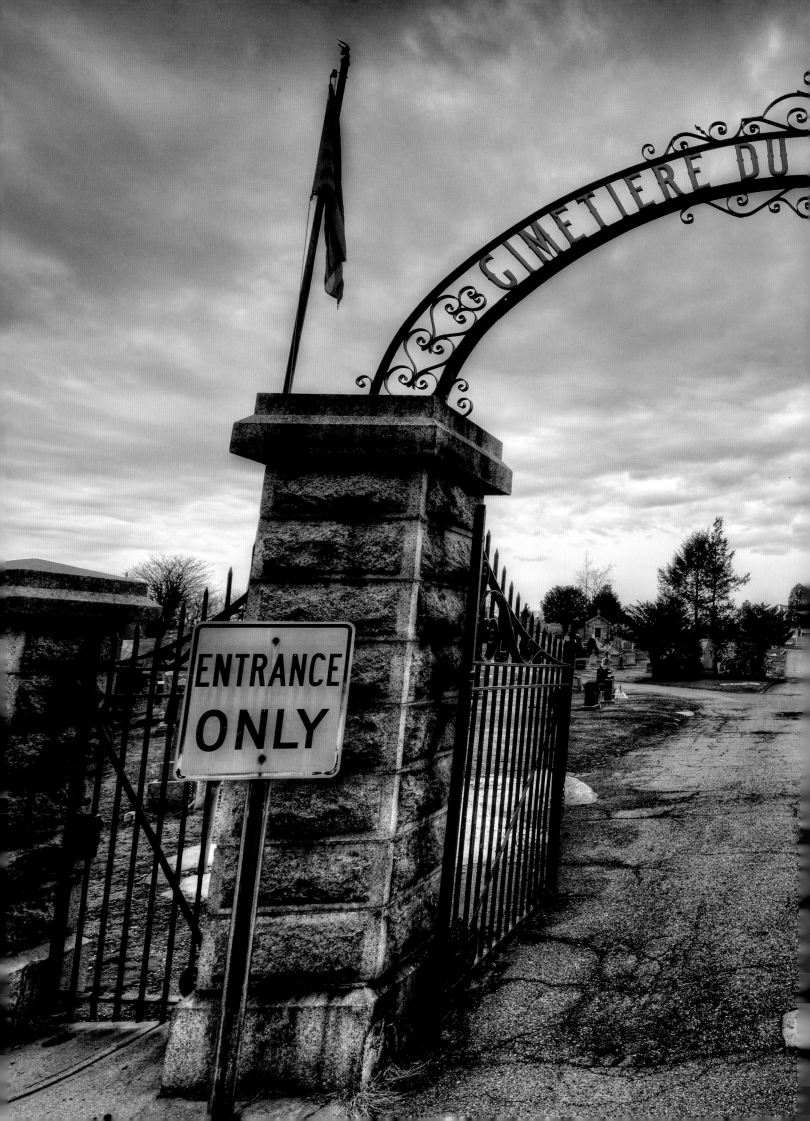

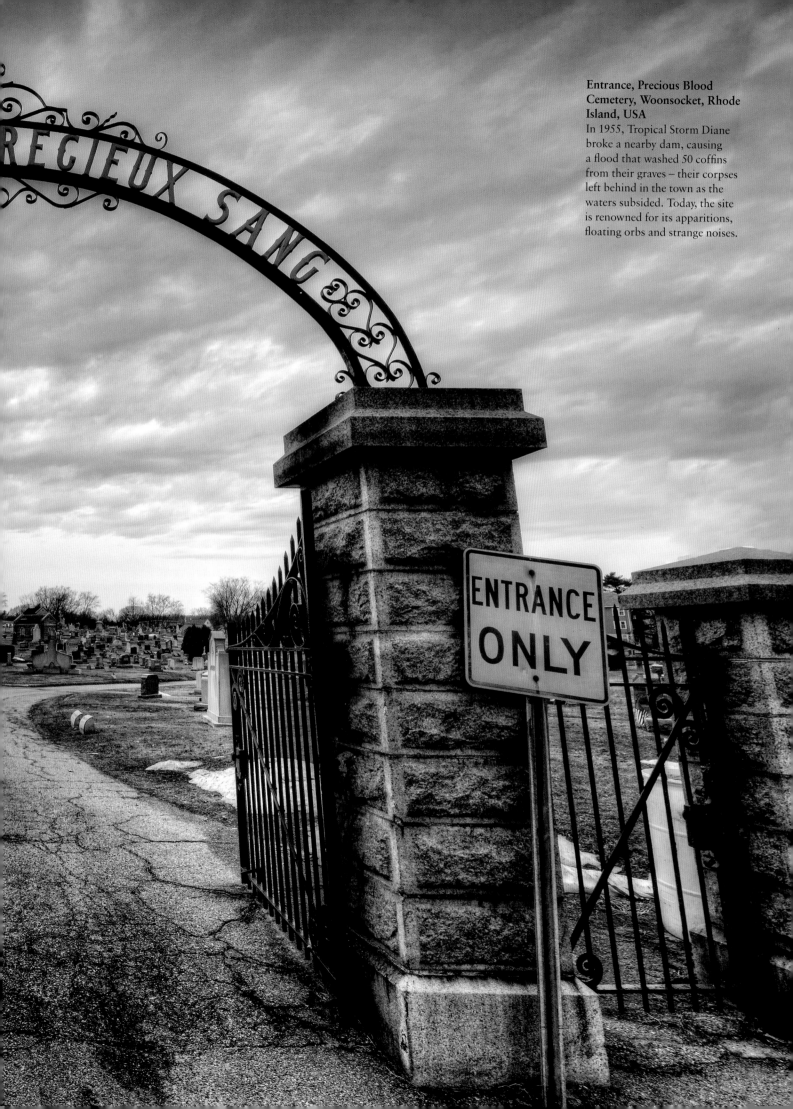

Entrance, Precious Blood
Cemetery, Woonsocket, Rhode
Island, USA
In 1955, Tropical Storm Diane
broke a nearby dam, causing
a flood that washed 50 coffins
from their graves – their corpses
left behind in the town as the
waters subsided. Today, the site
is renowned for its apparitions,
floating orbs and strange noises.

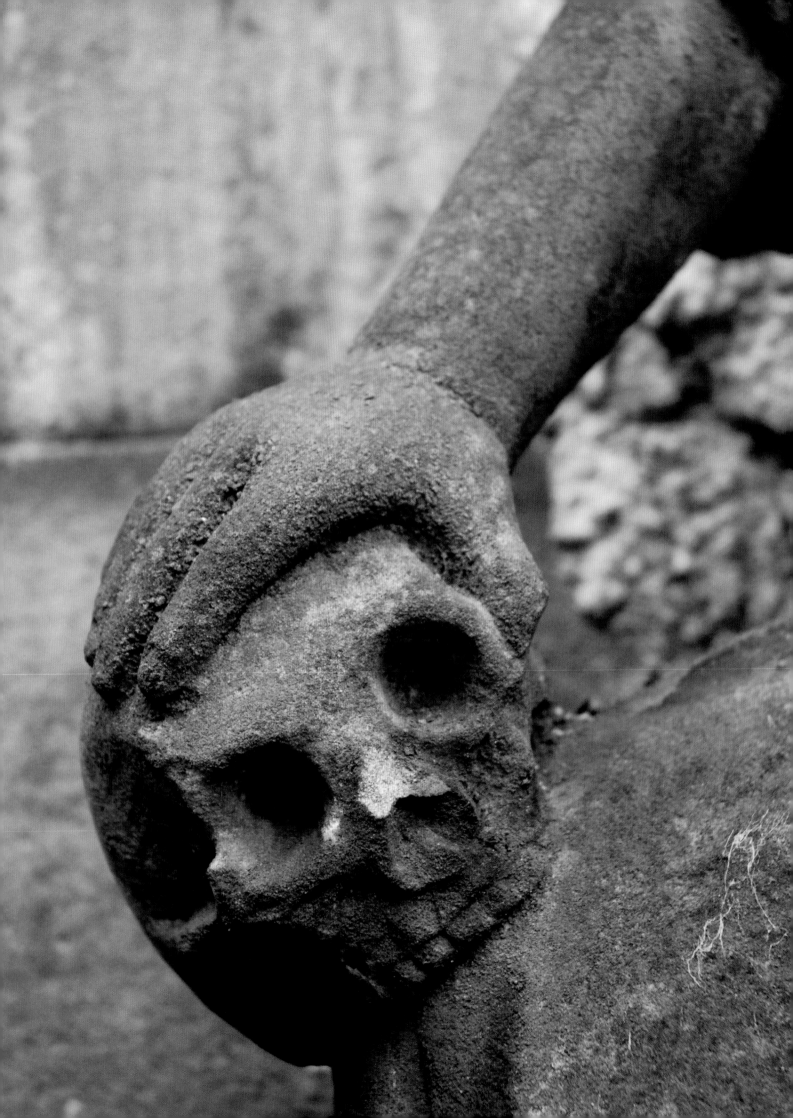

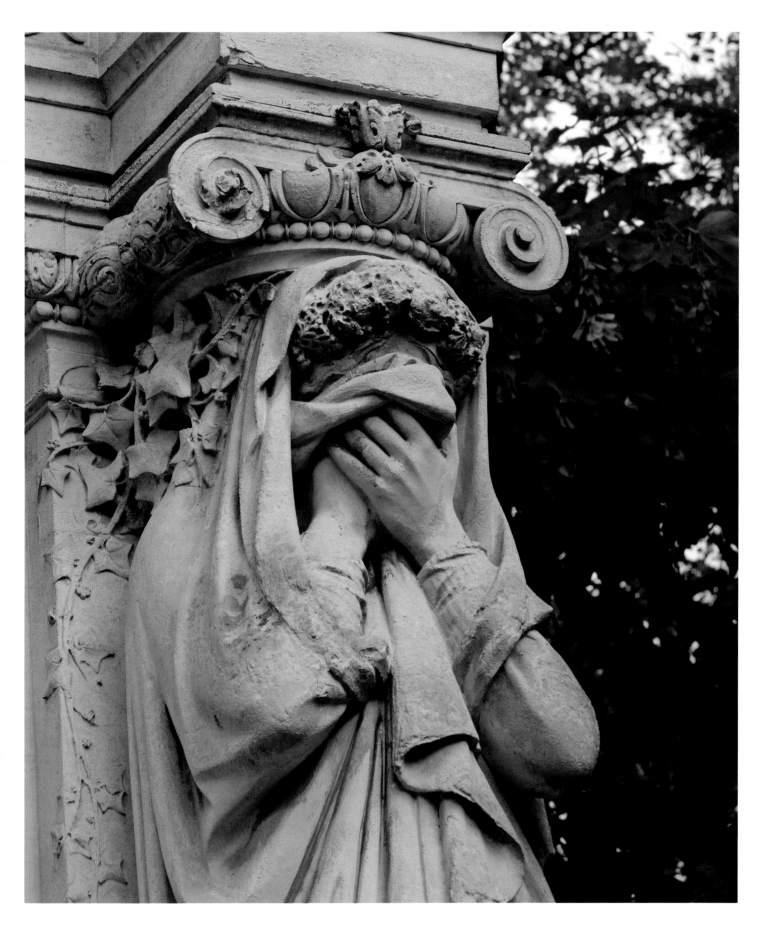

LEFT:

Sculpture, Greyfriars Kirkyard, Edinburgh, UK

The most famous resident spirit is Sir George 'Bluidy' Mackenzie, who had many people tortured and killed close to the spot where his mausoleum lies today.

ABOVE:

Sculpture, Père-Lachaise Cemetery, Paris, France

Now home to over one million graves, this world-famous cemetery opened in 1804. It is the final resting place of many famous people – and many restless spirits.

OVERLEAF:

Père-Lachaise Cemetery, Paris, France

Jim Morrison, the lead singer of The Doors, is said to walk near his grave, which is regularly daubed with graffiti and then cleaned on behalf of his family.

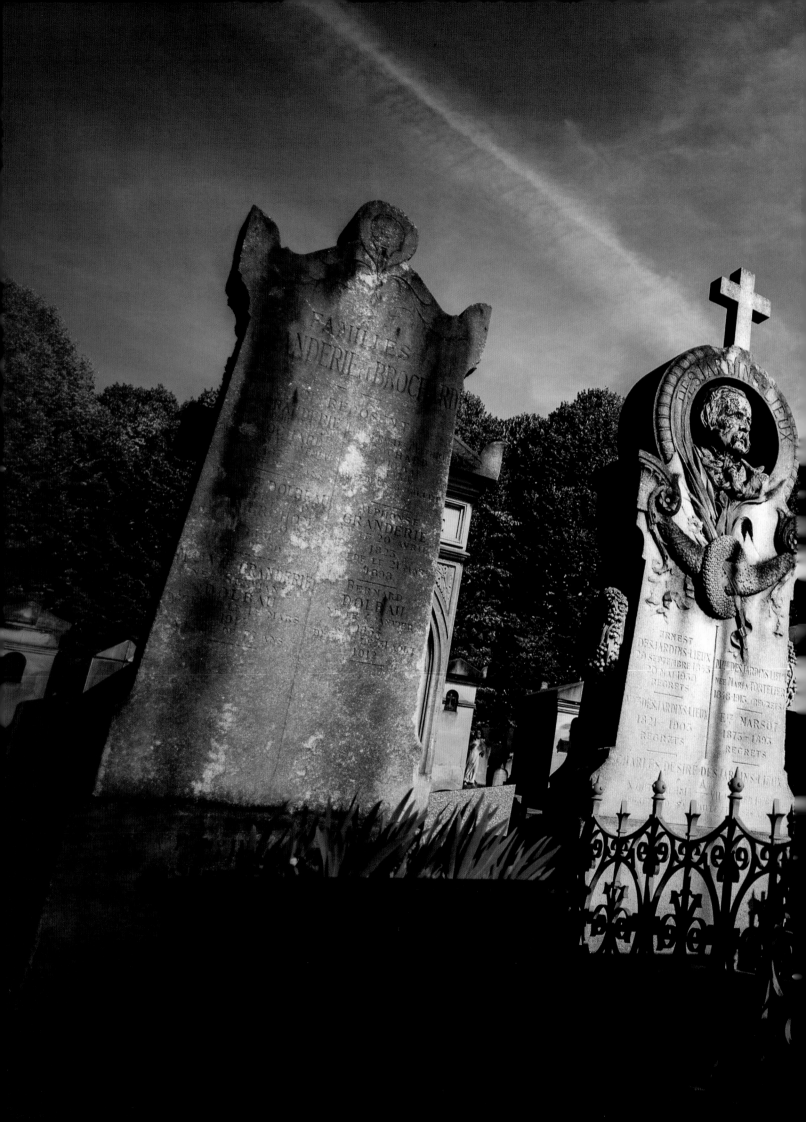

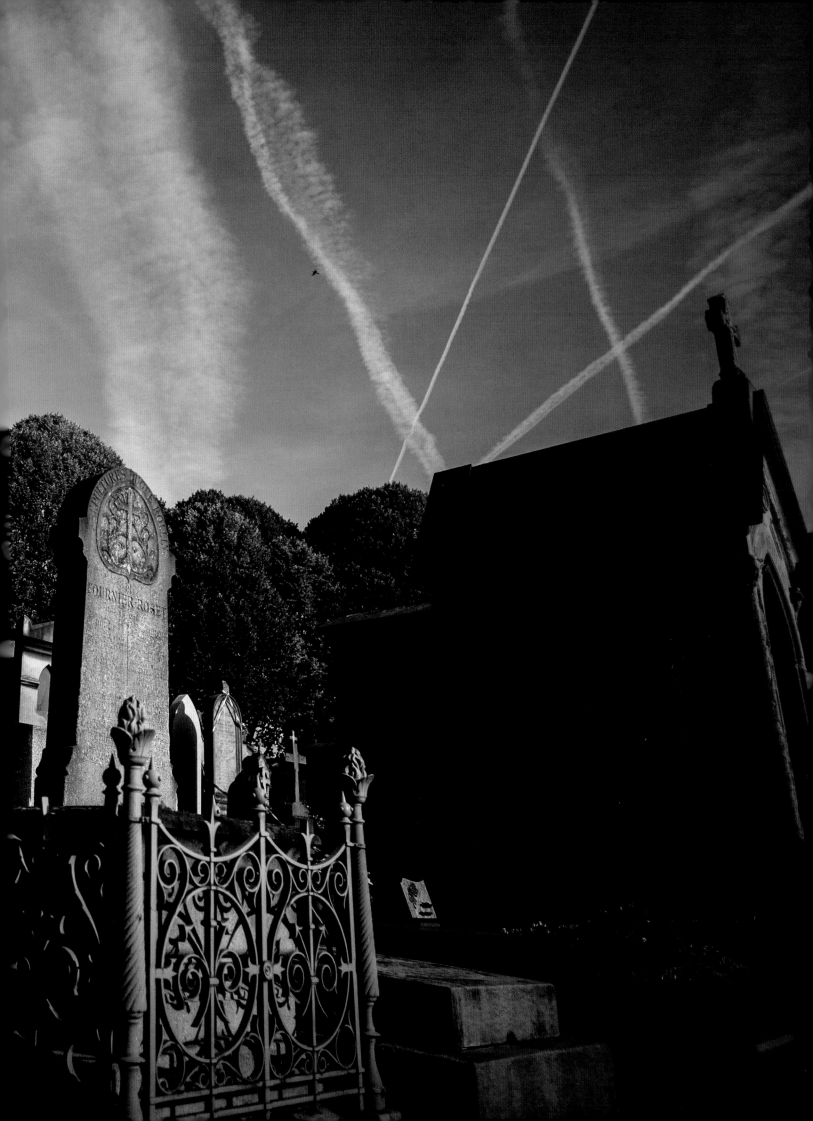

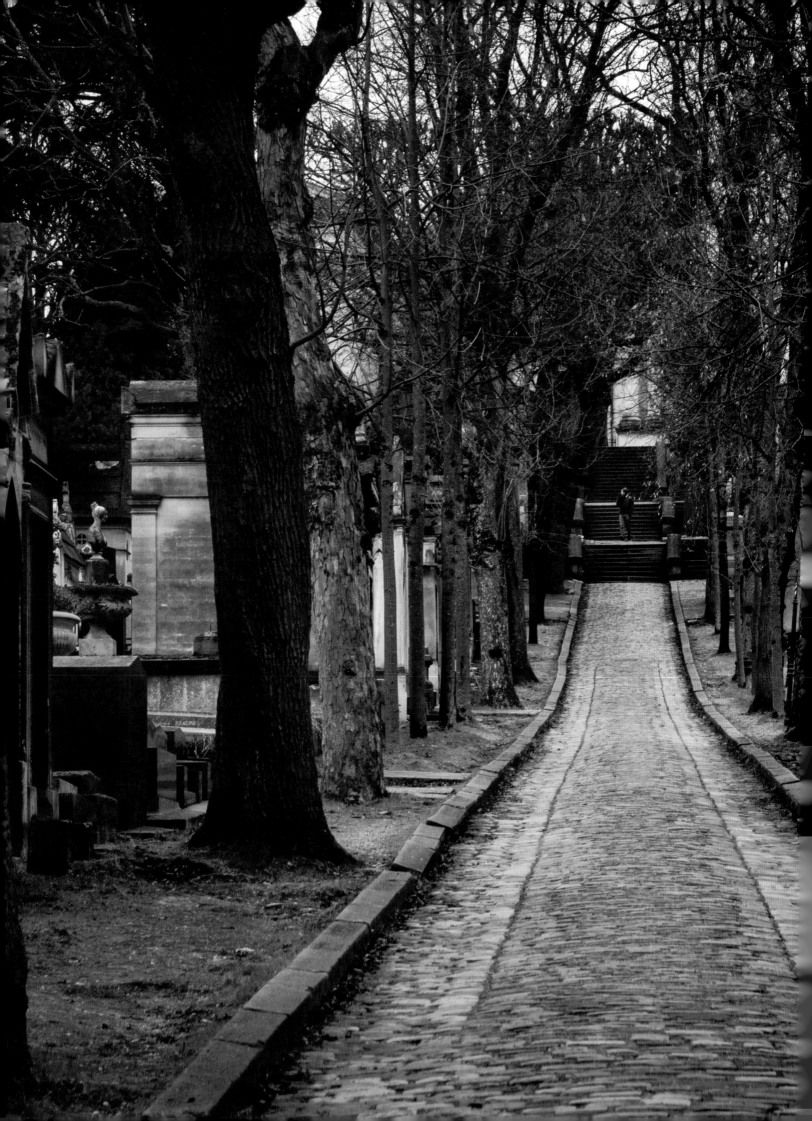

Path, Père Lachaise Cemetery, Paris, France
The spirits of Marcel Proust and Maurice Ravel – who were partners in life – are said to leave their graves and go in search of each other each night.

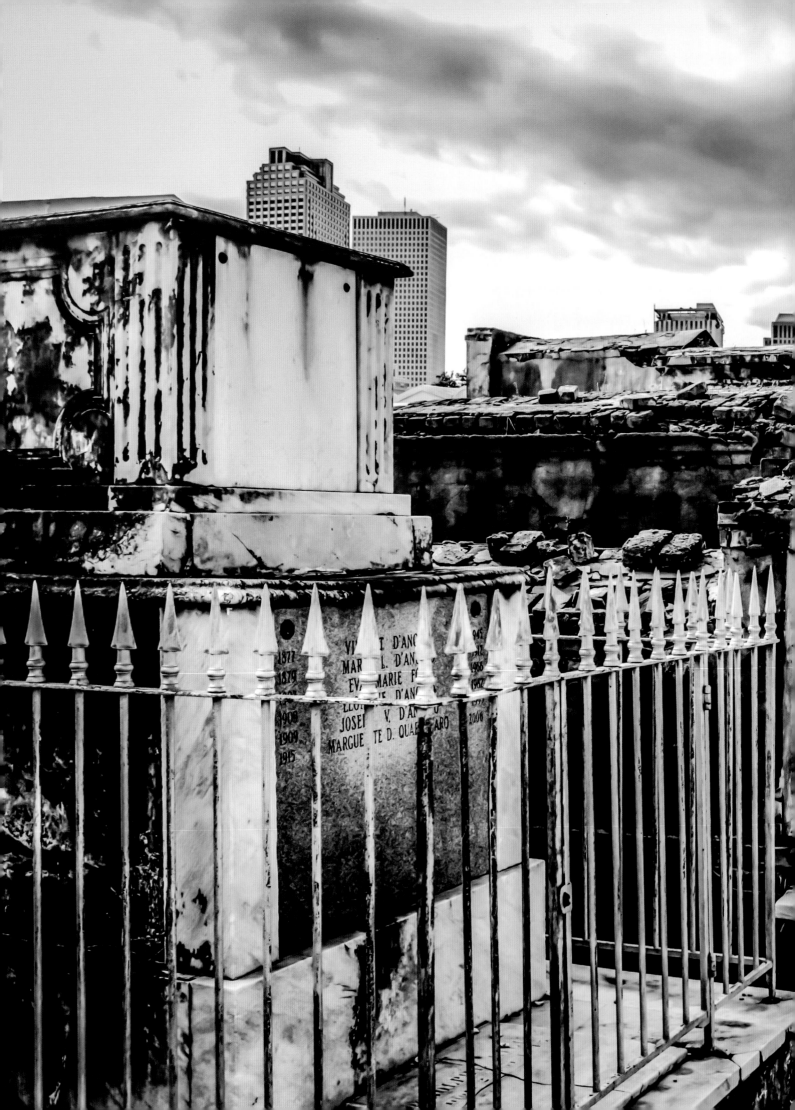

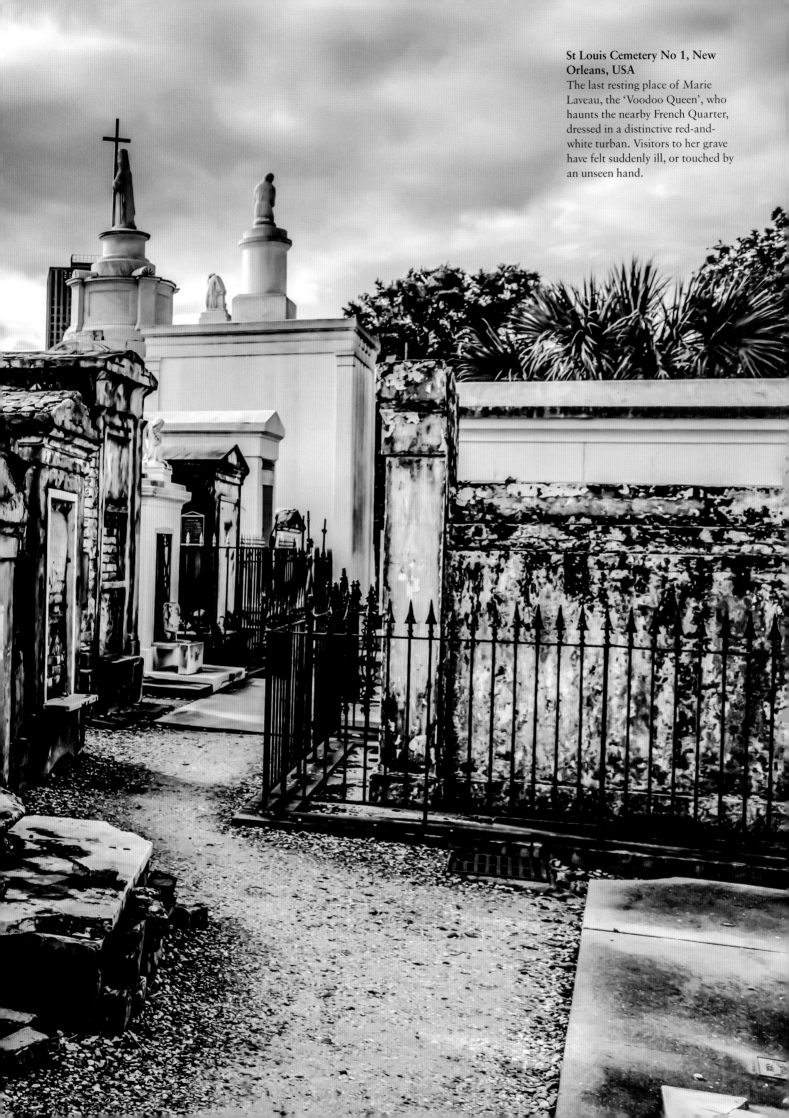

St Louis Cemetery No 1, New Orleans, USA
The last resting place of Marie Laveau, the 'Voodoo Queen', who haunts the nearby French Quarter, dressed in a distinctive red-and-white turban. Visitors to her grave have felt suddenly ill, or touched by an unseen hand.

Easton Baptist Church, Connecticut, USA
Behind the church at Easton is a sinkhole in which a number of victims' corpses have been found. Visitors to the area report a number of audio and visual phenomena, including a pair of floating red eyes.

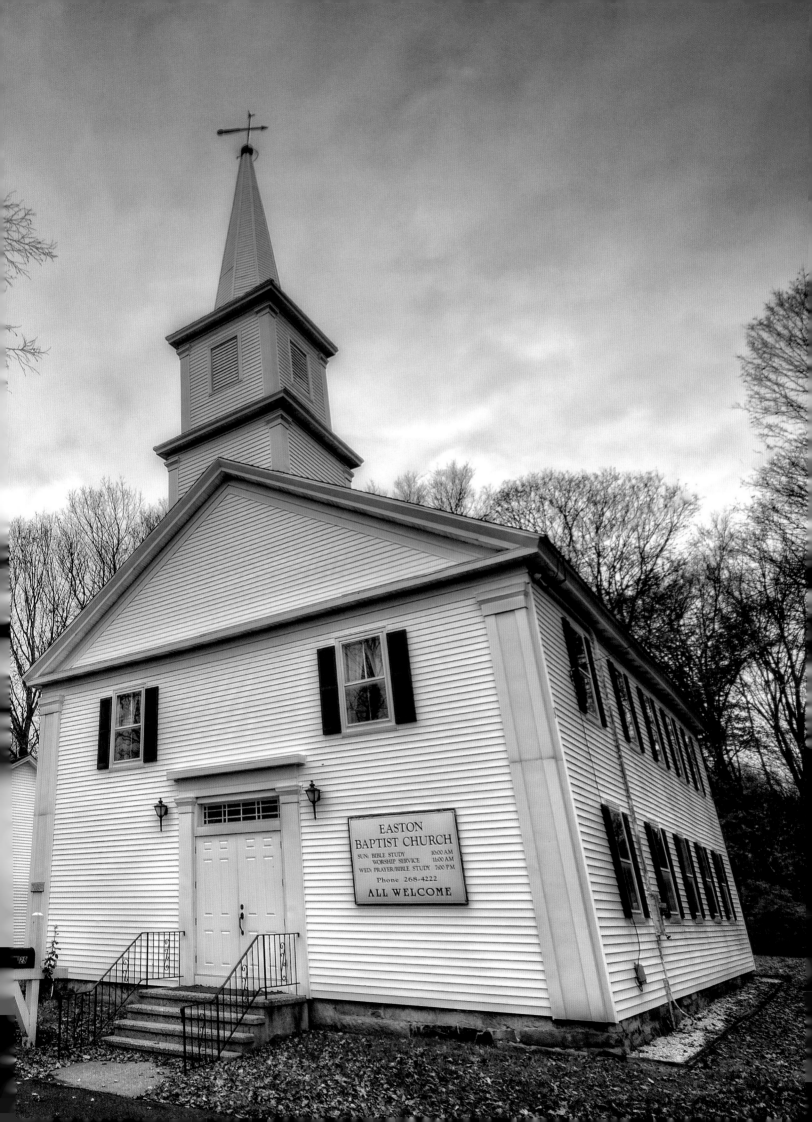

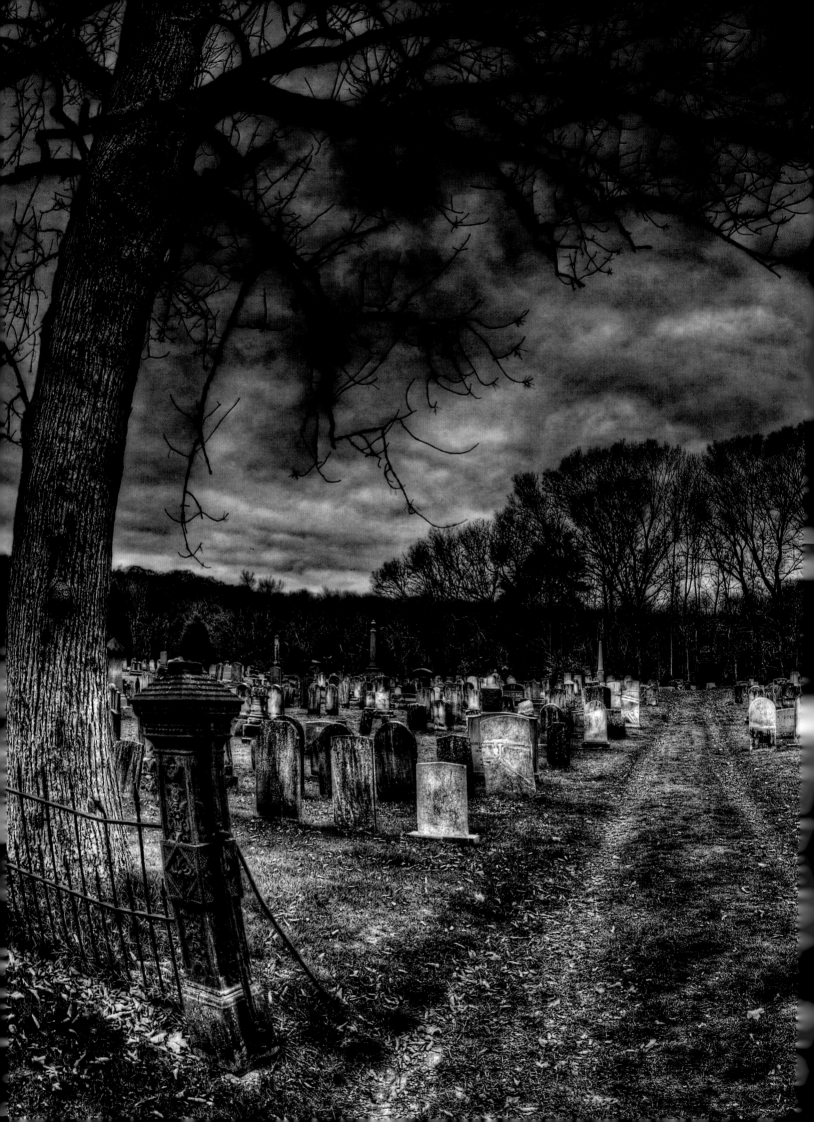

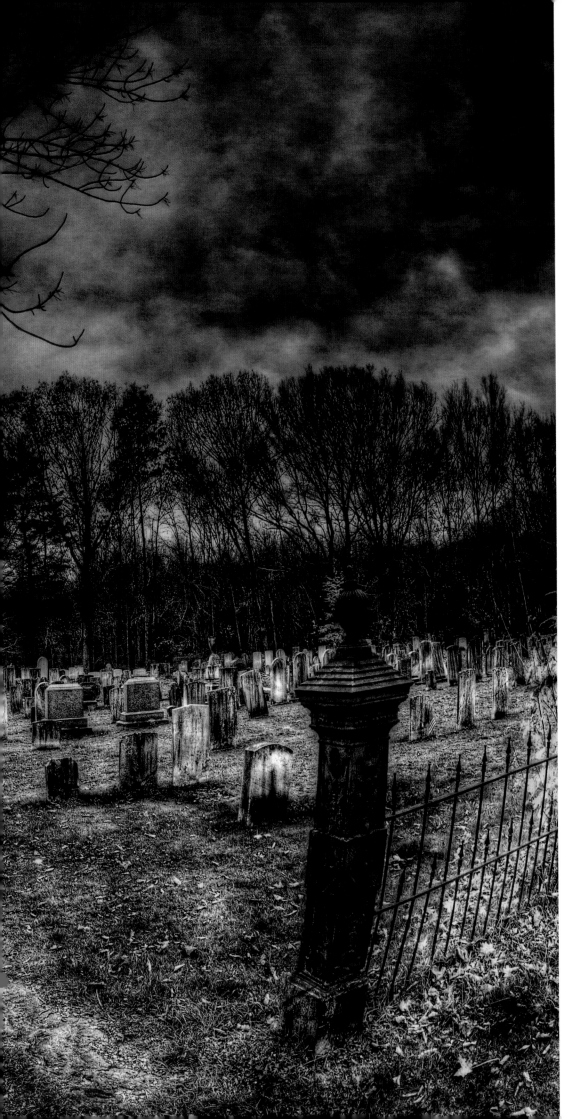

Union Cemetery, Easton, Connecticut, USA
Opened in the early 18th century, this burial ground is haunted by a 'White Lady' who may be wearing a wedding dress. A number of motorists have reported hitting a woman on one of the nearby roads, but no body can be found when they stop. Sightings of the lady date back to the 1940s, and her fame has brought many visitors to Easton.

**'Mad Jack' Fuller's Mausoleum,
Brightling Churchyard,
East Sussex, UK**

Fuller was a colourful character
who enjoyed building follies like
his mausoleum, constructed in
1811. He is said to be sat upright
inside, wearing a top hat and
with a bottle of claret wine next
to him on a table. However, his
ghost is supposed not to haunt the
churchyard, as why would anyone
want to leave a good claret?

Hotels & Public Places

Some locations are frequented by so many people that it is inevitable, due to the laws of probability alone, that some tragedy would occur that could lead to reports of paranormal activity. Deaths from natural causes are quite commonplace in hotels, but occasionally a single event will take place – a murder, or a suicide – that may leave a restless spirit behind. Reports of mass hauntings are less common but do occur, a most notable example being at the site of the horrific Joelma Building fire in São Paulo. Some of the poorest areas of cities would have high population densities and poor sanitation, allowing disease and death to spread throughout the community quickly, and the tensions and temptations of living in close proximity would lead to a high murder rate. For some communities, such as in the Far East with World War II, the arrival of war saw mass deaths, torture and imprisonment. For those in the American Gold Rush, there was plenty of opportunity for self-enrichment, but life was hard, and many found solace in whisky and the seamier side of society. In these public places, it appears that many spirits have not found rest. From mysterious figures in celebrity haunts to unexplained noises in the lane made famous by The Beatles, it proves there is nothing normal about the paranormal.

LEFT:
Blair Street Vaults, Edinburgh, UK
Formed by the building of the North and South bridges in the late 18th century, these vaults were initially used for storage before becoming housing for the city's poorest inhabitants. It is rumoured that Burke and Hare, the infamous bodysnatchers, hunted for some of their victims here. Abandoned in the 19th century, the vaults lay forgotten about until a chance rediscovery in 1985, since when several ghosts have been reported.

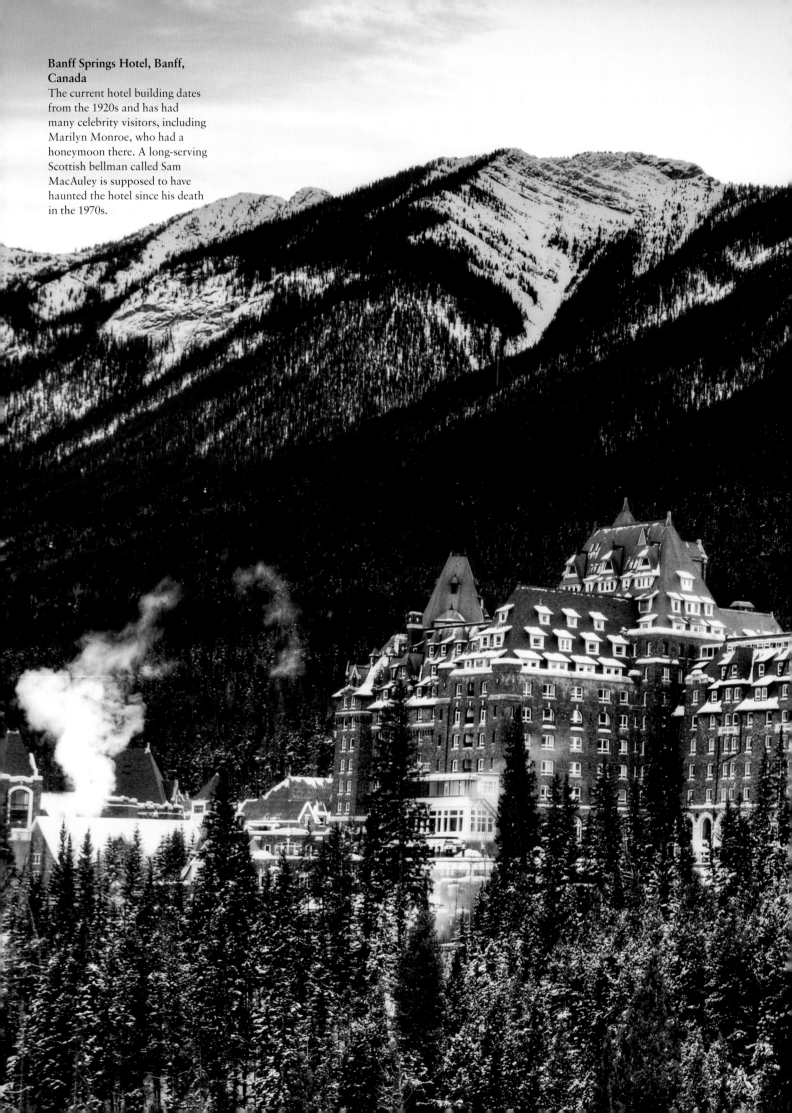

Banff Springs Hotel, Banff, Canada
The current hotel building dates from the 1920s and has had many celebrity visitors, including Marilyn Monroe, who had a honeymoon there. A long-serving Scottish bellman called Sam MacAuley is supposed to have haunted the hotel since his death in the 1970s.

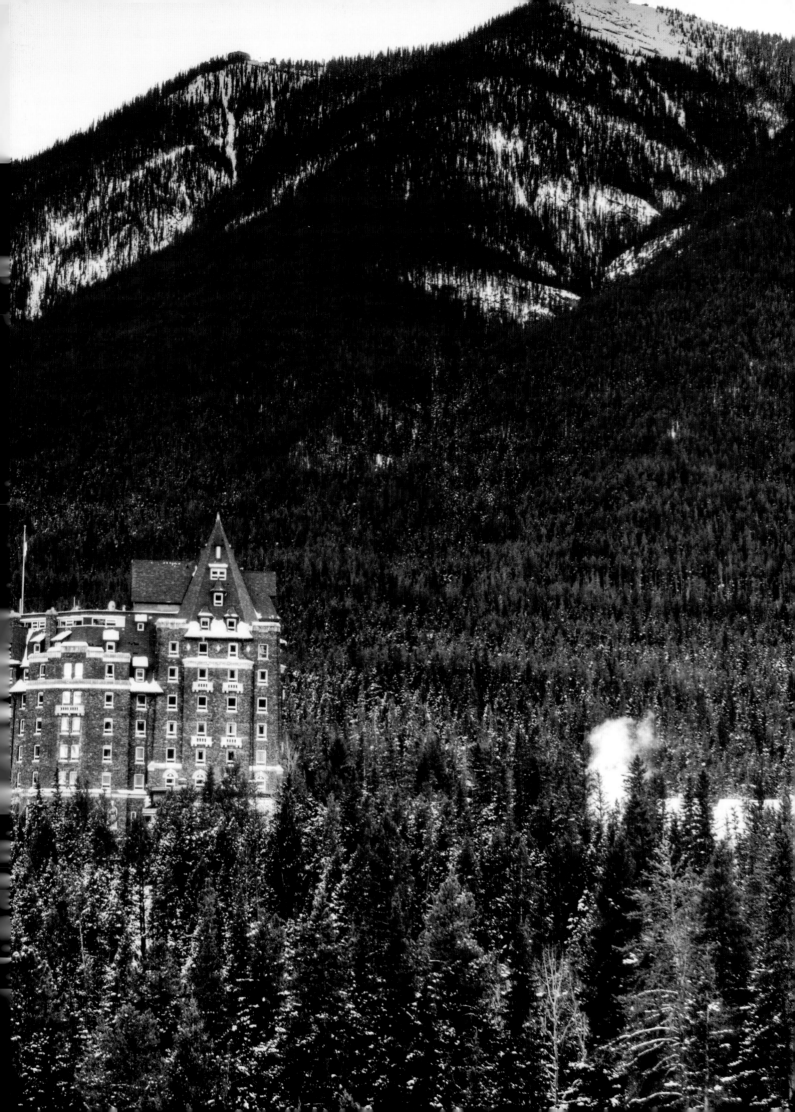

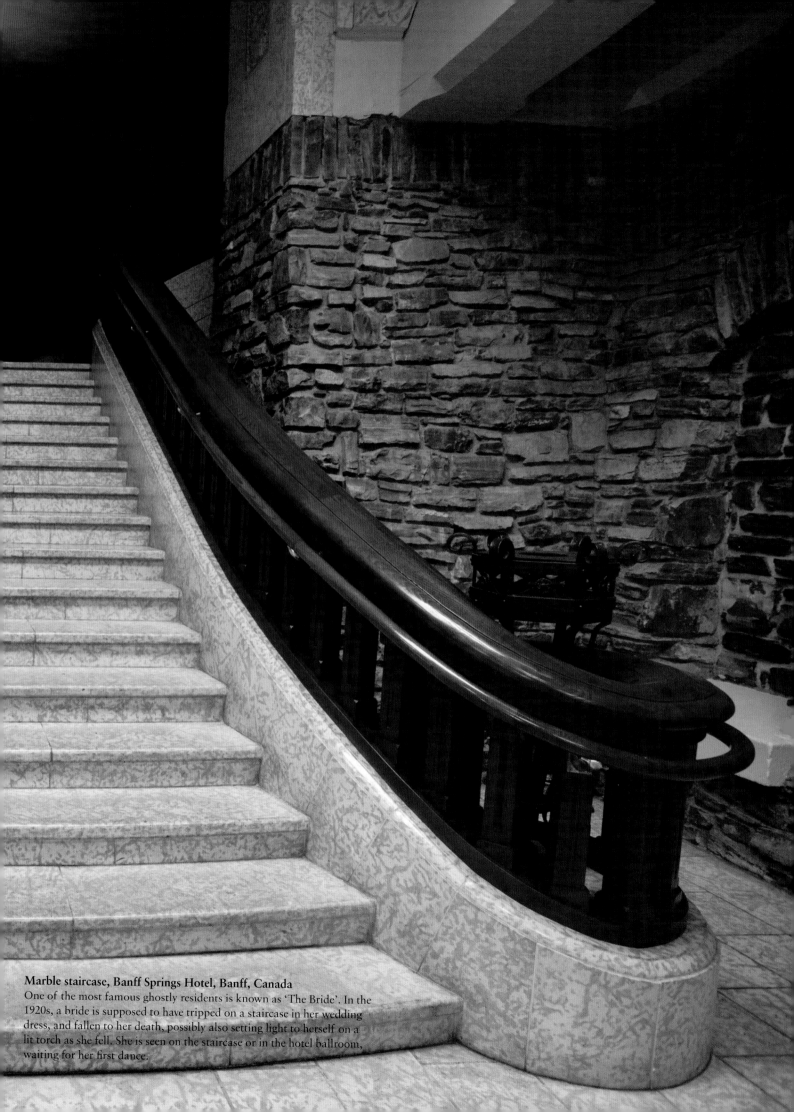

Marble staircase, Banff Springs Hotel, Banff, Canada
One of the most famous ghostly residents is known as 'The Bride'. In the 1920s, a bride is supposed to have tripped on a staircase in her wedding dress, and fallen to her death, possibly also setting light to herself on a lit torch as she fell. She is seen on the staircase or in the hotel ballroom, waiting for her first dance.

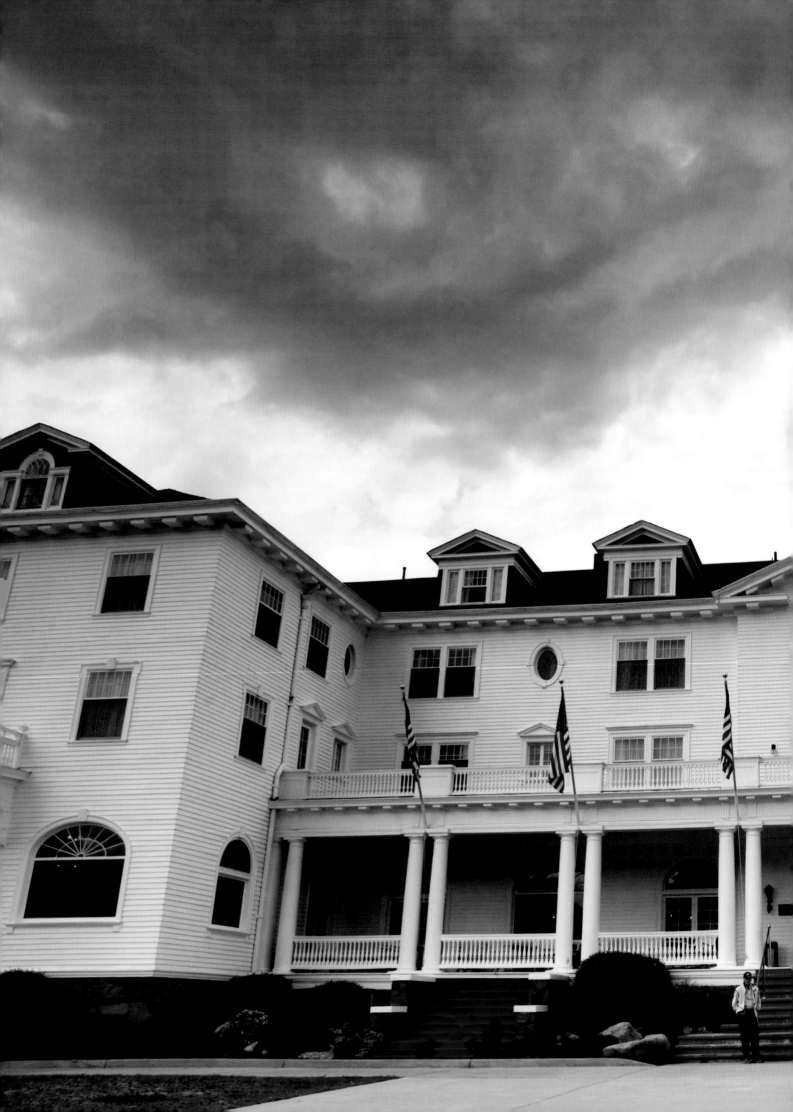

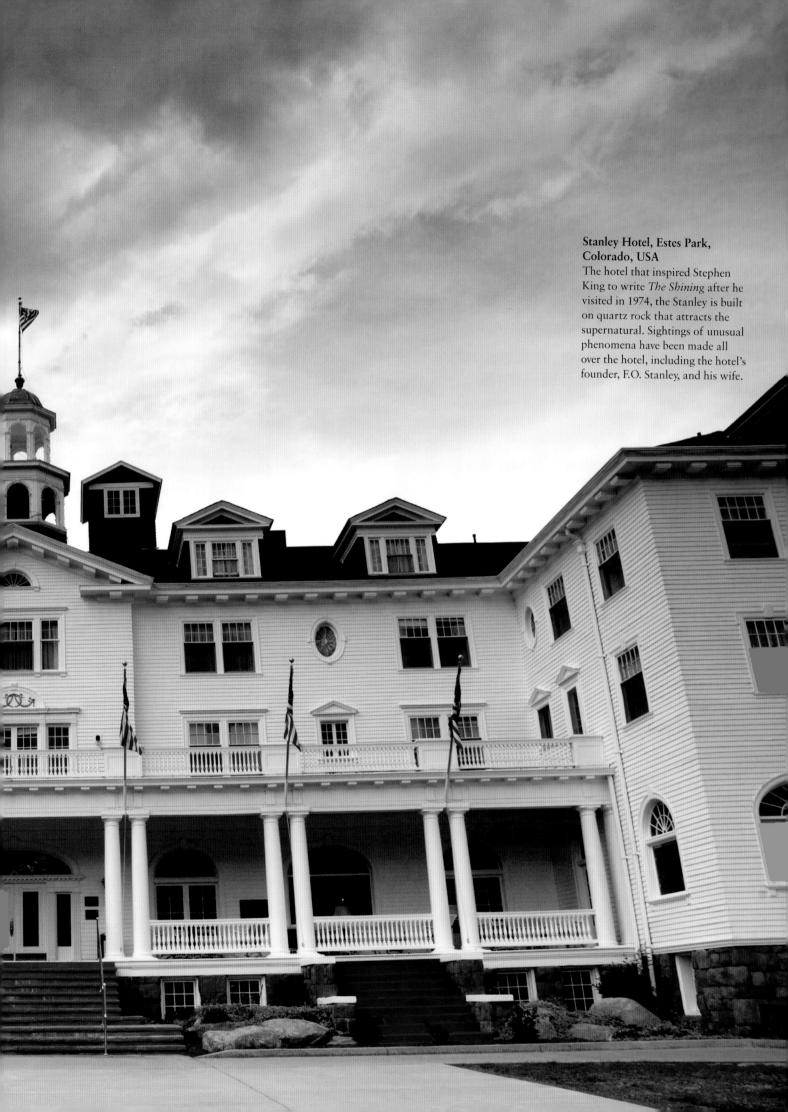

Stanley Hotel, Estes Park, Colorado, USA
The hotel that inspired Stephen King to write *The Shining* after he visited in 1974, the Stanley is built on quartz rock that attracts the supernatural. Sightings of unusual phenomena have been made all over the hotel, including the hotel's founder, F.O. Stanley, and his wife.

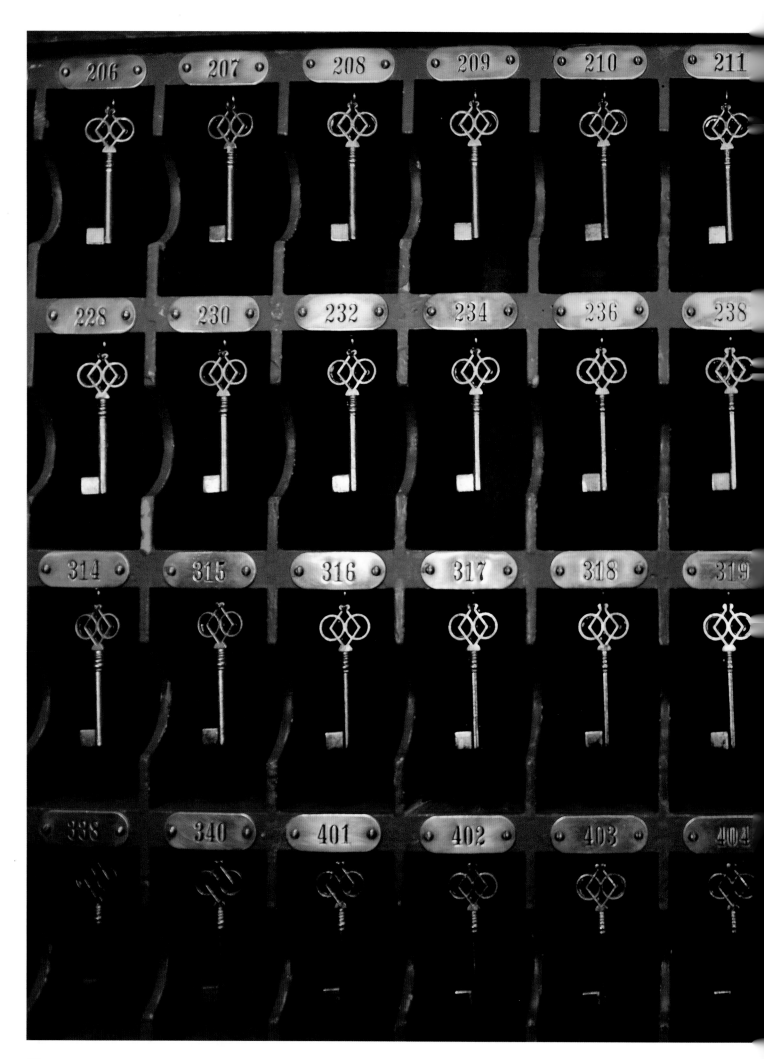

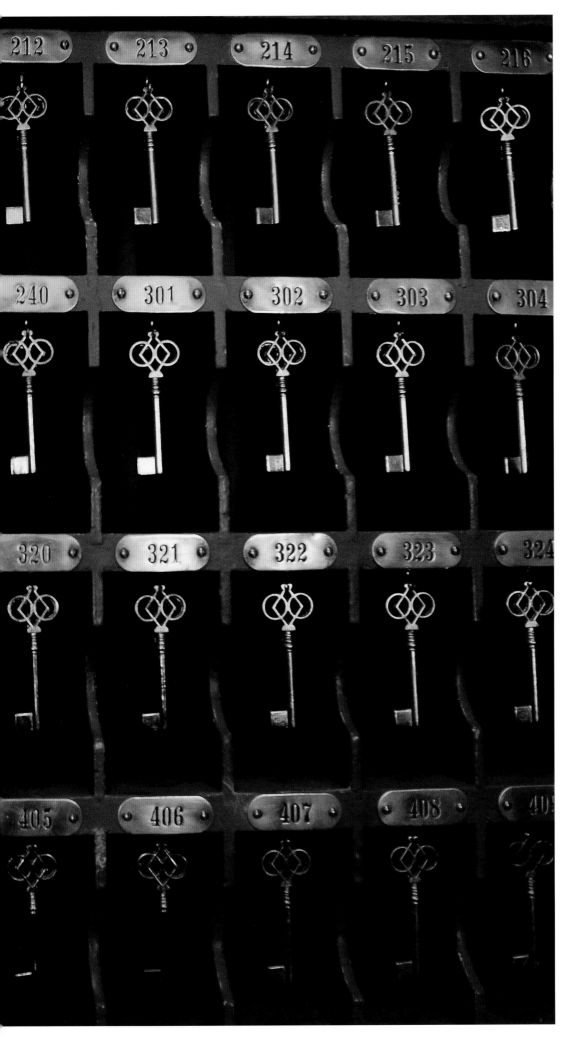

Original room keys, Stanley Hotel, Estes Park, Colorado, USA
Room 217 is supposed to be haunted by Elizabeth Wilson, a former chambermaid who, in June 1911, was blown into the dining room below in a gas leak explosion. She survived with broken ankles, but came back to work at the hotel until her death in the 1950s. She reportedly unpacks and puts away guests' clothing.

Mary King's Close, Edinburgh, UK

During the 17th century, the plague struck this close below the City Chambers inhabited by some of Edinburgh's poorest. It was later partly closed off, with victims' bodies allegedly still in place.

Ghostly figure, Mary King's Close, Edinburgh, UK

In 1992, a Japanese psychic touring the close encountered 'Annie', a young girl supposedly left behind to die by her family, who tugged at her leg. Annie's room has since become a much-visited attraction.

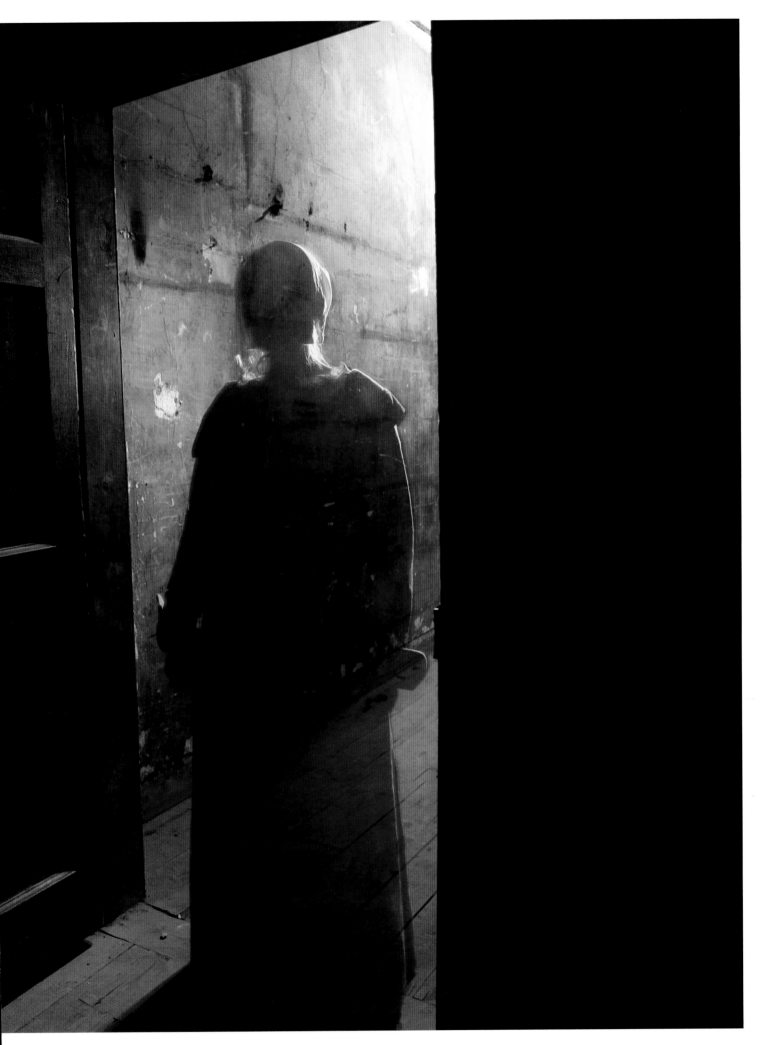

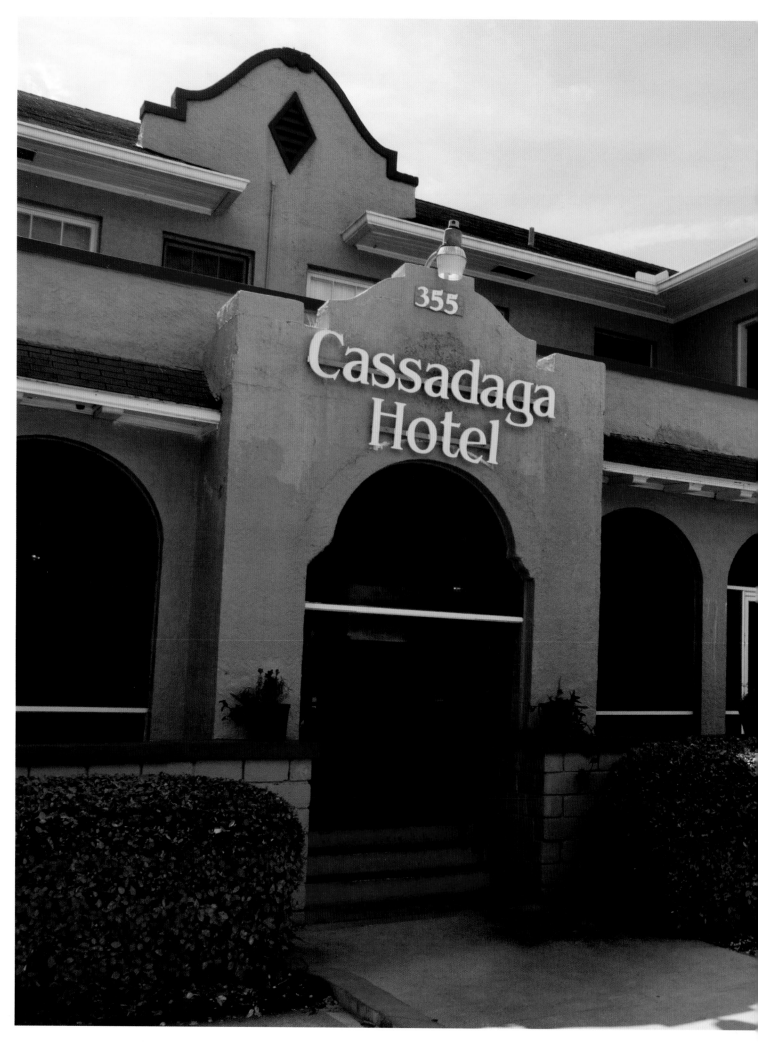

Cassadaga Hotel, Cassadaga, Florida, USA
Built to help service the visitors to the Cassadaga Spiritualist Camp, the hotel is now renowned for its many ghostly inhabitants. The best known is an Irish singer called 'Arthur', who lived and died at the hotel in the 1930s. There are many reports of guests smelling gin, cigars and even Arthur's body odour in Room 22.

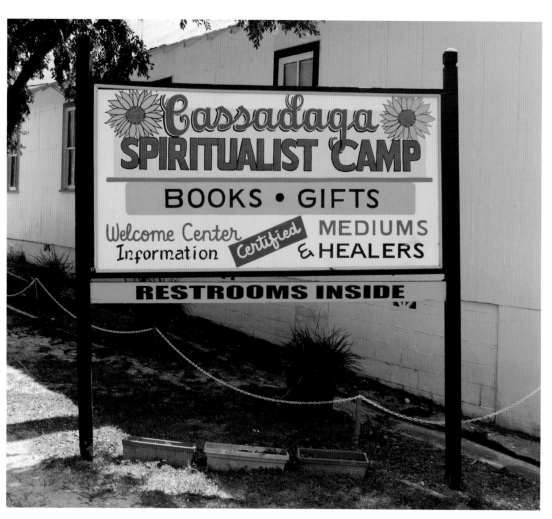

LEFT:
Cassadaga Spiritualist Camp, Cassadaga, Florida, USA
George Colby, a medium from New York, was told by his spirit guide, 'Seneca', to found a community in Cassadaga for fellow spiritualists in 1875. The town has become a leading centre for those wishing to commune with the dead.

BELOW:
Cassadaga Hotel, Cassadaga, Florida, USA
Other ghosts that have been encountered at the hotel include 'Gentleman Jack', who is fond of women, and two small girls named 'Sarah' and 'Kaitlin'.

RIGHT:
Edificio Praça da Bandeira, São Paulo, Brazil
Formerly the Joelma Building, this was the scene of a deadly fire in 1974 that killed 179 people. Renamed and refurbished, the building reopened a few years later, but occupants have reported fire alarms being triggered without cause, and numerous apparitions seen on the building's stairs.

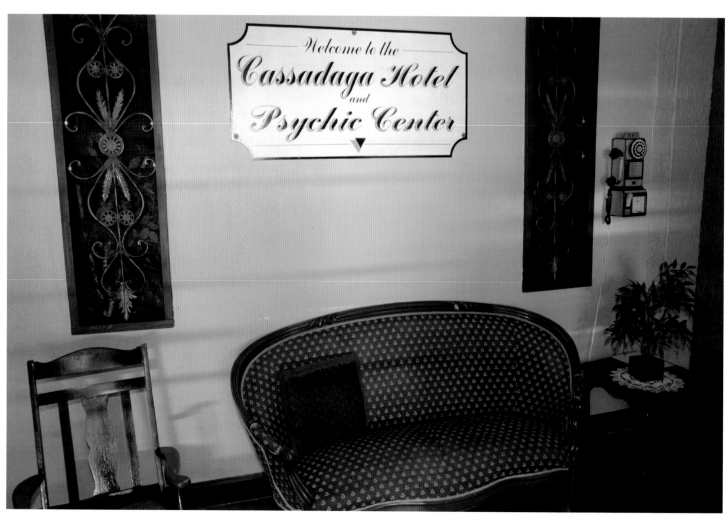

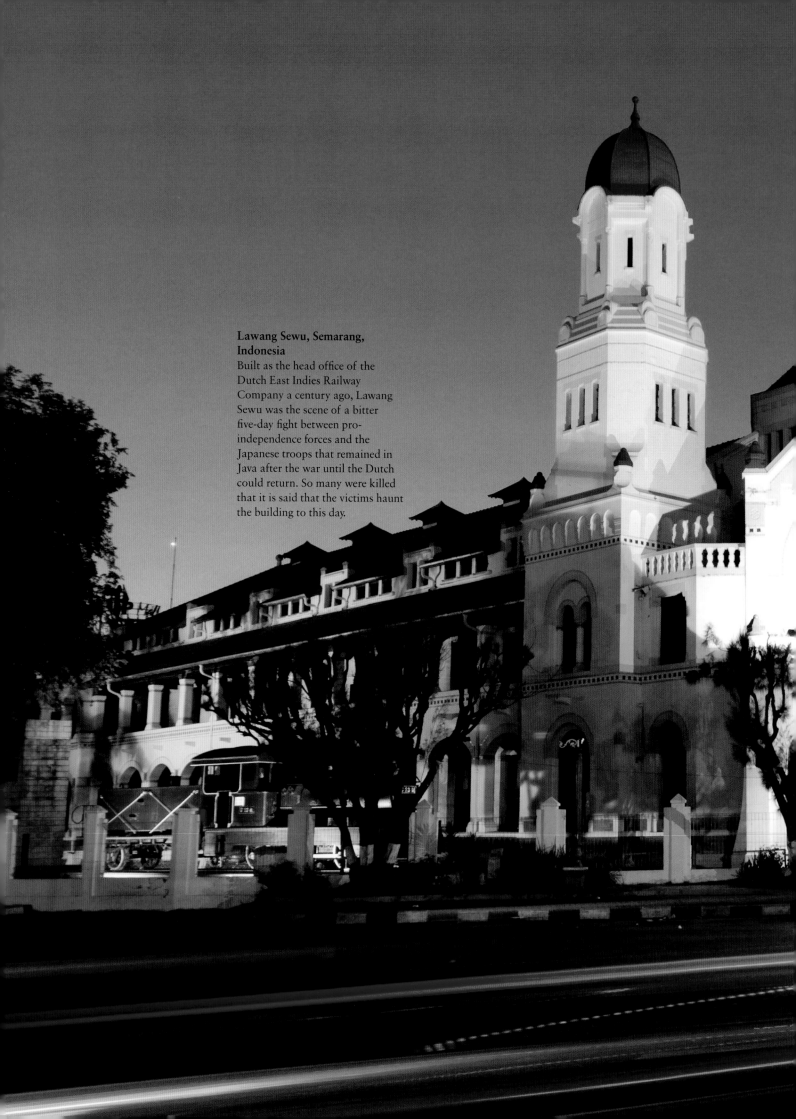

Lawang Sewu, Semarang, Indonesia
Built as the head office of the Dutch East Indies Railway Company a century ago, Lawang Sewu was the scene of a bitter five-day fight between pro-independence forces and the Japanese troops that remained in Java after the war until the Dutch could return. So many were killed that it is said that the victims haunt the building to this day.

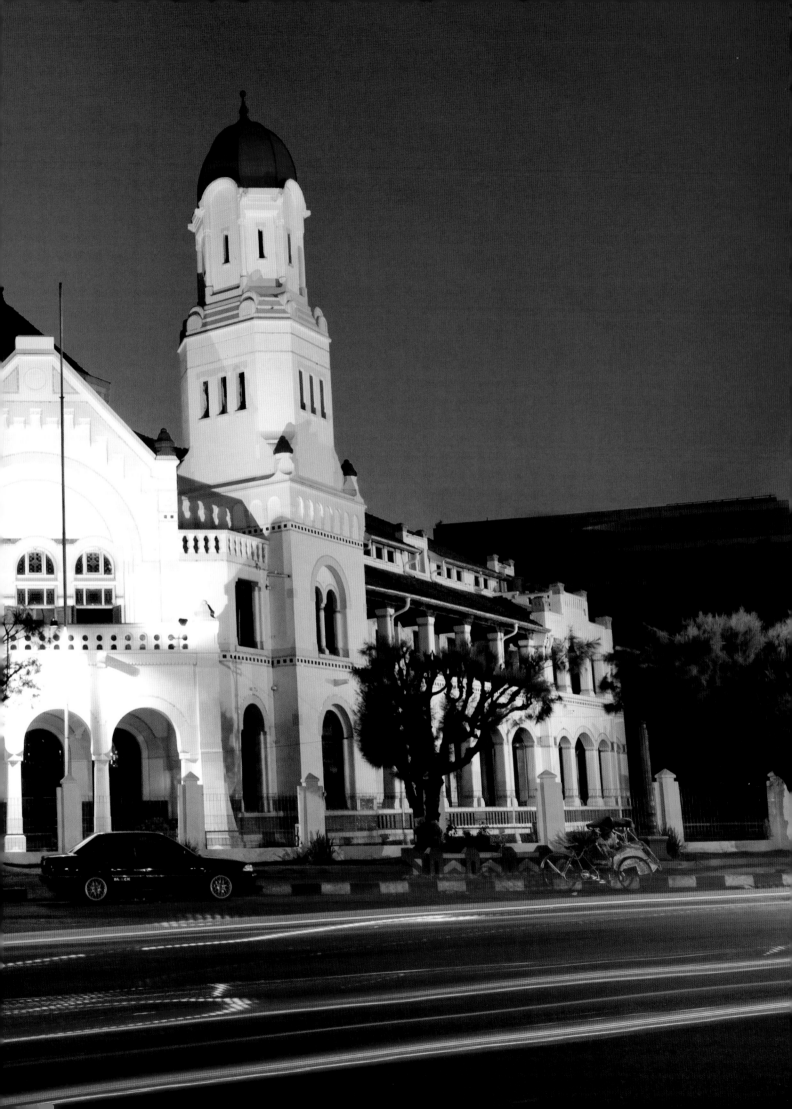

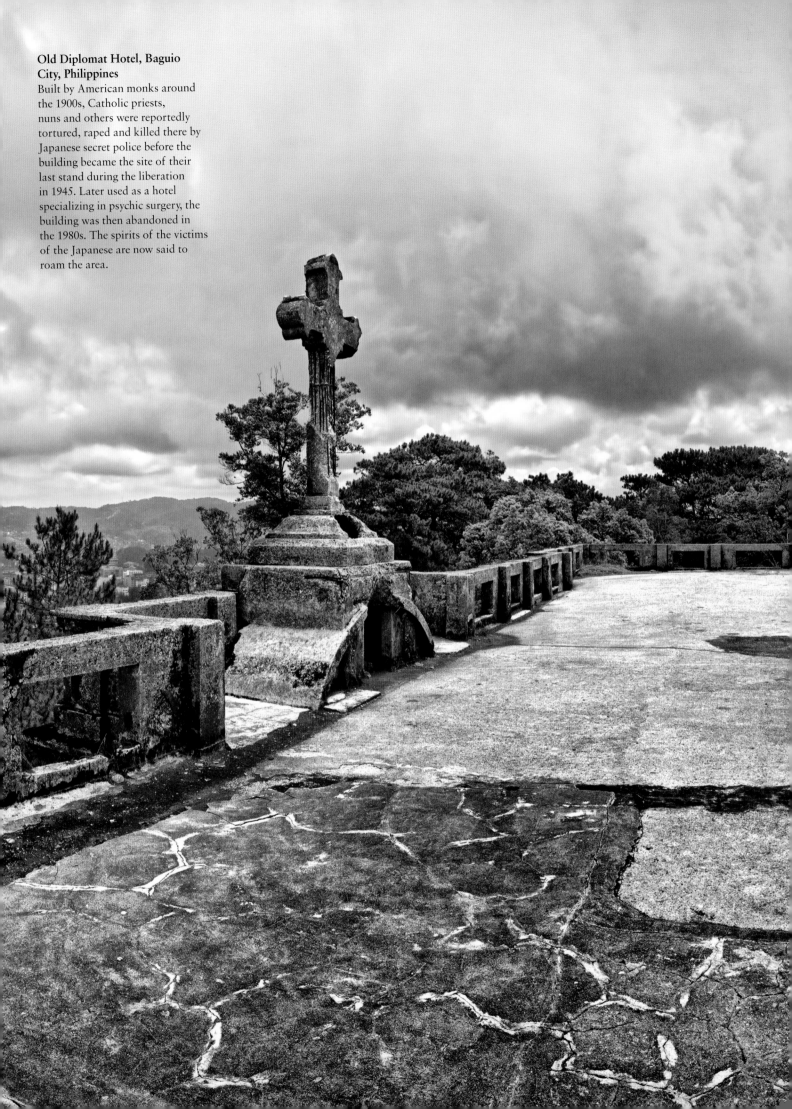

Old Diplomat Hotel, Baguio City, Philippines
Built by American monks around the 1900s, Catholic priests, nuns and others were reportedly tortured, raped and killed there by Japanese secret police before the building became the site of their last stand during the liberation in 1945. Later used as a hotel specializing in psychic surgery, the building was then abandoned in the 1980s. The spirits of the victims of the Japanese are now said to roam the area.

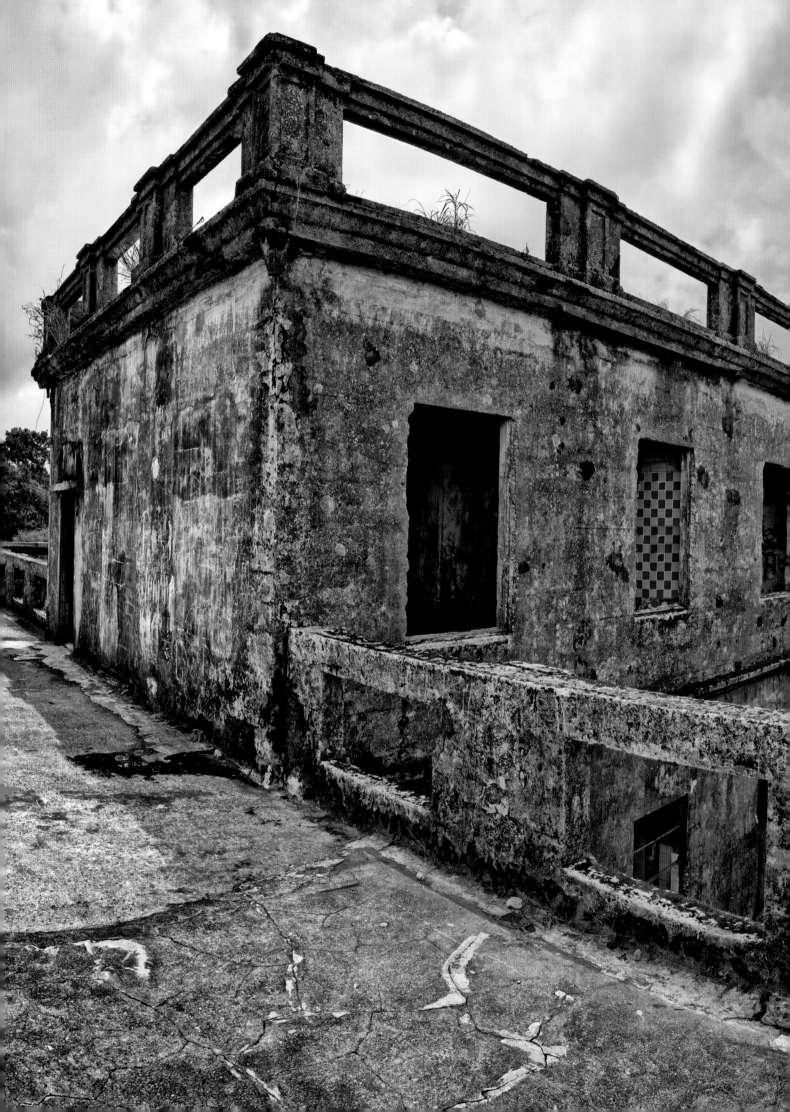

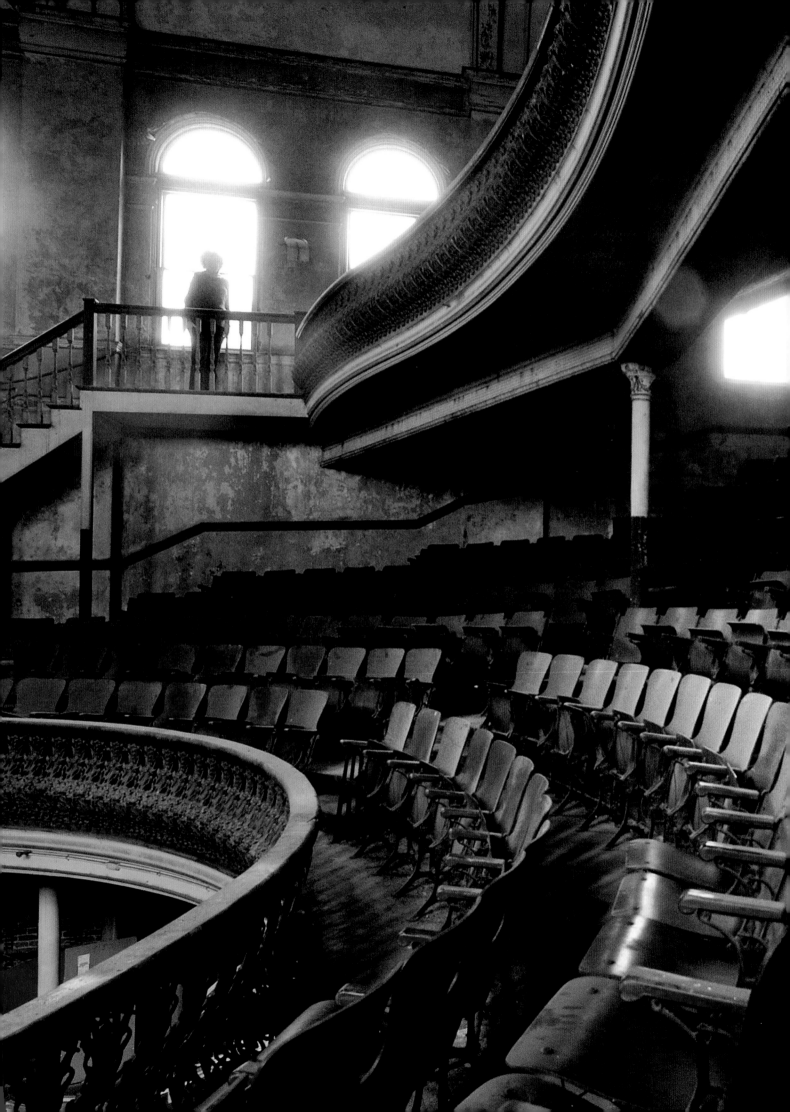

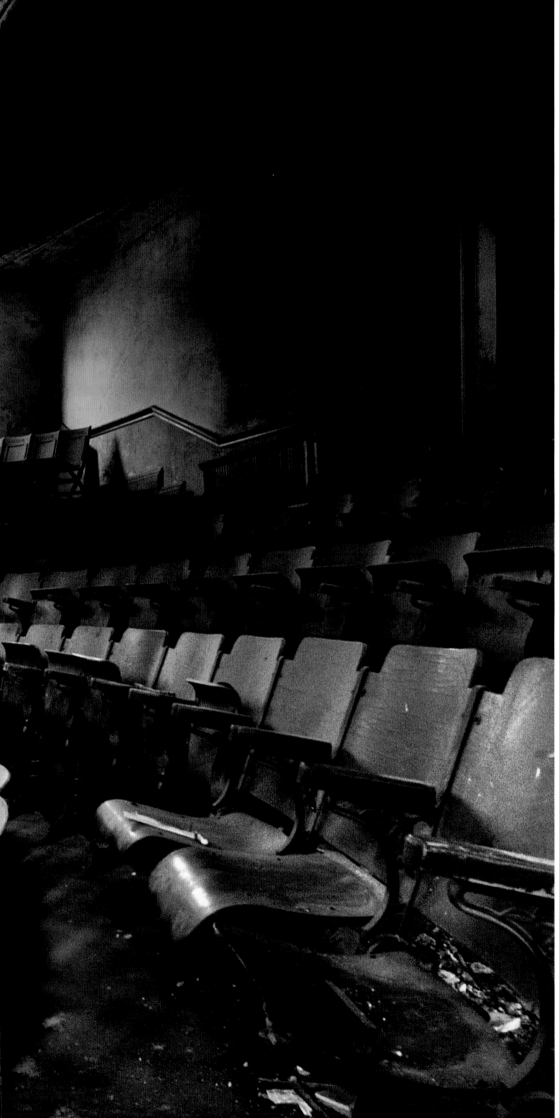

Interior, Sterling Opera House, Derby, Connecticut, USA
Built in 1889, the opera house is no longer in use but has been the scene of several supernatural encounters, including doors being closed and lights switching on and off. A ghost is said to be often found sitting in one of the seats in the lower right of the photograph.

Bird Cage Theatre, Tombstone, Arizona, USA

Opened on 26 December 1881, the Bird Cage quickly gained a rough reputation that reportedly saw 26 people killed during its eight years of operating as a 24-hour theatre, brothel, saloon and casino.

BELOW:

Interior, Bird Cage Theatre, Tombstone, Arizona, USA

Shut at the end of the silver-mining boom, the theatre was closed up for more than 50 years before reopening in 1934 as a museum. Visitors report seeing the spirits of former miners and prostitutes, and hearing old music and laughter.

OPPOSITE:

Monte Vista Hotel, Flagstaff, Arizona, USA

A bank robber died of his wounds in the hotel bar while celebrating his heist, and his spirit is said to greet the bar staff when they open in the morning.

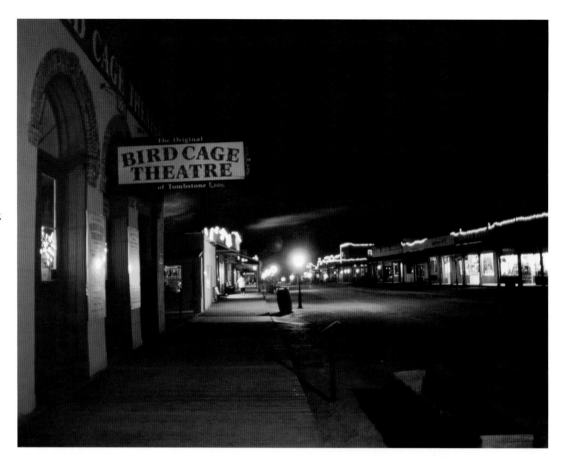

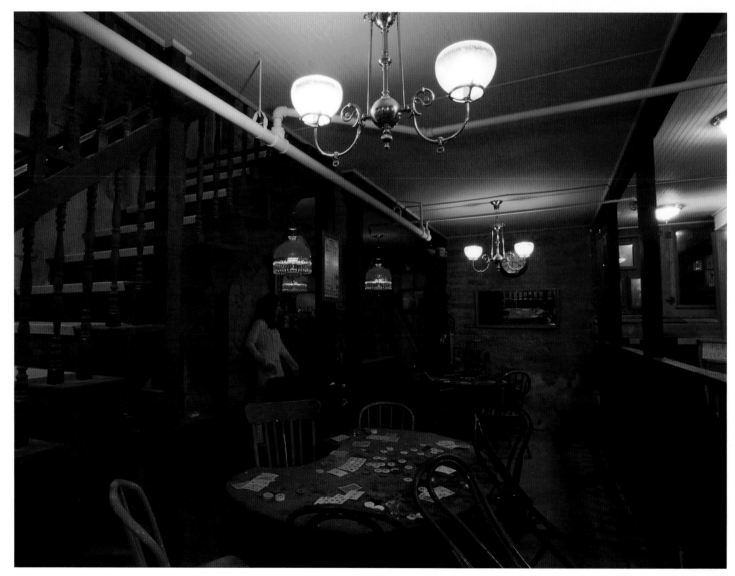

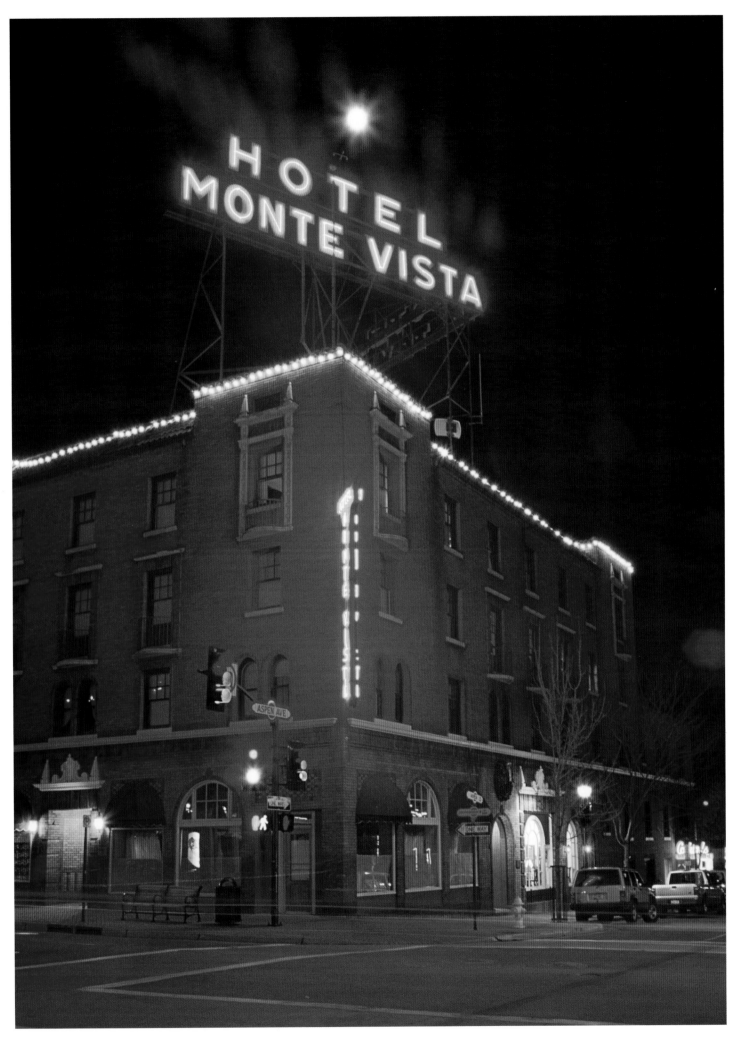

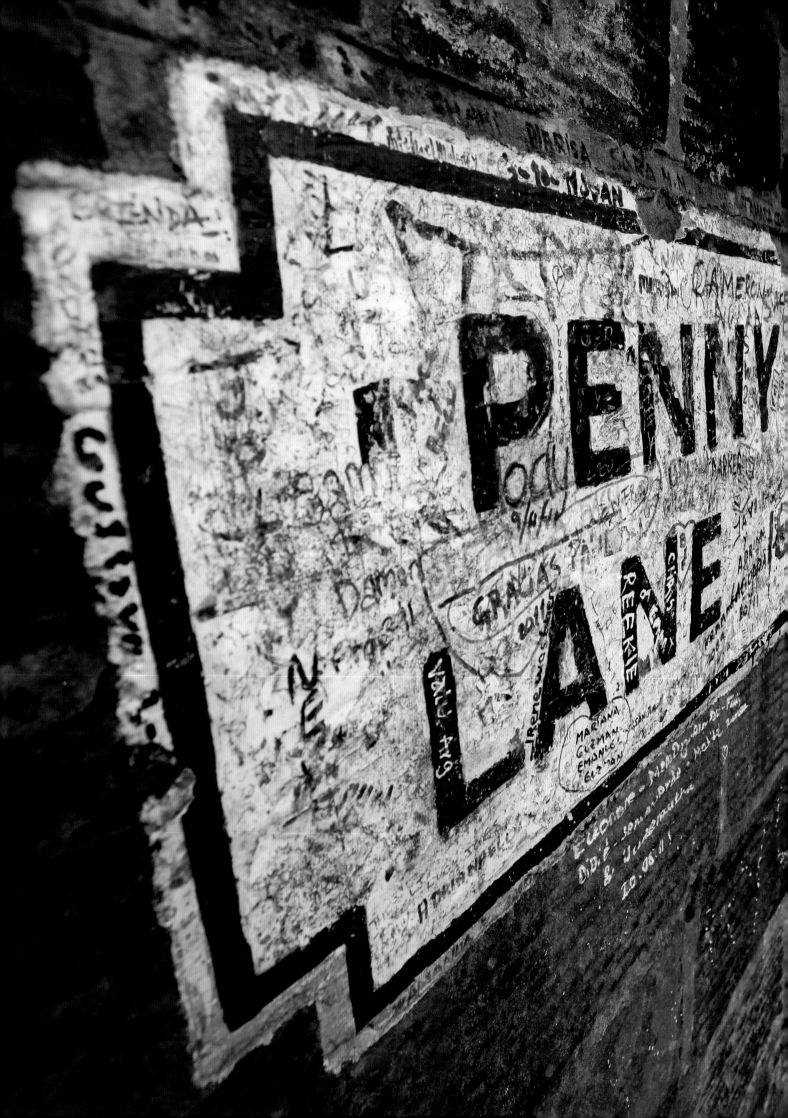

Penny Lane, Liverpool, UK
The road made famous by The Beatles' song has been the scene of paranormal activity since the 1890s and has its own haunted house. Number 44 has a spirit that has been heard walking at night by the house's occupants and their neighbours, and a girl with long blonde hair has been seen at one of the upper windows.

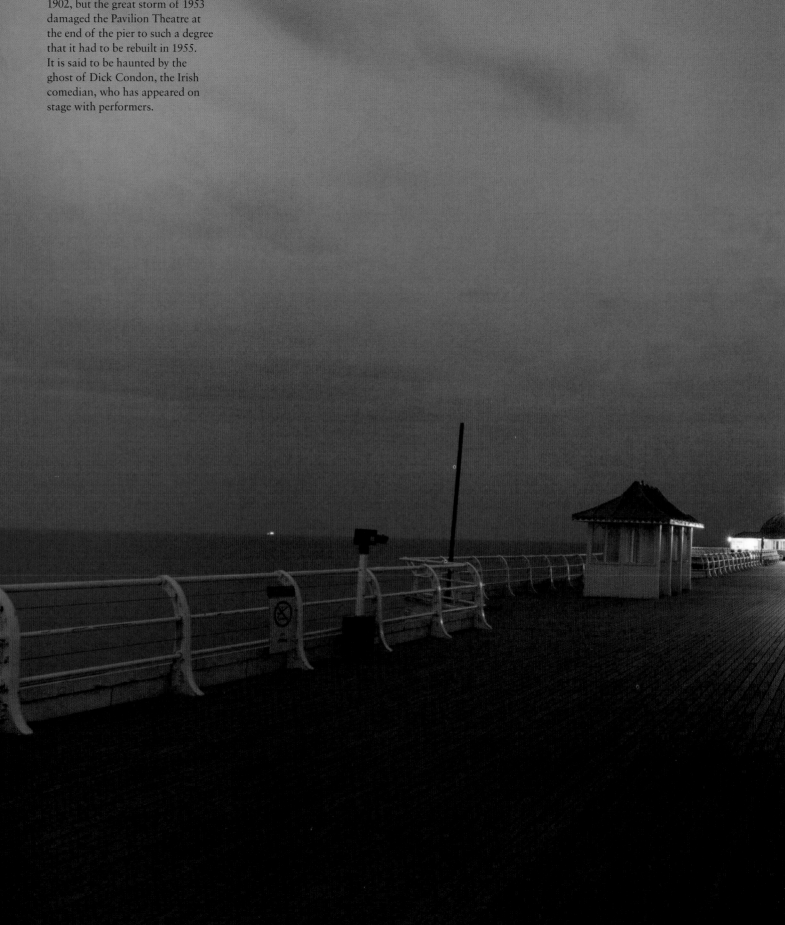

Cromer Pier, Cromer, Norfolk, UK
The current pier was built in 1902, but the great storm of 1953 damaged the Pavilion Theatre at the end of the pier to such a degree that it had to be rebuilt in 1955. It is said to be haunted by the ghost of Dick Condon, the Irish comedian, who has appeared on stage with performers.

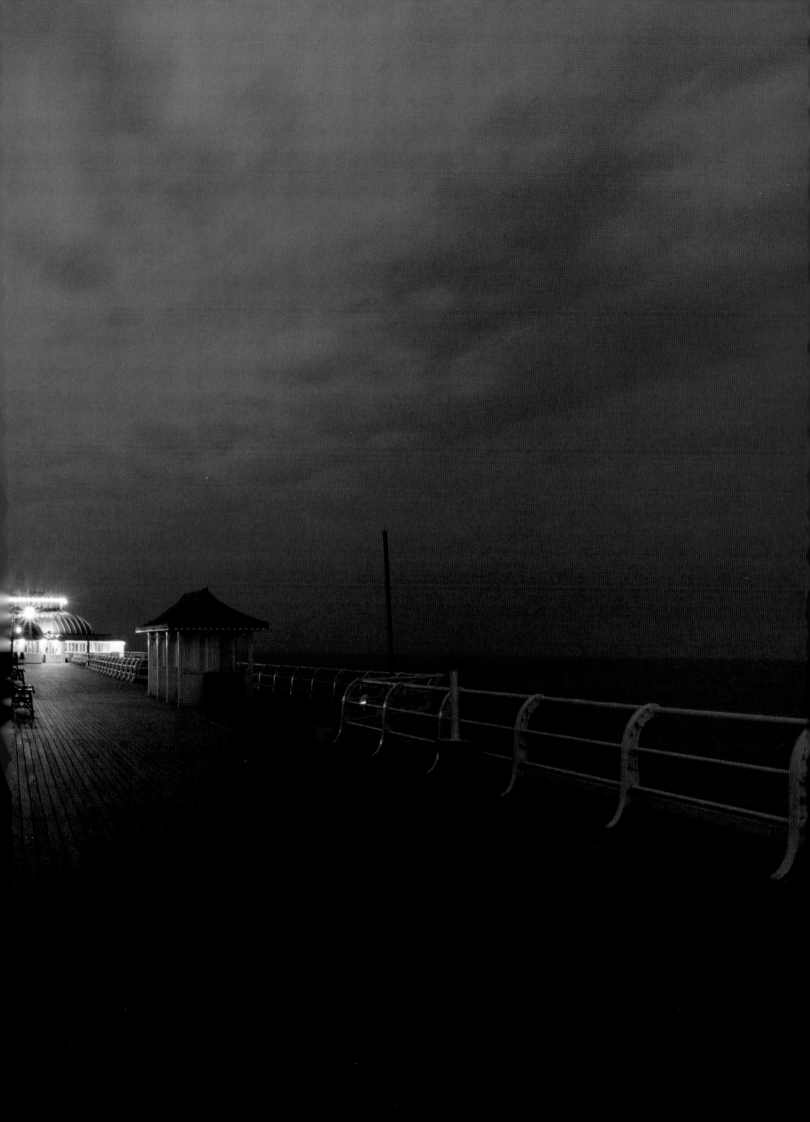

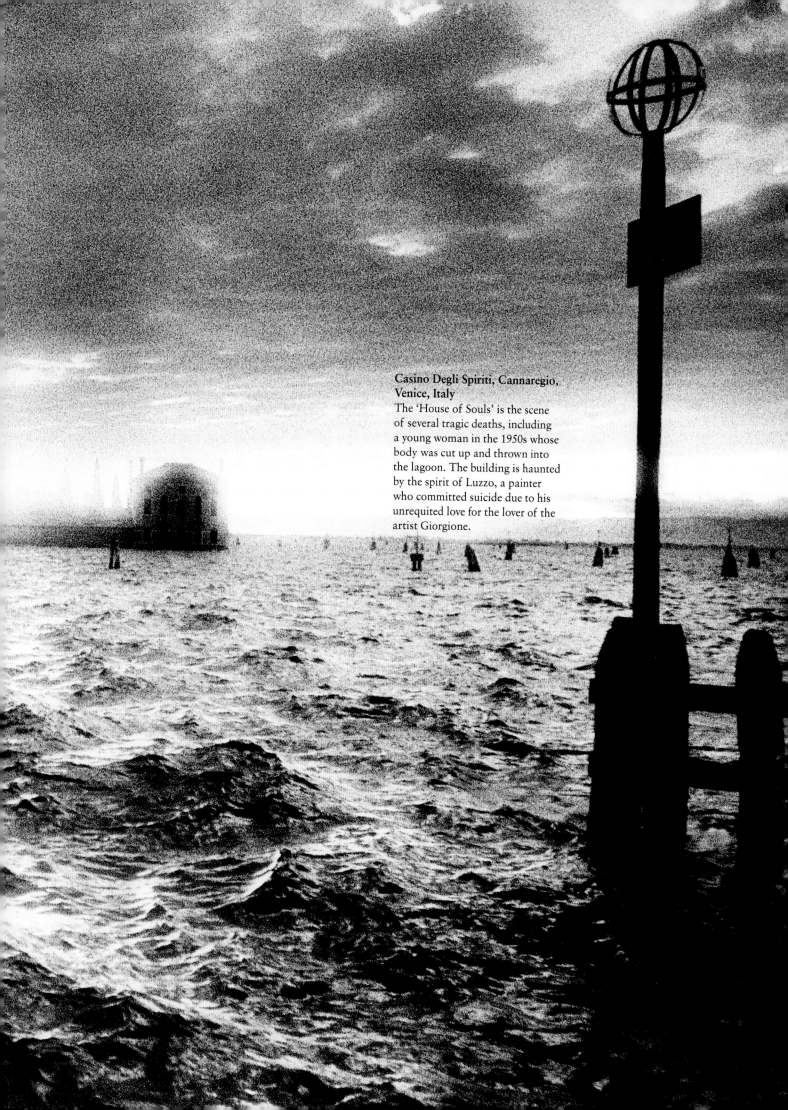

Casino Degli Spiriti, Cannaregio, Venice, Italy
The 'House of Souls' is the scene of several tragic deaths, including a young woman in the 1950s whose body was cut up and thrown into the lagoon. The building is haunted by the spirit of Luzzo, a painter who committed suicide due to his unrequited love for the lover of the artist Giorgione.

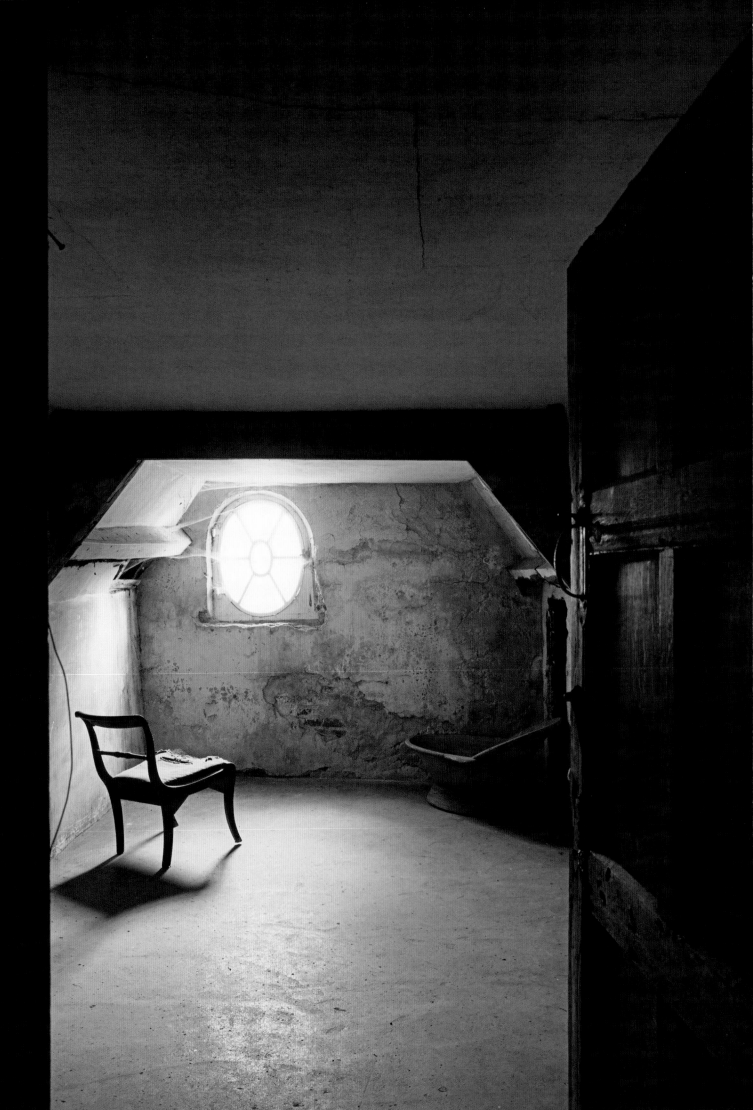

Houses, Mansions & Palaces

Even the grandest houses sometimes hide the darkest secrets. In previous centuries, a rich family could hide a dark deed or an embarrassing illness from prying eyes, regardless of the consequences. From murders to mental illness or even possible suicide, social scandal could be avoided by incarceration or concealment. It was easier for the individual to suffer rather than the family as a whole. However the stories could never be fully hidden, thanks to servants or other locals, and many stories that have subsequently emerged of ghosts and hauntings have now become things of celebration, encouraging visitors to these grand old buildings.

Experience of the paranormal reaches as high as the French royal family and the sightings of Marie Antoinette herself in the gardens of Versailles. In Germany, too, former politicians are reputed to haunt their parliament building, while a Belgian family allegedly continue to reside in their long-abandoned grand home in a Cairo suburb. Not all of these sightings are of ancient, historical figures, however. As you will discover in this chapter, John Lennon both saw paranormal activity and has reportedly been seen by those visiting the Dakota Building after his death. It seems that money can't buy you love or eternal rest…

LEFT:
Mad Woman's Room, Norton Conyers, Yorkshire, UK
The inspiration for the character of Mrs Rochester in Charlotte Brönte's *Jane Eyre*, according to legend, a mad woman was kept locked in this room at Norton Conyers during the 18th century. The spirit of 'Mad Mary' is supposed to be still in residence.

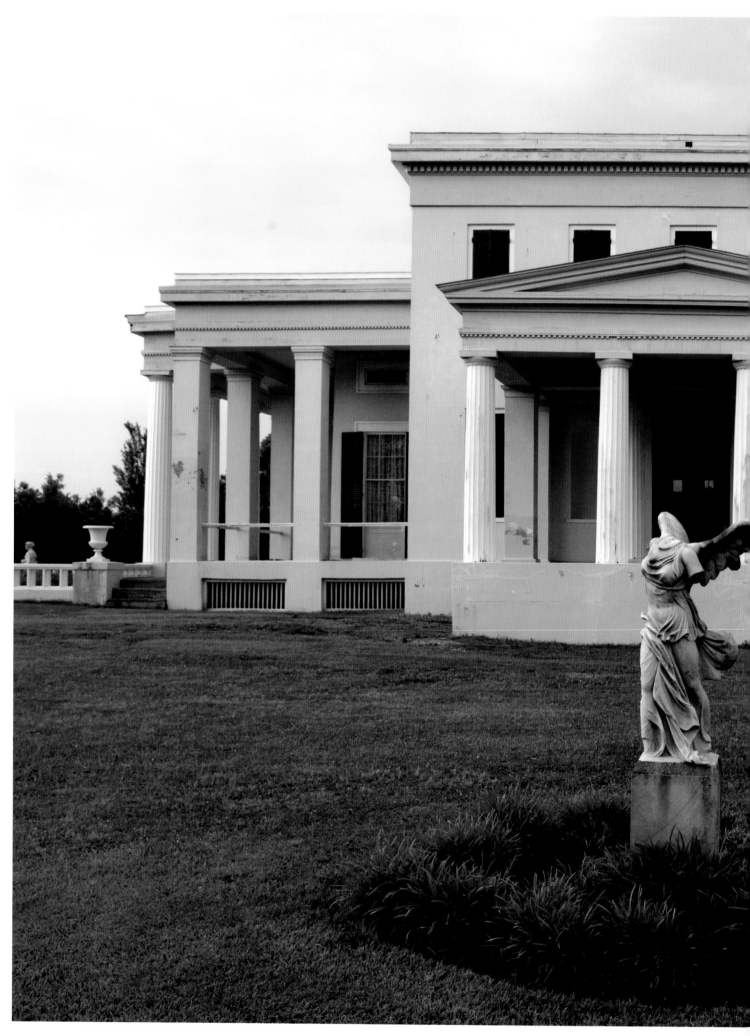

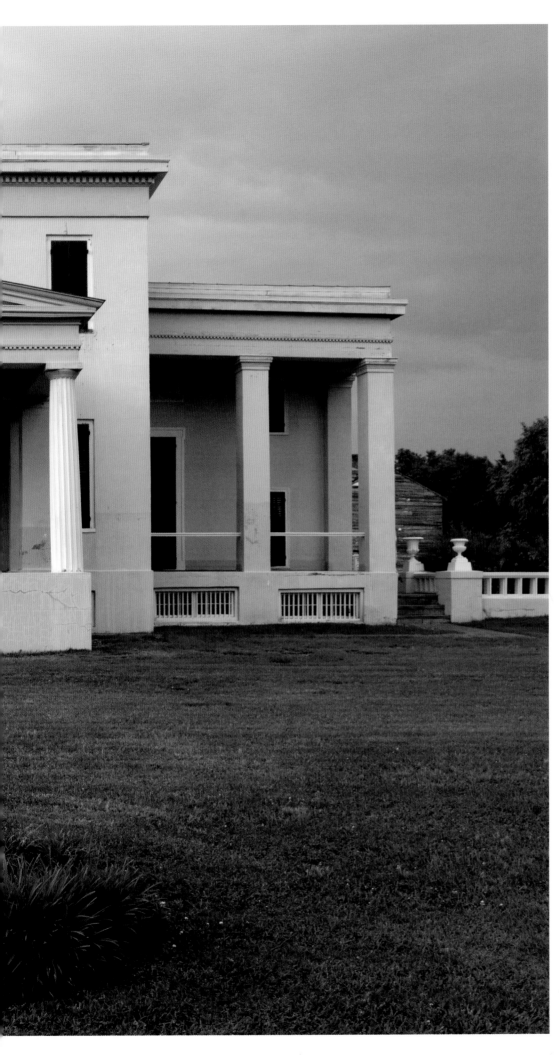

Gaineswood, Demopolis, Alabama, USA
Built by General Nathan Whitfield just before the American Civil War, the house is reportedly haunted by the general's sister-in-law, Evelyn Carter. After her death, her body could not be buried as the ground was frozen, and she was kept in a sealed box in the cellar. It was said that her spirit objected to this, as the haunting began shortly after her death, and continued even after her body was finally laid to rest the following spring.

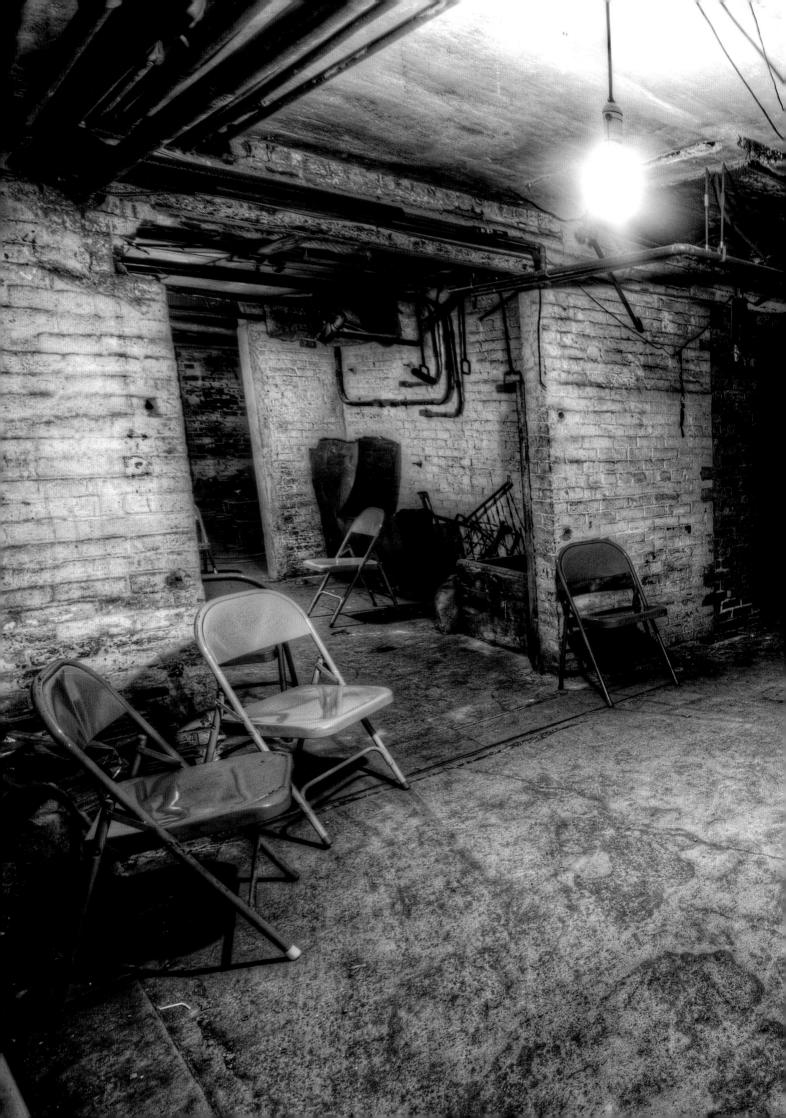

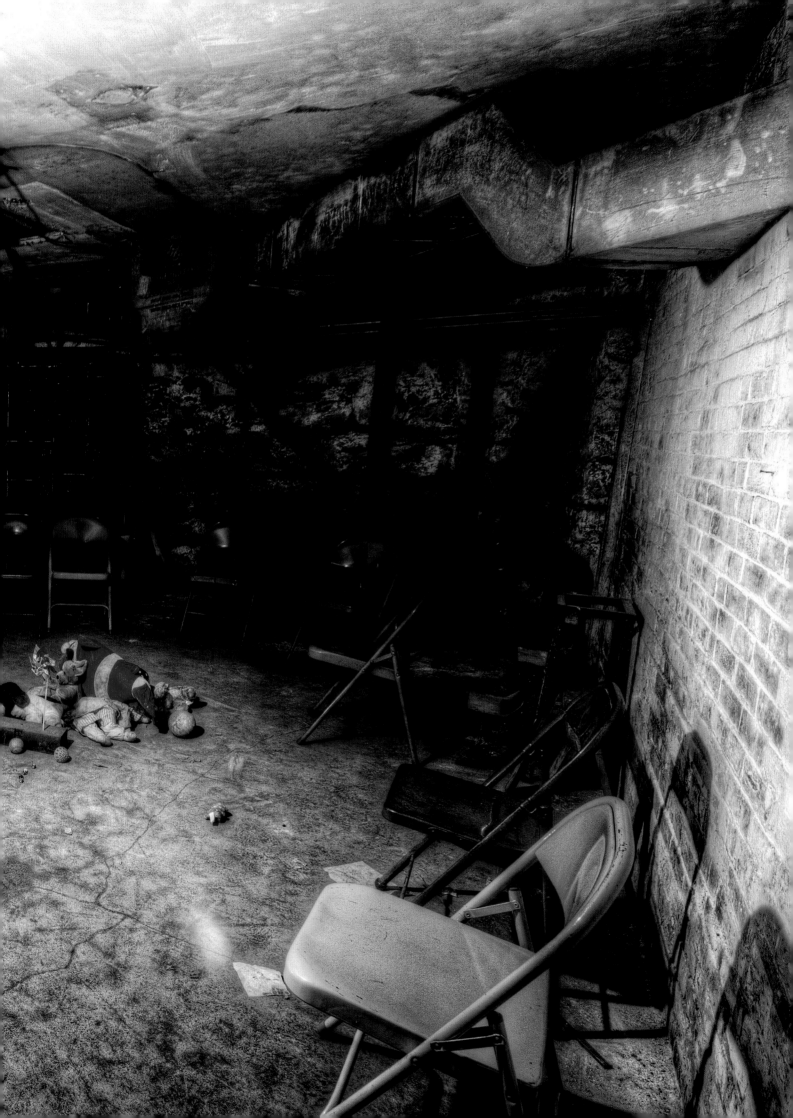

PREVIOUS PAGE:

Basement, Houghton Mansion, Massachusetts, USA
Built by A.C. Houghton, the first mayor of North Adams, the mansion is haunted by members of the family as the result of a tragic car accident.

RIGHT:

Interior, Houghton Mansion, Massachusetts, USA
The mayor's youngest daughter died after the car driven by their chauffeur rolled over. The chauffeur was exonerated, but shot himself in the grounds of the house the next day.

BELOW:

Houghton Mansion, Massachusetts, USA
Within a fortnight, Houghton himself died of his injuries sustained in the crash.

OPPOSITE:

Interior, Houghton Mansion, Massachusetts, USA
The house is now owned by the Masons. Members have reported hearing unexplained noises and doors opening and shutting without warning.

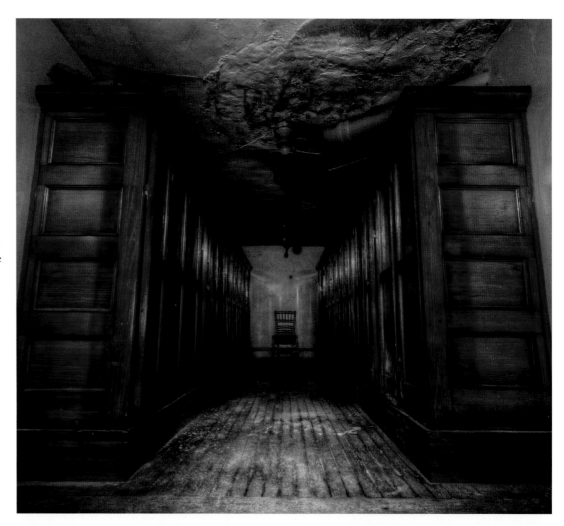

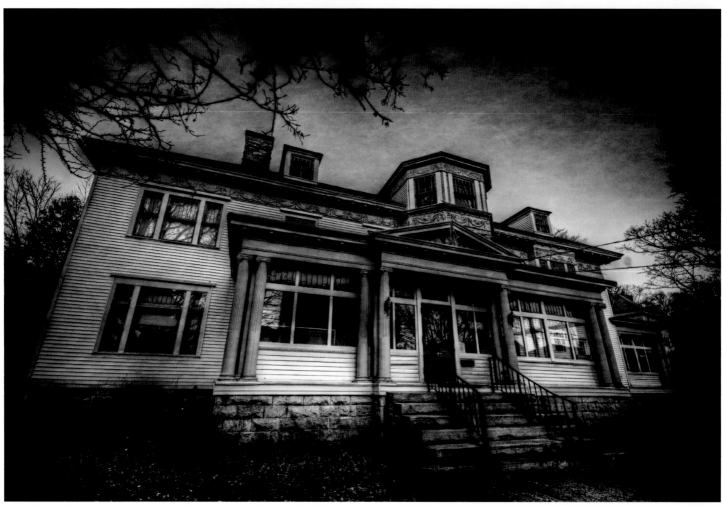

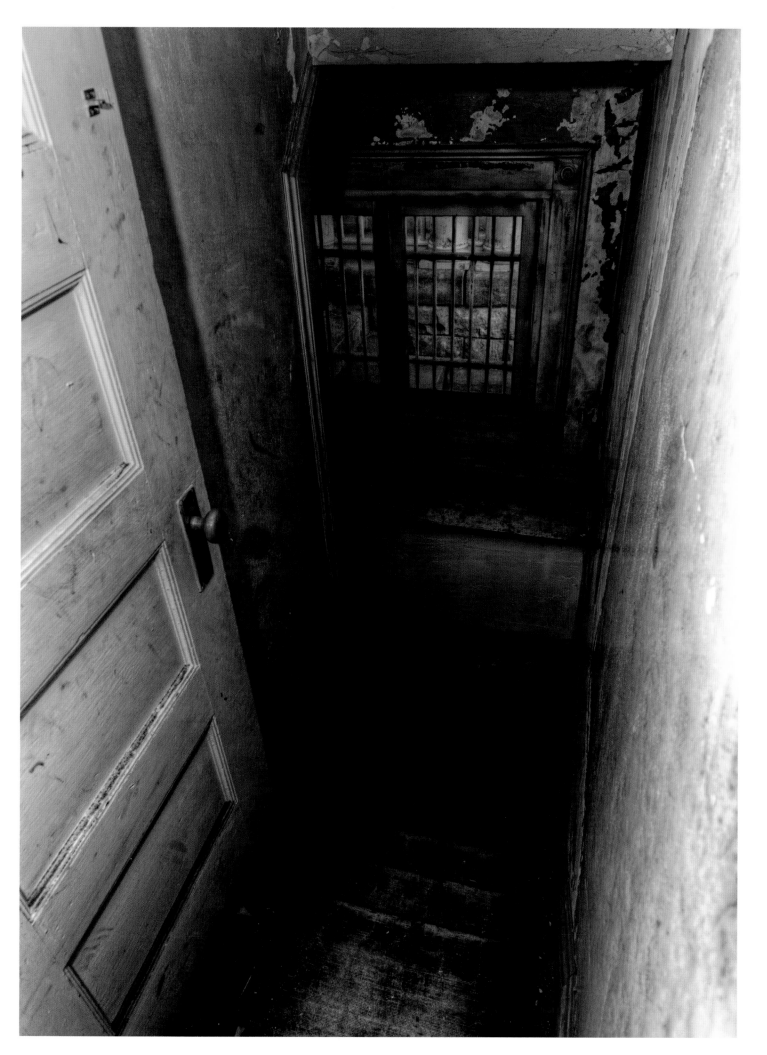

Vaile Mansion, Independence, Missouri, USA

Colonel Vaile and his wife Sophia built this house between 1871 and 1881. Two years later Sophia, who had been diagnosed with suspected stomach cancer, was found dead of a morphine overdose while Colonel Vaile was away on business. She is reported to haunt the mansion, as a ghostly figure has been seen by many visitors.

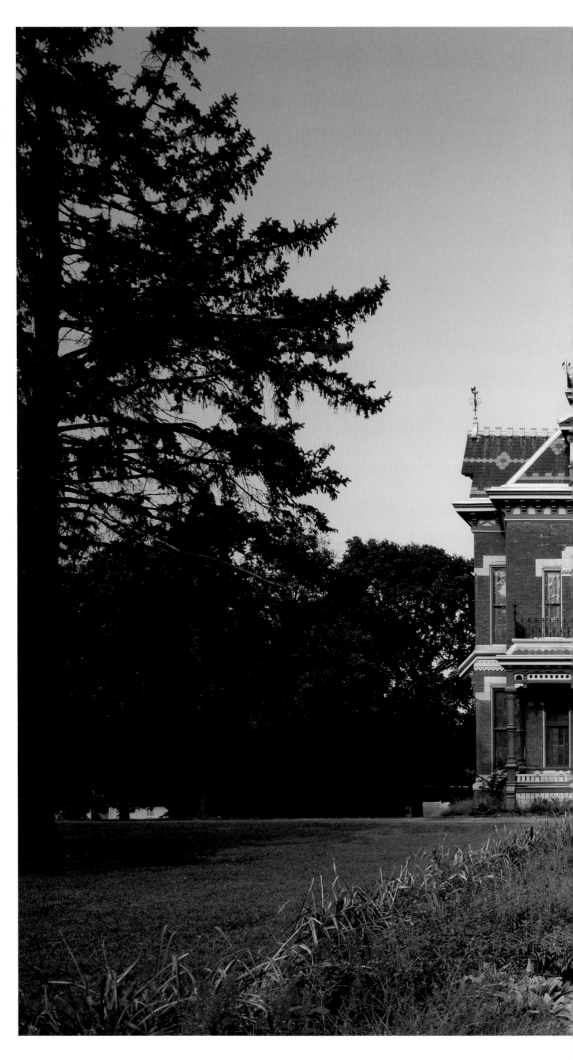

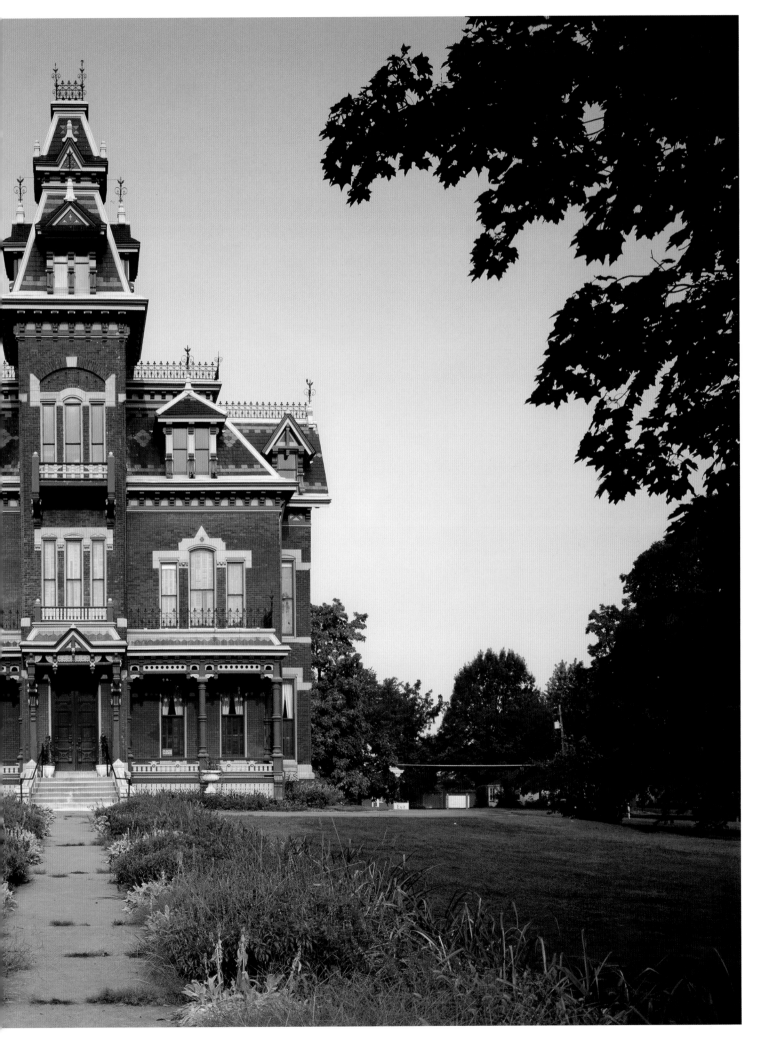

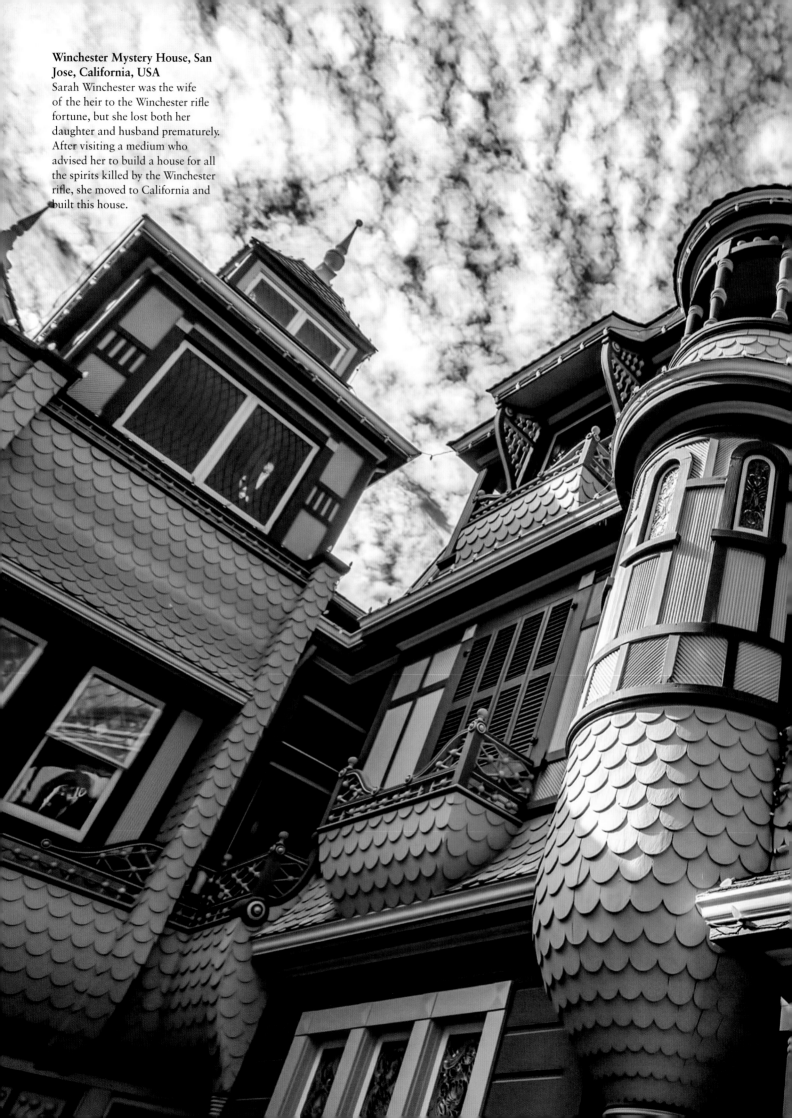

Winchester Mystery House, San Jose, California, USA
Sarah Winchester was the wife of the heir to the Winchester rifle fortune, but she lost both her daughter and husband prematurely. After visiting a medium who advised her to build a house for all the spirits killed by the Winchester rifle, she moved to California and built this house.

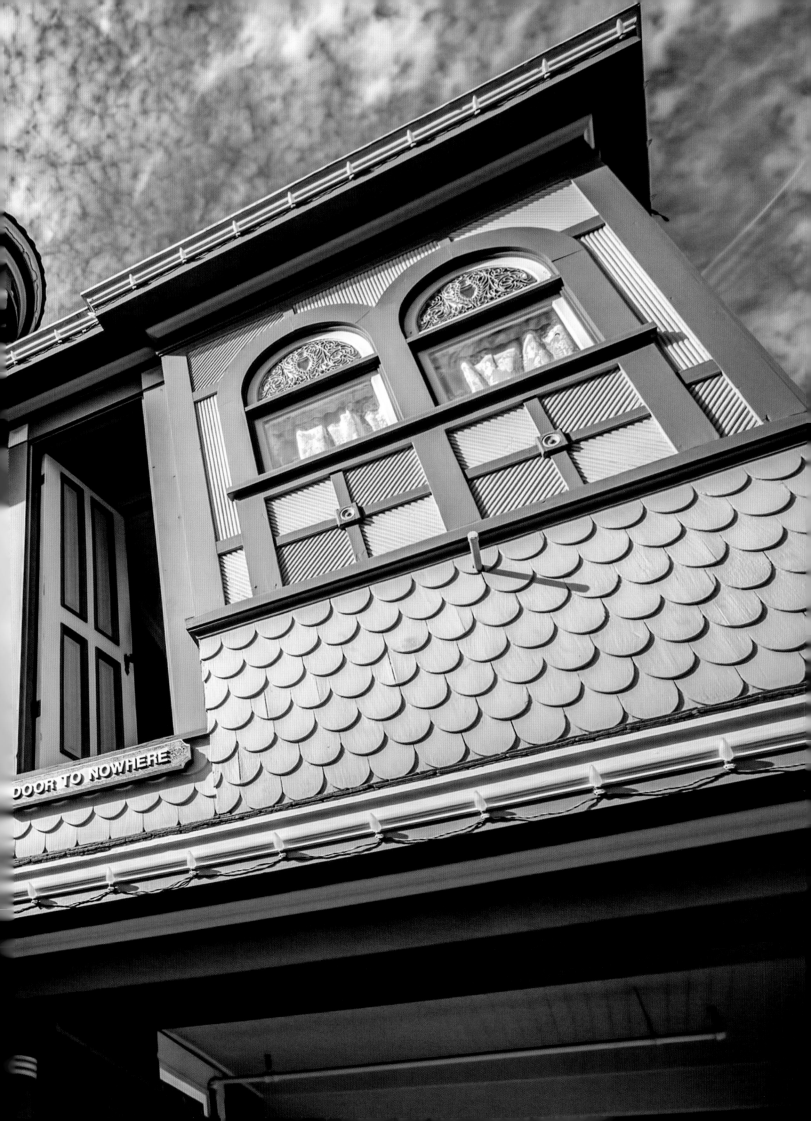

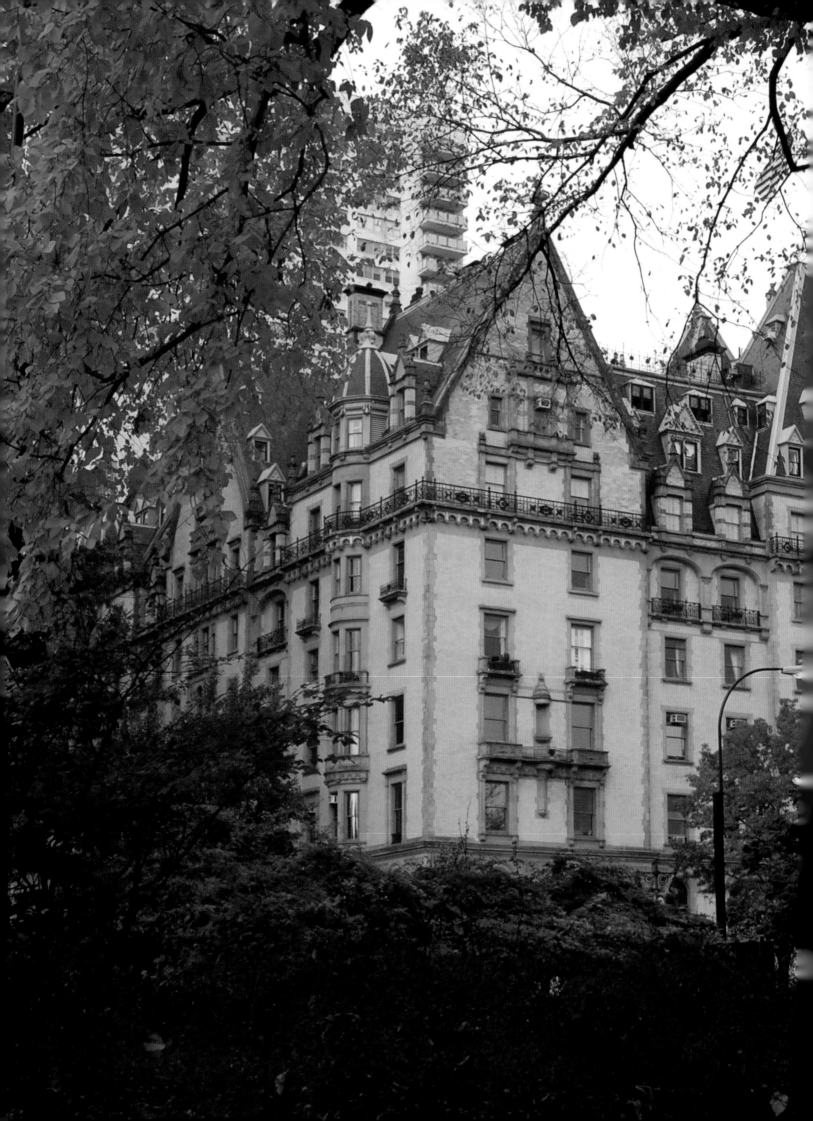

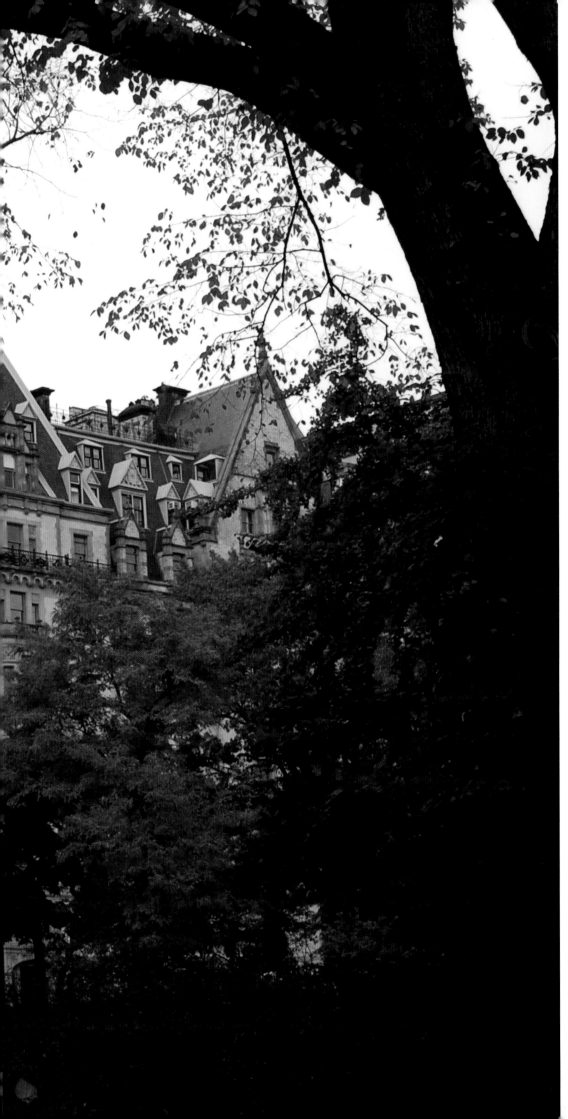

Dakota Building, New York, USA

Most famous as the place where John Lennon was shot, the Dakota is also known for its spirits. Lennon himself saw a ghost that he named the 'Crying Lady', and some have claimed to have seen his ghost. Other apparitions include the 'Little Girl', who often smiles at visitors, a 'Young Man' with the face of a boy, and Edward Clark, who built the Dakota Building in the 1880s.

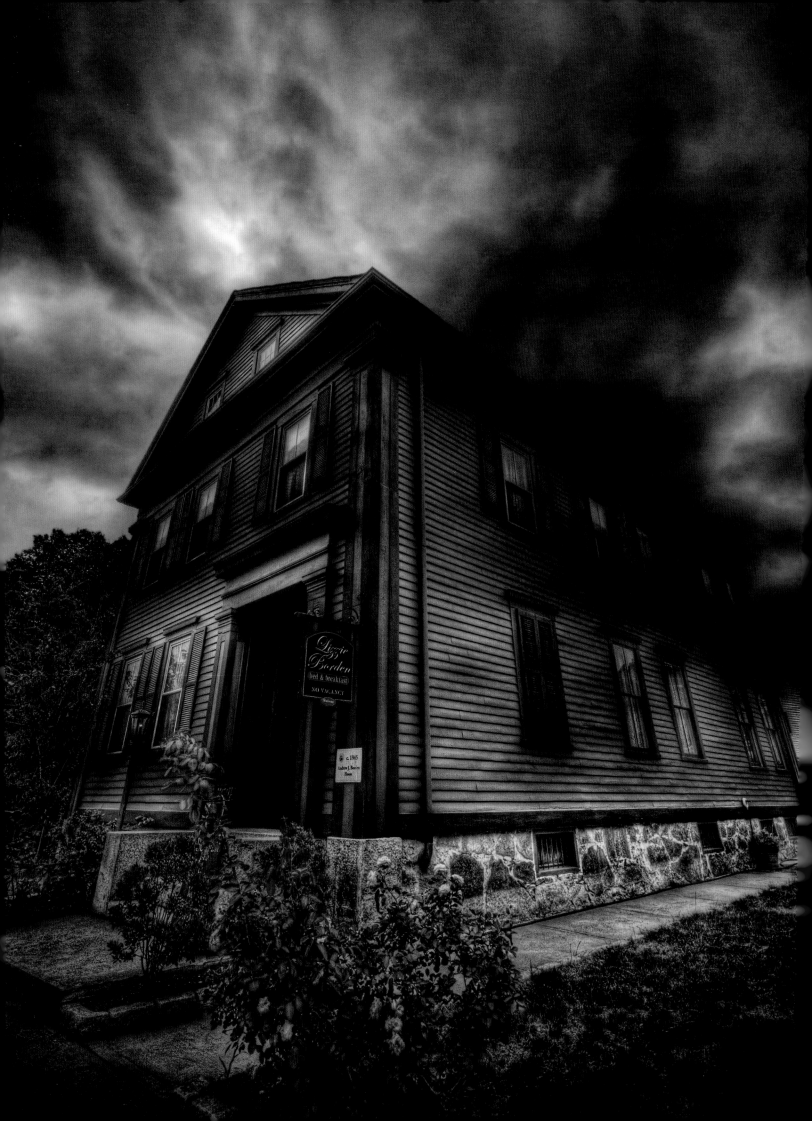

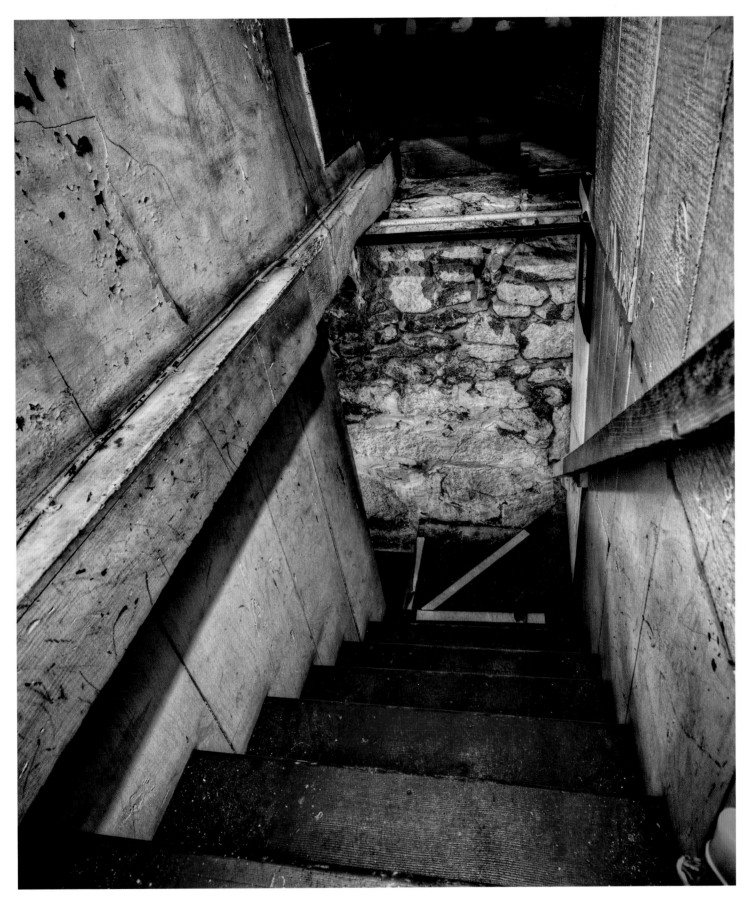

LEFT:

Lizzie Borden Bed and Breakfast, Fall River, Massachusetts, USA
Lizzie Borden was the daughter of Andrew, a property developer who had remarried after her mother's death. On 4 August 1892, Andrew and his second wife were killed.

ABOVE:

Staircase, Lizzie Borden Bed and Breakfast, Massachusetts, USA
Lizzie was a prime suspect, but was acquitted by a jury. It is thought by some that the spirits of Andrew and Abby, the two victims, remain in the house to this day.

LaLaurie House, New Orleans, USA

Delphine LaLaurie was a society hostess who had a reputation for mistreating the slaves who worked in her house. In 1834, a fire broke out in the kitchen and witnesses described finding the cook chained to the fireplace, and other slaves who had been horribly mutilated. A grave was reportedly discovered with bodies of slaves showing similar mistreatment. LaLaurie fled before she could be tried, but her victims' spirits remain in the house.

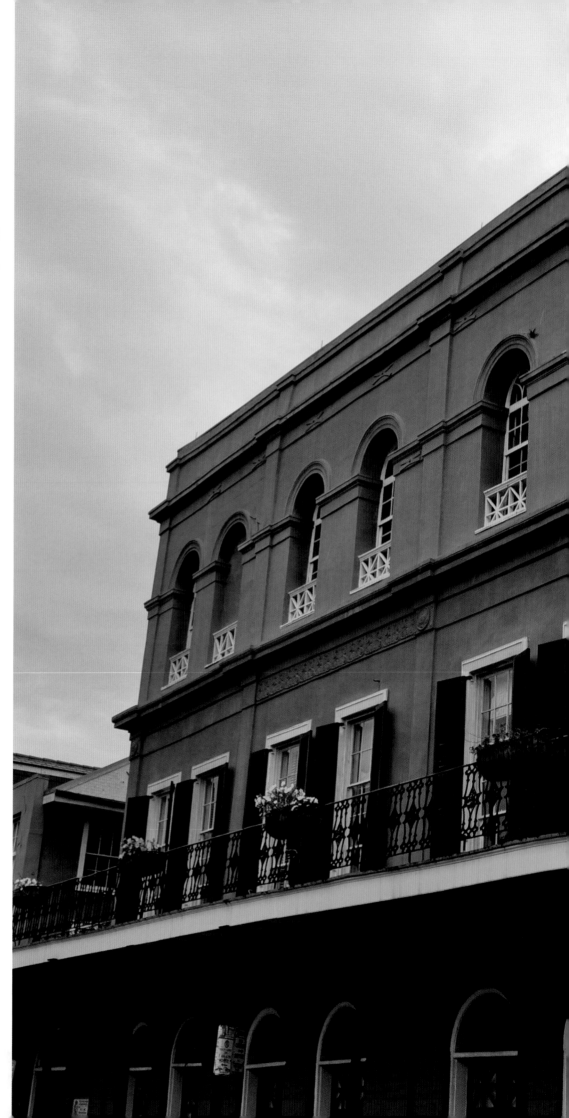

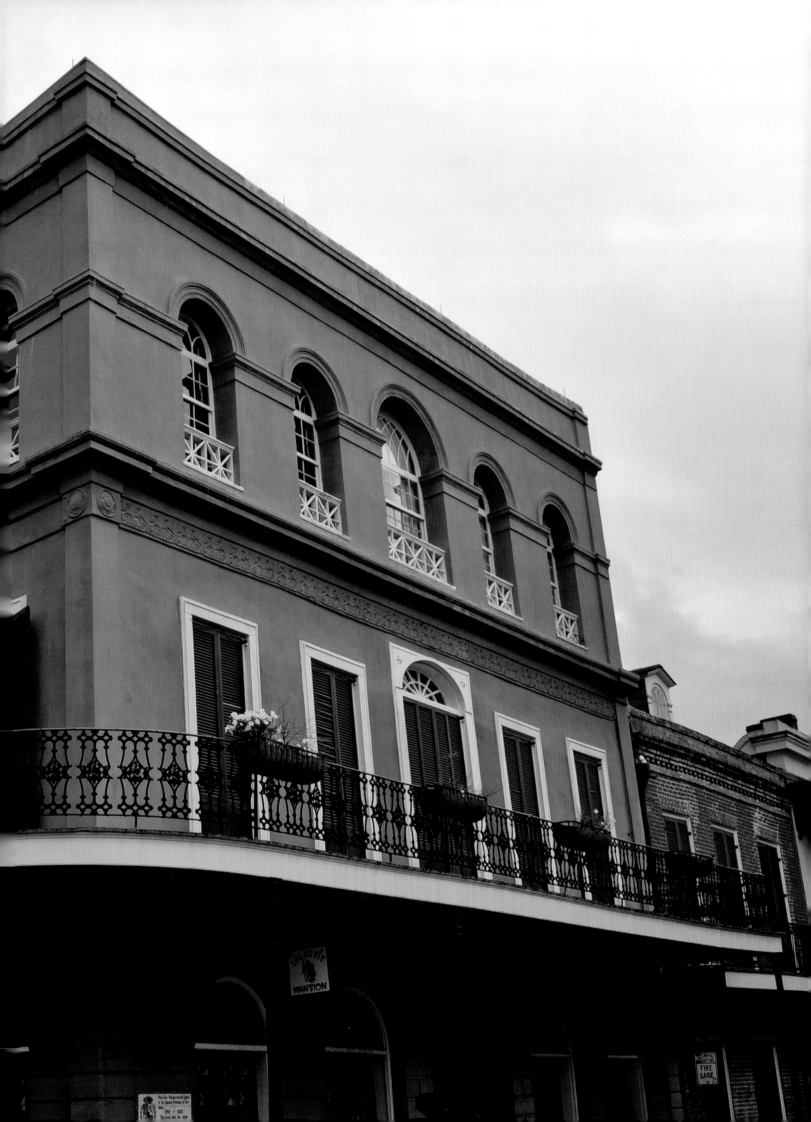

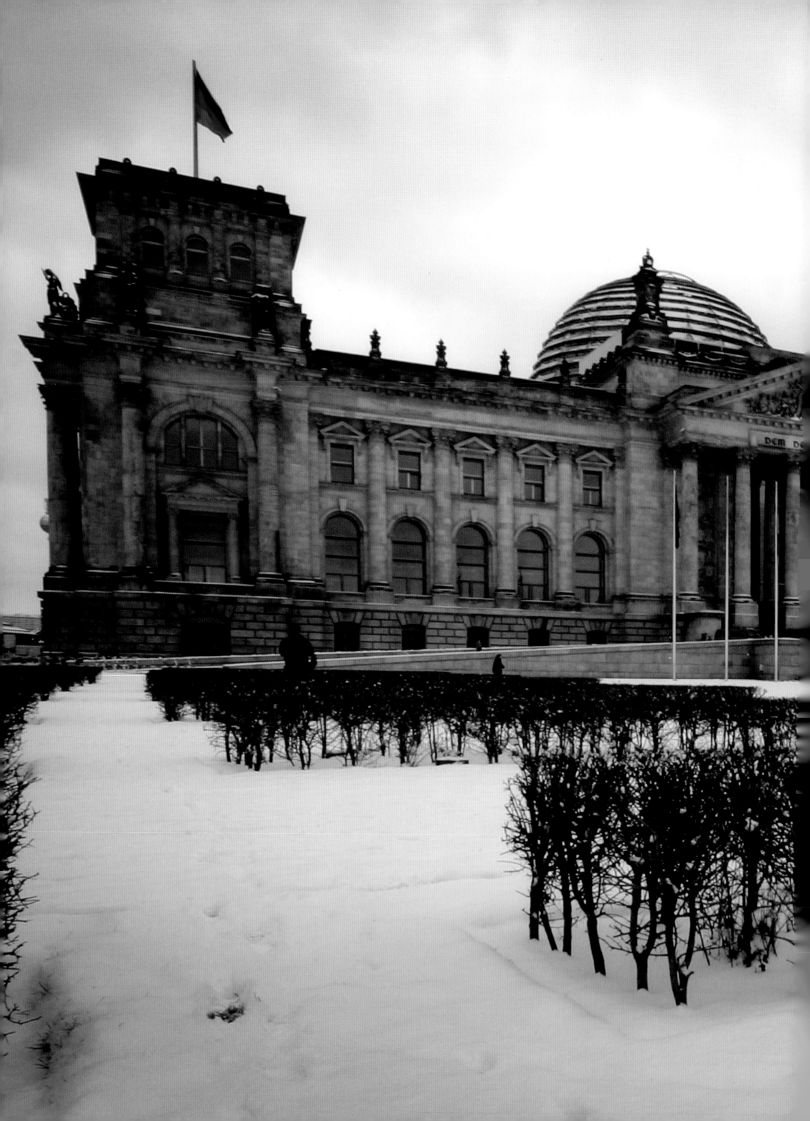

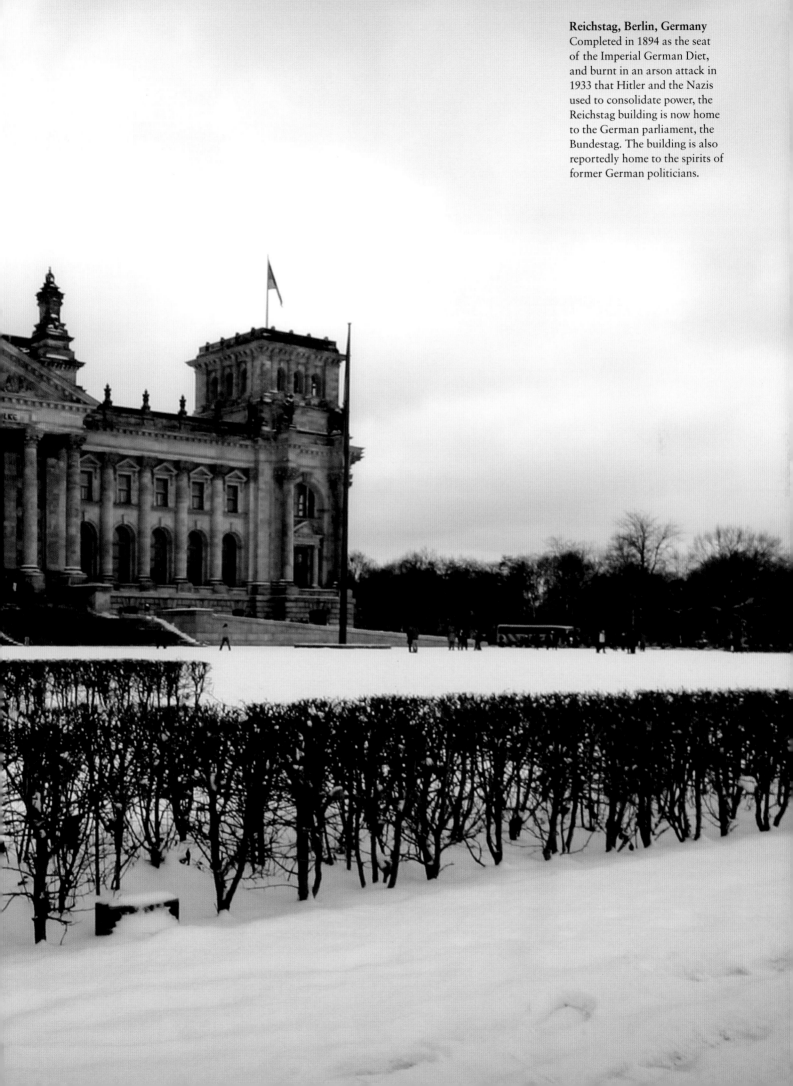

Reichstag, Berlin, Germany
Completed in 1894 as the seat
of the Imperial German Diet,
and burnt in an arson attack in
1933 that Hitler and the Nazis
used to consolidate power, the
Reichstag building is now home
to the German parliament, the
Bundestag. The building is also
reportedly home to the spirits of
former German politicians.

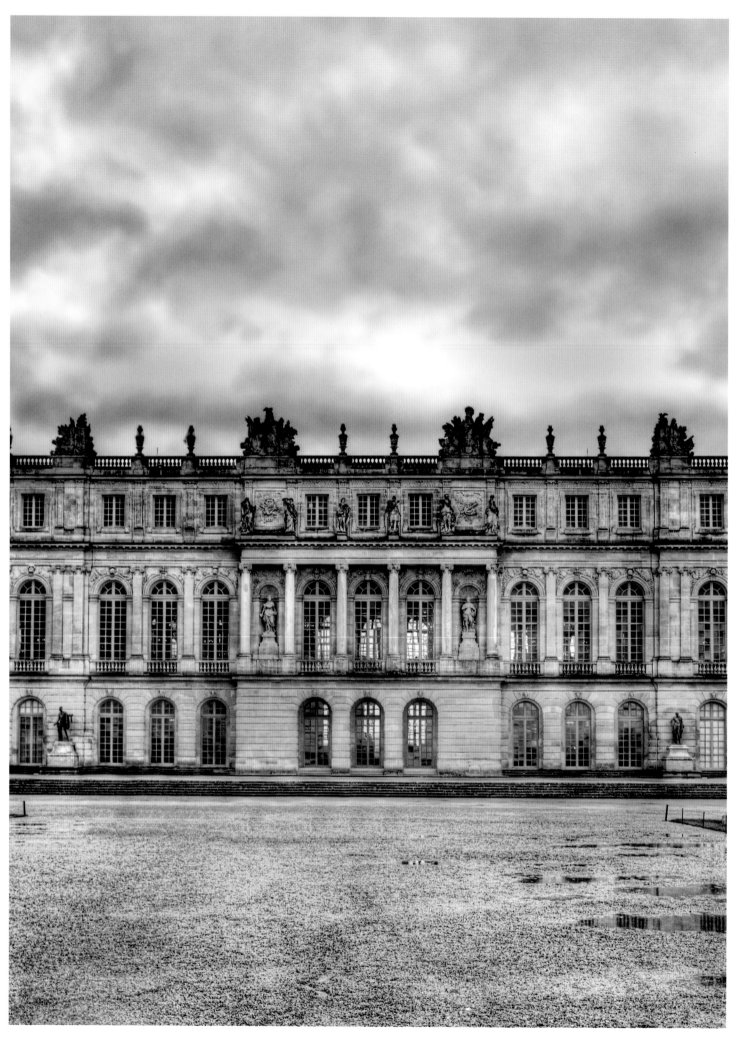

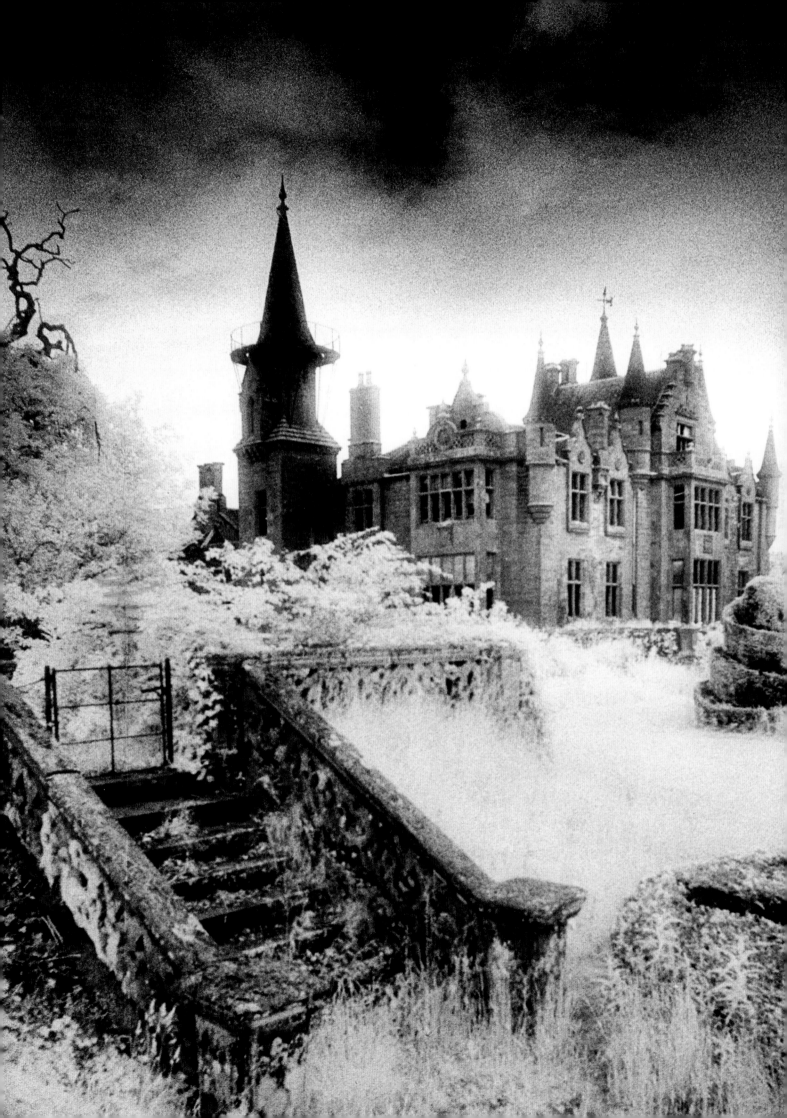

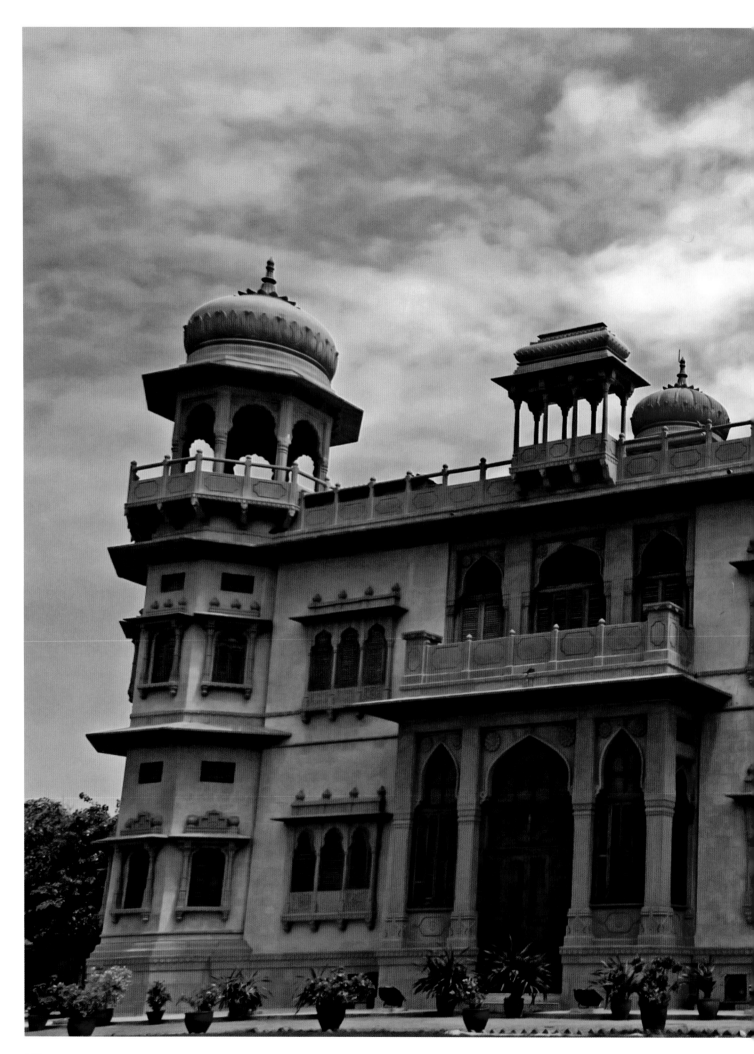

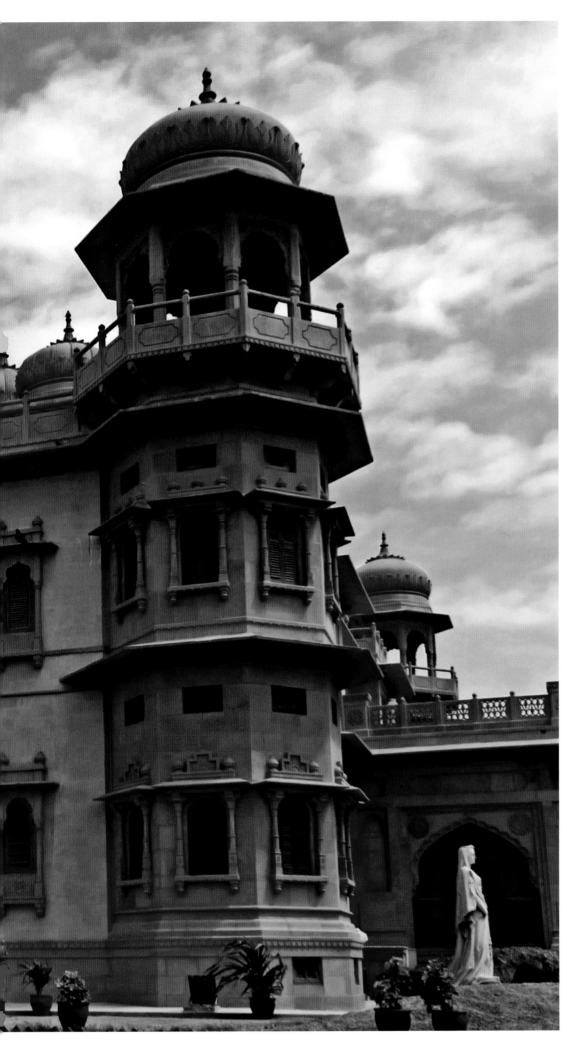

PREVIOUS PAGE, LEFT:

Palace of Versailles, France

In 1901, two English academics, Anne Moberly and Eleanor Jourdain, had a series of strange encounters during a visit to Versailles, not least with Marie Antoinette herself, as well as some guards and an 'evil' count. They later discovered they had visited on the anniversary of the sacking of Versailles in 1792, during the French Revolution.

PREVIOUS PAGE, RIGHT:

Ecclesgrieg House, St Cyrus, UK

Local legend tells of an Eskimo curse on the Forsyth-Grant family who used to own the house. Osbert Forsyth-Grant was cursed in 1911 by some Eskimos on a whaling ship that he commanded, which was wrecked shortly afterwards. His body was never found, but it is said his father's spirit is still seen on the terrace today, watching for his son's return home.

LEFT:

Mohatta Palace, Karachi, Pakistan

A former summer residence of Shivratan Chandraratan Mohatta, a businessman from Rajasthan in what is now India, the palace is now home to an art collection. There have been reports of objects being moved without explanation and loud noises with no apparent cause. Some guards claim that the spirits come from the time of the British Raj, when the United Kingdom ruled the country.

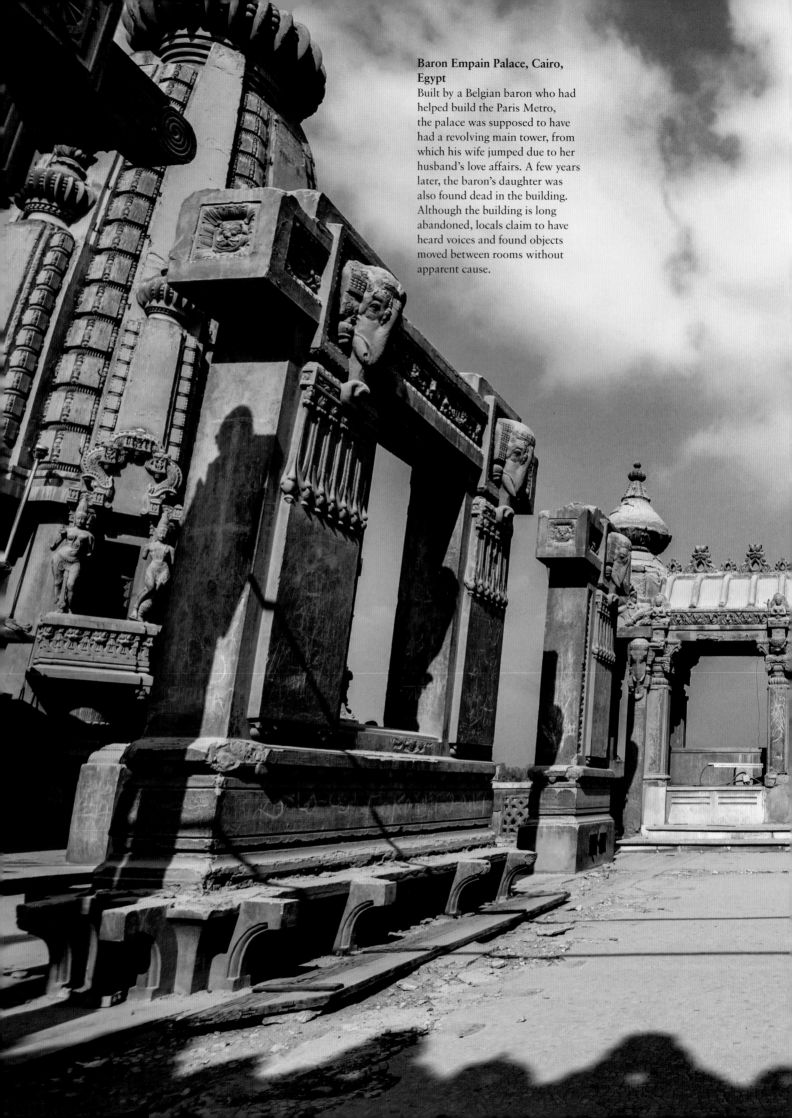

Baron Empain Palace, Cairo, Egypt
Built by a Belgian baron who had helped build the Paris Metro, the palace was supposed to have had a revolving main tower, from which his wife jumped due to her husband's love affairs. A few years later, the baron's daughter was also found dead in the building. Although the building is long abandoned, locals claim to have heard voices and found objects moved between rooms without apparent cause.

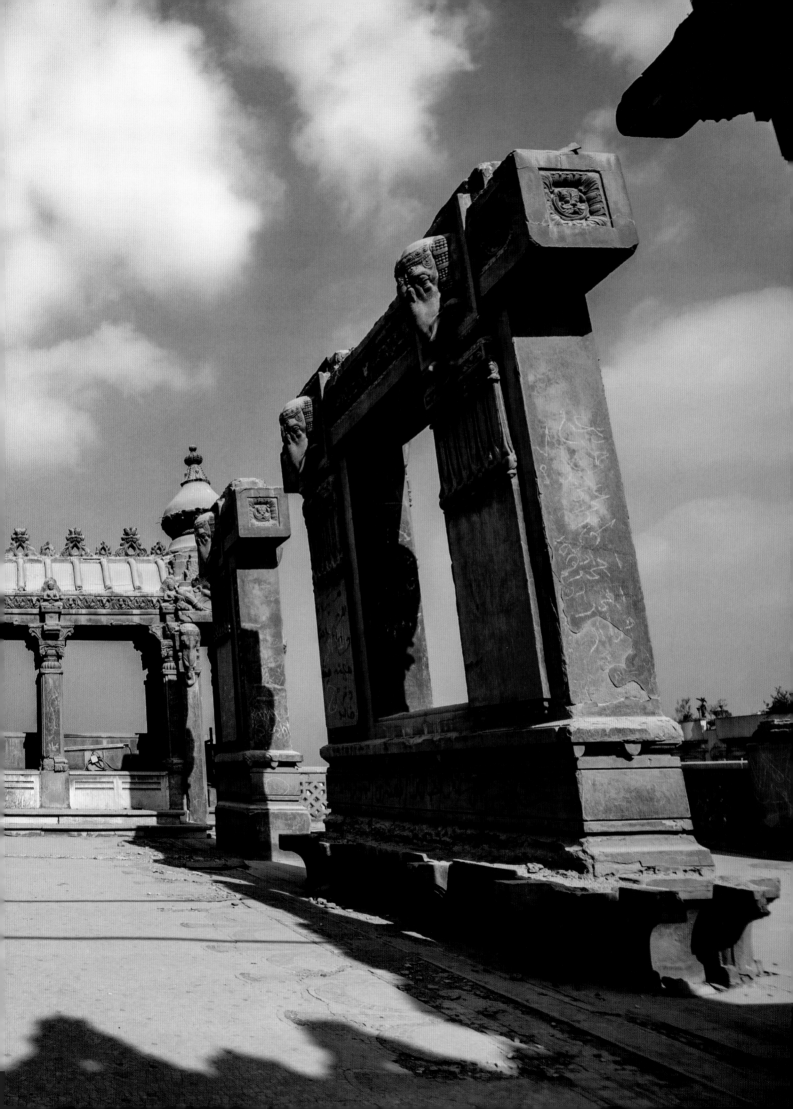

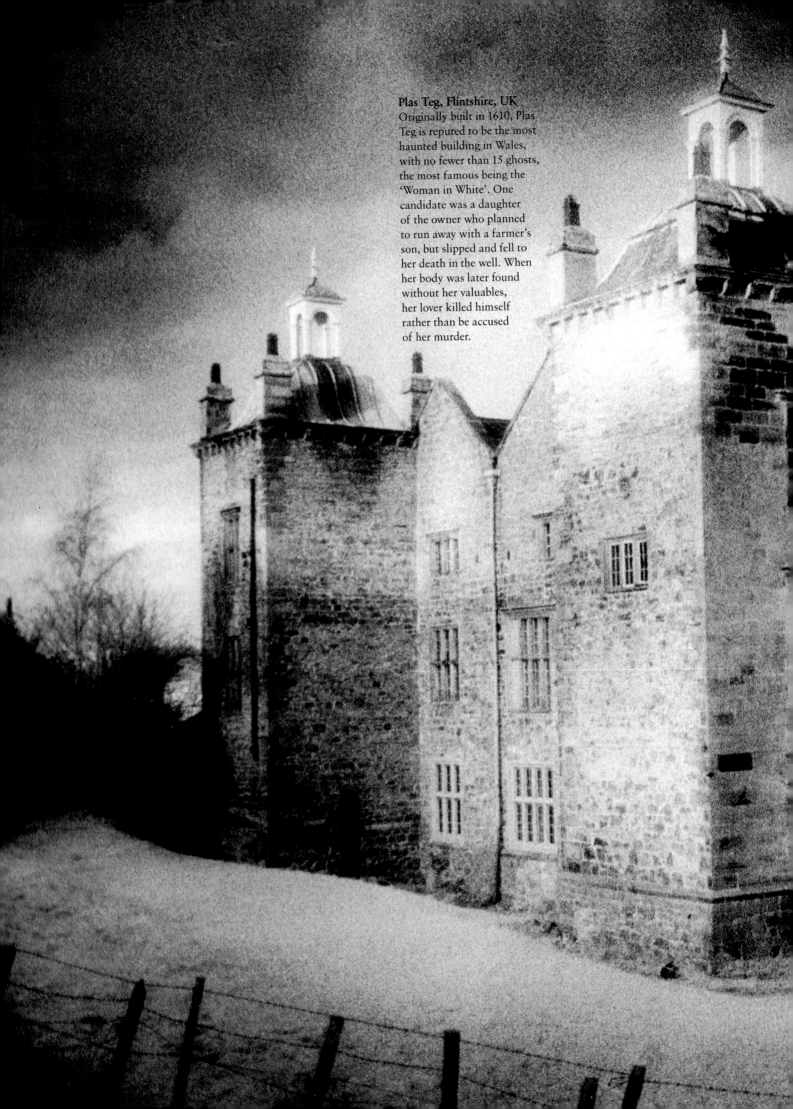

Plas Teg, Flintshire, UK
Originally built in 1610, Plas Teg is reputed to be the most haunted building in Wales, with no fewer than 15 ghosts, the most famous being the 'Woman in White'. One candidate was a daughter of the owner who planned to run away with a farmer's son, but slipped and fell to her death in the well. When her body was later found without her valuables, her lover killed himself rather than be accused of her murder.

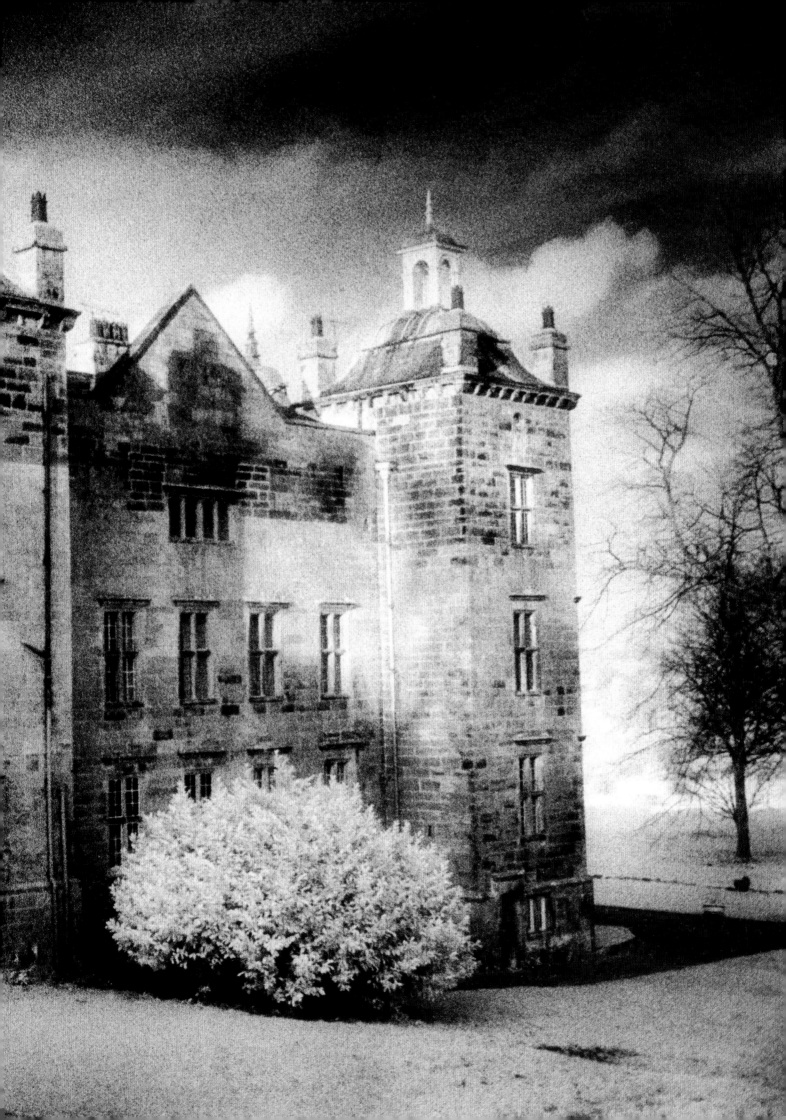

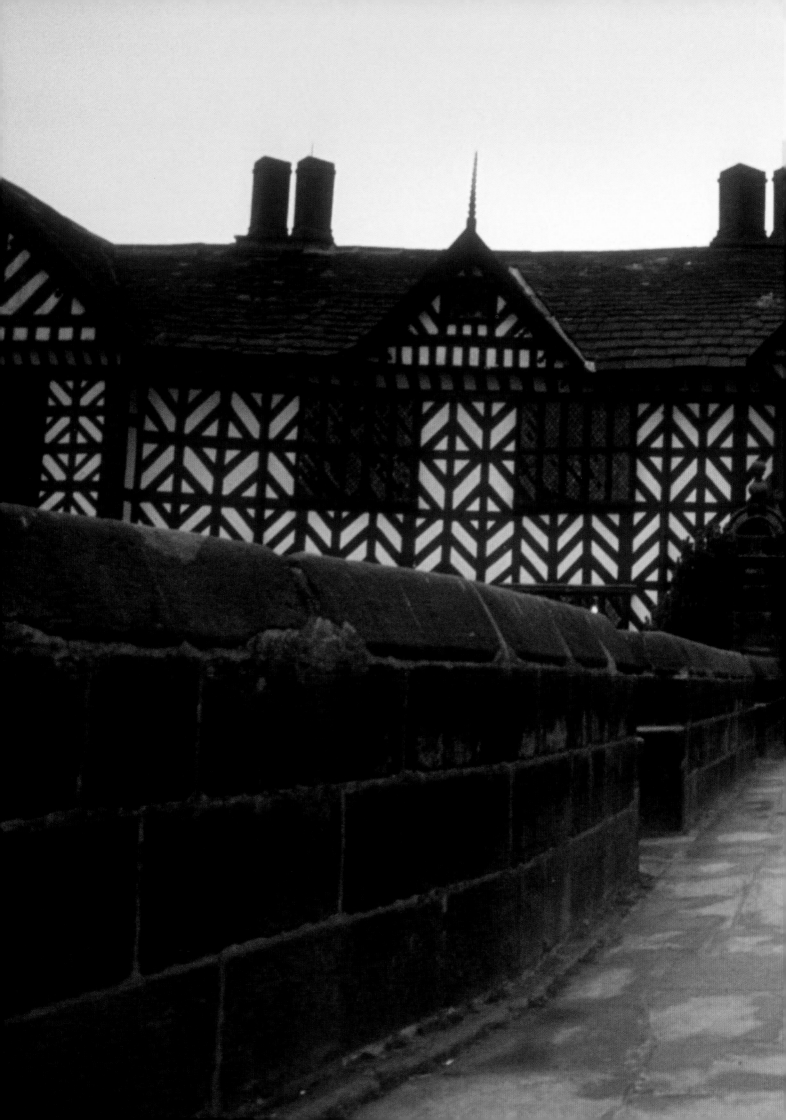

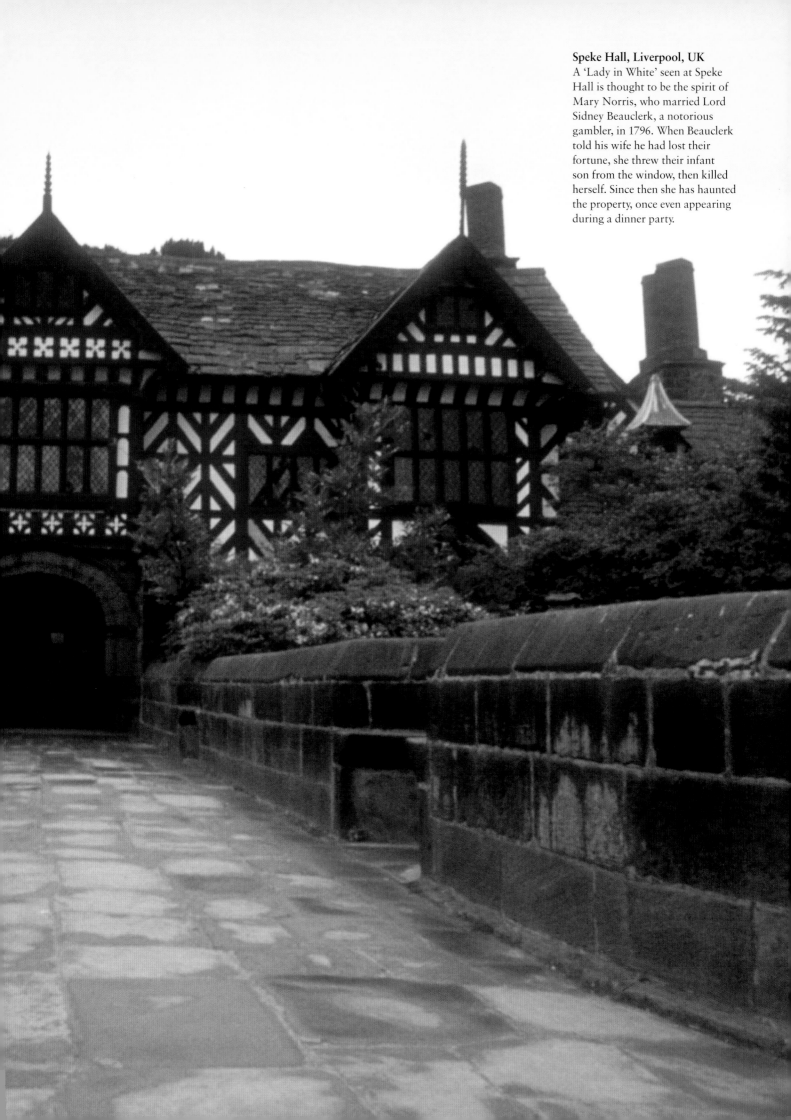

Speke Hall, Liverpool, UK
A 'Lady in White' seen at Speke Hall is thought to be the spirit of Mary Norris, who married Lord Sidney Beauclerk, a notorious gambler, in 1796. When Beauclerk told his wife he had lost their fortune, she threw their infant son from the window, then killed herself. Since then she has haunted the property, once even appearing during a dinner party.

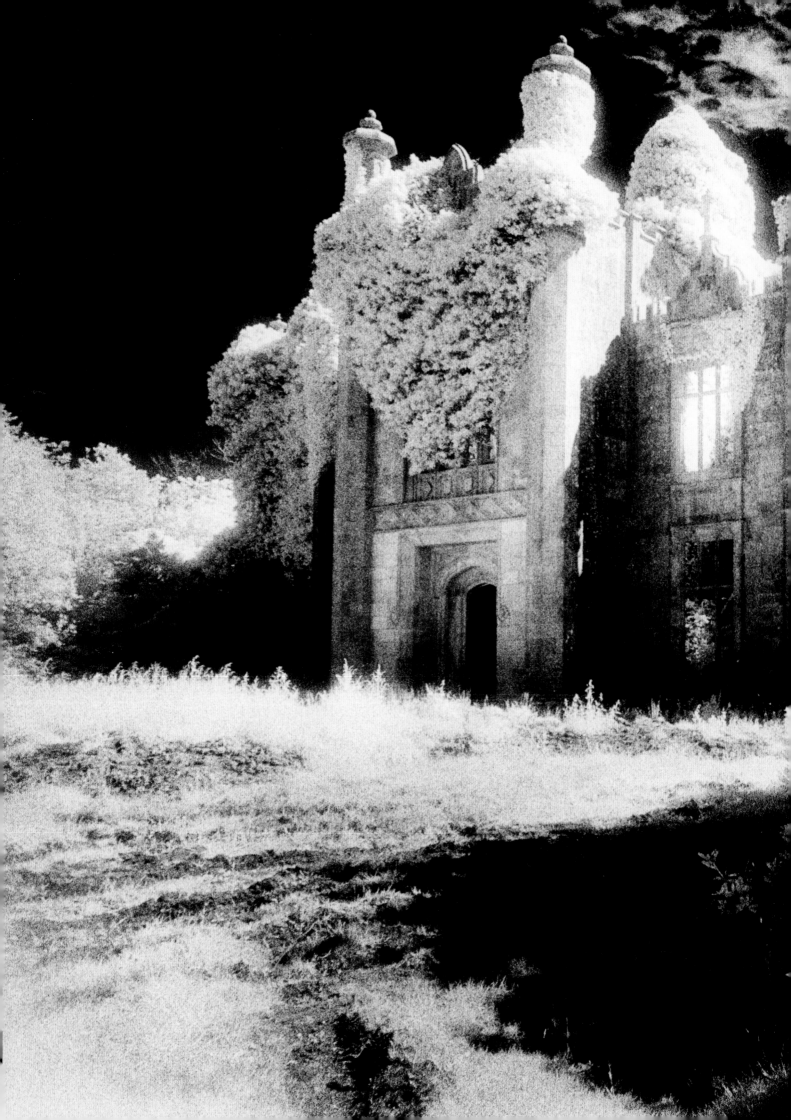

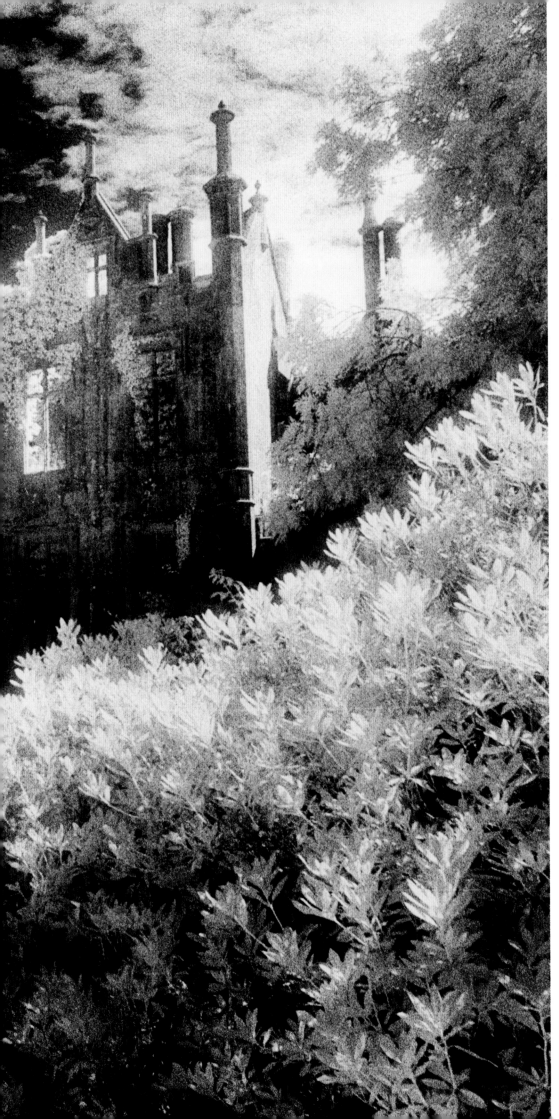

Coolbawn House, County Wexford, Ireland
Built in the 19th century for a newly married couple, Coolbawn is haunted by a servant girl who was struck by lightning during a storm and instantly killed, leaving the outline of her body etched into the window glass. The house was later burnt by the IRA, but her figure is still seen at the window where she died.

Sturdivant Hall, Selma, Alabama, USA

Sturdivant Hall was the former home of John McGee Parkman, President of the First National Bank of Selma. Parkman lost the bank a significant sum speculating in cotton, and was imprisoned by the local governor. He tried to escape prison in 1867 but was killed in the attempt, and is now believed to haunt his former home. Visitors have seen doors and latches being opened, chairs rocking by themselves, and heard footsteps moving around.

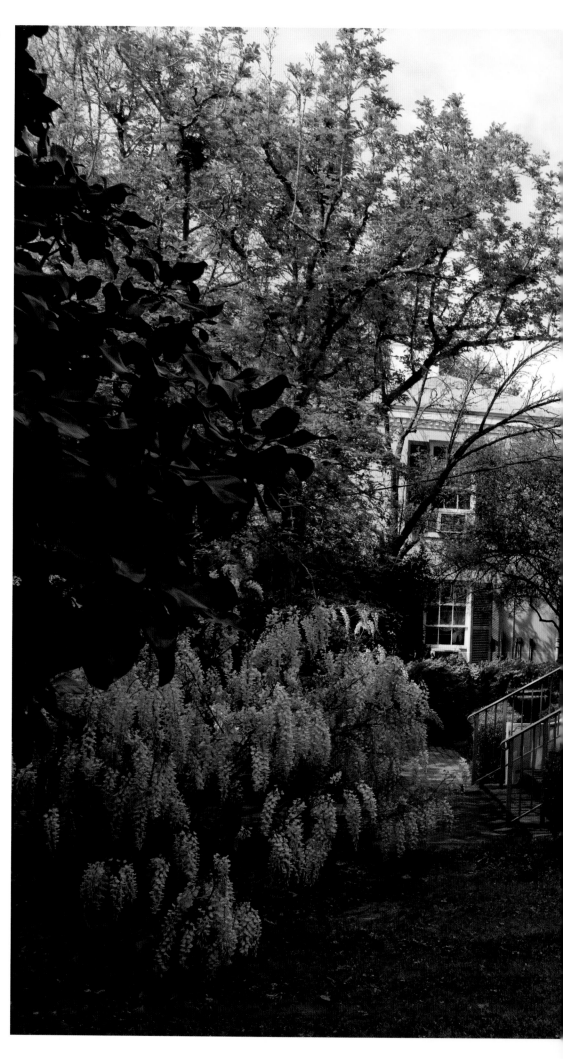

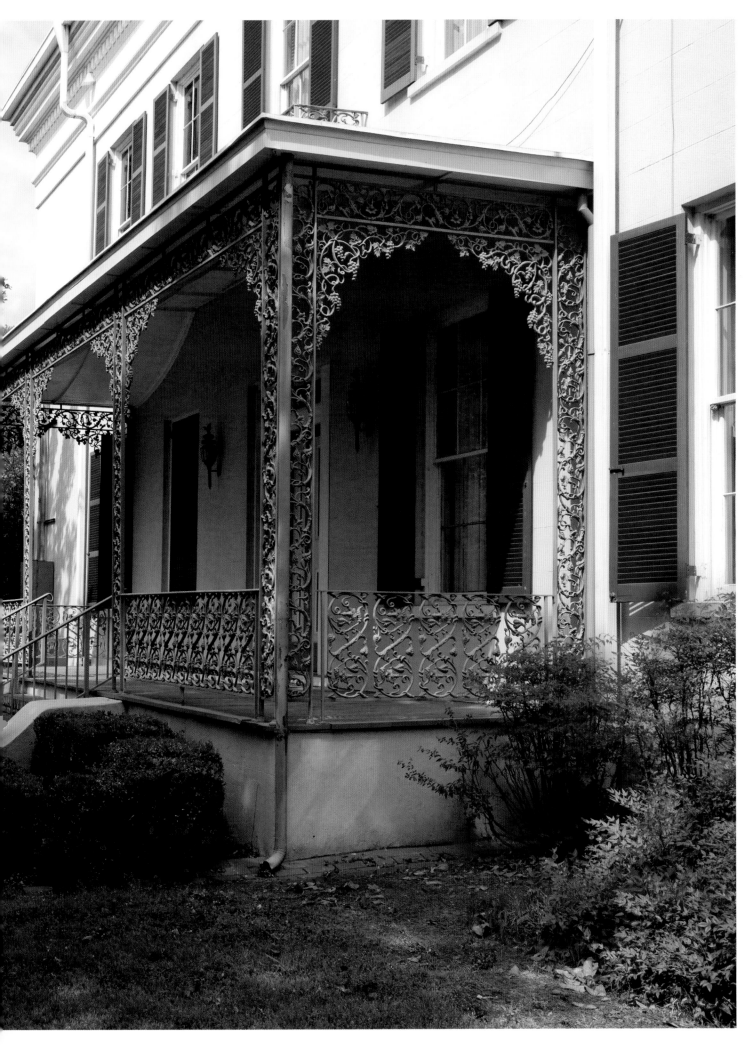

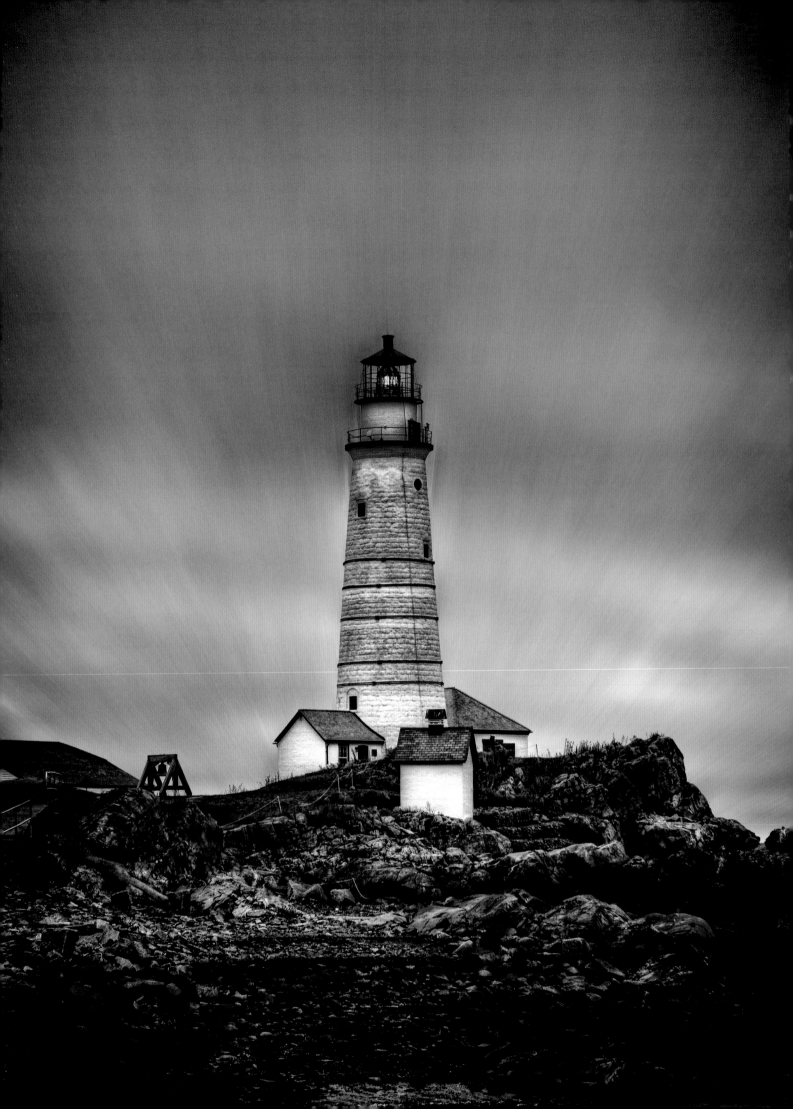

Industry

Industrial locations may not seem at first to be the most likely source of hauntings, but, as this chapter shows, there is no shortage of unexplained phenomena in the workplace. Without modern health and safety standards, accidents were commonplace in the industrial era, and those accidents were often gruesome and horrific, due to the primitive machinery in use at the time. Even relatively simple tasks like painting the exterior of a lighthouse could lead to a fatal fall, and tragic events involving children were frequent, as many worked alongside adults in dangerous conditions. Buildings that once housed hundreds or even thousands of workers have been left abandoned for decades, leaving behind eerie silence where once machinery rang out, and perhaps the odd figure half-glimpsed in the distance. Even when the building has been restored and reopened as a museum, as with Slater Mill and Sloss Furnaces, for example, reports of unexplained occurrences and sensations felt by visitors have not diminished. In locations where many have died over the years, it is often difficult to identify who may be responsible for any haunting activity, unless you have such a well-documented case as 'Slag' Wormwood of Sloss Furnaces, whose legendary cruelty casts a shadow that looms large a century after his death.

LEFT:
Boston Light, Little Brewster Island, Boston, USA
First established in 1716, the Boston Light is the oldest lighthouse site in the country. The first keeper, George Worthylake, drowned with his family and others in November 1718 on his way back to the lighthouse. Two weeks later, his replacement also drowned. Modern keepers have recounted unexplained laughter and a little girl sobbing, while radios playing rock music have been switched suddenly to a classical station.

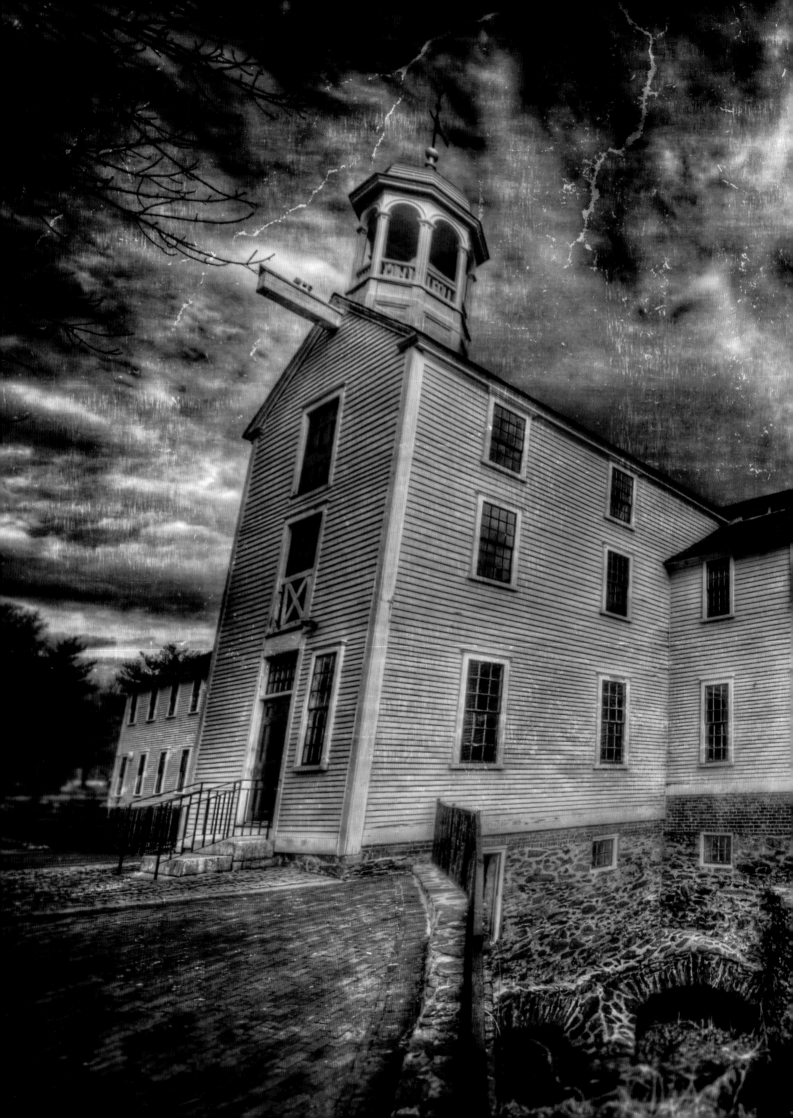

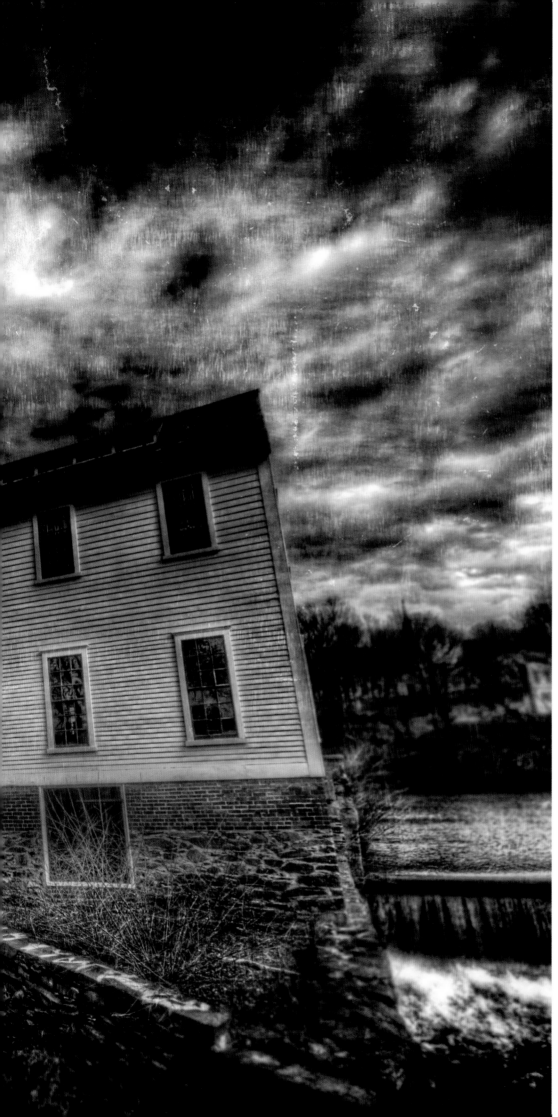

Slater Mill, Rhode Island, USA
Built in 1793, Slater Mill was the first water-powered textile mill in America. In the early years of the mill, small children were used to clean or repair the machines while they were in operation, which could lead to injuries or death. Now an industrial museum, visitors have reported hearing the death cries and screams of these young children.

Slater Mill, Rhode Island, USA
Other buildings on the Slater Mill site are also haunted by malevolent spirits who have been known to scratch visitors, an unknown male and female presence, and a little girl called 'Becca' who answers questions by divining rod.

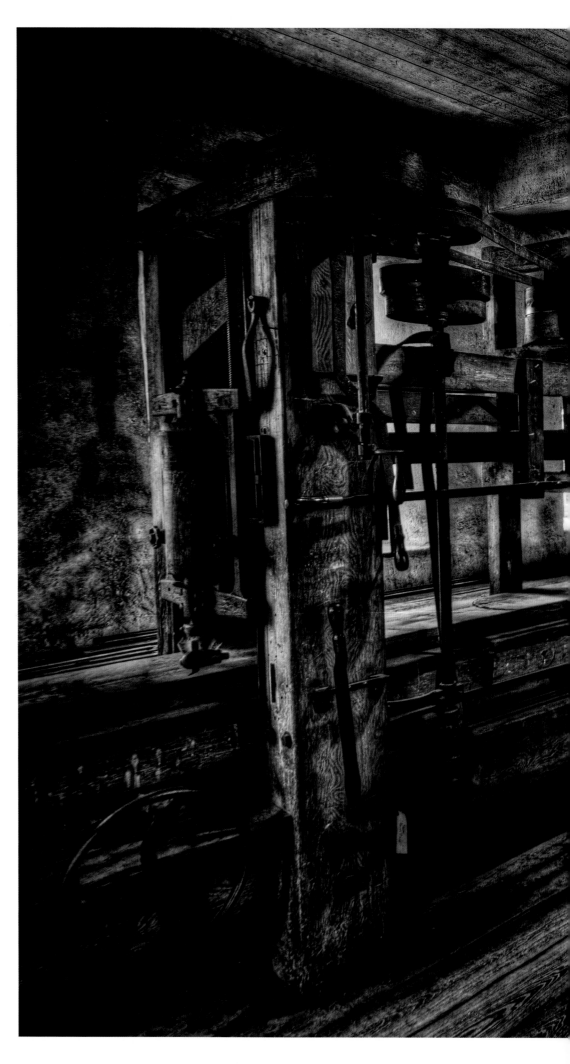

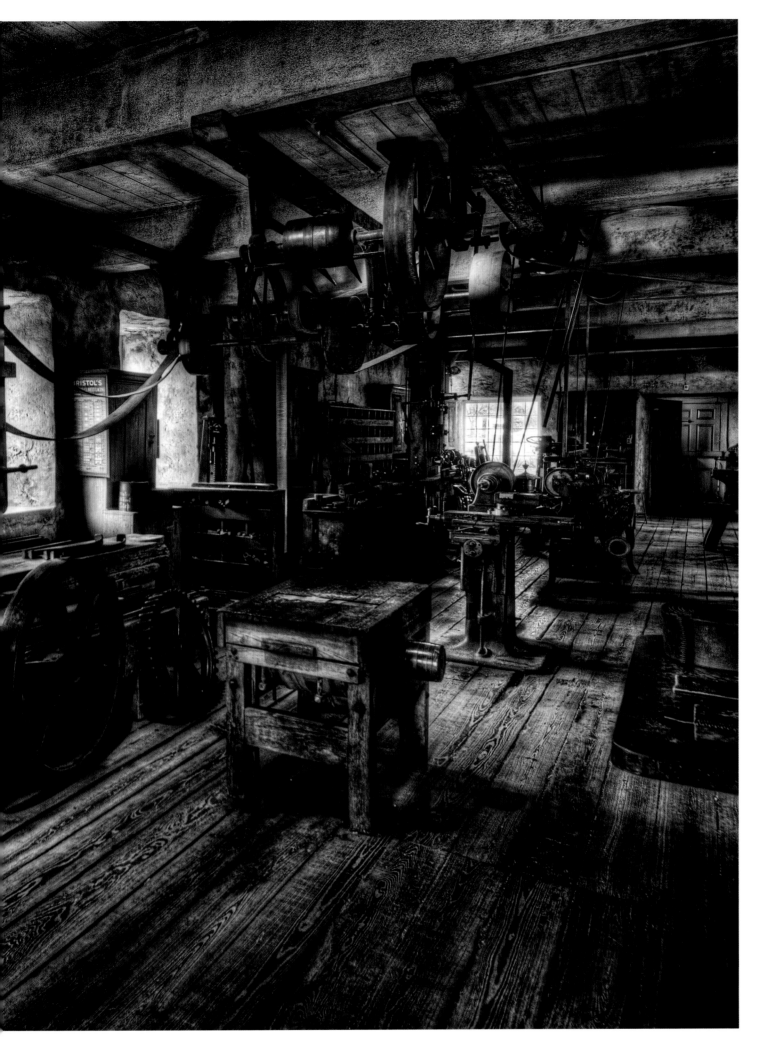

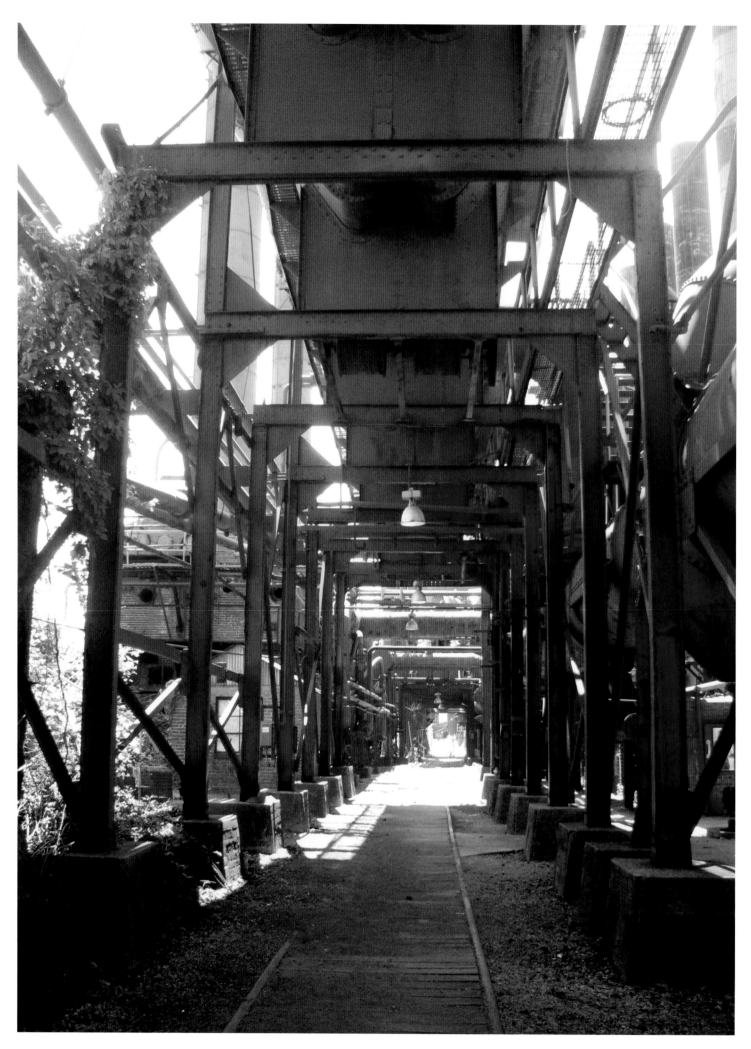

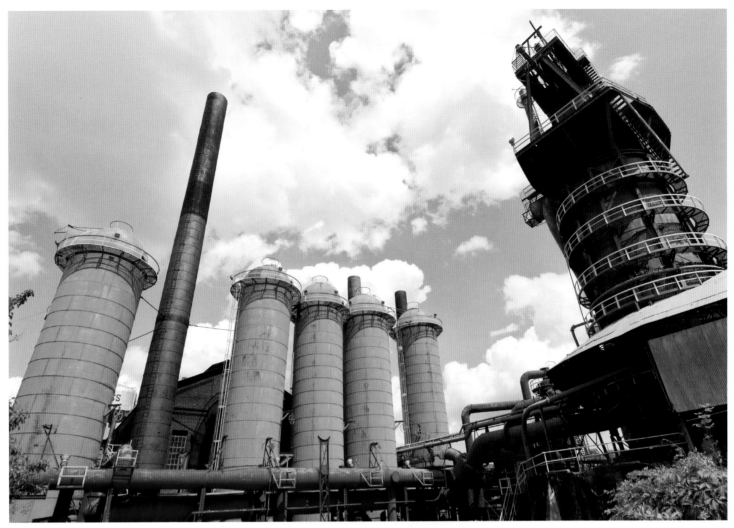

LEFT:
Sloss Furnaces, Birmingham, Alabama, USA
From 1882 to 1971, the Sloss Furnaces produced iron for building projects all over America. However, it was notorious as a dangerous place to work, especially those who worked for James 'Slag' Wormwood on the graveyard shift.

ABOVE:
Sloss Furnaces, Birmingham, Alabama, USA
No fewer than 47 people died under Wormwood's supervision, while many others were injured or maimed in accidents caused by overwork. His reign of terror ended in October 1906, when he fell into a vat of melting ore, and was instantly vaporized. He is said to haunt the site today, pushing visitors and shouting at them to get to work.

RIGHT:
Sloss Furnaces, Birmingham, Alabama, USA
Today the site is preserved as a monument to America's industrial heritage, but it is also one of the country's most haunted places.

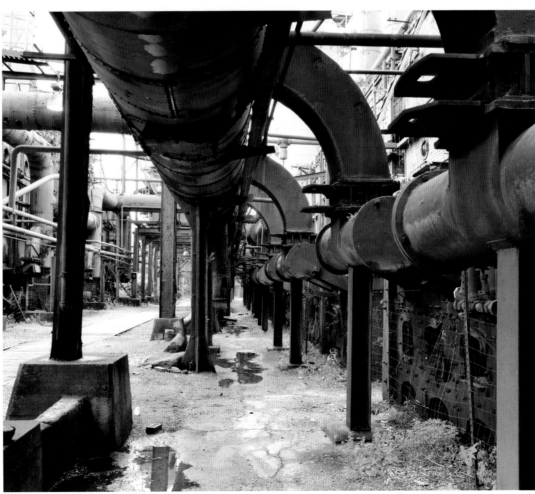

Little Brewster Island, Boston, USA
Several miles to the east of the island on which the Boston Light sits is an area of sea known as the 'Ghost Walk', reputed to be haunted by local sailors. The lighthouse's beam of light and foghorn cannot penetrate this mysterious area.

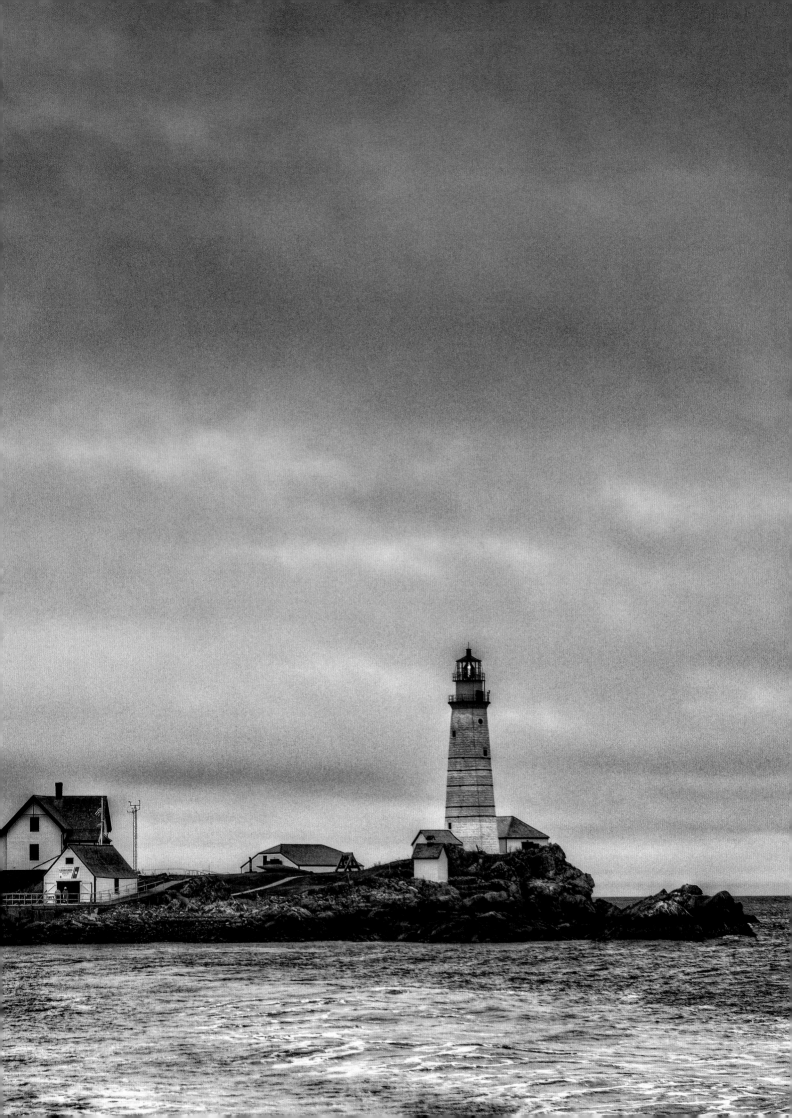

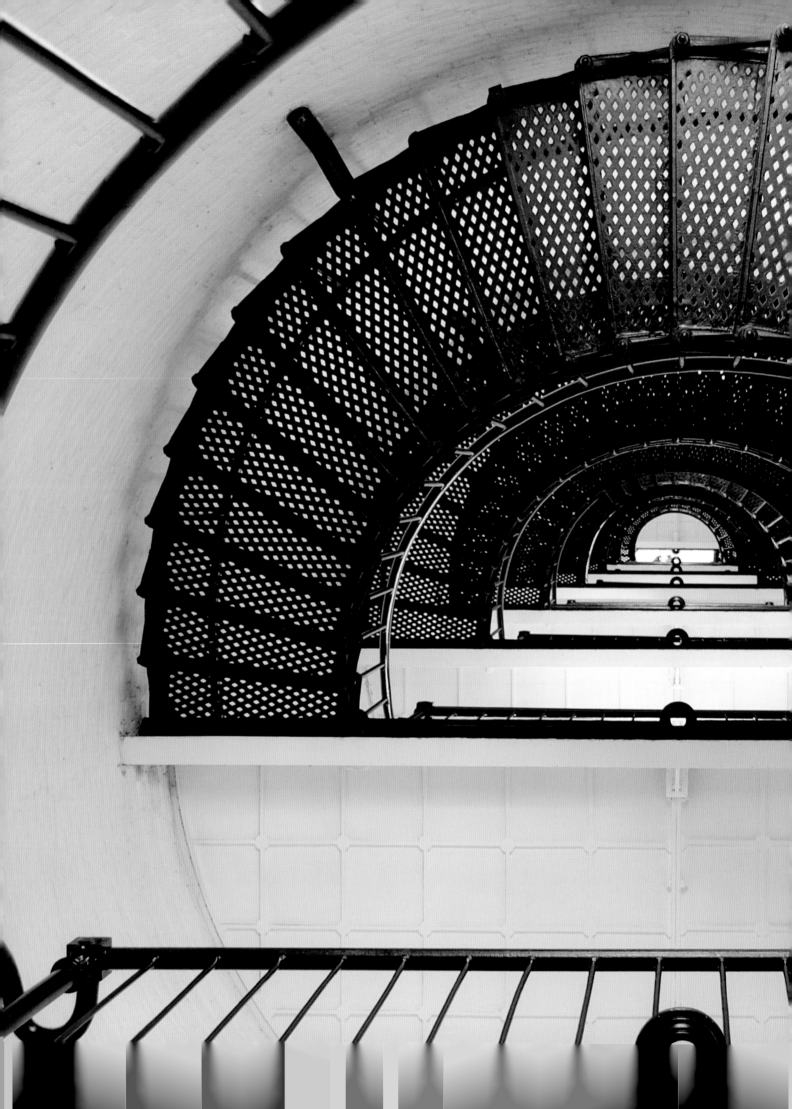

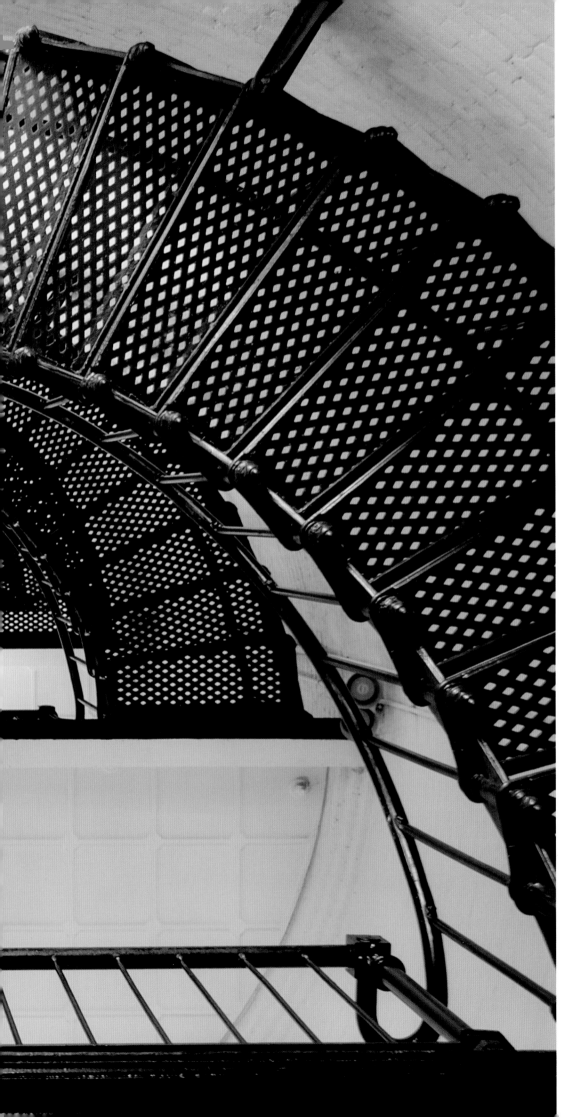

St Augustine Lighthouse, Florida, USA

Although St Augustine is the oldest city in America, the lighthouse is relatively modern, and was built in 1824. One of its keepers, Mr Andreu, was painting the tower when he fell to his death. Another keeper, Peter Rasmussen, was a regular cigar smoker, and his cigars can still be smelt by visitors today. In the late 1800s, Hezekiah Pity was hired to renovate the lighthouse. His two daughters disobeyed his instructions to stay away from his cart, and they slid to their death in the bay below. Their laughter can occasionally be heard at night.

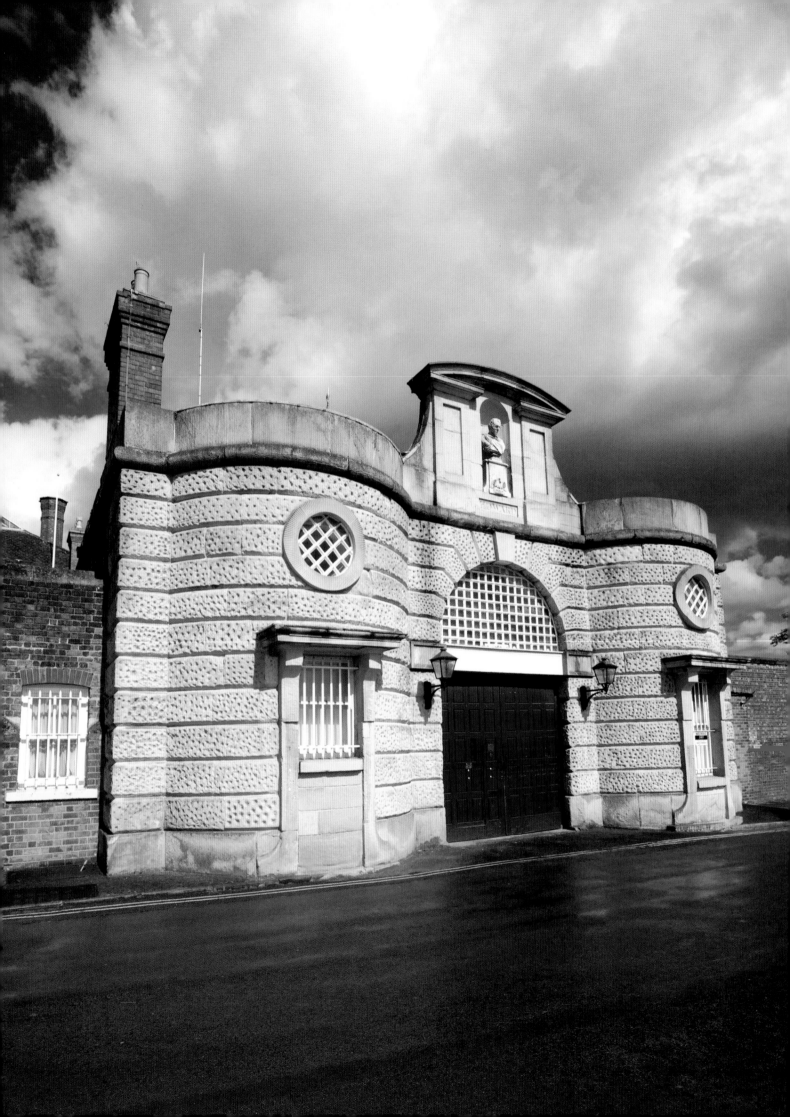

Institutions

Modern treatment methods for those unfortunate enough to find themselves at the fringes of society, as either criminals or the mentally ill, are exactly that: modern. It is only in the last few decades that we have seen more compassionate regimes introduced in some of society's institutions. Many of the former prisons and asylums were built with good intentions and the latest thinking, but quickly they became the worst kind of place, overcrowded, insanitary and a source of suffering in themselves. What is most shocking, perhaps, is how recently these bastions of Victorian-era thinking and architecture were closed. Although

for many inmates conditions did improve from the nadir of the early 20th century, the decaying buildings and fabric designed for outdated purposes and needs would have remained an unpleasant experience. In the light of this suffering, it is no surprise to hear stories of horrific deaths and abuse, sometimes at the hands of the guards themselves rather than other inmates, as well as suicides and rioting. Many visitors to the locations in the following pages report hearing unexplained screaming. Some institutions have found new lives as fashionable homes or tourist attractions, but many now stand ruined, as testament to those who never left their confines.

LEFT:
Former HM Prison Shrewsbury, Shropshire, UK
The former prison in Shrewsbury was built on the site of a much older gaol, known as the Dana. Several executions took place there in the 20th century alone, with the bodies buried in unmarked graves, and it became notorious for a high rate of suicides among inmates held there. Visitors have reported seeing figures, hearing footsteps and strange noises, and cell doors shutting unexpectedly.

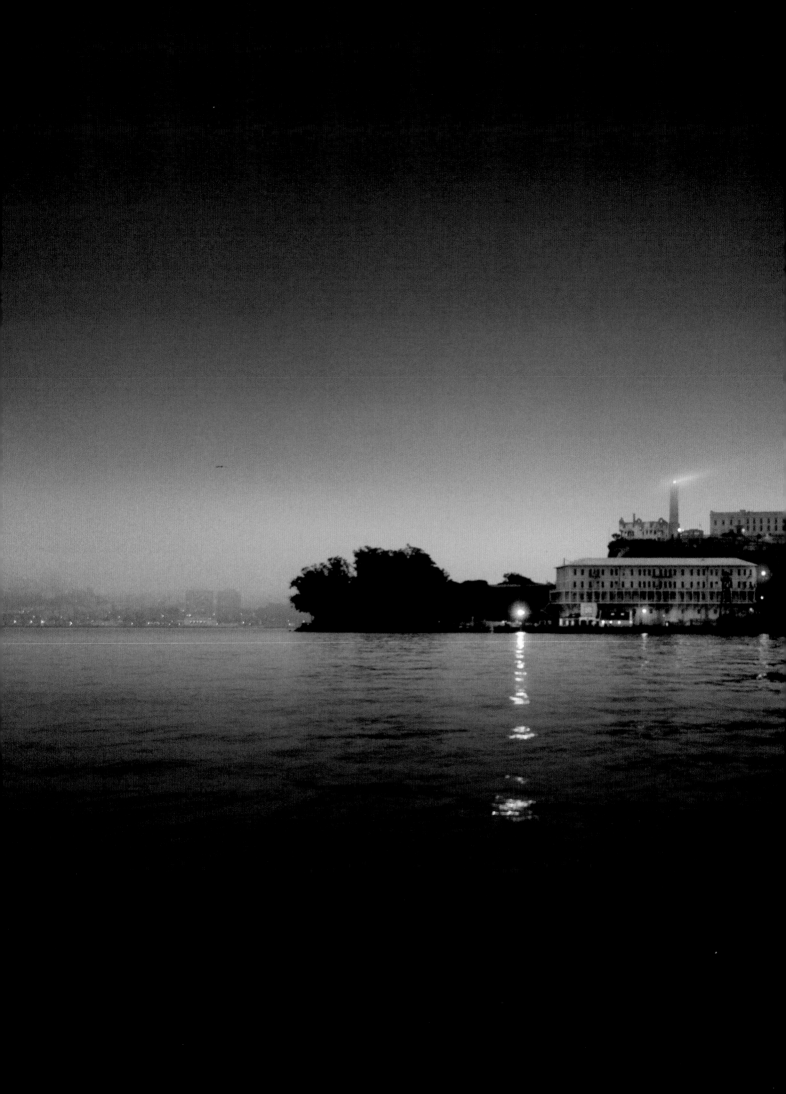

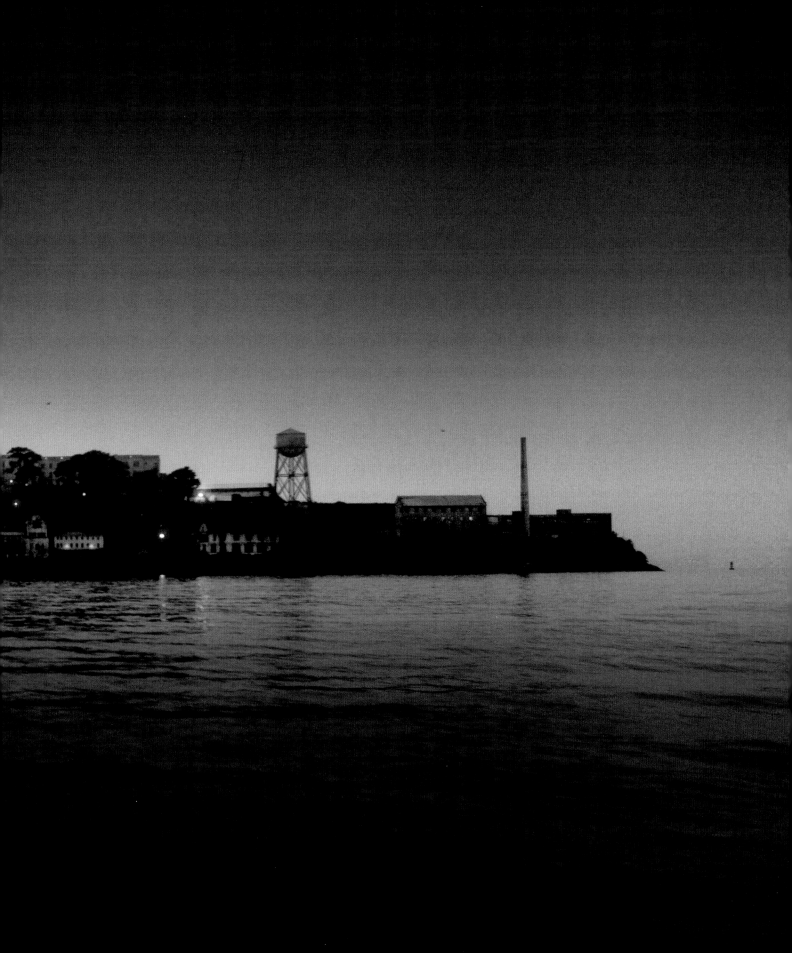

PREVIOUS PAGE:
Alcatraz Island, San Francisco, California, USA
Alcatraz has been a military fort and, briefly, a haven for the dispossessed, but it is rightly notorious for its use as a prison, especially in the 20th century, with inmates including Al Capone and 'Machine-Gun' Kelly.

RIGHT:
Underground tunnel, Alcatraz, San Francisco, California, USA
The prison regime was harsh, and a number of inmates died. In the 1940s one prisoner complained of a presence in his cell with glowing eyes. Despite his screams he was not allowed out. His body was found, strangled, the next morning. Today, tour guides regularly report the sounds of screaming and other unexplained noises – even a banjo, Al Capone's favoured instrument while he was held there.

OVERLEAF:
Former Atlanta Prison Farm, Atlanta, Georgia, USA
Opened in 1945, this prison facility was a fully functioning farm for minor offenders, with up to a thousand inmates at its peak. The site was closed and abandoned in 1995, and experienced a major fire in 2009, but a number of visitors have encountered paranormal activity and even glimpsed faces of former inmates.

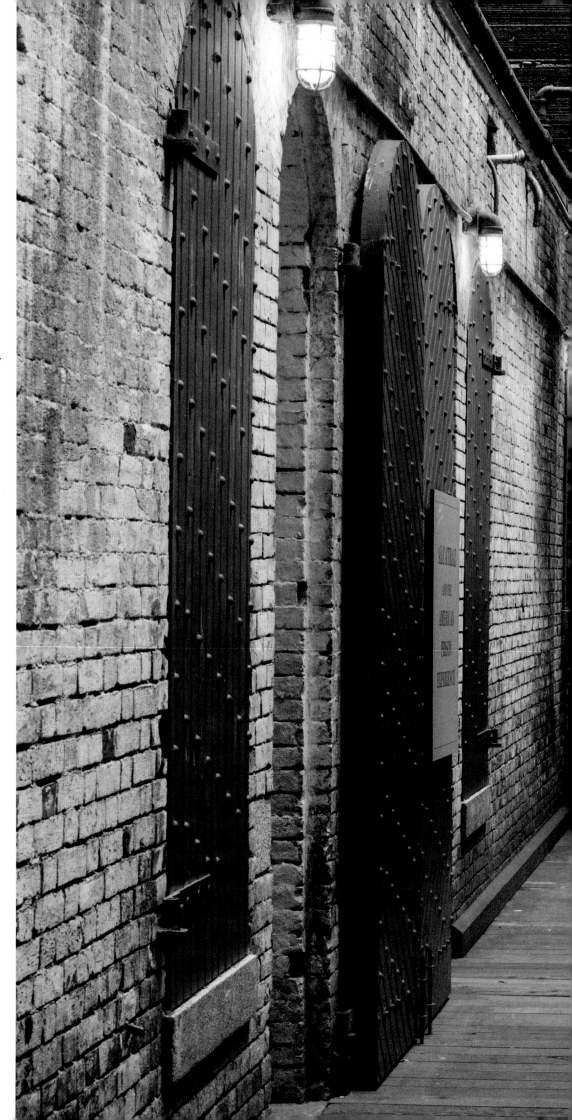

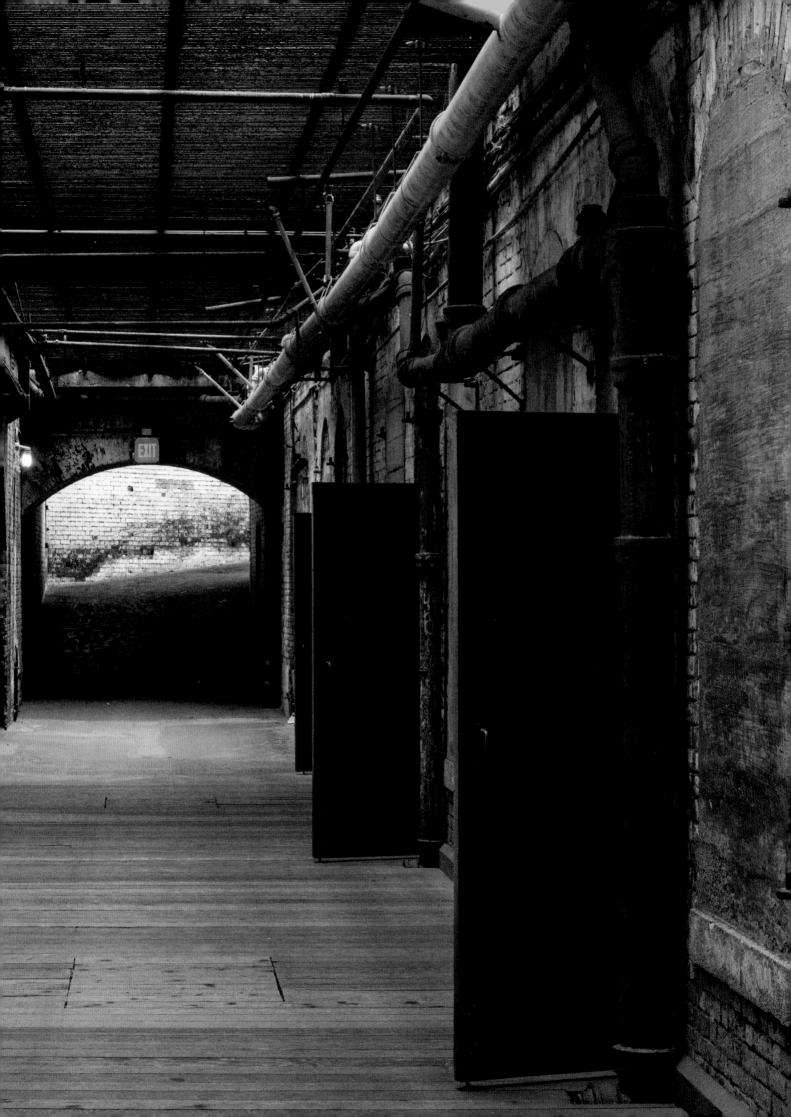

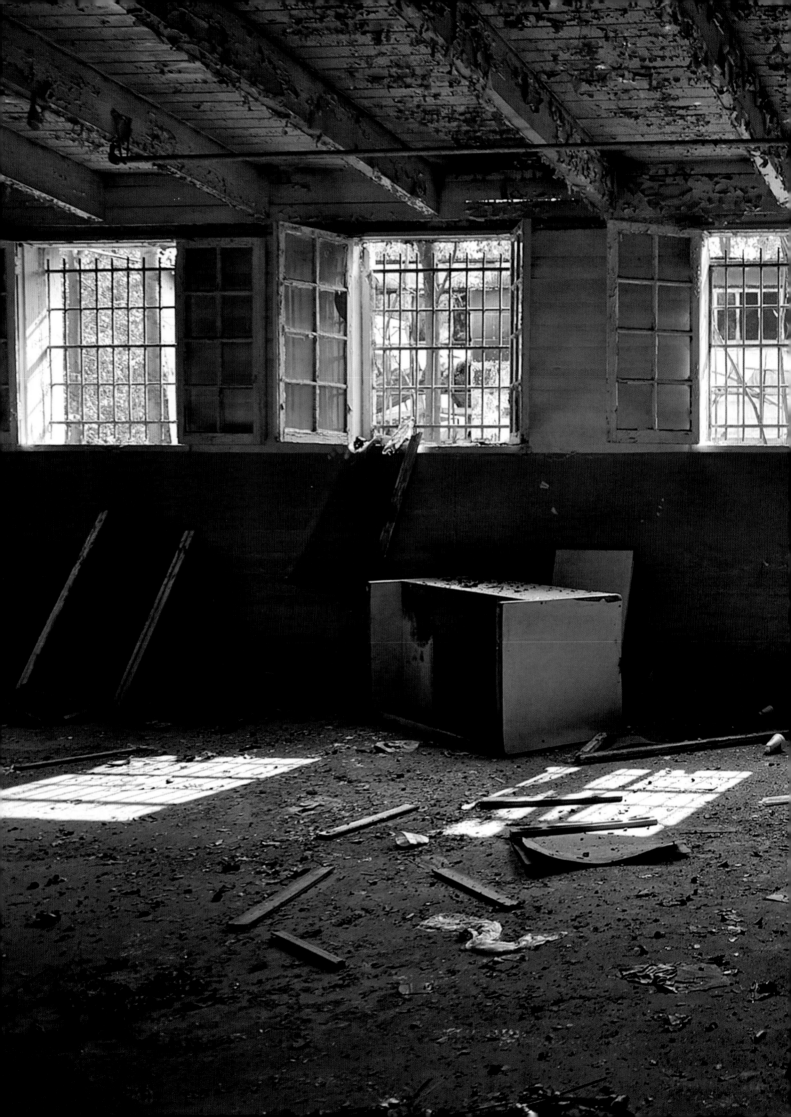

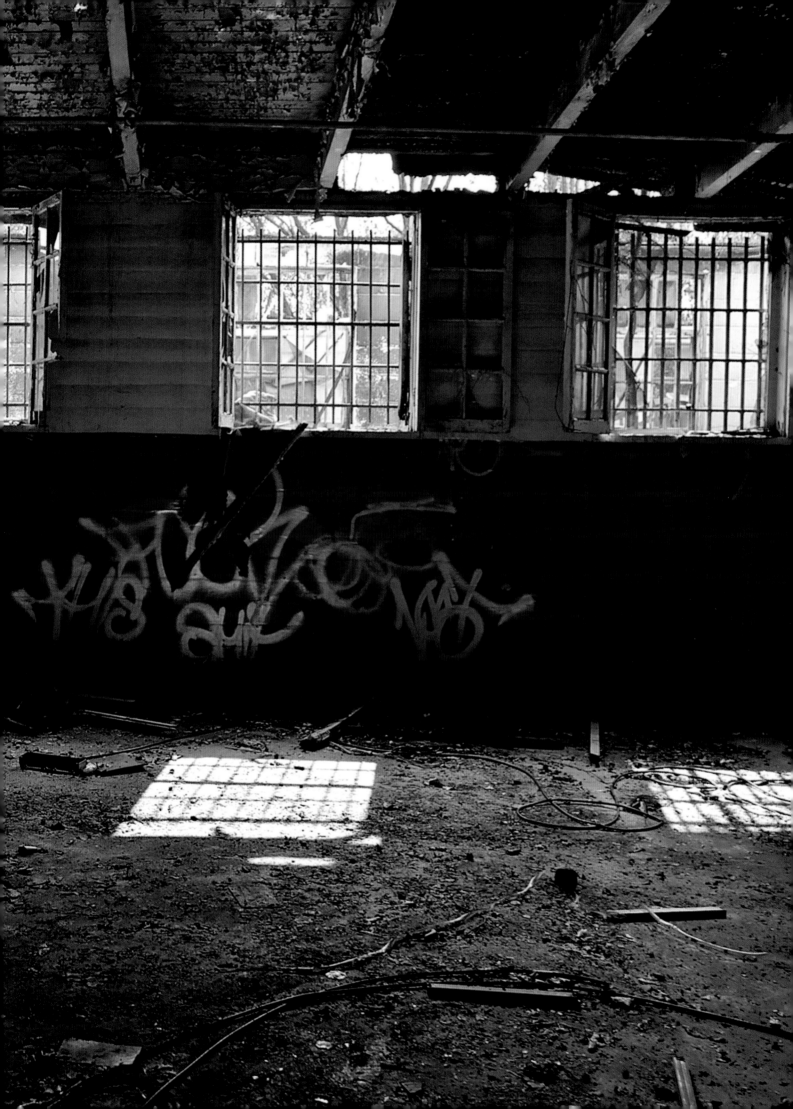

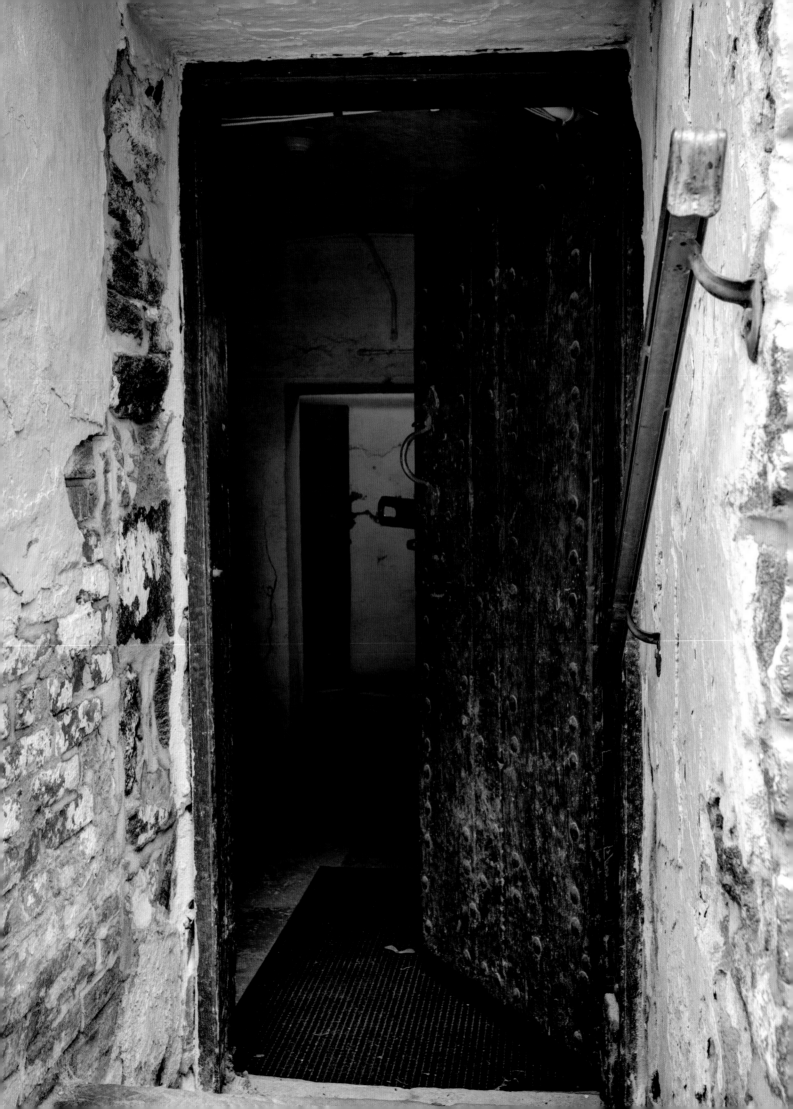

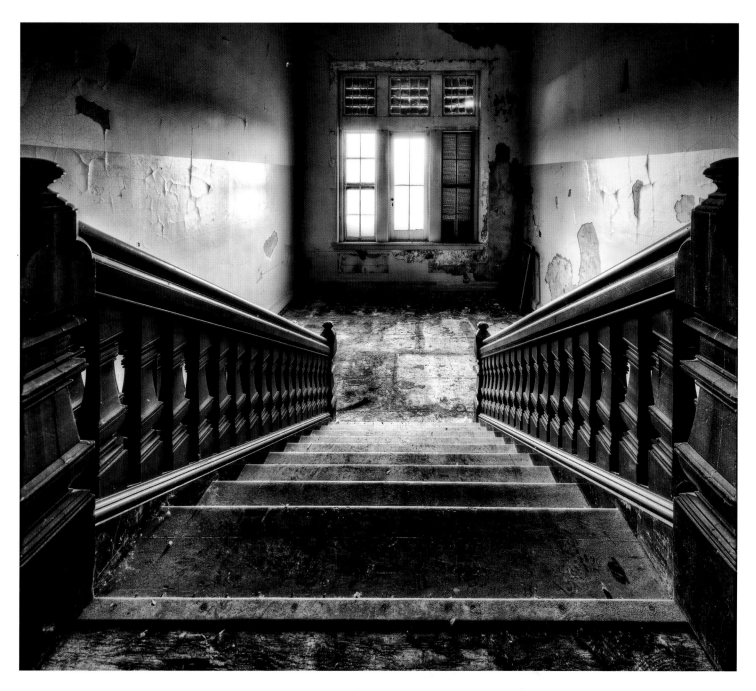

LEFT:

Entrance, Burlington County Prison, Mount Holly, New Jersey, USA

The last execution was held at Burlington County jail in 1906, but the prison remained active until 1965. Now a museum, a few of those who died here remain, especially near the maximum-security cell on the second floor. Workmen have heard screams and strange noises, while tools have been moved without warning.

ABOVE:

Staircase, Buffalo State Asylum, New York, USA

Opened in 1880, the asylum was an attempt to improve treatment and general conditions for patients, but many of the methods used would not be seen as humane today, and it was extremely crowded and insanitary. The asylum closed in 1974, but unofficial visitors to the site report regular loud and unexplained screams.

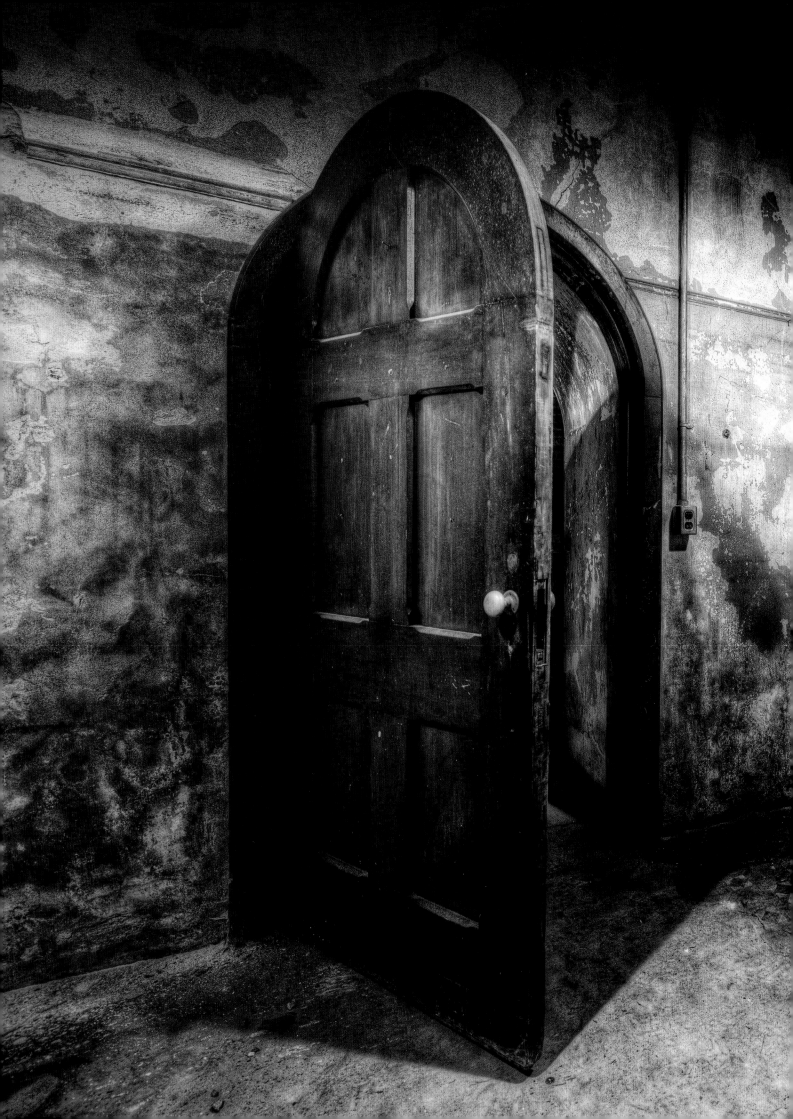

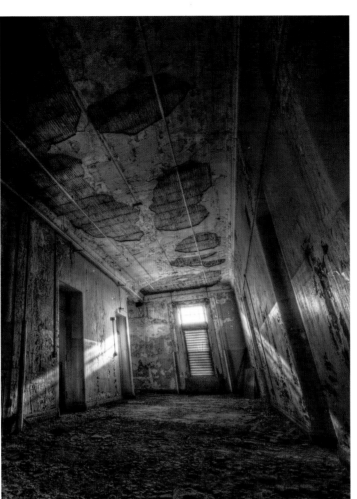

OPPOSITE:

Doorway, Buffalo State Asylum, New York, USA

Some of the treatments used at Buffalo State included trepanning and experimentation with destroying parts of the brain to see the effects.

LEFT:

Corridor, Buffalo State Asylum, New York, USA

Classifying and diagnosing patients was at a very primitive stage and so patients with different conditions were kept incarcerated here, ranging from those with simple cognitive issues to the criminally insane, although they were kept separate from each other.

BELOW:

Buffalo State Asylum, New York, USA

Other noises heard by those on the site are those usually associated with suffering. The former asylum is now listed as a heritage building, and redevelopment plans have been submitted, so it is likely to have new occupants soon.

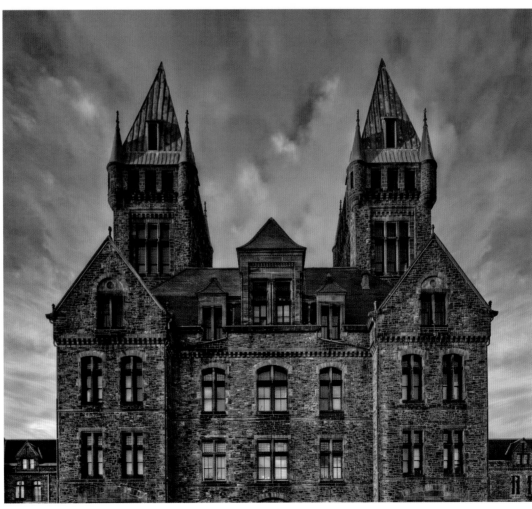

BELOW:

Eastern State Penitentiary, Philadelphia, USA
Opened in 1829, the Eastern State Penitentiary was extremely innovative in its treatment of prisoners. Each prisoner was to be kept in solitary confinement so that they could reflect upon their crime and truly repent. Famous former inmates include Al Capone and 'Slick' Willie Sutton.

OPPOSITE:

Gargoyle, Eastern State Penitentiary, Philadelphia, USA
Although the Eastern State spawned many imitators, eventually the solitary confinement system fell out of favour and so the building was converted to a more conventional-style prison, until it was closed and abandoned in 1971.

OVERLEAF LEFT:

Cell 28, Cell Block 9, Eastern State Penitentiary, Philadelphia, USA
Conditions at the prison were harsh, with prisoners being put in cold-water baths then hung on a wall to dry in winter, gagged, or, for the worst inmates, left in the 'Hole', a dark, windowless cell without any facilities or daylight.

OVERLEAF RIGHT:

Cell, Eastern State Penitentiary, Philadelphia, USA
Suicides and deaths were common at the prison, and so a number of prisoners' spirits are thought to have remained behind. One tour guide has described how he was gripped by a negative energy in one cell as contorted faces appeared on the wall opposite him. Others report seeing figures and hearing footsteps, wailing and screams.

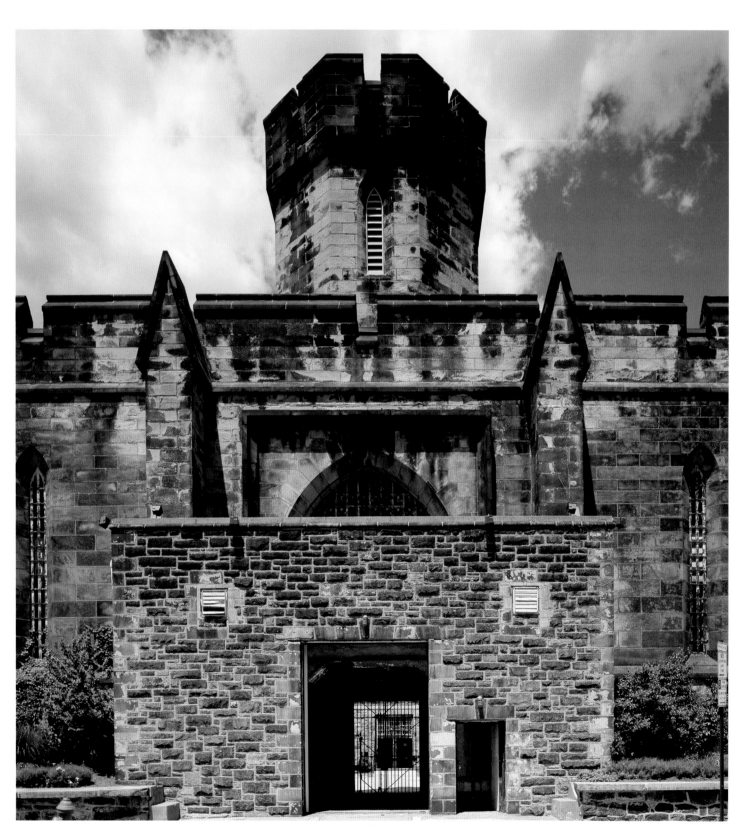

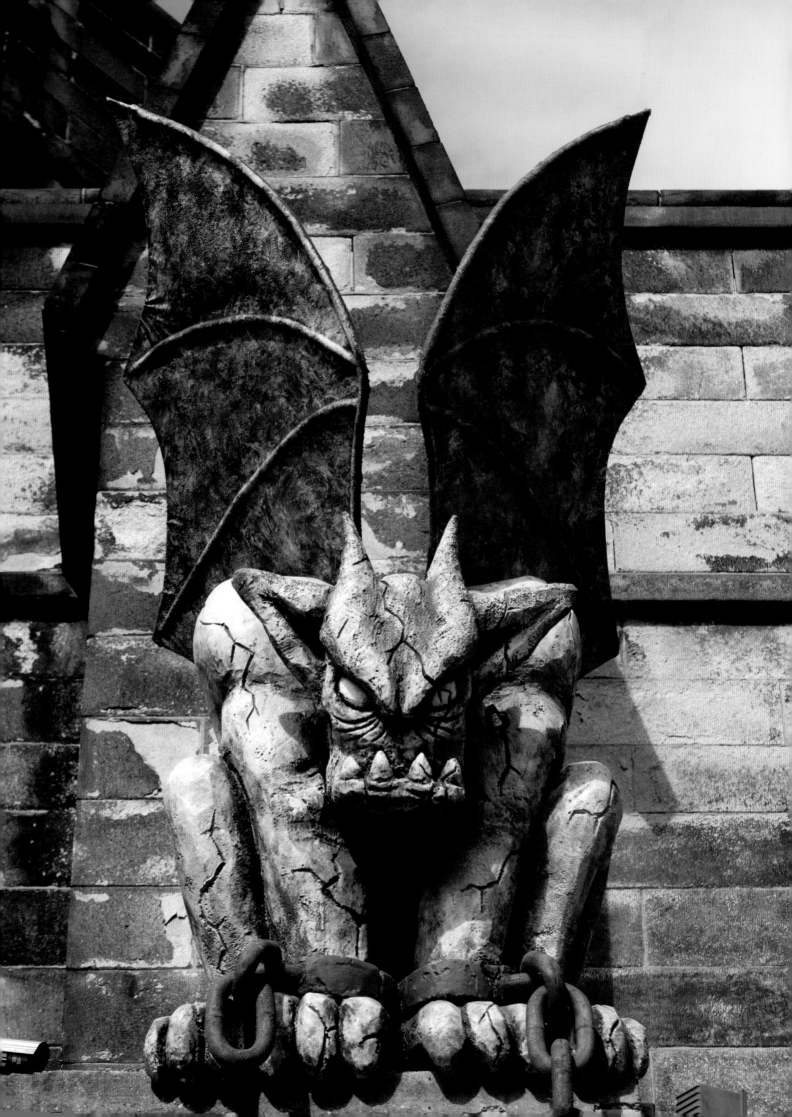

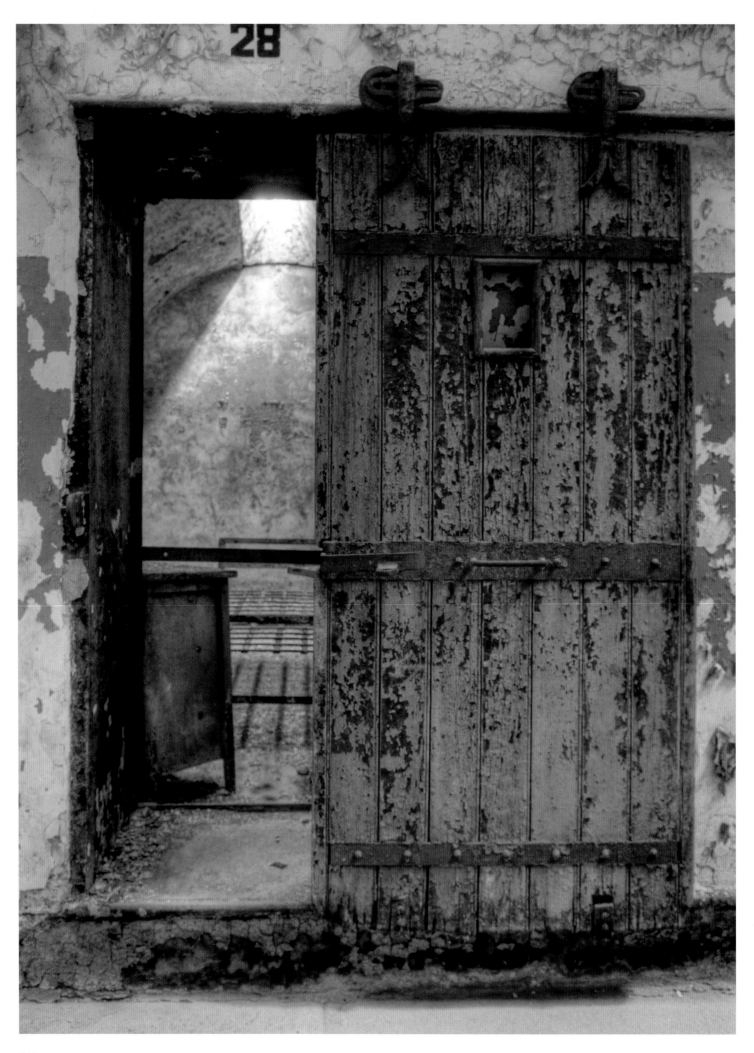

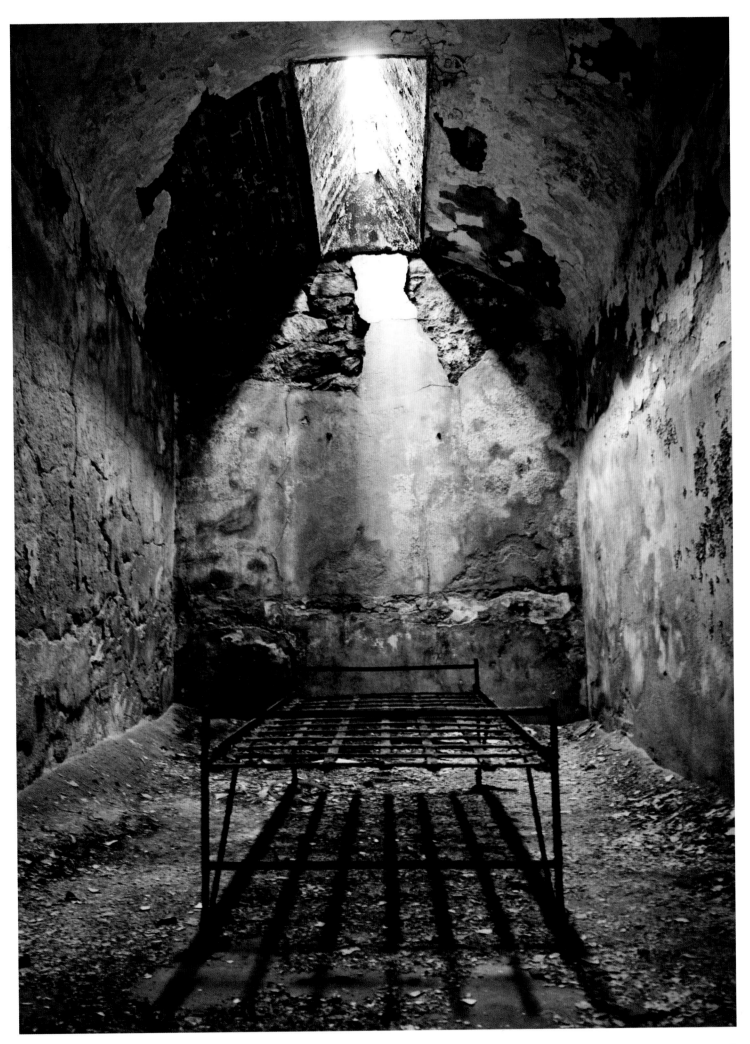

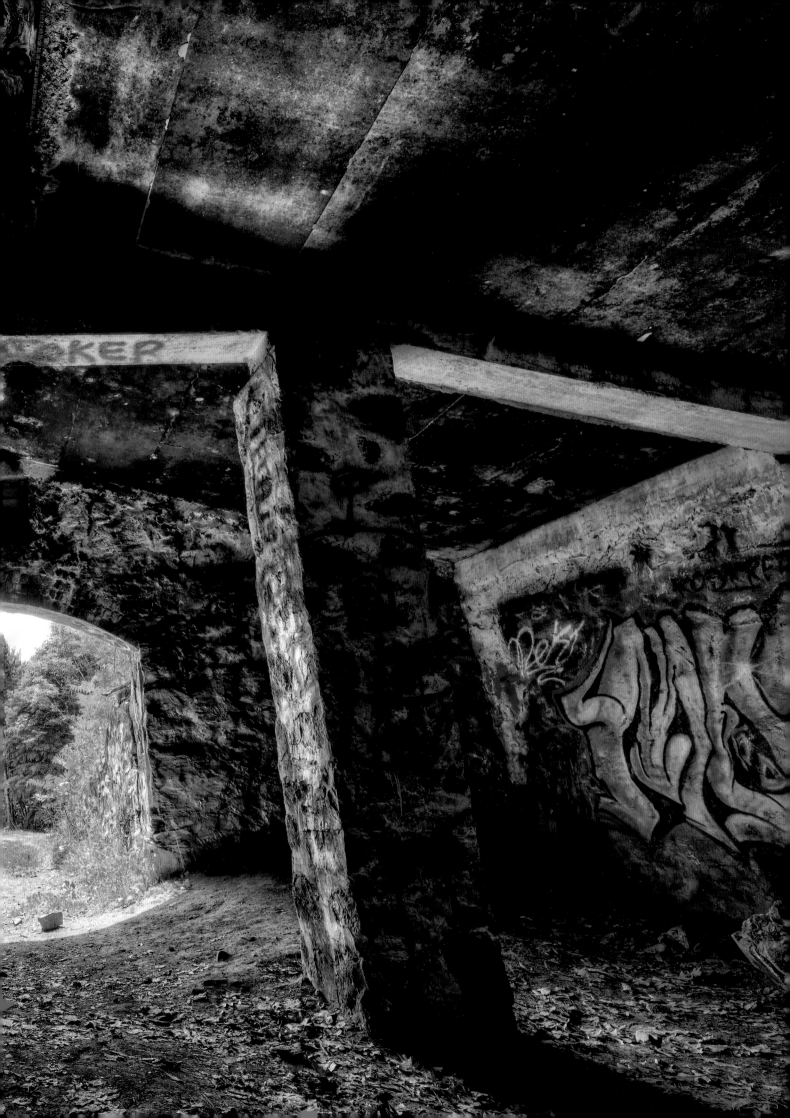

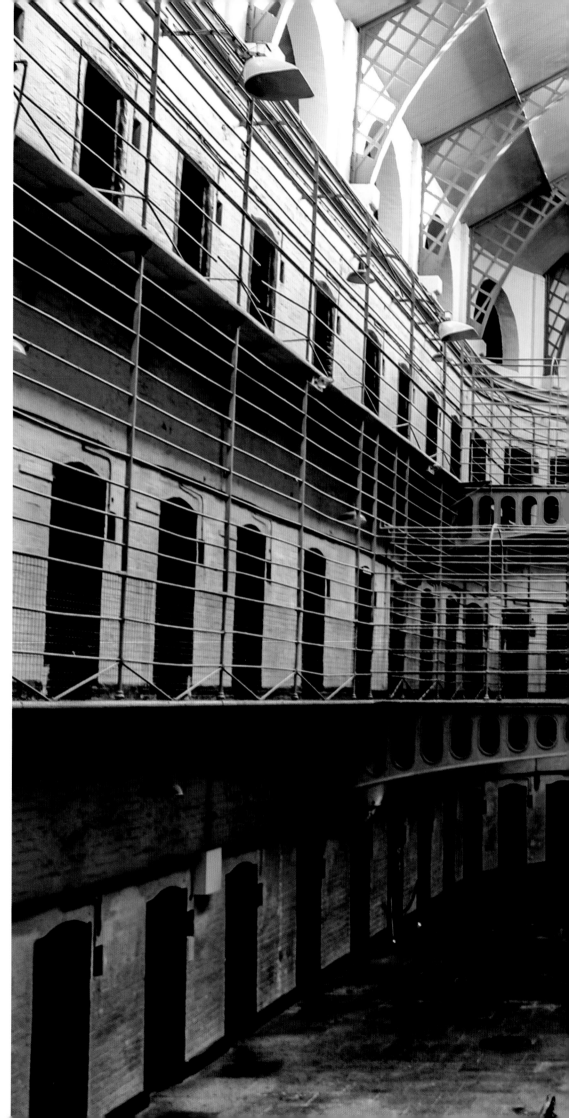

PREVIOUS PAGE:
Root Cellar, Rutland Prison Camp, Massachusetts, USA
Opened in 1903 in what is now a state park, the camp only remained in use for minor criminals until 1934, so little now remains. Some 59 inmates were buried at the site. Visitors to the site have reported strange noises and figures, including one spirit believed to be a warden's wife.

RIGHT:
Cell Block, Kilmainham Gaol, Dublin, Ireland
Described as 'Ireland's answer to Alcatraz', the gaol was built in 1796. Many of those fighting for Ireland's independence were held here, and some were executed by firing squad after the Easter Rising in 1916. The gaol closed in 1924, but numerous supernatural occurrences have been described, including one painter who was pinned against a wall by a strange force, lights being turned on repeatedly in the chapel, and sudden footsteps being heard without any apparent cause.

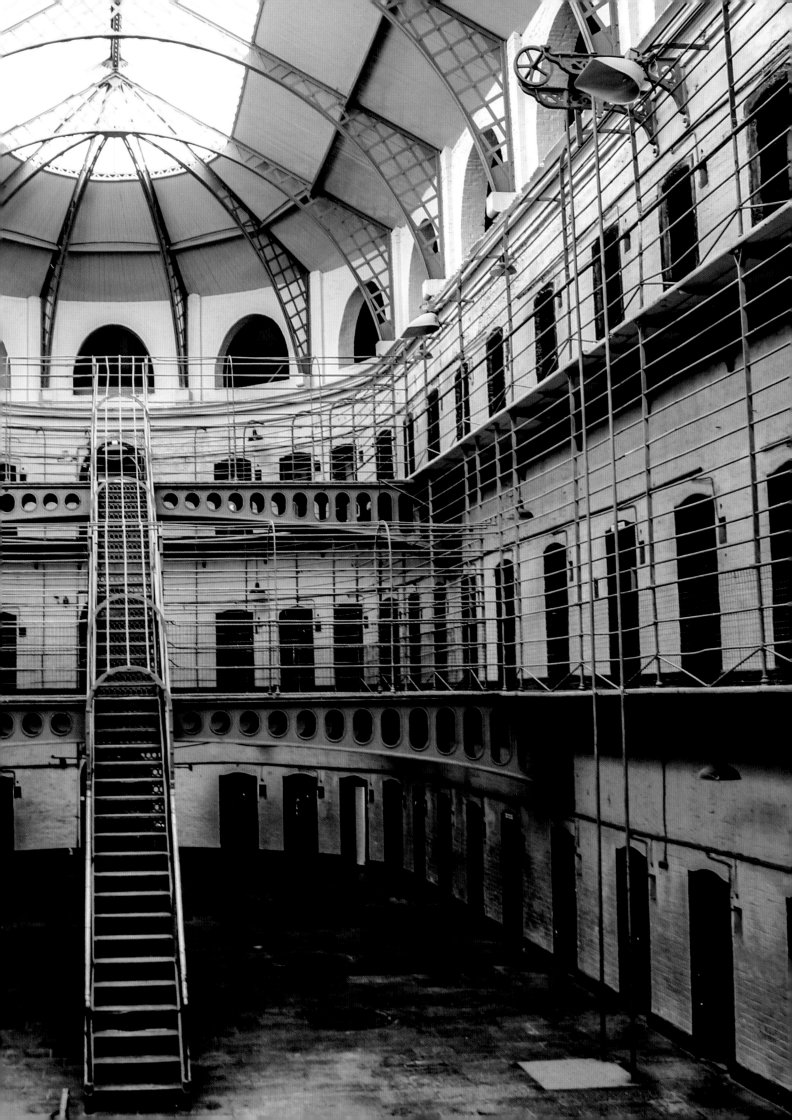

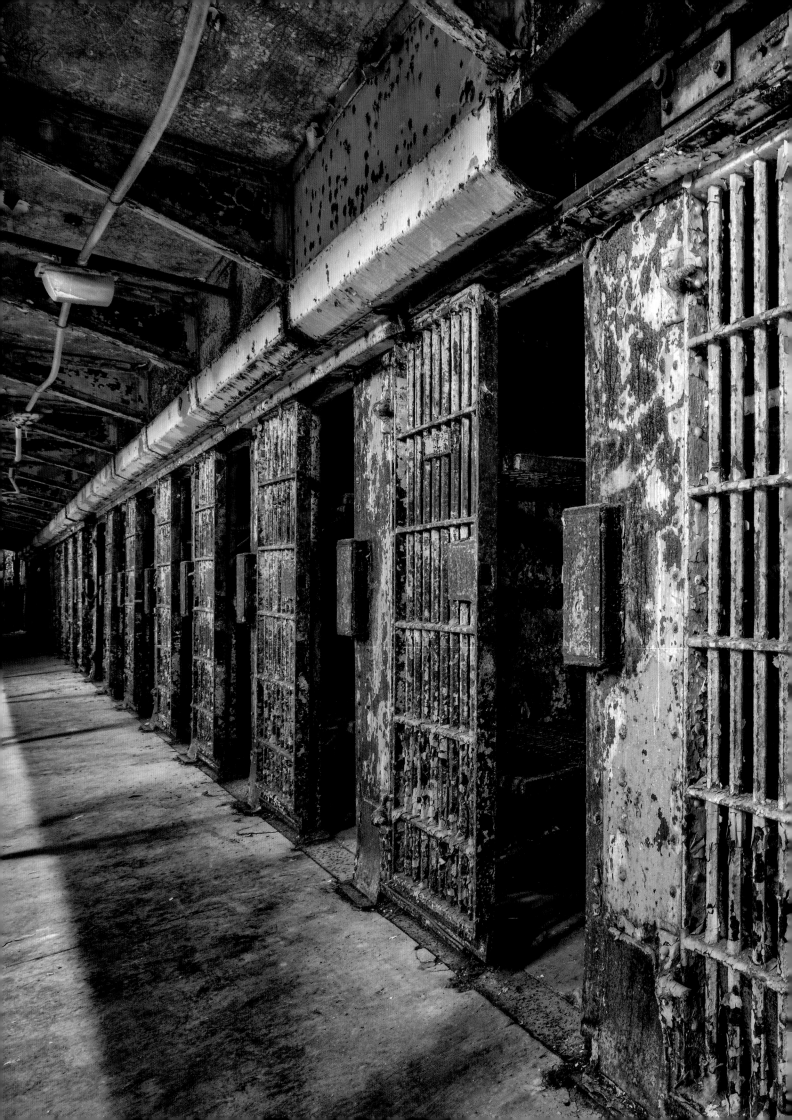

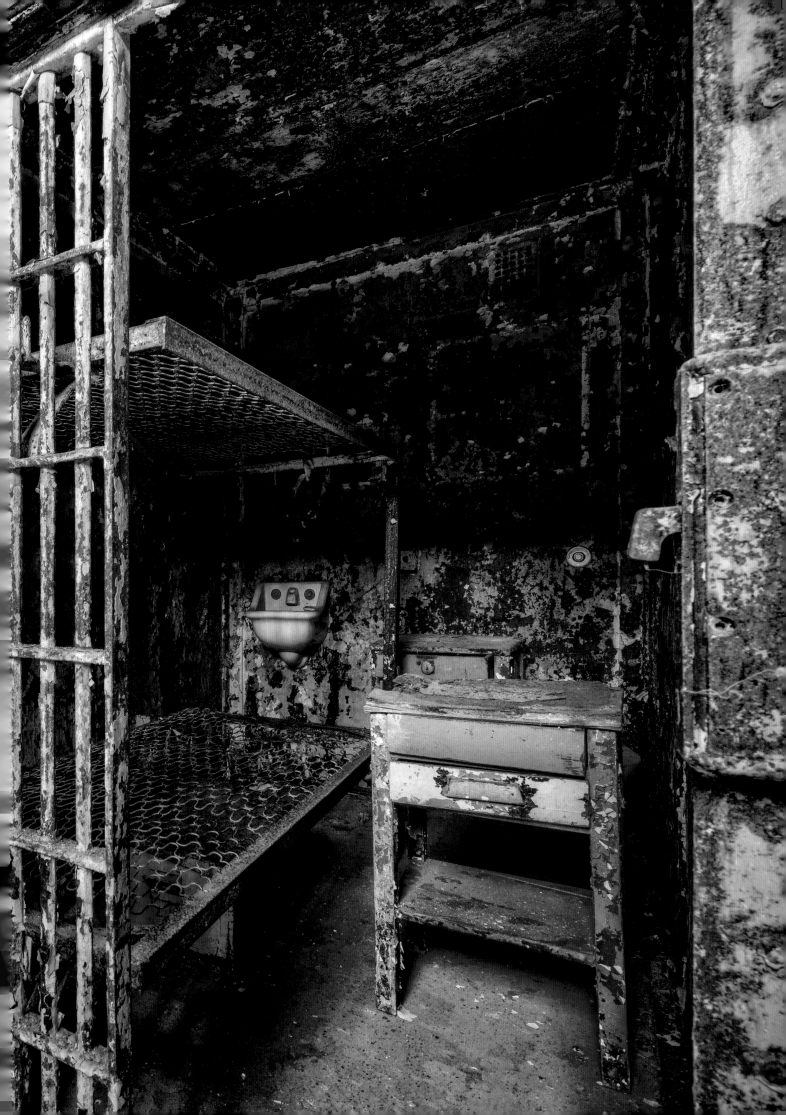

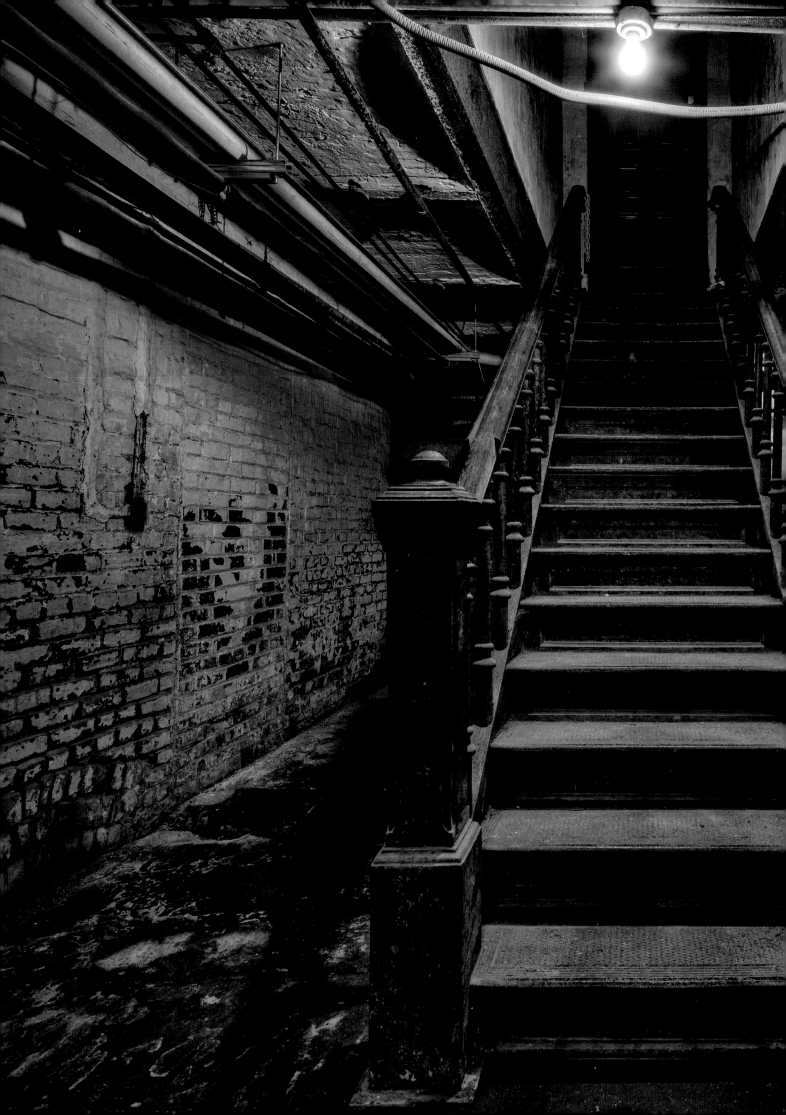

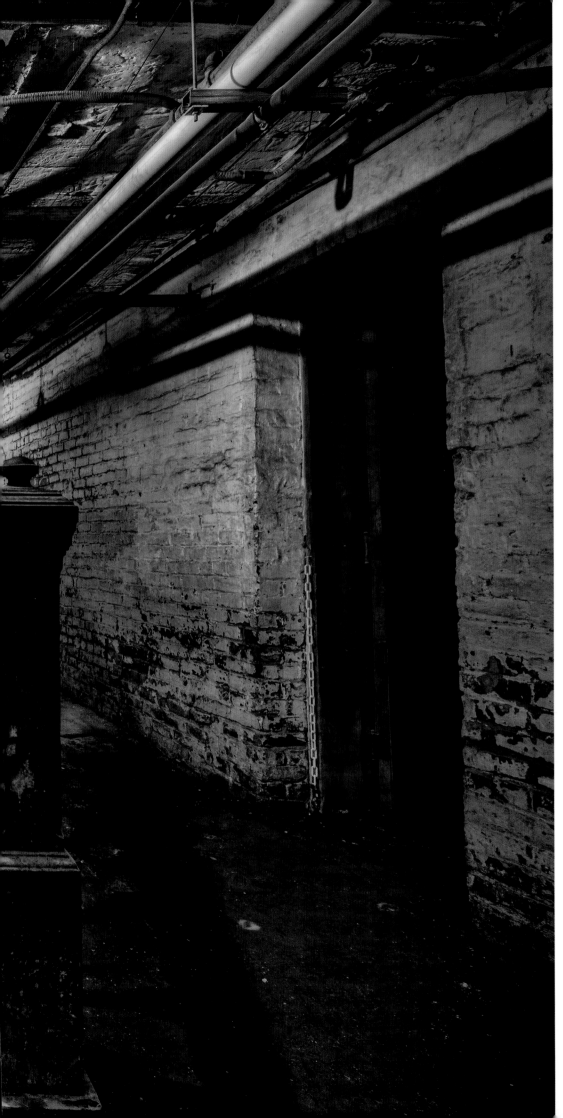

PREVIOUS PAGE:
Ohio State Reformatory, Mansfield, Ohio, USA
Originally intended as a place to reform young boys before they became criminals, the Reformatory building was converted to a prison in the early 20th century before closing in 1990. Although no executions were held here, a number of inmates were unlawfully killed. Various movies were filmed here, including *Tango and Cash* and *The Shawshank Redemption*.

LEFT:
Basement Staircase, Ohio State Reformatory, Mansfield, Ohio, USA
Helen, a warden's wife in the 1950s, accidentally shot herself with her husband's gun, and her spirit is said to haunt the old warden's office. Visitors to the cell blocks have felt strong forces pushing them, while the figure of a young man has been sighted running away from anyone entering the basement.

OVERLEAF:
Pennhurst State School, Spring City, Pennsylvania, USA
Opened in 1908 as the 'Pennhurst Home for the Feeble Minded and Epileptic', it was finally closed in the 1980s after a journalist investigated the school's practices. Visitors to the site have seen a 'Little Girl', as well as other supernatural phenomena.

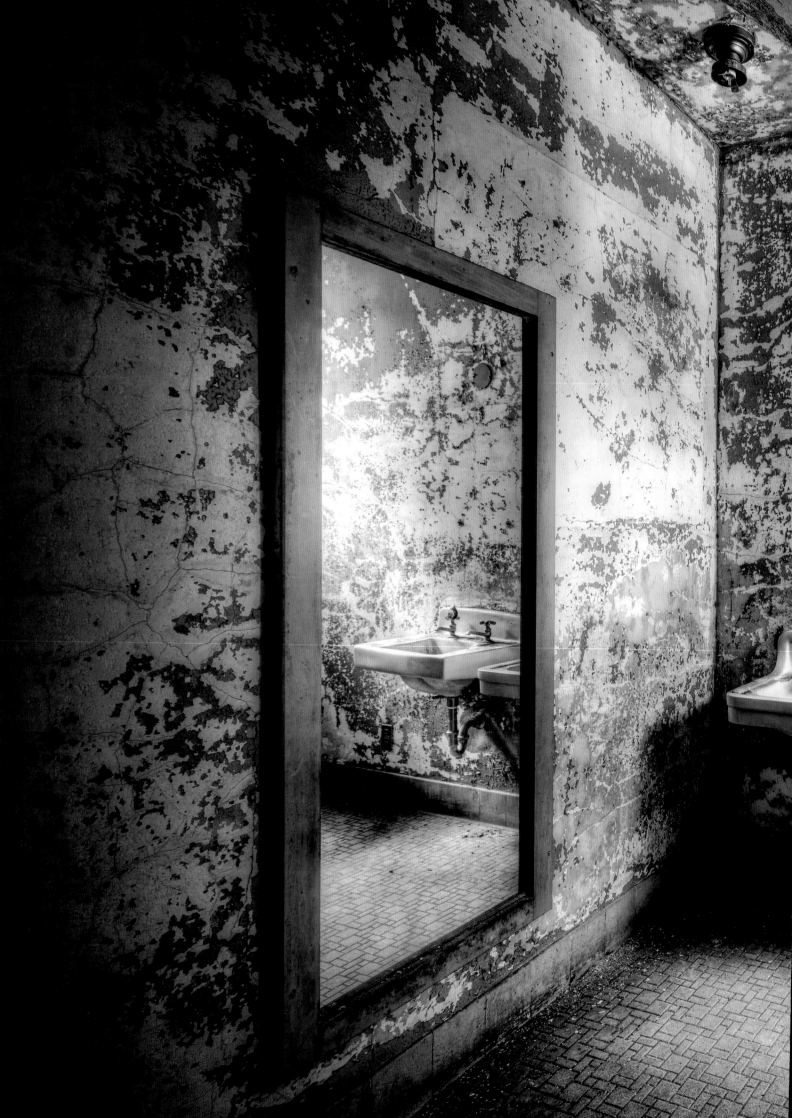

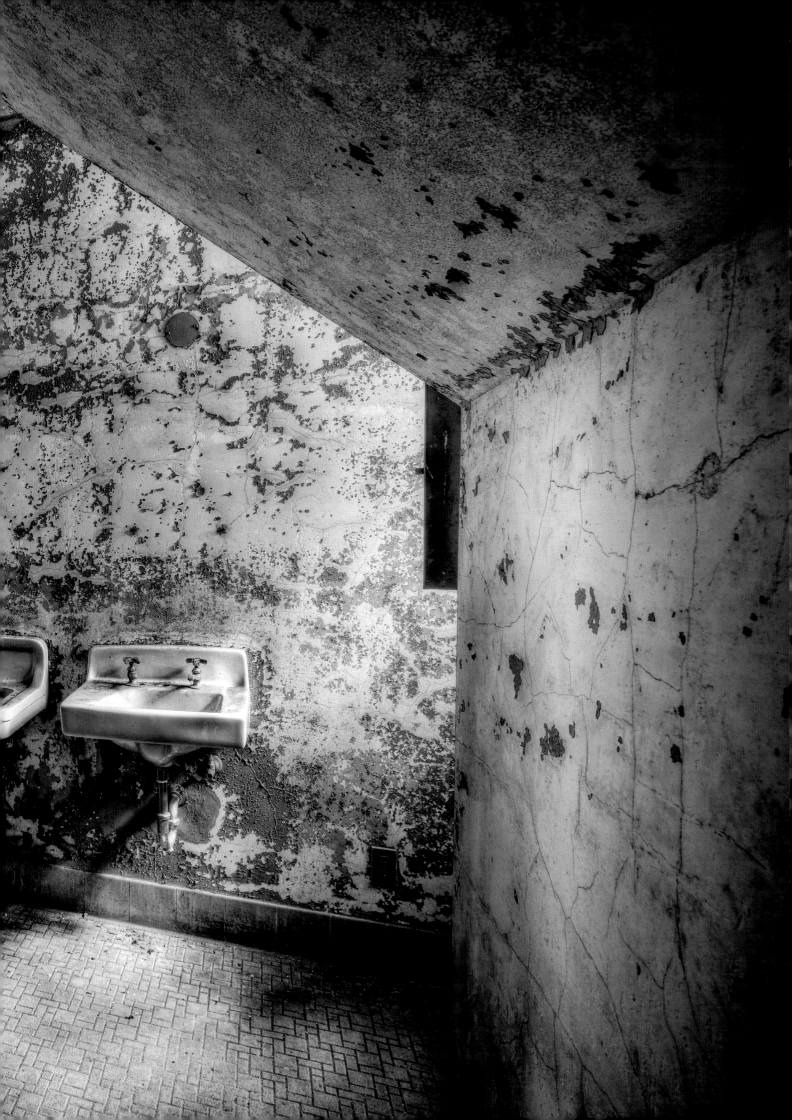

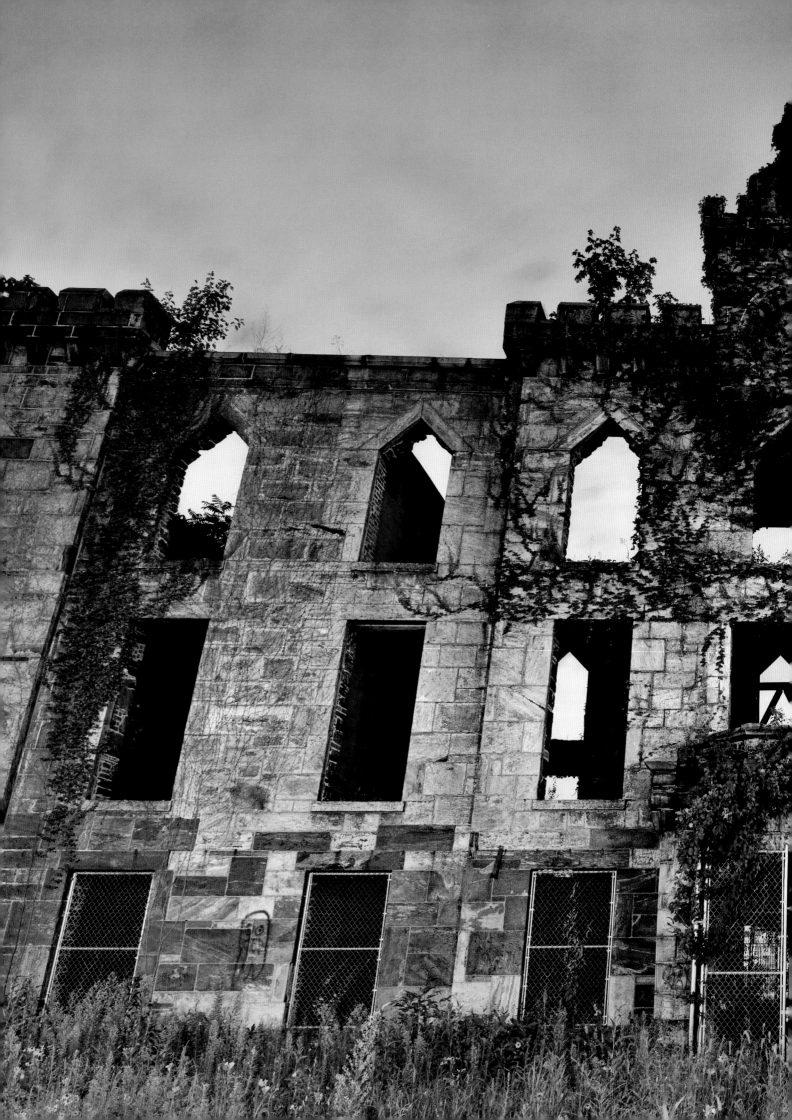

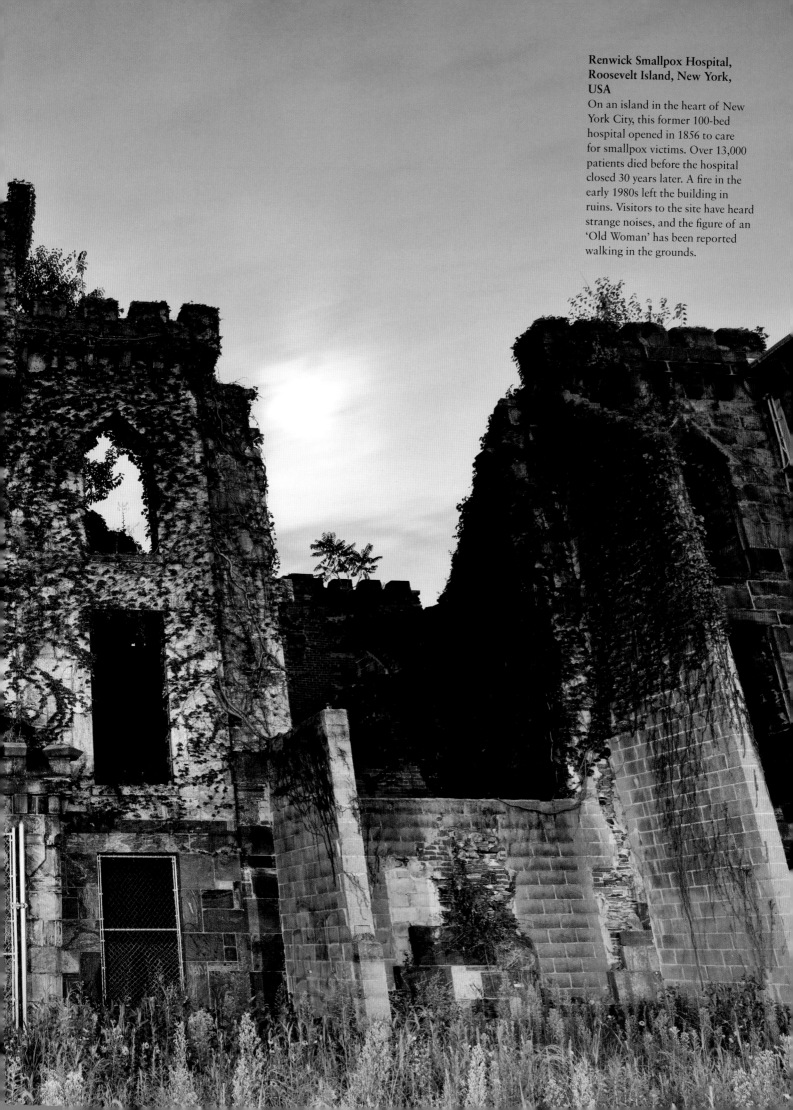

Renwick Smallpox Hospital, Roosevelt Island, New York, USA

On an island in the heart of New York City, this former 100-bed hospital opened in 1856 to care for smallpox victims. Over 13,000 patients died before the hospital closed 30 years later. A fire in the early 1980s left the building in ruins. Visitors to the site have heard strange noises, and the figure of an 'Old Woman' has been reported walking in the grounds.

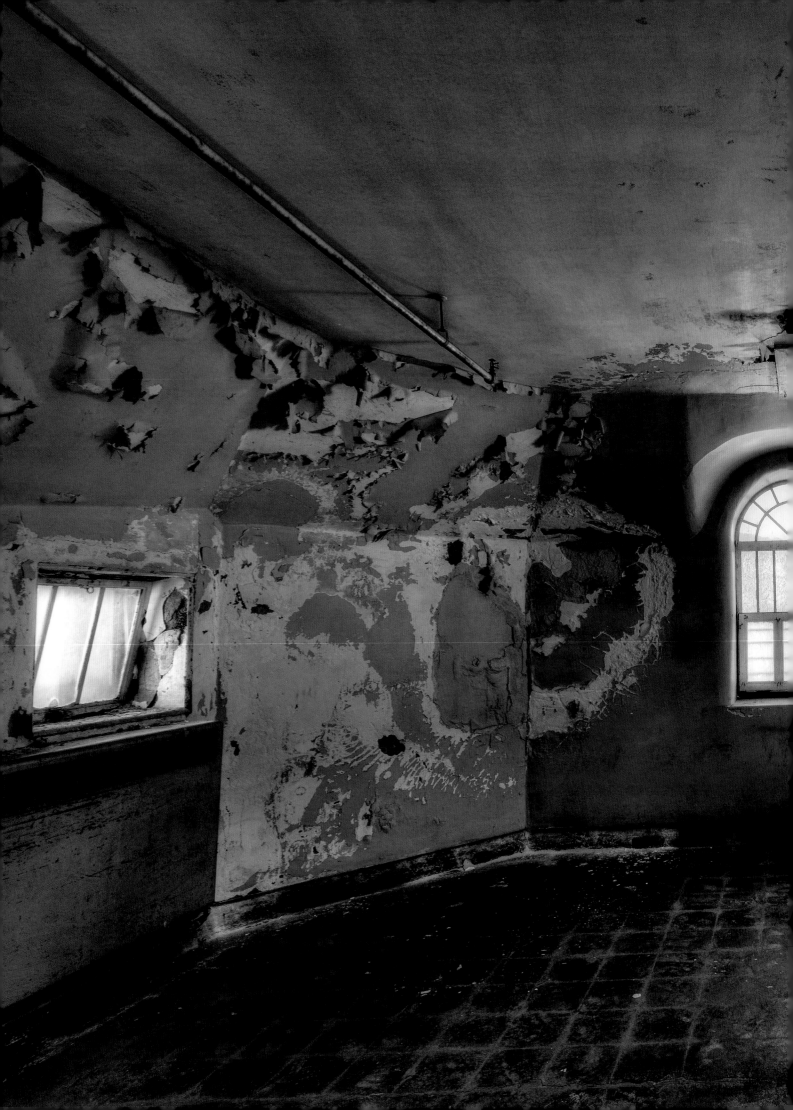

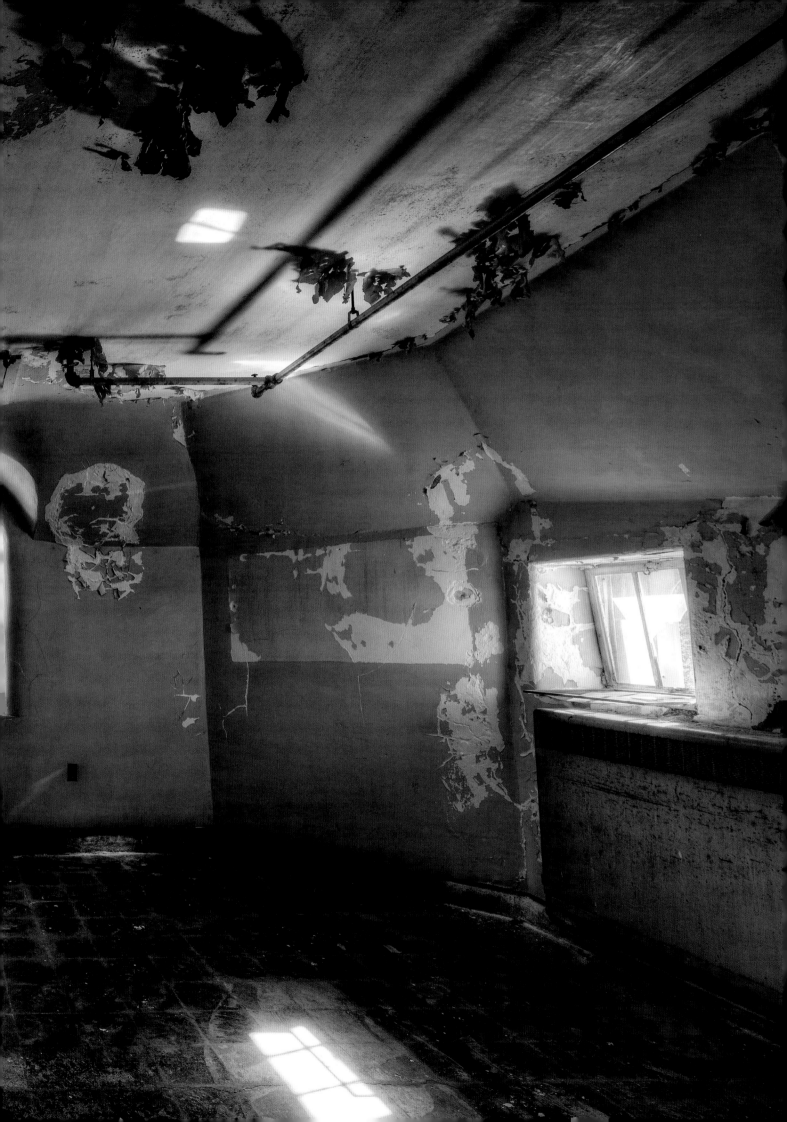

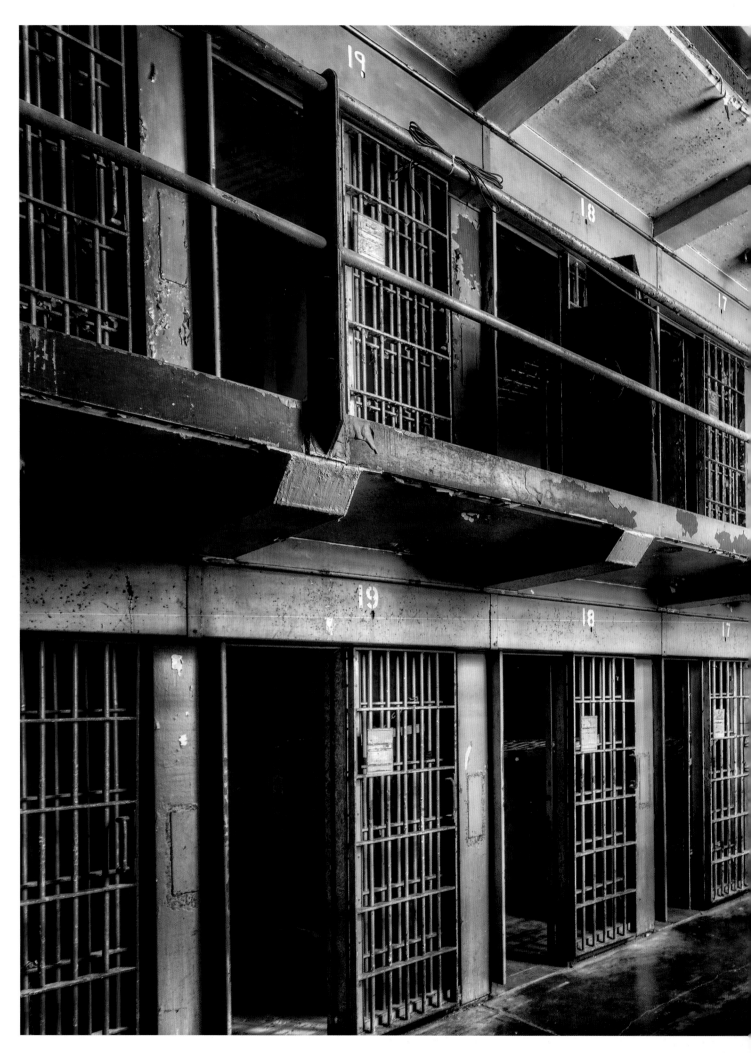

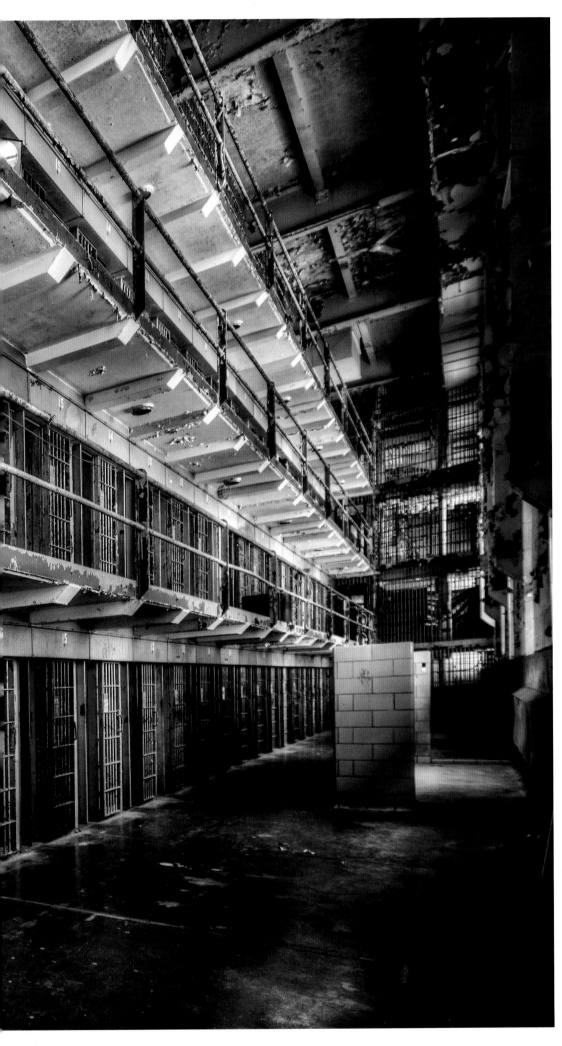

PREVIOUS PAGE:
Trans-Allegheny Asylum, West Virginia, USA
Opened in 1861 to improve the treatment of the mentally ill, almost 2,500 patients were housed in conditions designed for only 250 people. Many died in appalling circumstances – some of them murdered by other patients – before the asylum's closure in 1994. Many visitors have heard a number of unexplained noises including laughter, and a spirit called 'Jacob' allegedly calls the Civil War Wing his home.

LEFT:
Main Cell Block, West Virginia State Penitentiary, USA
Built in 1866, like many of the institutions of its time the building was quickly filled to overcapacity, with conditions for the inmates rapidly deteriorating. As well as the many executions carried out on site by hanging or electric chair, those incarcerated risked death from other violent prisoners, riots and disease.

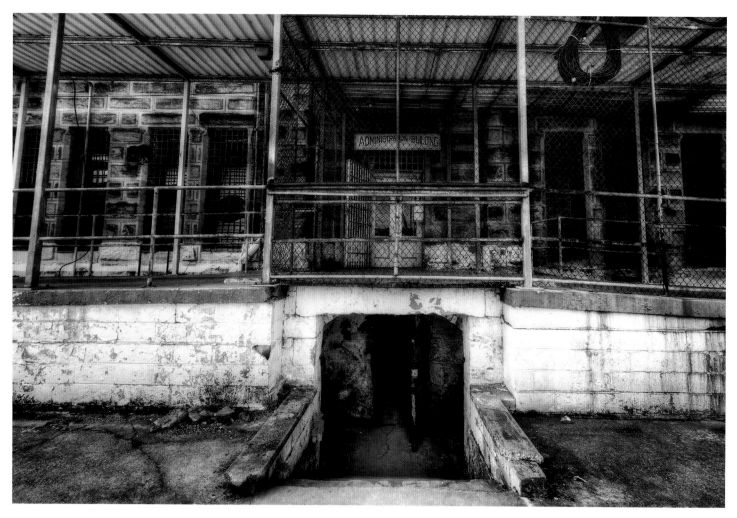

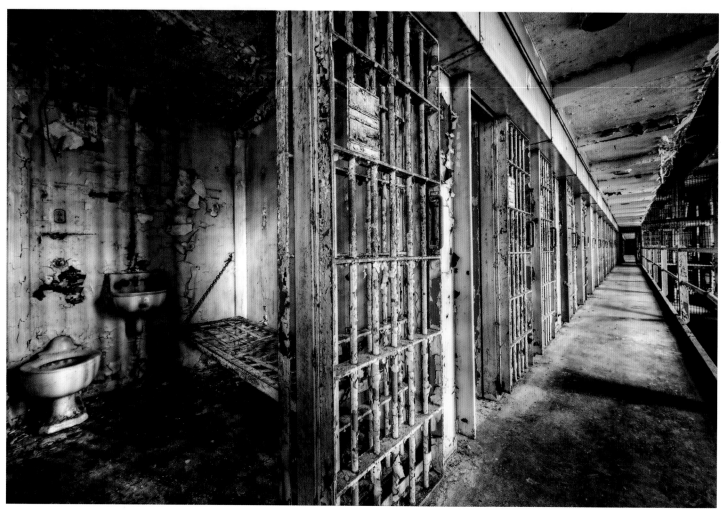

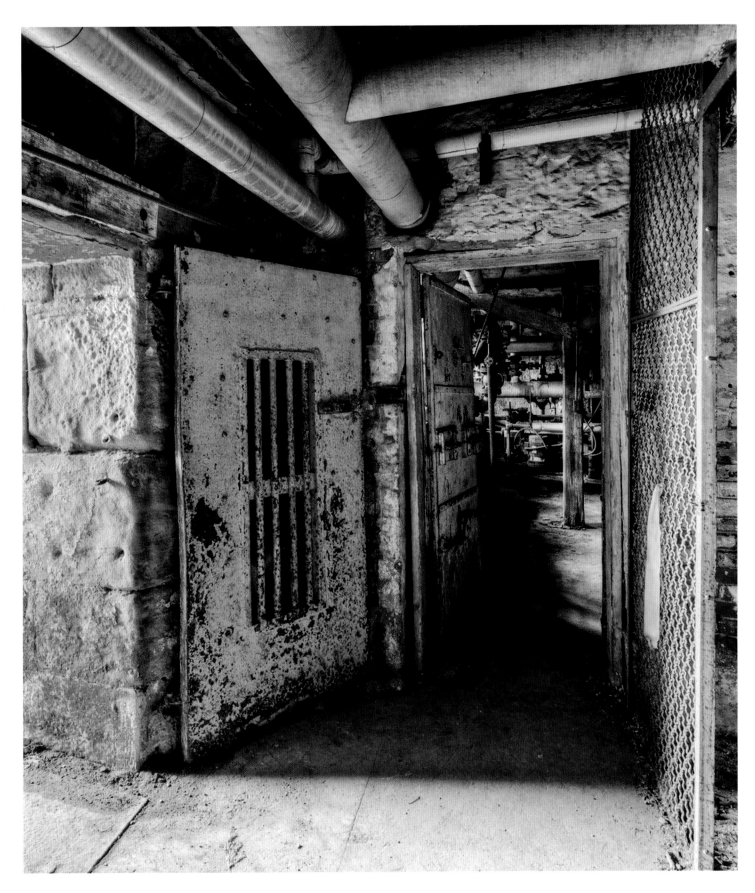

OPPOSITE TOP:

Interior, West Virginia State Penitentiary, USA

The prison closed in 1995, but its reputation as a haunted site had been established long before. The most frequent sighting is that of the 'Maintenance Man', killed by inmates because he informed on them to the prison guards.

OPPOSITE BELOW:

Interior, West Virginia State Penitentiary, USA

'Inmate Roberts' was the victim of a guards' beating in the 19th century that went too far. Roberts' remains were supposedly hidden behind a wall, and he haunts the room where he was killed.

ABOVE:

Maximum-Security Wing, West Virginia State Penitentiary, USA

The spirit of 'Avril Adkins' haunts the gallows where he was hanged, but the rope snapped and he fell to the bottom of the gallows, injuring his head badly. Undeterred by this, the guards promptly hanged him again, this time successfully.

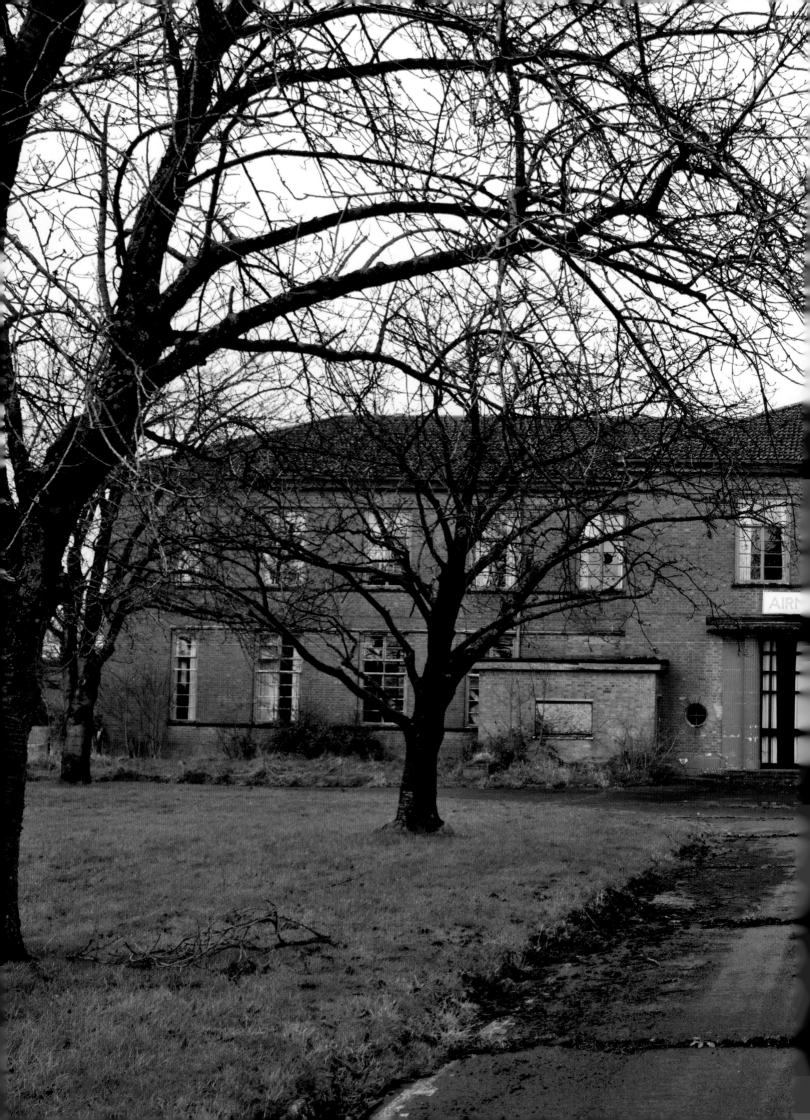

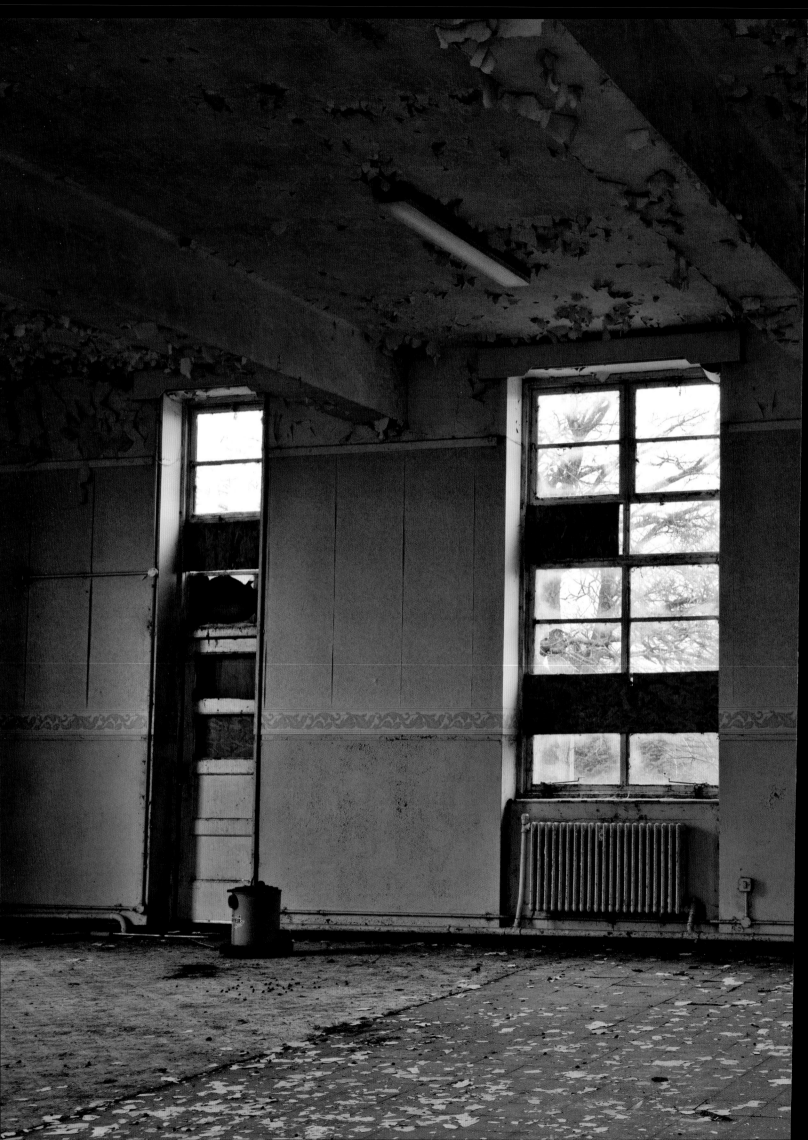

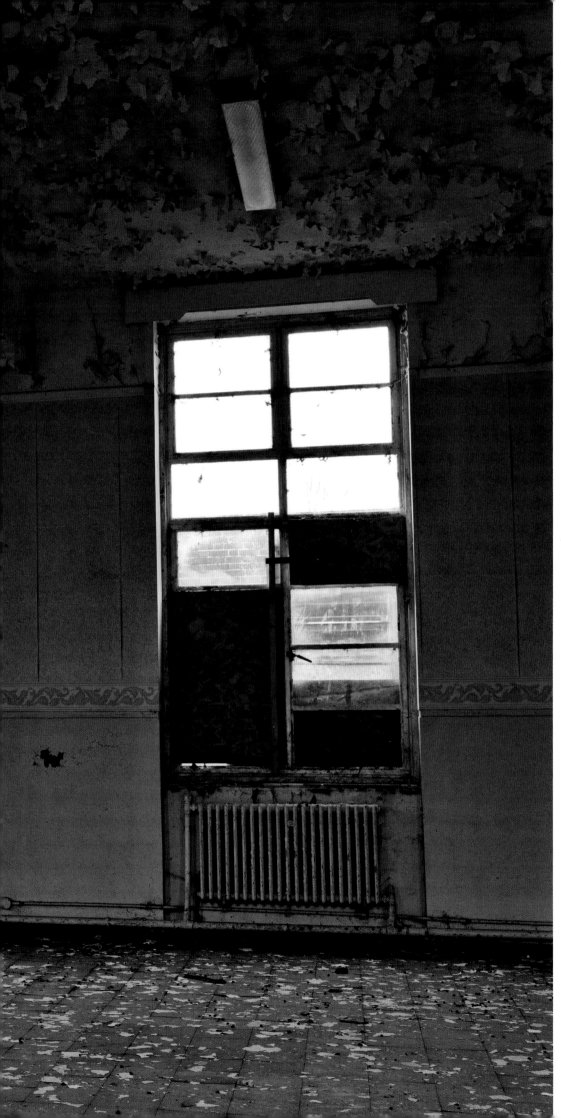

PREVIOUS PAGE:

Restaurant, RAF West Raynham, Norfolk, UK

An active RAF Bomber Command base during World War II, the station was closed in 1996 and has been left abandoned, but it has gained a reputation for being extremely haunted. One malevolent spirit, a 'Black Shadow', is found in the chapel, and is thought to be a murder victim.

LEFT:

Interior, RAF West Raynham, Norfolk, UK

The wife of an American officer stationed at the base had the spirit of a 'Polish Pilot' from World War II walk right through her and disappear through a wall. A 'Mechanic' who committed suicide in the armoury has been seen hanging from the building's rafters. Other visitors have seen strange lights on the base, and have reported strange noises from the base's former hospital.

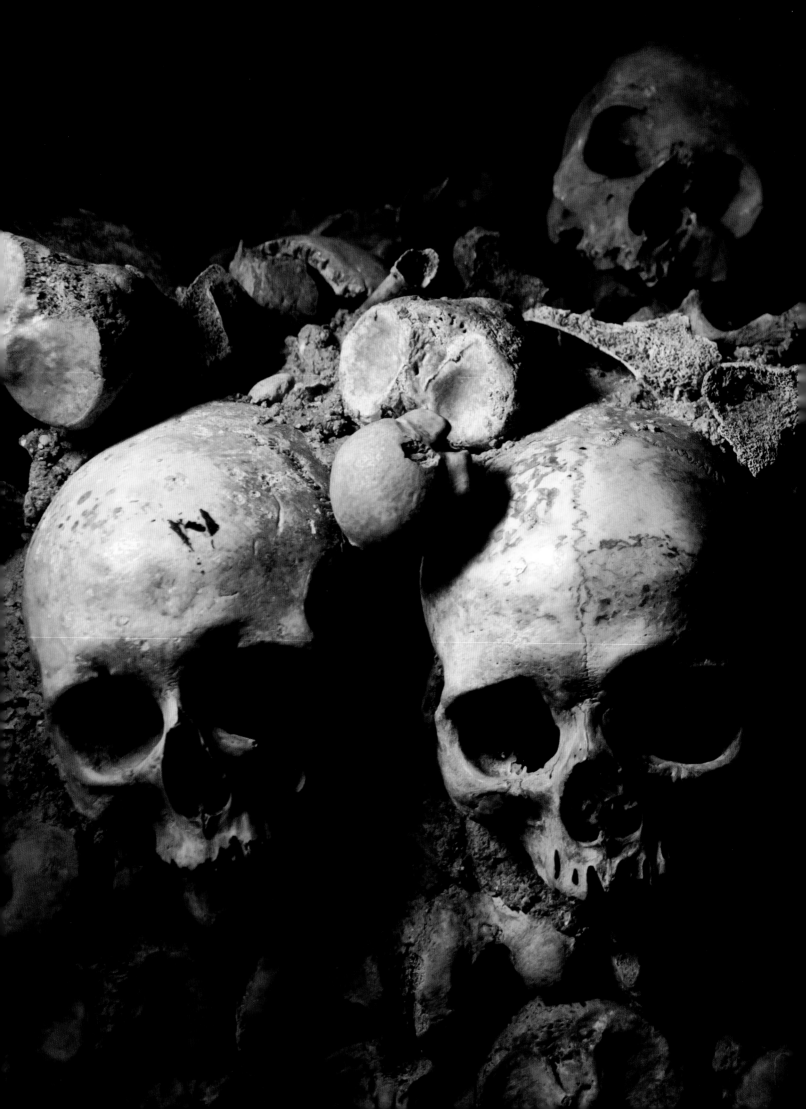

Religious Places

Where the divine is thought to be present, visions are often common. Sites such as churches and former monasteries that resonate with spirituality can act as lightning rods for unusual visions, so a neutral observer could argue that individuals might be predisposed to see and hear events and occurrences of a supernatural kind. Many religious places are also surrounded by or contain the resting places of the dead, so that death and the afterlife are never far from the thoughts of those who visit. In some locations shown in this chapter, the bones of the dead themselves provide decoration for the sites in question, where the bones of the poor or the long-ago buried have been used to create patterns or symbols that attract tourists and the curious. As cultures and beliefs have changed over time, so some of the sites that were once significant and thriving communities are now left as ruins, stripped of their treasures and allowed to decay, abandoned and neglected. So it is unsurprising, perhaps, that churches and monasteries should provide so many examples of sightings and unusual phenomena, particularly hooded monks or mysterious shadowy figures prowling the grounds. Perhaps the energies of these long-departed penitents pervade the stones and they re-enact their daily rituals still...

LEFT:
Skulls, Catacombs, Paris, France
The catacombs of Paris hold the remains of countless millions of the dead, shovelled into the former quarries under the streets of Paris when the old cemeteries could no longer cope. Access is now only permitted by tour, and many visitors have reported sightings, unexplained noises and temperature changes while visiting the limestone tunnels.

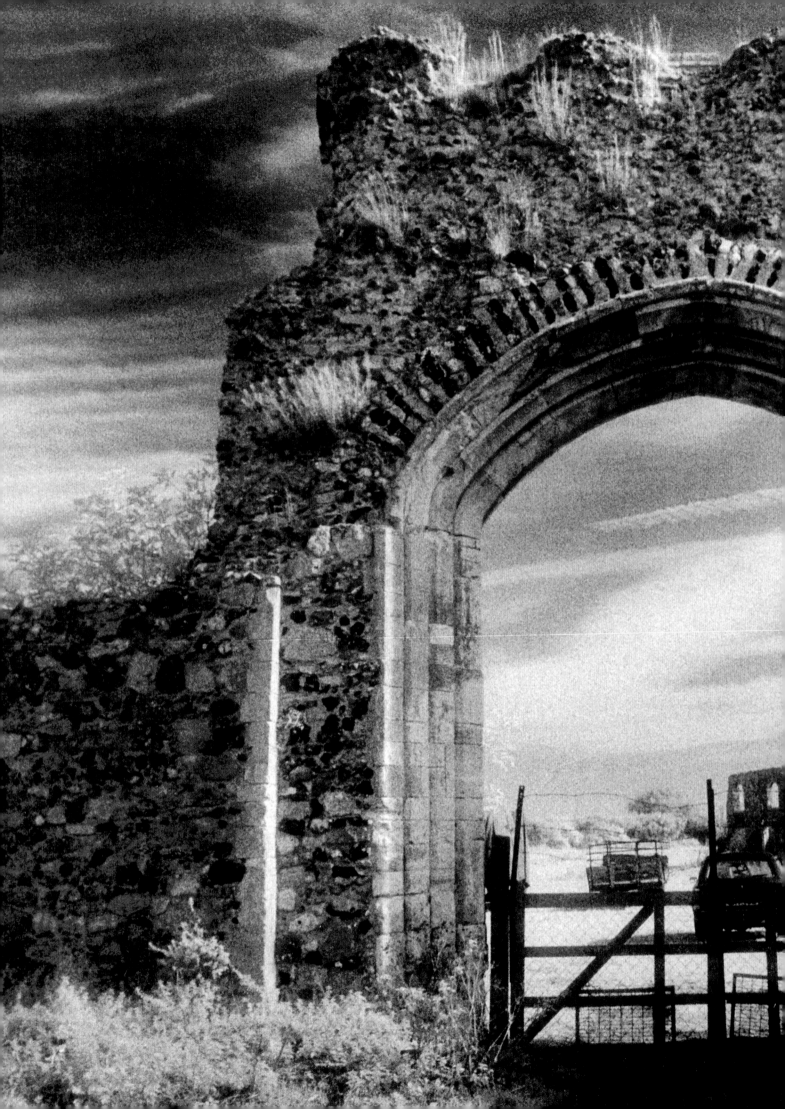

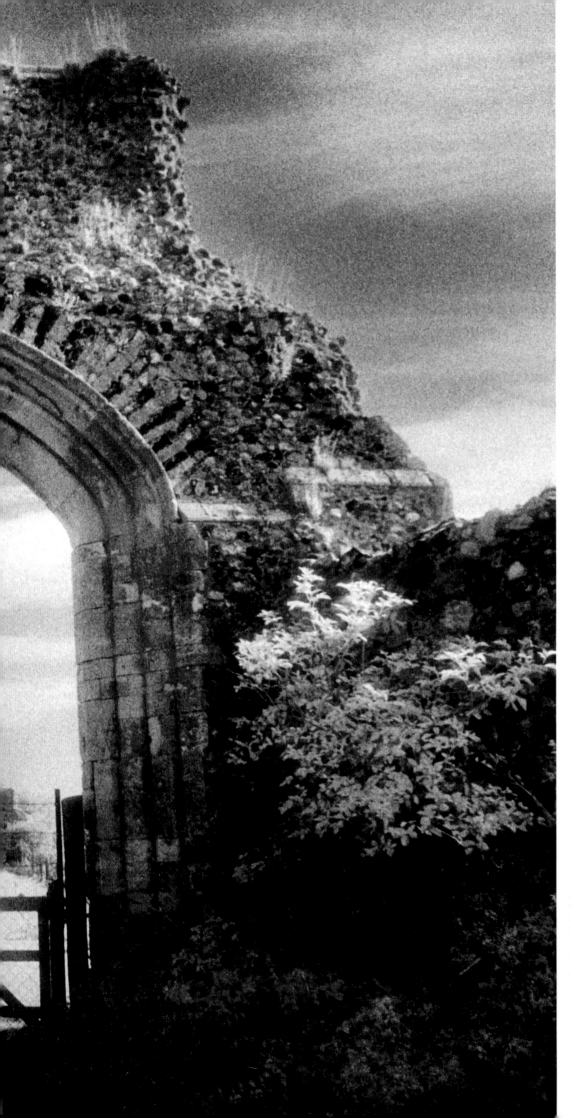

Entrance, Greyfriars Priory, Dunwich, UK
Little remains of the old medieval port of Dunwich, most of which has fallen into the sea. Locals say you can still hear the church bells tolling if the wind is blowing in the right direction. The ruins of the Greyfriars Priory still stand, and are said to be haunted by former monks who pace the boundaries of their old home.

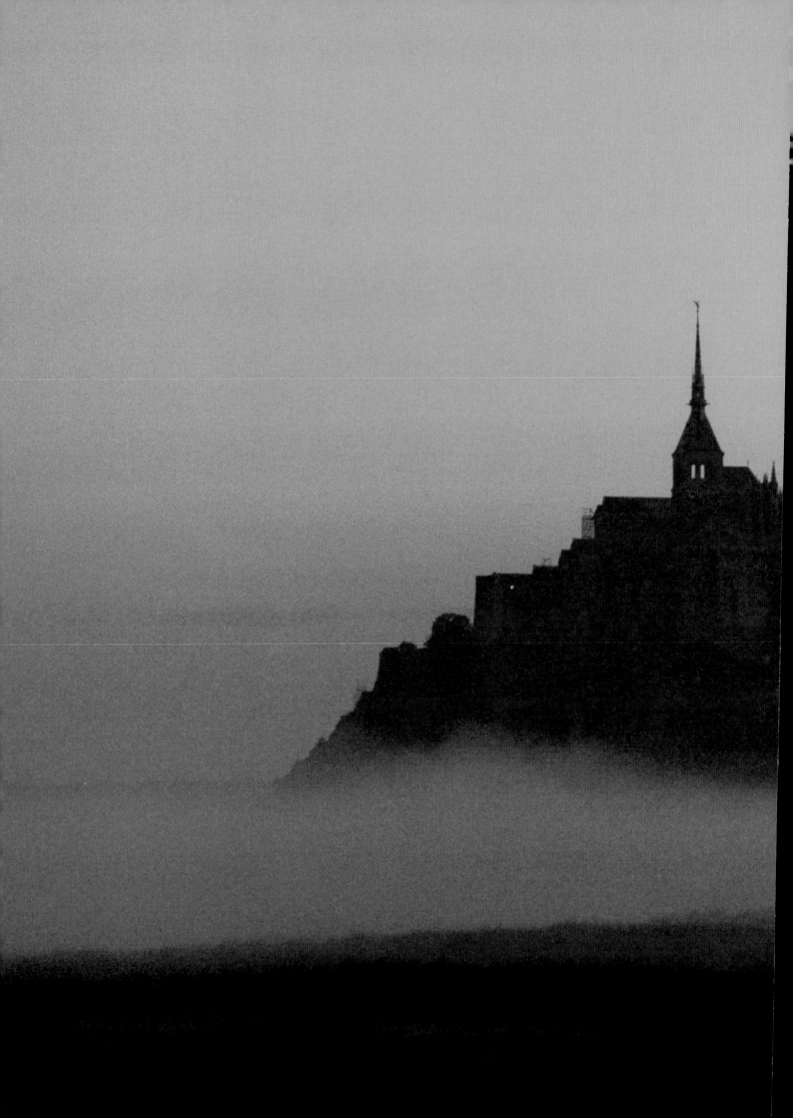

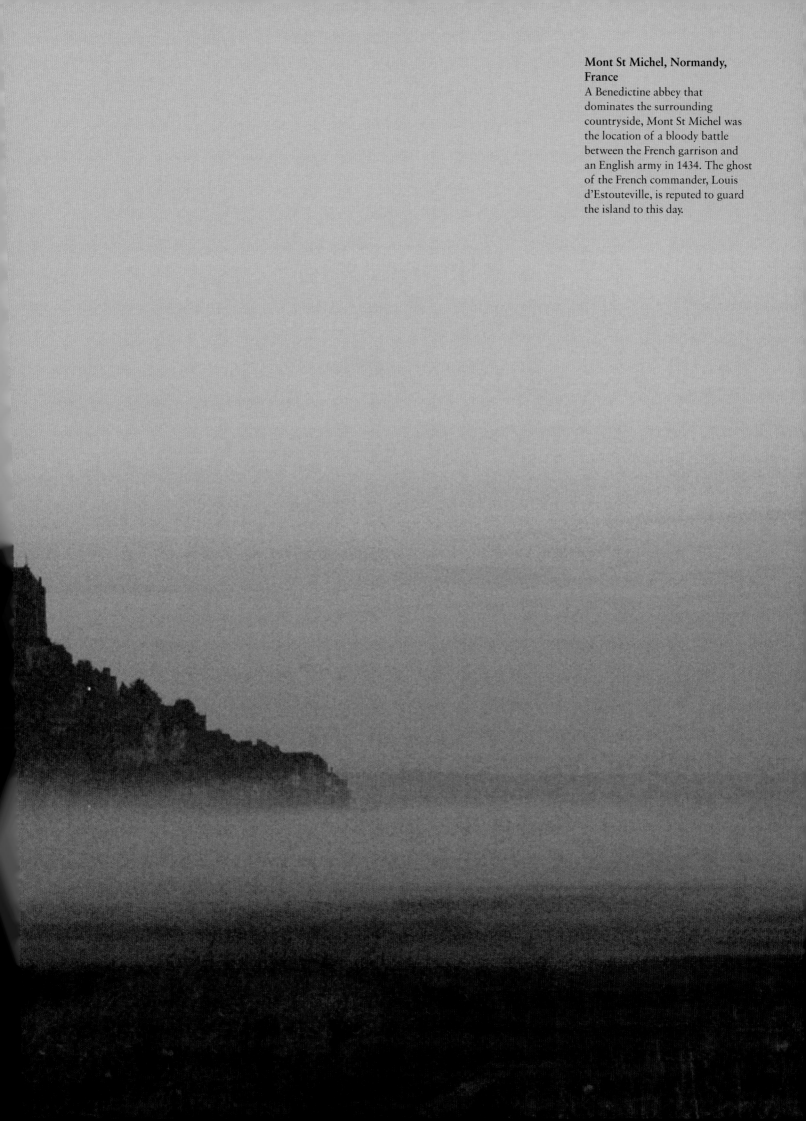

Mont St Michel, Normandy, France
A Benedictine abbey that dominates the surrounding countryside, Mont St Michel was the location of a bloody battle between the French garrison and an English army in 1434. The ghost of the French commander, Louis d'Estouteville, is reputed to guard the island to this day.

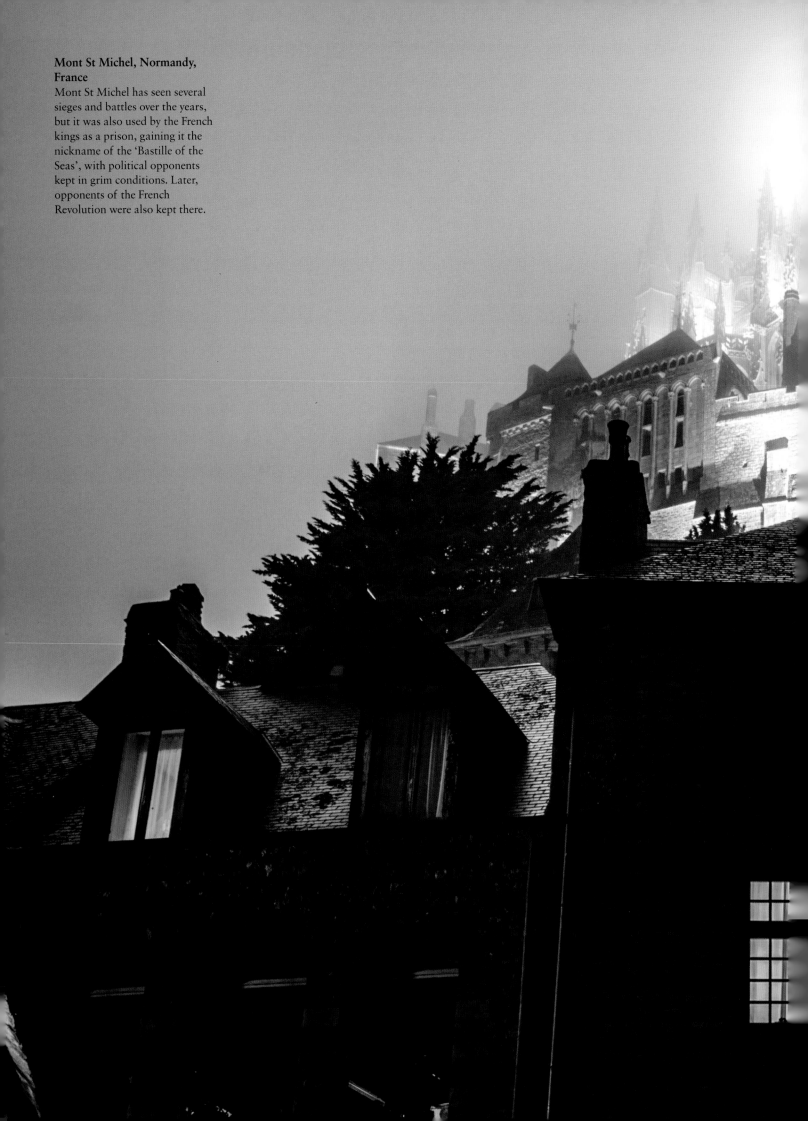

Mont St Michel, Normandy, France
Mont St Michel has seen several sieges and battles over the years, but it was also used by the French kings as a prison, gaining it the nickname of the 'Bastille of the Seas', with political opponents kept in grim conditions. Later, opponents of the French Revolution were also kept there.

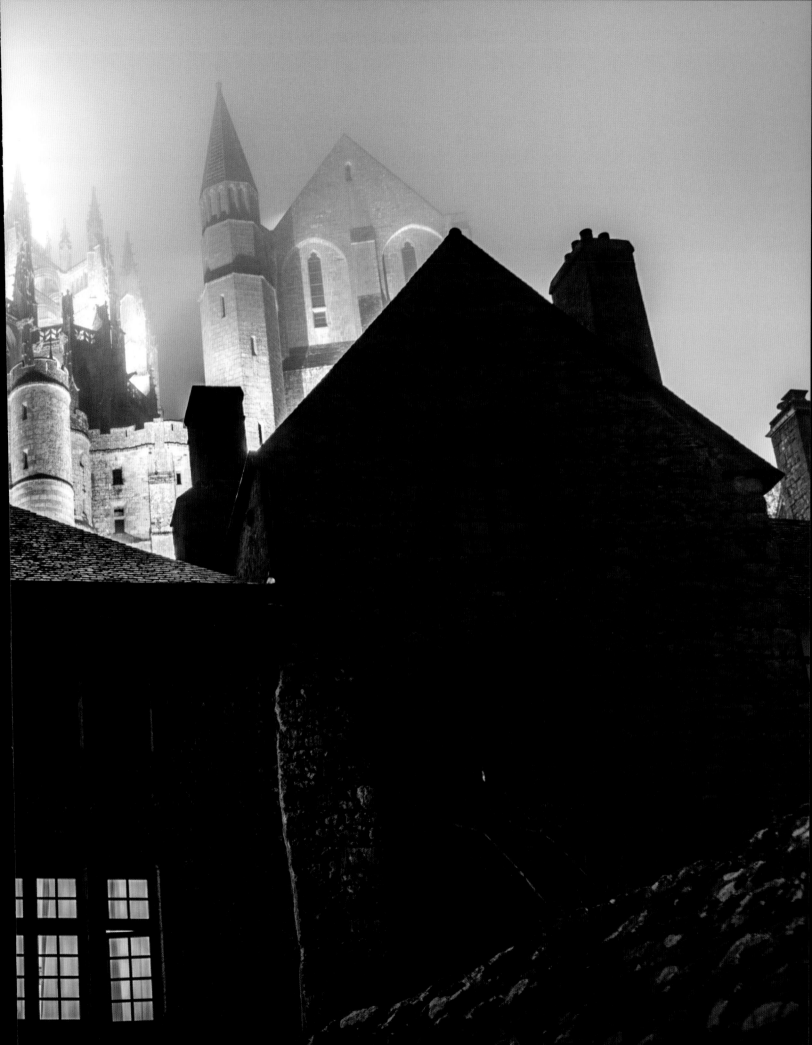

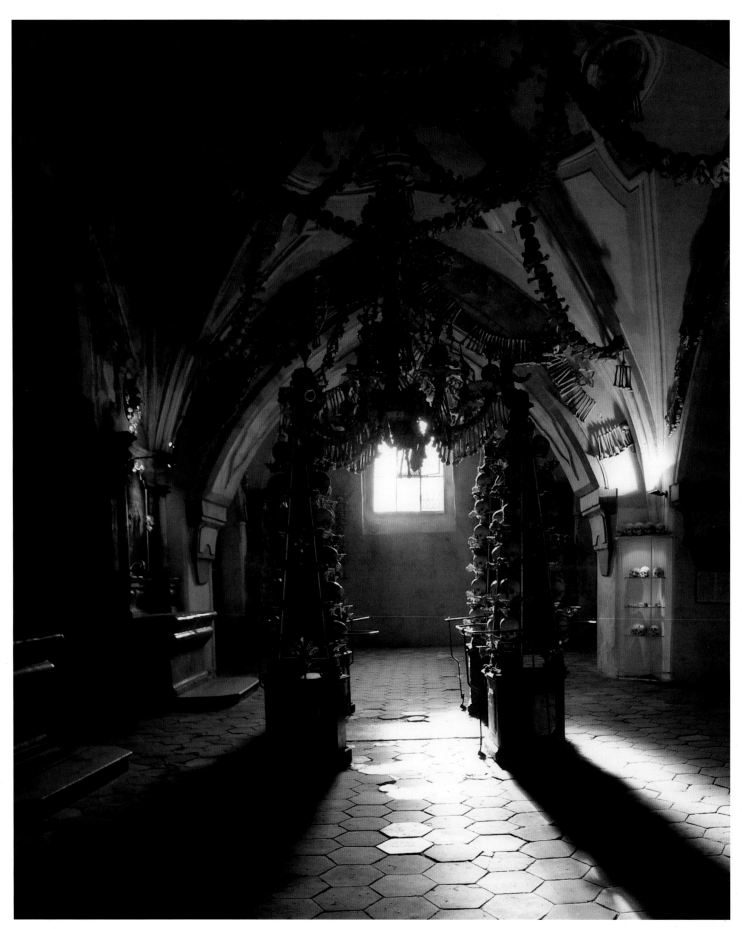

ABOVE:

Ossuary, Sedlec, Czech Republic
Sedlec became a popular burial site in Central Europe after an abbot sprinkled some soil from Golgotha (where Jesus Christ was crucified) over the chapel's graveyard in 1278.

RIGHT:

Ossuary, Sedlec, Czech Republic
Older bones in the graveyard were dug up and stored in the chapel to make room for new arrivals. These were arranged as decorations by a woodcarver in 1870.

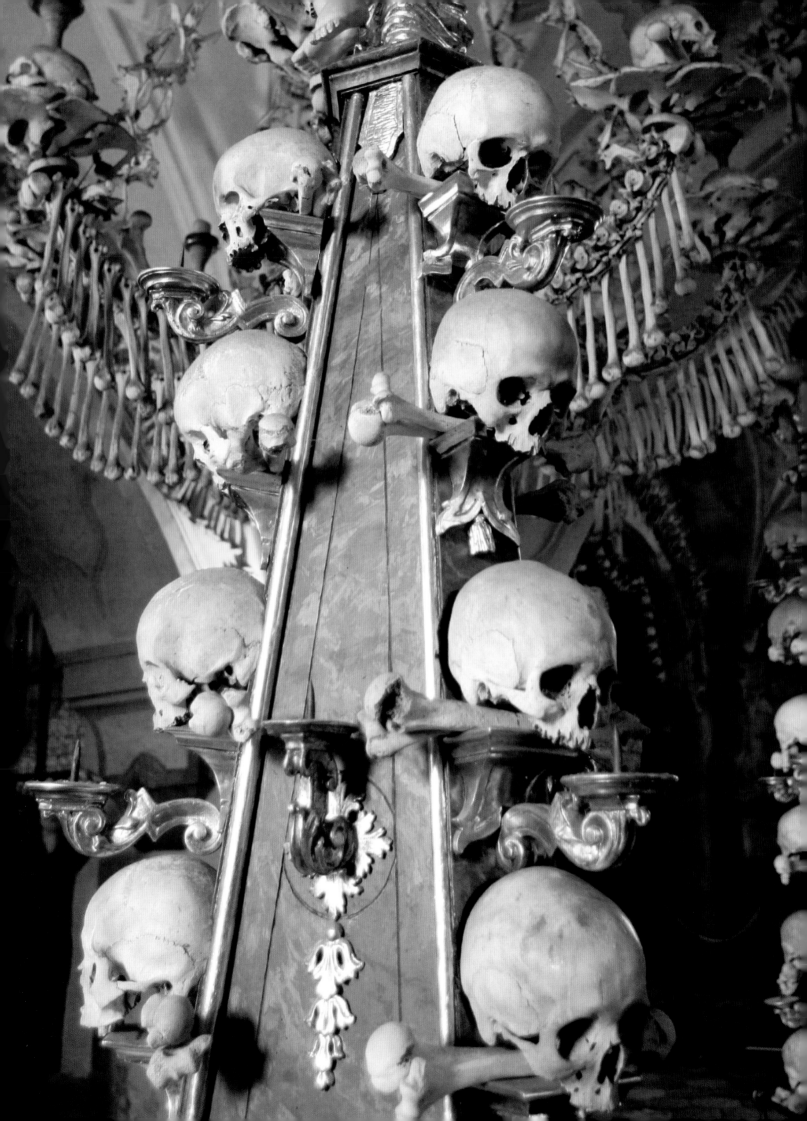

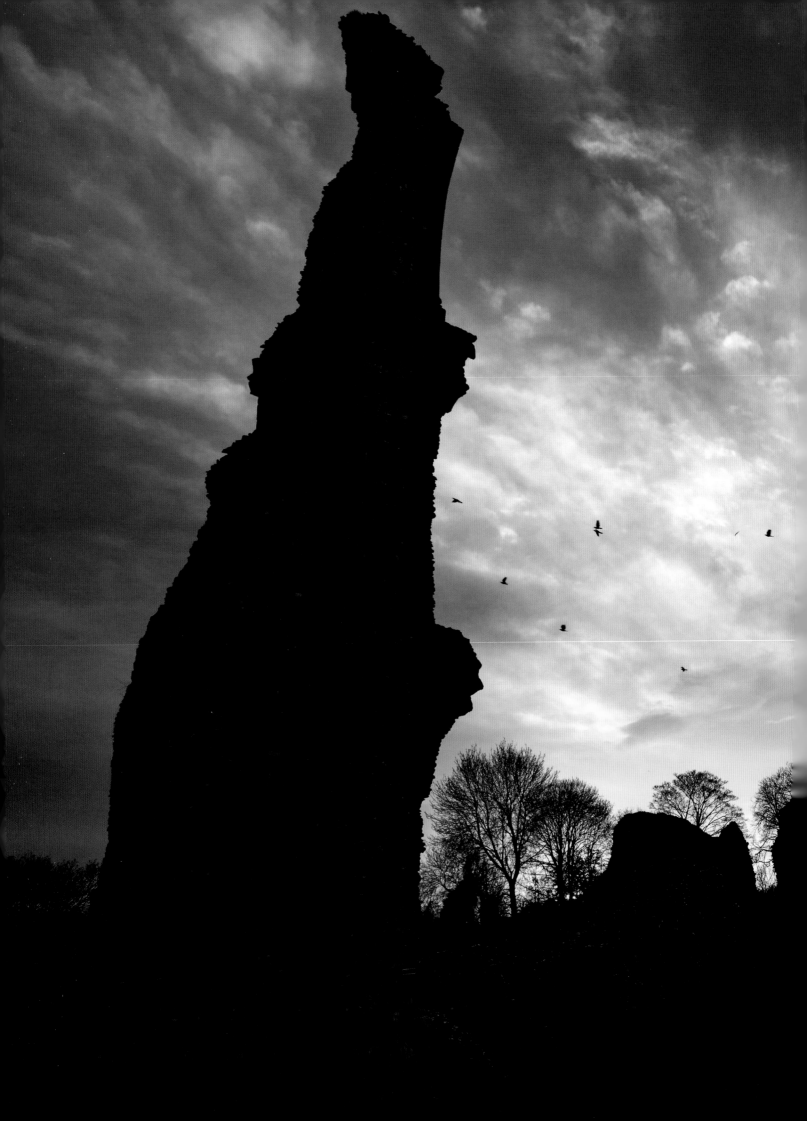

Ruins, Thetford Priory, UK
One of the many monasteries closed after the English Reformation, Thetford has become known for its sightings of monks clinking their keys and chanting in Latin, and a mysterious hooded figure dressed in black who disappears when approached.

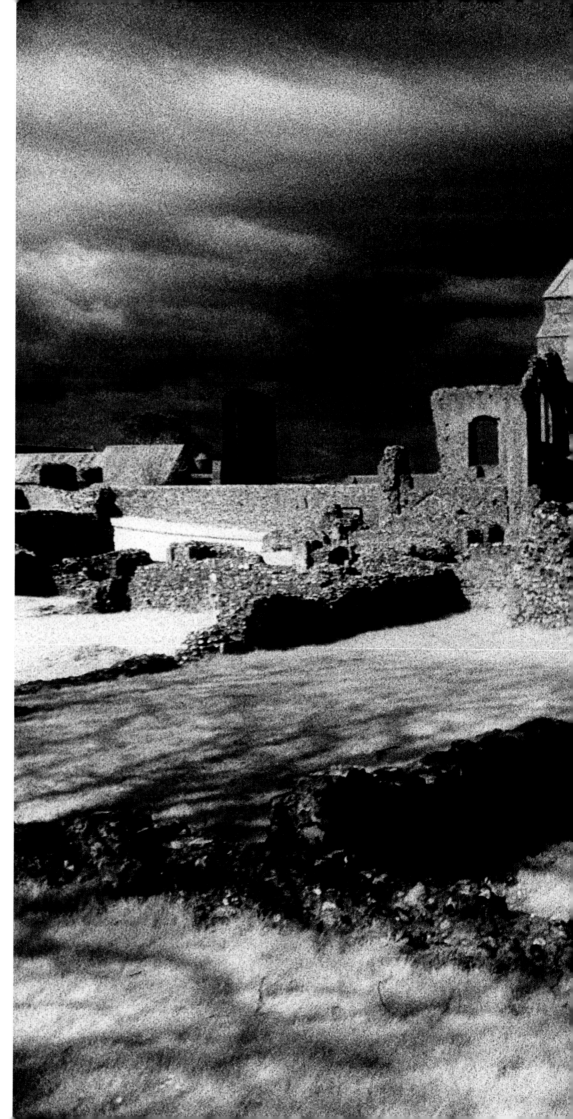

Parish Church and Ruins, Binham Priory, UK
A 'Black Monk' has been observed during services in the parish church, which stands on the site of the old monastery. An old tunnel nearby is haunted by Jimmy Griggs, a fiddler who entered the tunnel with his dog. Only the dog re-emerged, but Jimmy's fiddle can still sometimes be heard.

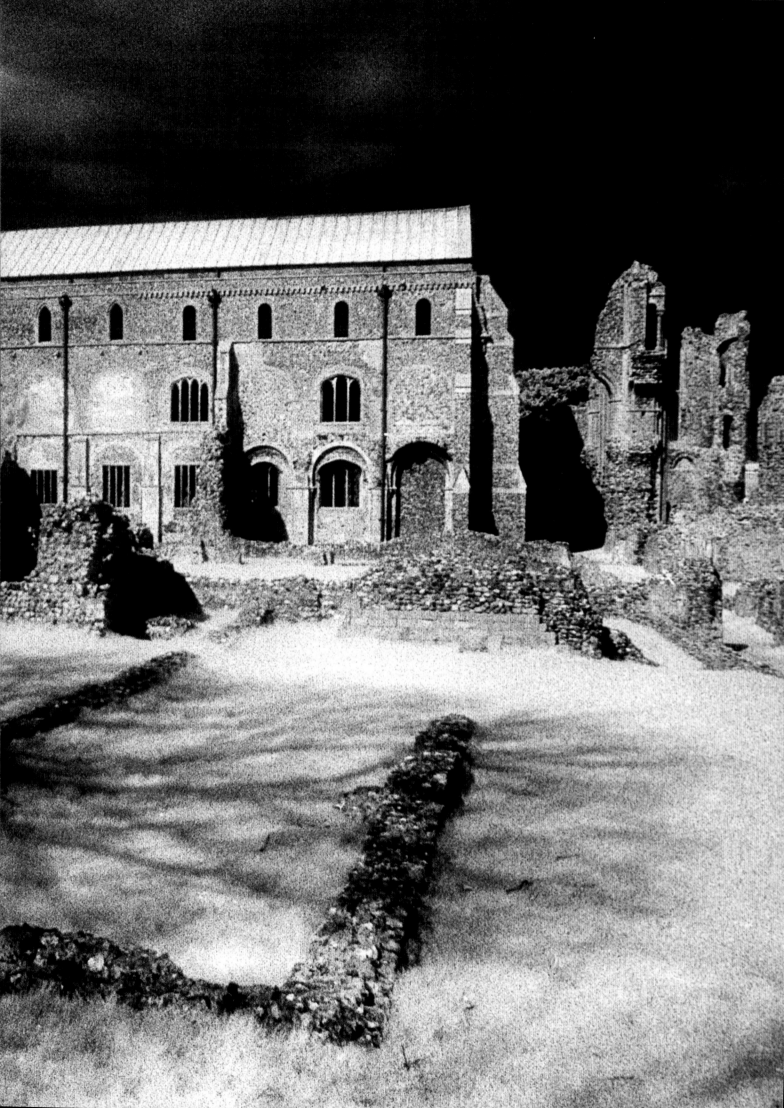

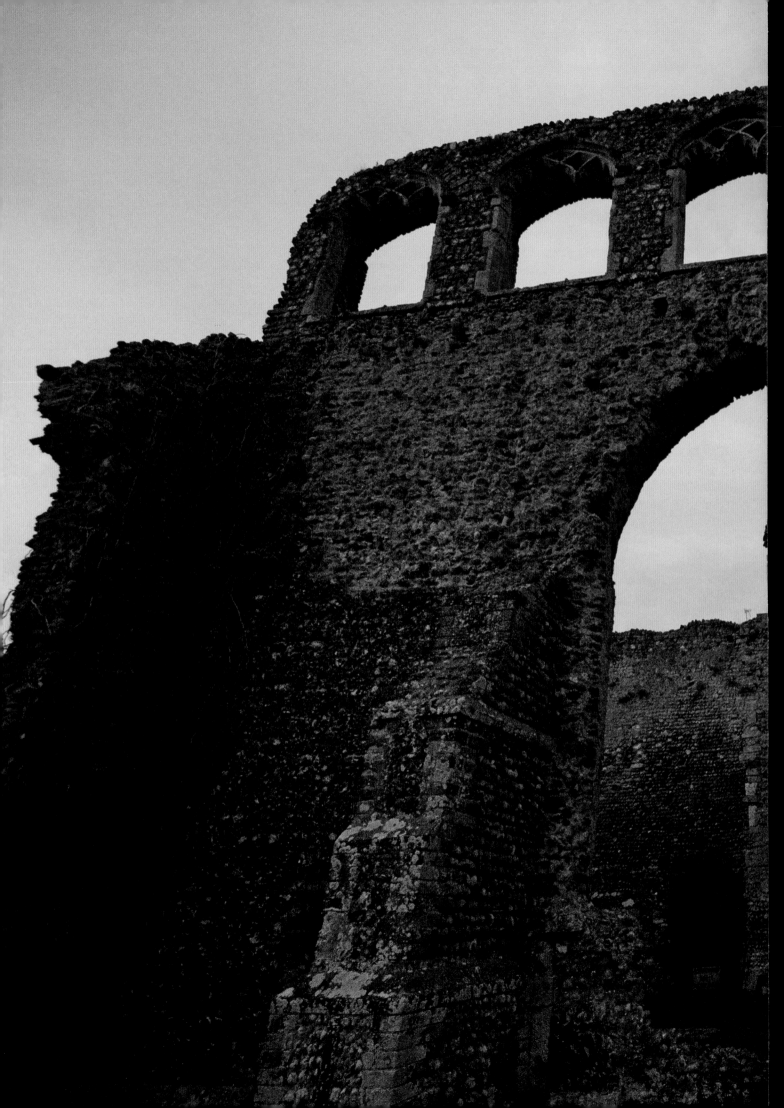

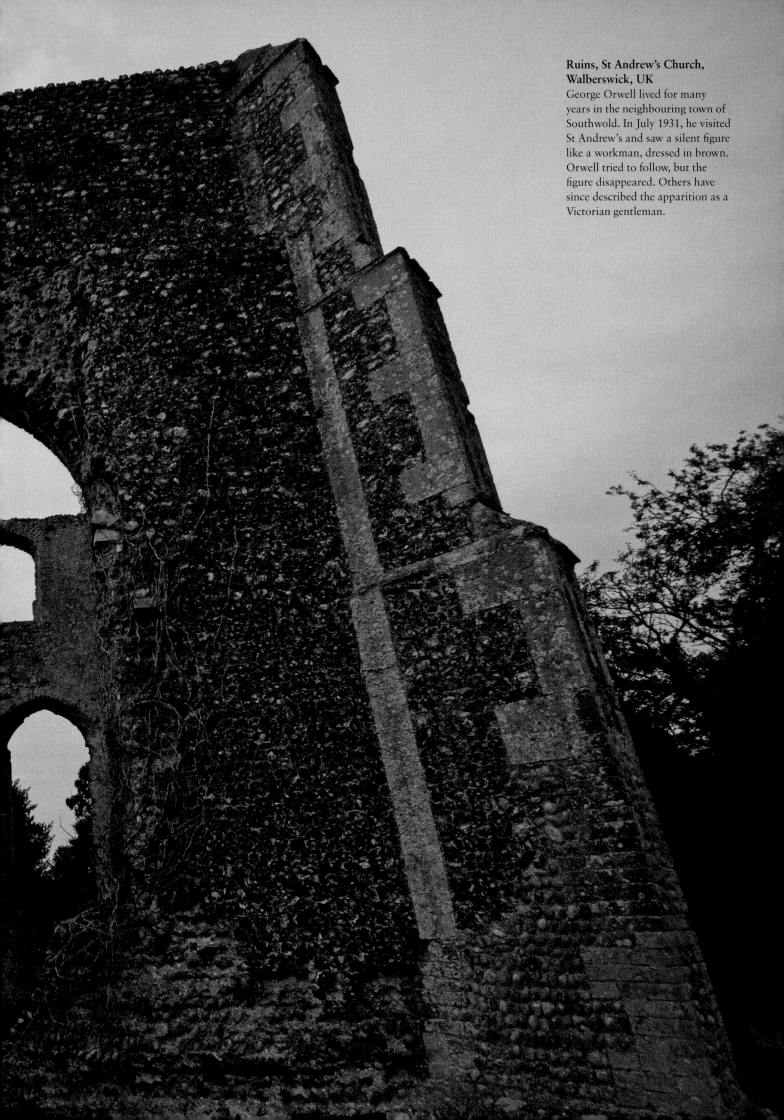

Ruins, St Andrew's Church, Walberswick, UK
George Orwell lived for many years in the neighbouring town of Southwold. In July 1931, he visited St Andrew's and saw a silent figure like a workman, dressed in brown. Orwell tried to follow, but the figure disappeared. Others have since described the apparition as a Victorian gentleman.

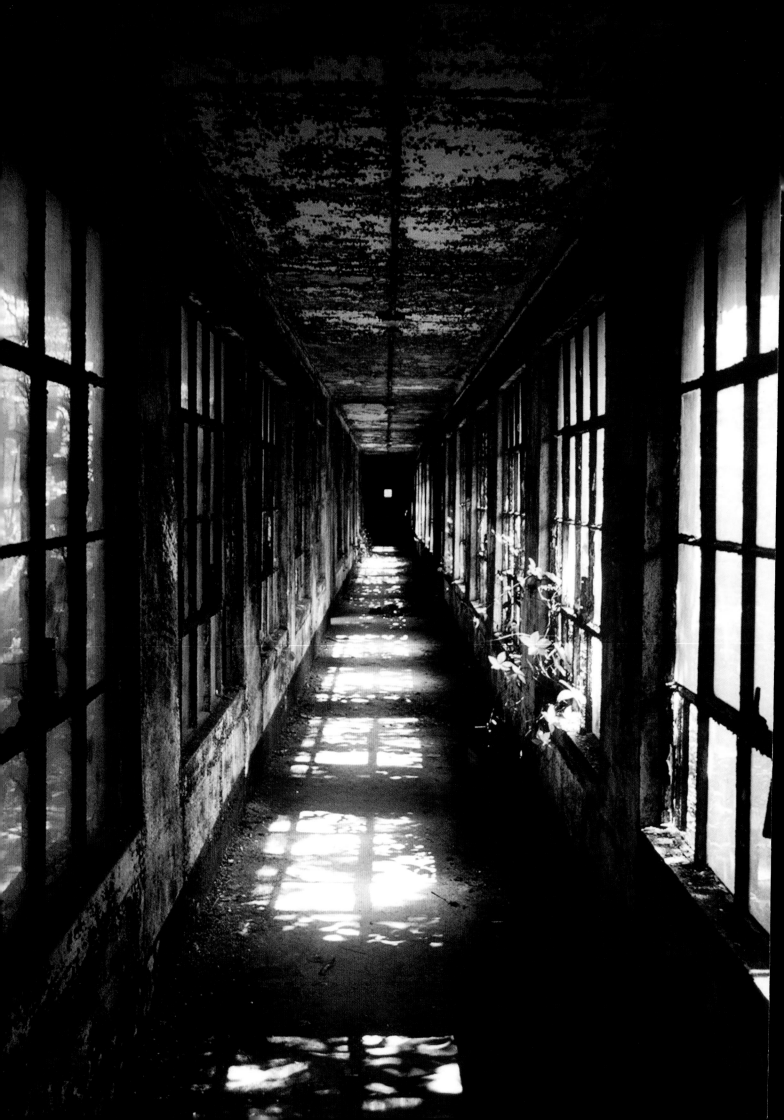

Towns, Cities & Islands

Immigration controls have been active for centuries – when the Black Plague arrived in Europe, it swept through entire communities, decimating them in weeks. The scale of the epidemics was such that bodies would pile up faster than they could be buried, with all the risk of further infection that entailed. For any survivors, the experience would have been scarring. The word 'quarantine' comes from Italian, after the Venetian practice of keeping those arriving at the city in isolation during plague years. Local legend tells that one of the islands in the Venetian lagoon used for plague burials is more human remains than soil. A similar method of controlling immigration was adopted by New York City centuries later when it established the hospital and processing centre on Ellis Island. Although the number of deaths may have been fewer and from different causes, there are still many buried on the island from those times. Islands encourage isolation, but the children's toys on the Island of the Dolls near Mexico City have brought visitors in the hope of hearing or seeing the figurines move or talk. One of the most famous events in American history is the Salem witch trials, when the Massachusetts town convinced itself of witchcraft in its midst, and innocents were killed. The spirits of those victims are said to haunt the town to this day.

LEFT:
Corridor, Ellis Island, New York, USA
In its 62 years of use, Ellis Island was the gateway to America for approximately 12 million people, but not all voyages to the 'Land of the Free' ended well. Many arrived at Ellis Island sick after their long journeys. Some 3,000 immigrants failed to recover and died in the purpose-built hospitals on the island, and some of their spirits are said to haunt the island still. Visitors have heard children's voices, and seen moving furniture.

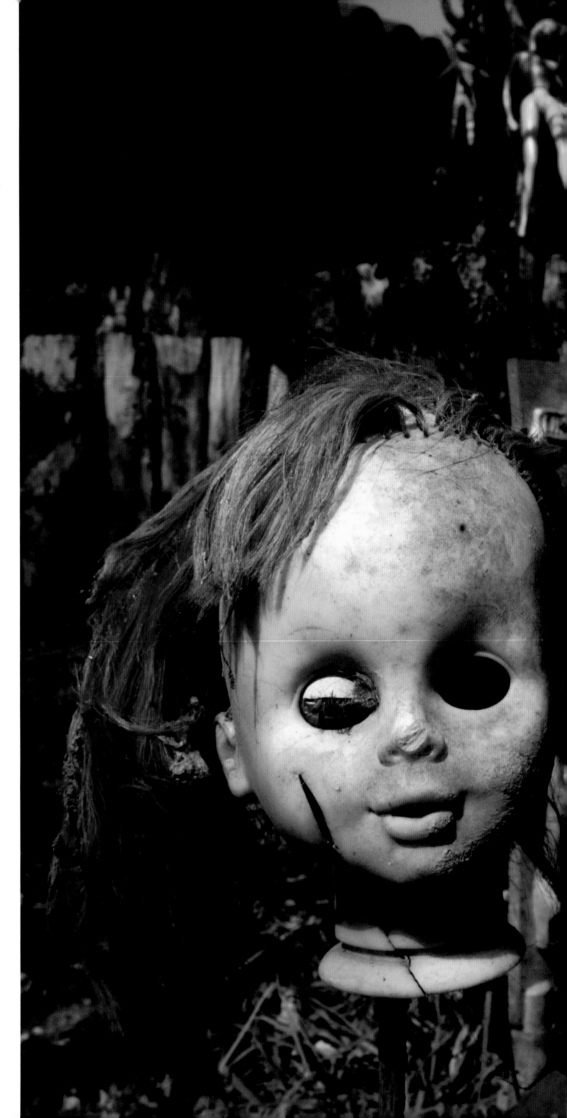

Island of the Dolls, Xochimilco, Mexico City, Mexico
Some years ago, Don Julian Santana Barrera found a young girl half-drowned in mysterious circumstances, but he was unable to save her life. He later found a doll floating in the water that he assumed belonged to the dead girl.

210

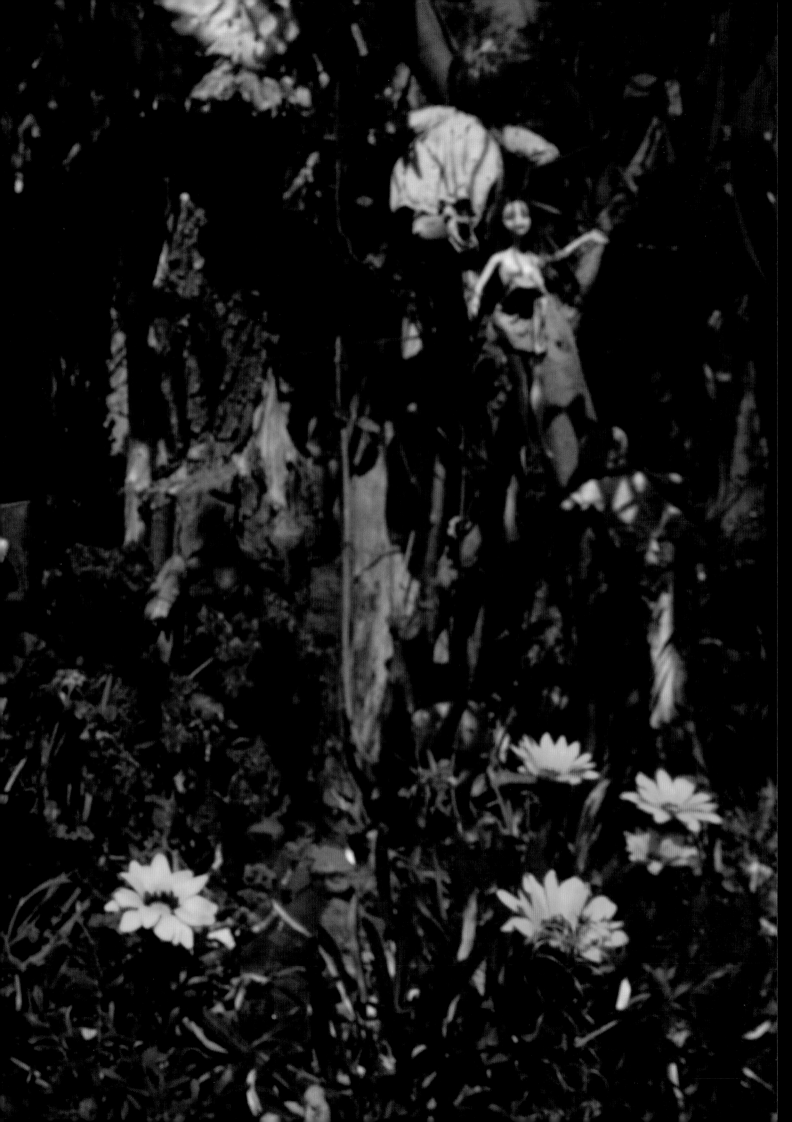

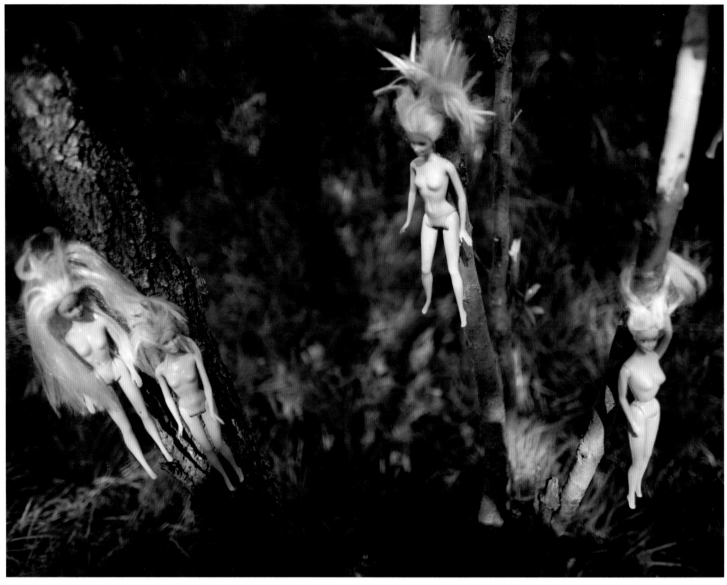

ABOVE:

Island of the Dolls, Xochimilco, Mexico City, Mexico

To appease the dead girl's spirit, Barrera hung the doll in one of the trees. He hung more and more dolls in the trees, but began to feel that the dolls themselves were possessed by the spirits of young girls.

RIGHT:

Island of the Dolls, Xochimilco, Mexico City, Mexico

In 2001, Barrera was found drowned in the same spot as the girl had been some 50 years before. Since then the island has become notorious, attracting tourists who have brought their own dolls to hang in the trees.

OPPOSITE:

Island of the Dolls, Xochimilco, Mexico City, Mexico

Some who have visited the island claim that they have heard the dolls talking to each other, and seen their heads moving.

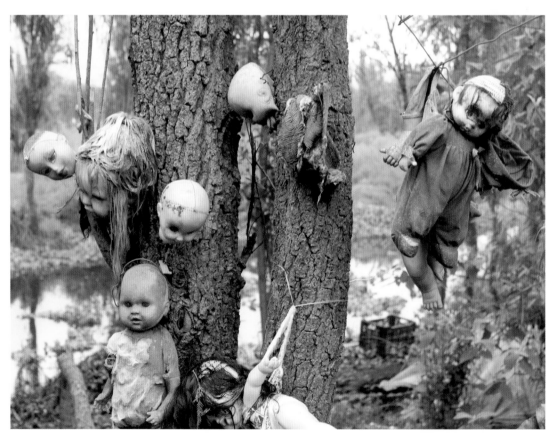

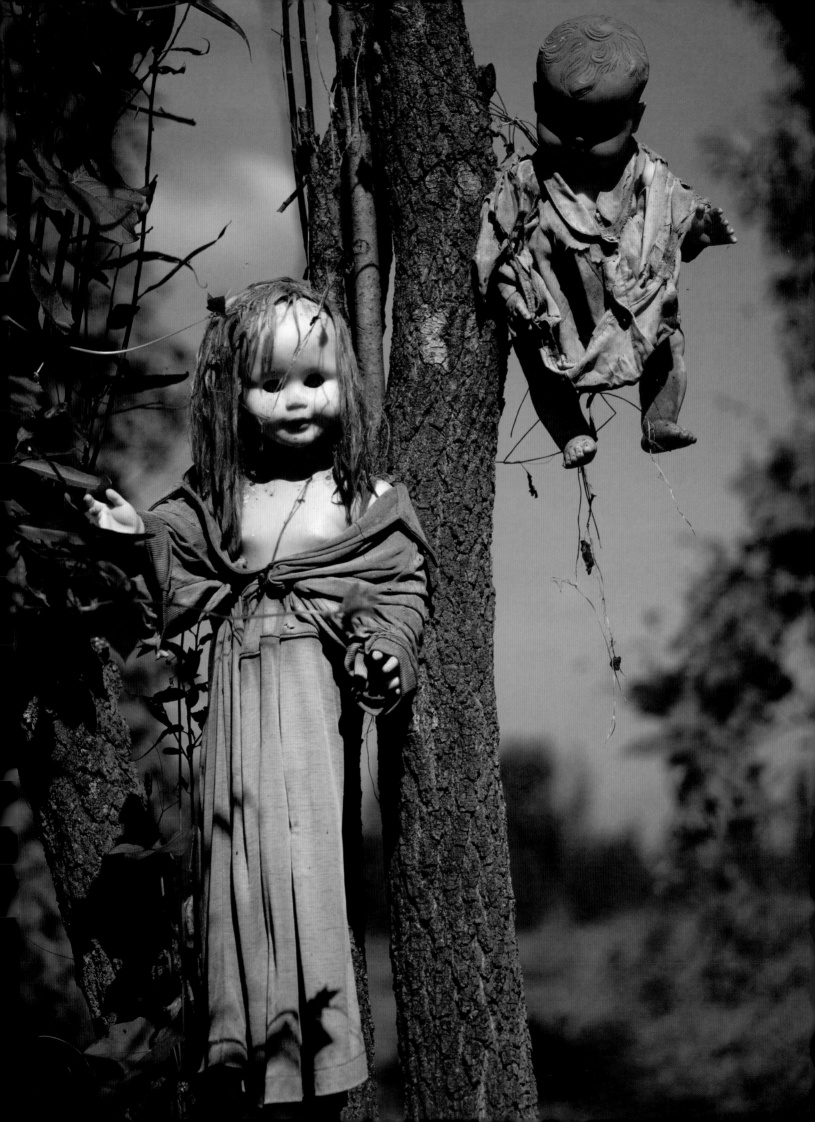

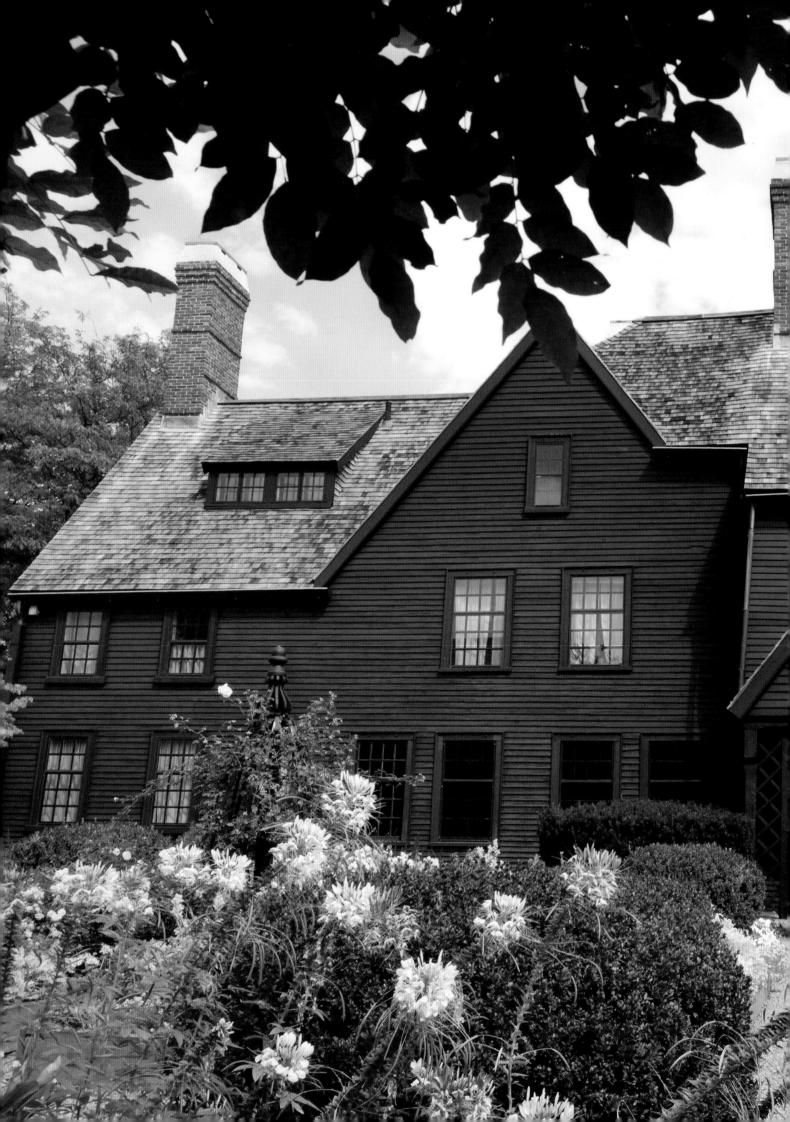

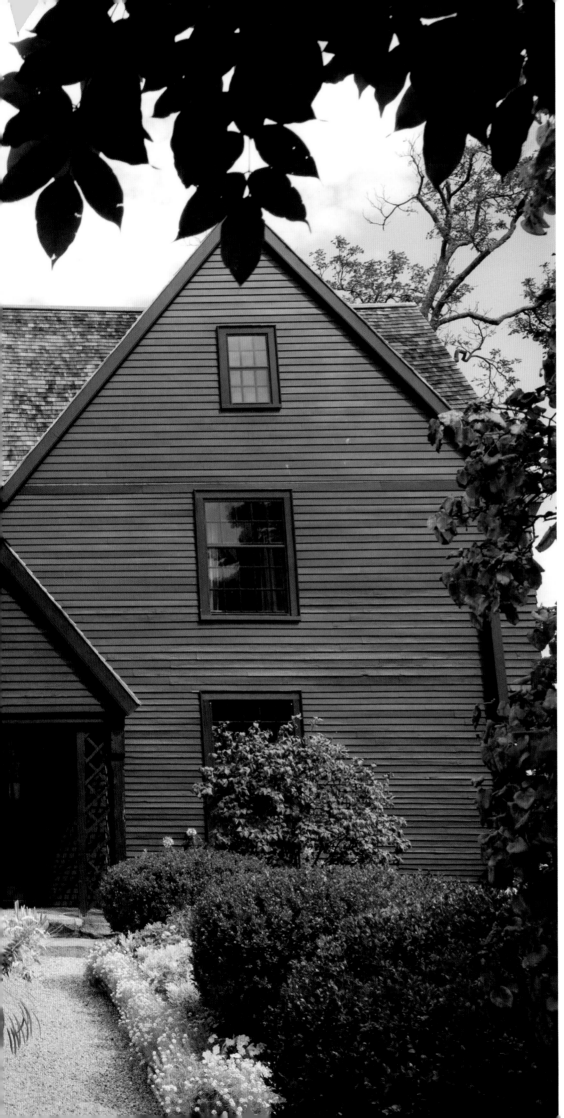

The House of the Seven Gables, Salem, Massachusetts, USA
Salem is known for its infamous witch trials that saw 19 people executed in the summer of 1692, but there are many other haunted sites in the town that attract over 250,000 visitors every October.

Gravestone, Salem, Massachusetts, USA
Bridget Bishop, owner of a tavern, was the first of the Salem witch trial's victims to be tried and executed. Her angry spirit is said to haunt a modern bar built on the site of an apple orchard that she owned, and Gallows Hill, where she was hanged on a gallows.

BRIDGE
HANGED
JUNE 10.

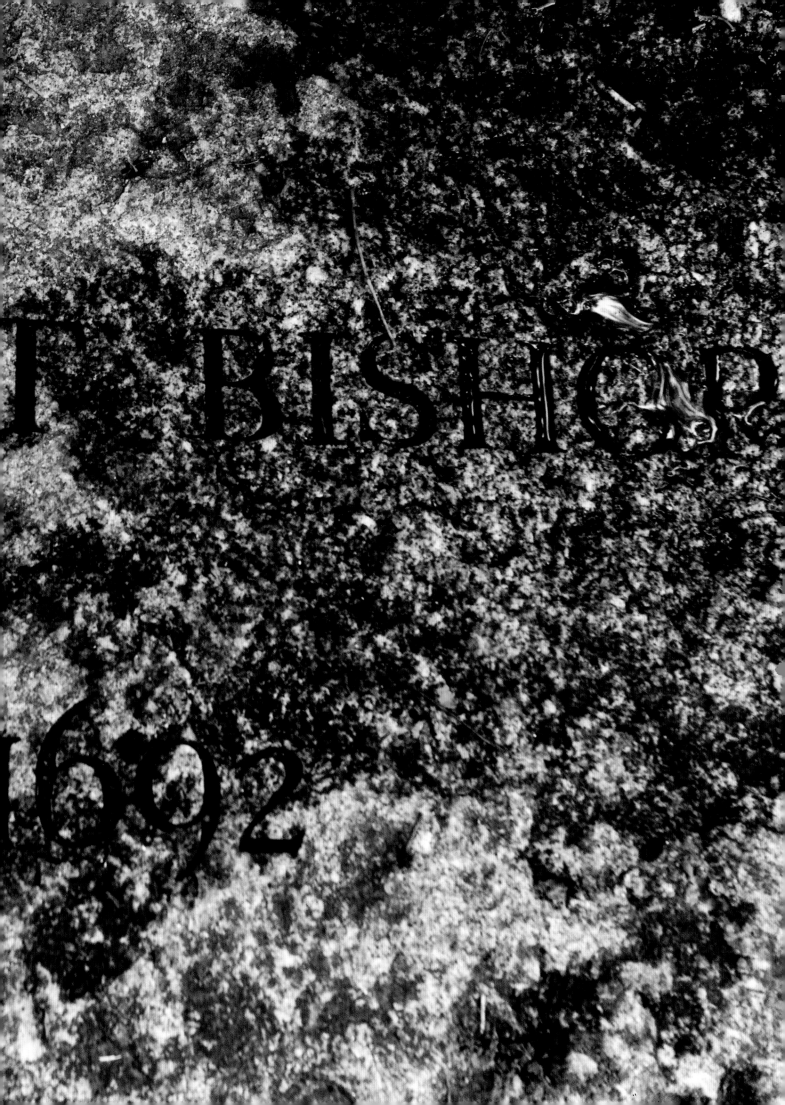

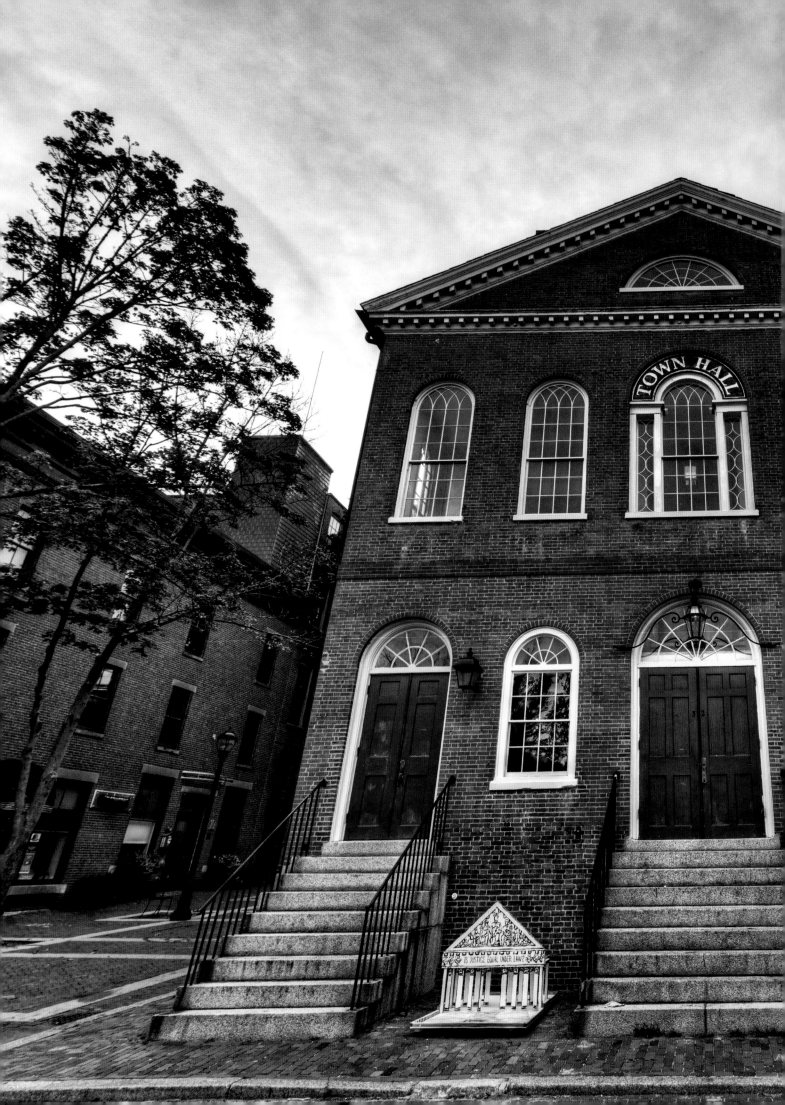

Museum, Salem, Massachusetts, USA

The history of the witch trials is told in the Salem museum, the former town hall, but many guides offer walking tours of the main haunted sites, including the Danvers State Hospital, built on the site of the house of one of the judges of the trials, whose spirit has been seen stalking the grounds. Other popular destinations include the House of the Seven Gables, haunted by a former resident, Susan Ingersoll, a relative of the author Nathaniel Hawthorne, and the old town jail, home of several restless spirits.

Chapel, Poveglia, Venice, Italy
The chapel on the island of
Poveglia in the Venetian lagoon
was once part of an asylum built
in the early 20th century, and later
abandoned. The doctor in charge
is supposed to have thrown himself
off the belltower after being
tortured by ghosts.

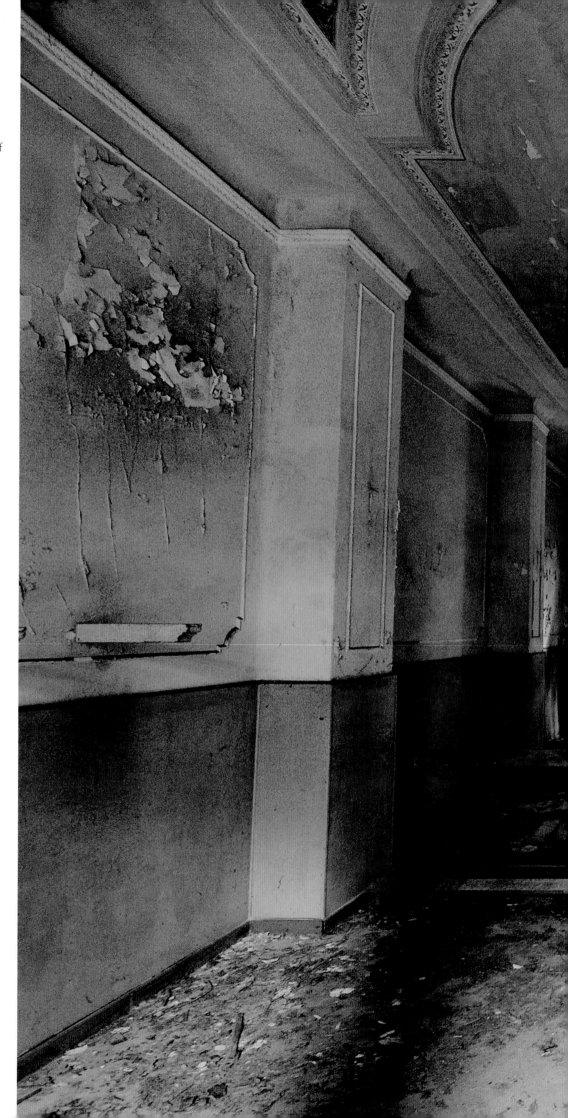

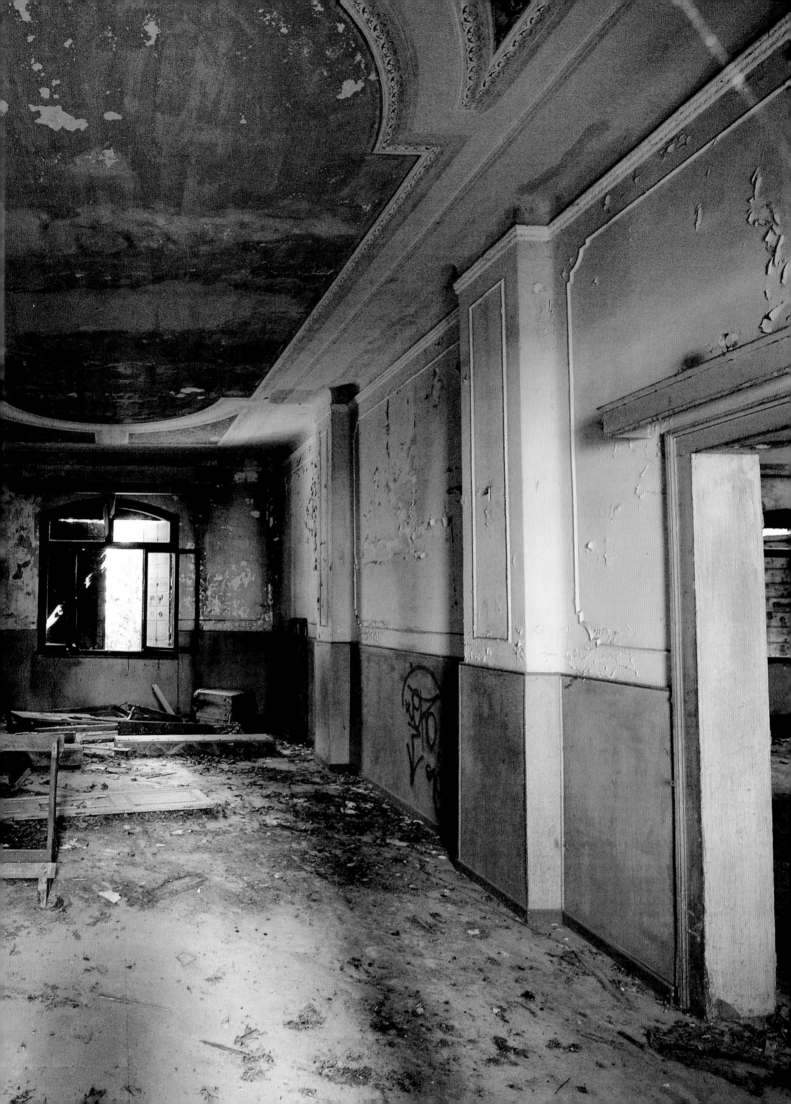

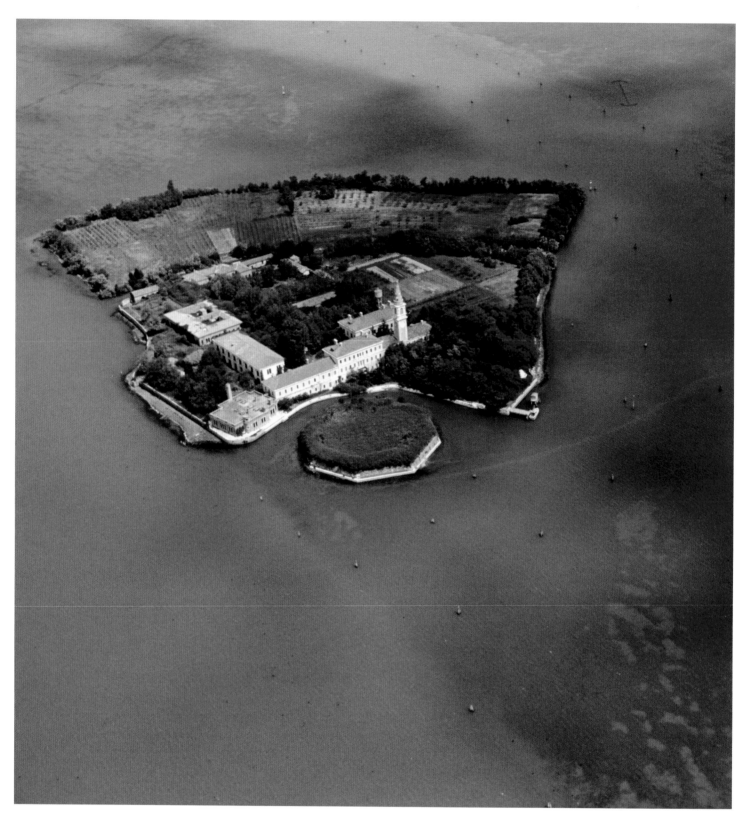

ABOVE:

Poveglia, Venice, Italy
The island was used in the 18th century as a quarantine station for ships arriving in Venice. Hundreds if not thousands died on the island of plague and other diseases, and many thousands more bodies of Venetian victims were buried there.

TOP RIGHT:

Mural, Poveglia, Venice, Italy
In one plague outbreak alone in 1576, about 50,000 people – one-third of the city's population – died, and there were 21 other attacks of the plague, including one in 1630–31 that killed 46,000.

BOTTOM RIGHT:

Mural, Poveglia, Venice, Italy
The island has a reputation for being full of restless souls, its soil more human remains than earth. The doctor who jumped is said to have survived thanks to a ghostly mist that rose from the ground, only for it to choke him to death.

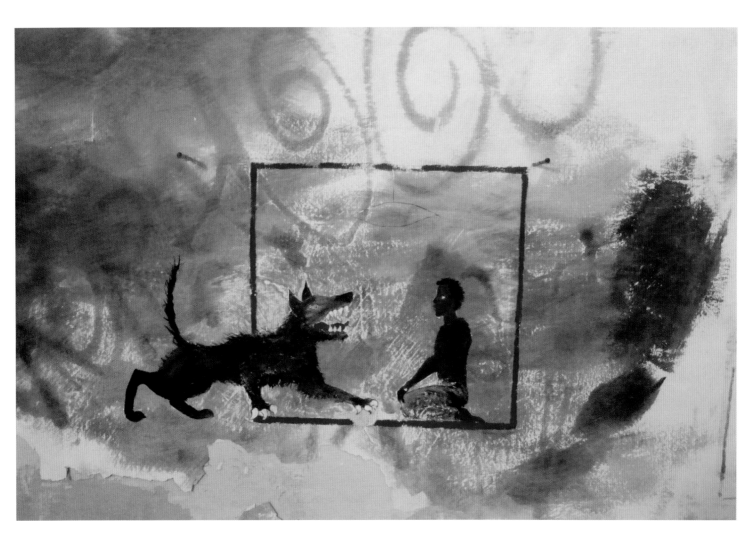

Picture Credits